PLAYS OF OUR OWN

Plays of Our Own is the first anthology of its kind containing an eclectic range of plays by Deaf and hard-of-hearing writers. These writers have made major, positive contributions to world drama or Deaf theatre arts.

Their topics range from those completely unrelated to deafness to those with strong Deaf-related themes such as a dreamy, headstrong girl surviving a male-dominated world in Depression-era Ireland; a famous Spanish artist losing his hearing while creating his most controversial art; a Deaf African-American woman dealing with AIDS in her family; and a Deaf peddler ridiculed and rejected by his own kind for selling ABC fingerspelling cards. The plays are varied in style – a Kabuki western, an ensemble-created variety show, a visual-gestural play with no spoken nor signed language, a cartoon tragicomedy, historical and domestic dramas, and a situation comedy. This volume contains the well-known Deaf theatre classics, *My Third Eye* and *A Play of Our Own*.

At long last, directors, producers, Deaf and hearing students, professors, and researchers will be able to pick up a book of "Deaf plays" for production consideration, Deaf culture or multicultural analysis, or the simple pleasure of reading.

Willy Conley is a retired professor/chairperson of Theatre and Dance at Gallaudet University in Washington, D.C. He is an award-winning playwright who has been widely published and produced. His recent book was *Visual-Gestural Communication: A Workbook in Nonverbal Expression and Reception* (Routledge, 2019).

Routledge Series in Equity, Diversity, and Inclusion in Theatre and Performance

Series Editor – Brenda Foley

The Equity, Diversity, and Inclusion (EDI) book series is an interdisciplinary forum for exploring diverse identities, concepts, practices, and people in theatre and performance. Through the series, the Theatre and Performance division at Routledge aims to expand its current offerings, in response to an overwhelming call to action by participants in the field. The new series reflects both a structure and an ethos, cutting across existing Routledge categories of theatrical production, theatre studies, and research monographs as a means to increase visibility and address the historical exclusion of marginalized voices.

The EDI series' commitment to diversity includes – but also extends beyond – that which we know to be lacking in the field of theatre and performance. We welcome proposals that expand our perspectives and that of the field and look forward to reading your submissions.

Fire Under My Feet
History, Race, and Agency in African Diaspora Dance
Ofosuwa M. Abiola

Plays of Our Own
An Anthology of Scripts by Deaf and Hard-of-Hearing Writers
Willy Conley

Stages of Reckoning
Antiracist and Decolonial Actor Training
Amy Mihyang Ginther

For more information about this series, please visit: https://www.routledge.com/Routledge-Series-in-Equity-Diversity-and-Inclusion-in-Theatre-and-Performance/book-series/EDI

PLAYS OF OUR OWN

An Anthology of Scripts by Deaf and Hard-of-Hearing Writers

Willy Conley

LONDON AND NEW YORK

Cover Image Credit: Willy Conley

First published 2023
by Routledge
4 Park Square, Milton Park, Abingdon, Oxon OX14 4RN

and by Routledge
605 Third Avenue, New York, NY 10158

Routledge is an imprint of the Taylor & Francis Group, an Informa business

© 2023 selection and editorial matter, Willy Conley individual chapters, the contributor

The right of Willy Conley to be identified as the author of the editorial material, and of the authors for their individual chapters, has been asserted in accordance with sections 77 and 78 of the Copyright, Designs and Patents Act 1988.

All rights reserved. No part of this book may be reprinted or reproduced or utilised in any form or by any electronic, mechanical, or other means, now known or hereafter invented, including photocopying and recording, or in any information storage or retrieval system, without permission in writing from the publishers.

Excerpt from "Above the Entrance to an Ancient Italian Cemetery, a Sign" by Joseph Castronovo used by permission of Gallaudet University Press. From *No Walls of Stone: An Anthology of Literature by Deaf and Hard of Hearing Writers*, edited by Jill Jepson, copyright (c) 1992 by Gallaudet University.

Trademark notice: Product or corporate names may be trademarks or registered trademarks, and are used only for identification and explanation without intent to infringe.

British Library Cataloguing-in-Publication Data
A catalogue record for this book is available from the British Library

Library of Congress Cataloging-in-Publication Data
Names: Conley, Willy, editor. Title: Plays of our own: an anthology of scripts by deaf and hard-of-hearing writers / [edited by] Willy Conley. Description: New York : Routledge, 2022. | Includes bibliographical references and index. |
Identifiers: LCCN 2022035290 (print) | LCCN 2022035291 (ebook) | ISBN 9780367632380 (hardback) | ISBN 9780367632373 (paperback) | ISBN 9781003112563 (ebook)
Subjects: LCSH: Deaf, Writings of the, American. | American drama—21st century. | Deaf authors.
Classification: LCC PS591.D4 P53 2022 (print) | LCC PS591.D4 (ebook) | DDC 810.8/035287—dc23/eng/20221003
LC record available at https://lccn.loc.gov/2022035290
LC ebook record available at https://lccn.loc.gov/2022035291

ISBN: 9780367632380 (hbk)
ISBN: 9780367632373 (pbk)
ISBN: 9781003112563 (ebk)

DOI: 10.4324/9781003112563

Typeset in Bembo
by codeMantra

To Deaf and hard-of-hearing playwrights

those no longer with us
thank you for creating inroads and showing us the way

those still writing
keep at it while exploring new ground

those in the future
uplift our Deaf culture and stories
to the world stages of tomorrow

In my sleep
Chants an old man in signs
"Those people lie in the dark!"

In my dream
Chants the old man in signs
"Go fetch the old book!"

In my rouse
Chants the old man in signs
"They shall rise!"

Joseph Castronovo
from *Above the Entrance to an Ancient Italian Cemetery, a Sign*

CONTENTS

Acknowledgments		*ix*
Contributor Biographies		*xi*

	Introduction	1
1	*The King of Spain's Daughter*★ by Teresa Deevy	10
2	*My Third Eye* by The National Theatre of the Deaf Ensemble	30
3	*A Play of Our Own* by Dorothy Miles	67
4	*The Ghost of Chastity Past or The Incident at Sashimi Junction*★ by Shanny Mow	111
5	*DEAF SMITH: The Great Texian Scout* by Stephen C. Baldwin	123
6	*WomanTalk* by Bruce Hlibok	143
7	*25 Cents* by Aaron Weir Kelstone	174
8	*META* by Patricia A. Durr	191
9	*The Middle of Nowhere* by Michele Maureen Verhoosky	226

10	*A Not So Quiet Nocturne* by Jaye Austin Williams	269
11	*Profile of a Deaf Peddler* by Mike Lamitola	315
12	*Goya – en la Quinta del Sordo (in the house of the deaf man)* by Willy Conley	336
13	*Reflections of a Black Deaf Woman* by Michelle A. Banks	368
14	*Lost in the Hereafter*★ by Sabina England	389
	Afterword	427

★ Denotes a play not about the Deaf experience, a D/deaf or hard-of-hearing person, nor Deaf culture.

ACKNOWLEDGMENTS

It would be very easy for me to simply say thank you, rattle off a list of names of those who helped me, and walk off the stage. To avoid lifelong guilt if I were to do that, here are my words of appreciation to those who contributed much time, thought, and energy in some capacity toward the creation of this tome.

For all information and materials related to Teresa Deevy, the following people were invaluable to me: Jack Deevy, Una Kealy, Hugh Murphy and Maynooth University, Jonathan Bank, and Peggy McHale. And, to Dr. Eibhear Walshe and Eric Malzkuhn – thank you for introducing me to this exceptional writer and her phenomenal achievements.

I am very grateful to Don Read, Lilly Shirey, and Joan Naturale on all materials and issues related to Dorothy Miles.

Those who offered tremendous assistance in compiling the elements of Bruce Hlibok's chapter were Albert and Peggy Hlibok (script and photos), Monique Holt and Ellen Roth (press articles and personal views), Ann Marie "Jade" Bryan (director of the DVD, On and Off Stage – The Bruce Hlibok Story), and especially Gregory Hlibok, who facilitated getting me most of the nitty-gritty details I needed regarding his older brother's work.

Many thanks to Linda Lamitola who was very generous in handing over all of the script and production contents of her late husband Mike Lamitola.

The assembly of the chapter on My Third Eye would not have happened without the huge help of Harvey Corson, who acted as my liaison with the NTD board toward getting permission to print the script; Paul Winters, former NTD executive director, and Craig Daigle, who years ago arranged and sent me a copy of the script; Patrick Graybill and Tim Scanlon, who addressed many of my questions about the script and their involvement as original members of the ensemble; and David Hays, former NTD founder and artistic director, who also answered some of my questions on the play.

Acknowledgments

I wish to thank the following at Gallaudet University for aiding me in my research, writing, and search for contacts: Ethan Sinnott, Theatre and Dance program director; Juanita Cebe, coordinator of Theatre Operations; Patrick Harris and Matthew Harchick, Video Services; and Christopher Shea, Archives.

To Jaye Austin Williams and Michelle Banks – much obliged for your help in digging up production info on A Not So Quiet Nocturne.

When I ran into a dead-end with trying to locate a production photo, playwright Michele Verhoosky volunteered to paint her own, for which I am extremely thankful.

For this anthology's introduction, special thanks go to Nicholas Taylor of NYU Press for permission to reprint parts of my book chapters from Deaf World, and to Erin Salvi of TCG Books for allowing me to use segments from my *American Theatre* magazine article.

Patti Durr and Karen Christie – hearty hand-waves to you two for having created the rich, multimedia/web resource, The HeART of Deaf Culture, and allowing me to use parts of it.

The following offered wonderful guidance as I was compiling this anthology over the years: Steve Baldwin (including photos, contacts, and information), Tim McCarty, Aaron Weir Kelstone, and Shanny Mow – my old pal, NTD tour roomie, drinking buddy, and walking playwriting companion/encyclopedia/guide.

To Jacqui Deevy, Mint Theater Company, New York Deaf Theatre, Annie Wiegand, Kayleigh Marshall, Sabrina Bergman, Eugene Bergman, Liz Deverill, Gallaudet University Theatre and Dance, and Jacob Fisher, who contributed (or were instrumental in helping me locate) photographs: I am forever grateful for your help in validating our art and history.

To Kitty Conley, James Selby, Leslie Smith, and Helen Frost, who read portions of this book: Your thoughts and feedback were of tremendous value to me.

To Edna Sayers, my ever-steady writing and editing colleague and friend – I always cherish your feedback and guidance. You make me a better writer.

To Barbara Frost and Barbara Schum – working your copy-editing and copy-typing magic was much appreciated.

A special thanks to the following for their contributions to the early development of this book: Samantha Beaver, DawnSignPress, Dr. Don Bangs, Eugene Bergman, Ingrid Leonard, and Alison Appenzellar.

Ingrid Weidner, mein Liebe – I am indebted to you for all of your help in digitizing most of the scripts, providing constructive thoughts on aspects of the manuscript, and giving moral support throughout the past year when I made the final push to consolidate everything.

And, finally – an exuberant shout-out to my Routledge editorial team Laura Hussey, Brenda Foley, and Swati Hindwan. All of you were kind, professional, and supportive throughout the entire process.

CONTRIBUTOR BIOGRAPHIES

Stephen C. Baldwin, a retired educator from Austin, TX, holds a BA in History, an MA in Deaf Education, and a PhD in Theatre History, Theory, and Criticism. Baldwin has had 26 plays produced, most related to Deaf culture and history. He is the author of *Pictures in the Air: The Story of the National Theatre of the Deaf* (Gallaudet University Press), and *Backspace*, a novella (Savory Words Publishing).

Michelle A. Banks, a native of Washington, D.C., is an award-winning actress, writer, director, producer, choreographer, motivational speaker, and teacher. She co-wrote the plays *There's Butter, But No Bread* – an adaptation of *Waiting For Godot*, and *Black Women Stories: One Deaf Experience* for Onyx Theatre Company. Banks holds a bachelor's degree in Drama Studies from the State University of New York at Purchase and a master's degree in Organizational Management from Ashford University. She founded Onyx Theatre Company in New York City, the first Deaf theater company in the United States for people of color. Currently, she is the Artistic Director of Visionaries of the Creative Arts in D.C.

Willy Conley, originally from Baltimore, MD, is a retired professor and former chairperson of the Theatre Arts Department at Gallaudet University in Washington, D.C. Conley, who has an MA in Playwriting from Boston University and an MFA in Theatre from Towson University, is an award-winning playwright whose work has appeared in numerous publications and productions internationally. He is the author of *The World of White Water – Poems, Listening Through the Bone – Collected Poems, The Deaf Heart – a Novel, Vignettes of the Deaf Character and Other Plays, Broken Spokes, Visual-Gestural Communication – a Workbook in Nonverbal Expression and Reception,* and *Broken Spokes*.

Teresa Deevy, a prolific and established Irish playwright of the early 20th century, studied at University College Dublin and University College Cork. Beginning in the mid-1920s, the Abbey Theatre produced her plays *Reapers, A Disciple, Temporal Powers, The King of Spain's Daughter, Katie Roche,* and *The Wild Goose.* She was elected to the Irish Academy of Letters in 1954.

Patricia A. Durr was a founding member, artistic director, and board member of LIGHTS ON! for a number of years. An award-winning filmmaker, she has written, directed, and produced *The Grey Area: His Date/Her Rape, HIV/AIDS Prevention for Deaf, Me Too, Exodus, Worry,* and *Don't Mind?* She holds an MS in Deaf Education from the University of Rochester/NTID and a BA in Sociology from LeMoyne College and is a retired professor of Deaf Cultural Studies and Social Sciences at NTID in Rochester, NY.

Sabina England is a fully Deaf playwright, performance artist, and award-winning filmmaker. She graduated with a Bachelor of Arts in Theatre from the University of Missouri and a certificate in Filmmaking from London Film Academy. Her plays have been produced in London, UK, at such locations as Soho Theatre, Tristan Bates Theatre, Theatre Royal Stratford East, and East 15 Acting School: *How the Rapist was Born*; *A Study of the Human Condition*; *I Love to Eat, Drink and be Sad*; *Chess for Asian Punks, Greek Losers, and Dorks*; and *Dear Me, Where's My Angel?* She currently lives and works in St. Louis, Missouri.

Bruce Hlibok, from New York City, was a playwright, director, and the first Deaf actor to play a Deaf character on Broadway performing in the 1978 hit musical, *Runaways*. His plays *Going Home, The Passion of Rita H,* and *WomanTalk* were produced off-off Broadway. He is the author of the children's book, *Silent Dancer*.

Aaron Weir Kelstone has been an actor, director, playwright, an artistic director, and business administrator for various theater organizations over the past 15 years. He has an MA degree in English Literature from Cleveland State University, and an EdD in Education from Northeastern University. He is currently a principal lecturer at the National Technical Institute for the Deaf in Rochester, NY, and also serves as the development officer for the Department of Performing Arts.

Mike Lamitola was a teacher, actor, playwright, storyteller, and advocate, devoted to Deaf theater. After earning his degree in Social Work from RIT, he toured with the National Theatre of the Deaf as an actor to 49 states and abroad and conducted numerous theater workshops. He served for 14 years as a faculty member for Gallaudet University's Young Scholar's Program.

Dorothy Miles graduated from Gallaudet University (1961) with distinctions and performed with the National Theatre of the Deaf. Perhaps the best-known British Sign Language poet, Miles is the author of the books, *Bright Memory: The Poetry of Dorothy Miles*, *British Sign Language – a beginner's guide*, and *Gestures: Poetry in Sign Language*.

Shanny Mow, formerly of Santa Fe, NM, was often associated with the NTD as an actor, resident playwright, director, and instructor of acting and playwriting. He adapted Homer's *The Iliad*, *The Odyssey,* as well as *Gilgamesh* and *Parzival, From the Horse's Mouth*, which was performed at the Kennedy Center. As former artistic director of Fairmount Theatre of the Deaf – which became Cleveland SignStage Theatre – he wrote and directed *Counterfeits*, nominated for 1995 American Theatre Critics Association New Play Awards. His other works include *The Cat Spanking Machine*, *Love Thy Neighbor*, *Letters from Heaven*, *Shakespeare Unmasked*, *La Leyenda de la Llorona,* and *Bell in Hell*.

The National Theatre of the Deaf Ensemble, originally based at the O'Neill Theatre Center in Waterford, Connecticut, created and performed *My Third Eye*. The company comprised ten deaf actors, two hearing actors, and one hearing musician: Fredricka Norman, Patrick Graybill, Richard Kendall, Timothy Scanlon, Mary Beth Miller, Dorothy Miles, Linda Bove, Edmund Waterstreet, Joseph Sarpy, Bernard Bragg, Dave Berman, Carol Flemming, and Kenneth Swiger. For over 50 years, NTD has toured all over the world performing simultaneously in two languages: for the eye, American Sign Language, and for the ear, the spoken word.

Michele Maureen Verhoosky studied creative writing and theater arts at Emerson College, and graduated Phi Beta Kappa/Magna cum Laude from UCONN. Her award-winning plays include *A Laying of Hands*, *I See the Moon*, *The Middle of Nowhere*, and *Beyond the Blue,* a new original play at the 6th Annual Women on Top Theater Festival in Cambridge, MA.

Dr. Jaye Austin Williams is assistant professor and C. Graydon and Mary E. Rogers faculty fellow in the Department of Critical Black Studies at Bucknell University (Lewisburg, PA), where she specializes in the melding of drama, cinema, performance, and Black Feminist theories with Critical Black Studies. She worked for 30 years in professional theater as a director, playwright, actor, and consultant, on and off Broadway and regionally, including being director-in-residence for Onyx Theatre Company in New York City throughout the 1990s.

INTRODUCTION

In the United States and abroad, there has been a rapid growth of programs in American Sign Language (ASL), Deaf Studies, Deaf Education, Deaf History, ASL teacher's training programs, linguistics of sign language, and sign language interpreting. American universities are beginning to recognize ASL as a foreign language. Some primary and secondary schools teach students basic sign language. Occasionally, in the hearing world, parents learn that their infants can acquire language earlier via sign language, reducing frustration and temper tantrums by communicating early needs before the development of speech. We are seeing more and more Deaf and hard-of-hearing actors in plays, films, and TV shows. What all of this seems to indicate is an emerging and significant interest in the art, culture, and language of Deaf and hard-of-hearing people.

Throughout my 30 years of teaching theater at Gallaudet University, the world's only liberal arts college for deaf and hard-of-hearing people, I received many requests from deaf and hearing students, faculty, as well as national and international scholars to read my scripts or those of other Deaf playwrights. Every so often, producers and directors contacted me asking for "Deaf" scripts. Since there are currently no such published collections on bookshelves, I sensed it was time to assemble a pioneer compendium of plays by Deaf and hard-of-hearing writers.

Throughout this volume, the use of the capital letter D in the word "deaf" denotes an individual's or group's cultural and linguistic identification with the global Deaf community and its use of sign language. Often, people who are Deaf have great pride in their identity and typically do not see themselves as having a disability. A lowercase d in the word deaf simply indicates the medical/audiological status of one's hearing loss. Such a person usually does not identify as being culturally Deaf or belonging to the Deaf community.

This collection is by no means definitive. Many other Deaf and hard-of-hearing writers worldwide have written good plays, in different languages, some in collaboration with hearing writers. And some have created intriguing plays from a visual base that would be impossible to publish in written form; another volume, perhaps a series of visual plays in DVD form or in an online video streaming service, could be filled with such scripts.

The plays selected here are by Deaf and hard-of-hearing writers, mostly from the United States, who have made major, positive contributions to world drama or Deaf theater arts. Their topics range from those completely unrelated to deafness to those with strong Deaf-related themes. Some of the plays have had culturally significant productions in university or community theaters, while others have had professional productions. Some have had years of development attention in nurturing, artistic homes, while others have had little support for development or have been developed to death with no real hope of a full-scale, professional production.

These plays and their varied production histories seem to reflect our fractured Deaf theater community as well as Deaf culture and the deaf and hard-of-hearing community. A part of our Deaf artistic community has been decimated by AIDS, severe medical issues, or suicide. Many artistic deaf people have never joined the Deaf community due to the rapid, worldwide emergence of cochlear implants in deaf-born infants. Further, the dearth of viable training facilities, professional networks, and funding for Deaf theater artists has impeded young people from advancing their craft and hindered them in operating and sustaining their theaters.

The writers in this volume have made an extra effort at furthering communication and surpassing cultural or language barriers. First, being Deaf is about the challenges and joys of language access (or, if taking the medical viewpoint, it is about speech and language pathology). Second, it goes without saying that theater is a language art. Deaf playwrights must deal with these two facts. What follows in this collection are the various ways they have dealt with both facts – not only in how the scripts were composed (how they are conceived and how they are recorded), but what themes they explore.

Some of the accessible methods that the writers have invented to address those challenges and inequities include shadow characters that sign the lines of hearing characters. Some have created minor characters in inconspicuous roles to voice for deaf characters. A few have written dialogue that is easy to translate into signs and yet read idiomatically in English. One playwright used the Japanese theater convention of having the storytellers voice for the main characters, while some have created text slides, projections, visual media, and shadow play to eliminate the need for signing or voicing. And then there are those who wrote knowing that a director will probably go with the Deaf theater default set-up of having offstage voice actors dramatically read the lines of deaf characters. All of the playwrights herein are coming out of personal and cultural experiences of language access challenges (and joys); therefore, this affects how they write their plays and the topics they choose to write about.

Upon graduating from college, I worked in various places around the country during the 1980s–1990s, finding few, if any, sign language plays or deaf actors. If I was lucky, I could catch a Deaf theater company on tour or a community production in sign language once or twice a year. Usually, I would have to drive over a hundred miles or fly somewhere to see something. If nothing was happening, I went to see hearing plays, which were everywhere. Very few were sign-interpreted; most were static with talking heads against pretty backdrops.

In her article, *Theatre By and For the Deaf*, Hilary Cohen noted that sign-interpretation of spoken plays has been the "most widely known technique for making performances accessible to the deaf in the U.S."[1] Yet, contrary to popular belief, simply providing sign language interpreting does not create equal access for Deaf audiences. Interpreters are usually placed off to the side of the stage where they sit or stand immobile in a small spotlight. They translate the spoken text to the Deaf audience during performances created chiefly for the hearing audience. That is to say, these performances are produced with a focus on speech rather than movement.

For Deaf theater artists and audiences watching a sign-interpreted show, it is much like reading a script – it isn't close to what Philip Cook calls the "total theatre" experience. Cook pointed out in *How to Enjoy Theatre* that the playwright makes a concerted effort to engage all of the human senses to communicate and stimulate a reaction from the audience.[2] Technically, this is impossible to achieve for a Deaf audience corralled off to a small section on one side of the theater, their eyes darting back and forth between the interpreter off stage and the actors on stage. The rich language of the playwright gets watered down, and the subtleties in acting, directing, and design are lost. In *The Essential Theatre*, Oscar Brockett wrote what I believe many Deaf audience members dream of: "[to] go to the theatre hoping to be fully caught up in the performance, …too involved to pass judgment on what we are seeing."[3]

Inaccessibility narrows the vision of Deaf theater artists by making them work alone, or mostly with each other, limited to only viewing one another's work. As a result, they are prevented from (or delayed in) achieving the standard of excellence in their craft that would emerge in a wider field. Hearing theater artists are relatively advanced in their field because they see (and hear) lots of theater anytime, anywhere, and accessibly. They don't even have to read a script before seeing a play. This advancement in knowledge of stagecraft seems to stem partly (primarily, perhaps?) from incidental learning, which is accidental and unplanned rather than deliberate. This is a concept that hearing people in general tend to take for granted and may not seriously consider when it comes to the education of the deaf. Minor examples of incidental learning may be listening to NPR or a podcast on the radio while driving a car, or overhearing conversations in public spaces while in transport to another place – not to mention frequently seeing and hearing a wide variety of plays at any time that tickets are available. A hearing writer would also pick up snippets of conversation which could spark ideas for dialogue in a play or learn about some new or innovative theater technique

from an interview with a renowned theater artist. An English-speaking writer has accessibility to a very large world of culture in general, and to a sizeable and diverse theater world specifically.

In their book, *Turning the Tide*, Oliva and Lytle point out the importance of full communication access for Deaf and hard-of-hearing students in predominantly hearing schools. What these students miss – from conversations among hearing peers in hallways, buses, classrooms, club meetings, sports teams, announcements over the public address system, teachers talking with their backs turned to the class, etc. –

> …has serious consequences to [their] social-emotional development…. Deaf and hard of hearing children are several years behind in the development of pragmatic language [language used for social purposes]. Hearing children seem to learn this kind of language through incidental learning. Deaf children learn the same concepts much more slowly, imperfectly, and often need direct instruction simply because they are not picking up peer conversations. Anything that can be done to remedy that will improve life for deaf and hard of hearing children.[4]

This somewhat reflects the plight of Deaf playwrights, and theater artists, trying to make it and keep up in the professional hearing theater industry. Most of the Deaf and hard-of-hearing playwrights in this book are (or were) fluent in ASL. Unlike hearing playwrights of the English language who may occasionally incorporate dialect or second languages, many Deaf playwrights must work with the Deaf community's minority signed language, in most cases ASL, and its many dialects, as well as a range of signed English systems. They have the added task of considering the most accurate and efficient way of expressing this polyglot dialogue in written English. Due to its visual linguistic structure, ASL itself has no written form that is in general use among Deaf signers. Additionally, Deaf playwrights have to contend with writing down linguistic and cultural considerations like Simultaneous Communication (Sim-Com), Word-Codes, English glosses, bilingual puns and double-entendres, finger-alphabet play, pantomime scenarios, sign-mimes, Visual-Vernacular story sequences, and Deaf community traditions.

It is an incredible challenge to find a standardized way to create specific sign dialogue on the page, especially in a way that will be understood by other theater artists, let alone influential producers and directors. This is most likely one of the reasons that the hearing-operated theater industry rarely finds Deaf-written plays worth developing, nurturing, and producing in major professional playhouses. Nevertheless, we carry on doing our best to find ways to keep getting our work read and put up on a stage somewhere no matter how limited the run, audience, venue, production circumstances, or financial situation.

Typically, the signing actor, often the Deaf actor, must analyze his or her role to determine how to develop the manual communication mode most appropriate to

the character. The range of options include: universal gestures, pantomime, ASL with a grass roots feel, ASL with a regional dialect, ASL from a college-educated Deaf family, Signed English of a bilingual-bicultural background, Pidgin Signed English (sometimes euphemistically known as "Gallaudet signing"), Signed English of a strict English language education via word for word signs, to "Signing Exact English" an encoding system for spoken English that uses signs in conceptually incorrect ways to transcribe all of the prefixes, suffixes, contractions, and idiosyncrasies of the English language. One could go as far as Cued Speech with its little hand codes around the mouth. And, then there's Oralism, which uses no signs, and its sometimes valiant yet tragic attempts at speaking and lip-reading. Oralism is not manual communication, and Cued Speech is not commonly used or understood in the Deaf community, however both come with a whole set of comic or dramatic choices and faux pas for the playwright or actor.[5] Some of the plays in this compilation display the playwrights' diverse approaches to staging signed dialogue.

One may ponder why Deaf playwrights with a sign language background would use English to express their visual, three-dimensional, mobile language in a script. To record sign language as stage dialogue on paper would be like drawing a card stack of animated figures that indicate movement in their arms, hands, and faces, and then flipping through the cards like an old-fashioned peep show to read the signs. A Deaf playwright may use video to develop a script, but that would require a cumbersome combination of a video camera (or a smart phone camera), video-editing equipment or software, editing skills, and a considerable chunk of time splicing, structuring characters and signed dialogue into scenes, and, of course, it assumes a "reader" who is fluent in the Deaf language continuum.

Video recordings have been used to record raw footage of improvisations, which resulted in producing written lines in English. It is much easier to watch a video clip, rewind or fast-forward, and hit the Play/Pause button to jot down useful extracts of improvised ASL dialogue into English. Then, the playwright can shuffle around the English dialogue and structure it into an industry-standard playscript format with a word processor.[6]

As they say in the theater business, a script is just a blueprint for a play. In scripts written by hearing playwrights, one can see acting and voicing possibilities to explore during the rehearsal process. With scripts written by Deaf playwrights, there is the additional layer of sign dialogue and movement with all of its endless choices mixed in with the voices and acting possibilities. This maximizes the dramatic potential of a theatrical production.

It is interesting to note that in Broadway history, a number of well-known plays involving deafness or deaf character(s), to some extent, were written by hearing writers and with hearing protagonists, through whom the audience sees the deaf character. Three of the plays won a Tony Award for Best Play: *The Miracle Worker* by William Gibson, *Children of a Lesser God* by Mark Medoff, and *Clybourne Park* (also a Pulitzer-Prize-winning spin-off of Lorraine Hansberry's

play, *A Raisin in the Sun*) by Bruce Norris. *Johnny Belinda*, penned by Elmer Harris, led to the famous film adaptation that won Jane Wyman an Oscar for Best Actress in the title role of a deaf character. Other plays were: *Runaways* (in which Bruce Hlibok, one of the writers in this anthology, had a main role) by Elizabeth Swados (earned Tony Award nominations), *The Hands of Its Enemy*, by Mark Medoff, *Tribes* by Nina Raines (Drama Desk Award), *I Was Most Alive With You*, by Craig Lucas, *The Little Flower of East Orange*, by Stephen Adly Guirgis, *The Heart is a Lonely Hunter*, a novel written by Carson McCullers and adapted for the stage by Rebecca Gilman.

To explore this glut of cultural appropriation by hearing writers a little further, one could look at Deaf West Theatre's stage adaptations of *Big River* and *Spring Awakening*. Although both of these came from original stories that did not have deaf characters to begin with, they were adapted by hearing writers who included deaf characters (and perhaps Deaf actors) in collaborations with Deaf West.

Deaf culture theater is rarely recognized. According to JAMA and the National Association of the Deaf, over 48 million deaf and hard-of-hearing people reside in the United States, yet there has never been a play written by a Deaf or hard-of-hearing playwright that was produced on Broadway or in a LORT theater in America. Overseas, there is one comparable, significant accomplishment by Teresa Deevy, an Irish deaf playwright whose work was produced at the Abbey Theatre during the 1930s in Dublin, Ireland. It should be noted, however, that none of Deevy's plays involve deafness or deaf characters.

> The Gallaudet Encyclopedia of Deaf People and Deafness contains this unfortunate fact: '…no play with a deaf theme written by a deaf playwright has been produced by commercial theatre.' That statement was published in 1987 and is still true today.[7]

With the exception of Deevy, all of the Deaf and hard-of-hearing playwrights in this anthology were/are fluent in sign language. They have had the benefit of communicating in signs with actors and production team via sign language and/or with the help of production sign language interpreters who would facilitate communication during the rehearsal process. Since it is not economically feasible to cater only to the Deaf audience, I believe most of the playwrights in this volume have worked very hard to create ways to make their plays accessible to both Deaf and hearing audiences. After all, they have experienced barriers watching live theatrical performances created by hearing writers. The result of overcoming these barriers is the creation of these scripts – plays of our own. Therein lies the challenge of how to get non-ASL users to comprehend and appreciate these works of art since dealing with two languages and cultures on the page is quite complex. Ultimately, this leads to the very human desire we have had over centuries for a universal language, and in our case, universal accessibility.

Each chapter introduces the playwright, the script, a synopsis, the production history, and thoughts on the play. Some remarks in the "Thoughts on the Play" section were contributed by the writers themselves or their collaborators. This was to ensure that the reader had greater insight into the writers' thoughts on their process and work. Also, a statement on

> Deaf-gain" is included in every chapter. Deaf-gain is a term that upends the traditional understanding of Deaf people. The idea is to draw people's primary focus away from a person suffering a hearing-loss to one of a Deaf person's contribution to, or enjoyment of, life. It is also a reframing of people's perception so that they see the benefits rather than the deficits of "the unique sensory orientation of d/Deaf people.[8]

While the plays are listed in chronological order, they can also be grouped in specific categories found along the theater spectrum. To give the reader a better sense of where each play fits, the scripts have been classified into five groups: Deaf Culture Classics, Plays Unrelated to Deaf Culture, Historical Plays, Plays Involving Social Justice, and Domestic Dramas.

Deaf Culture Classics

My Third Eye – National Theatre of the Deaf Ensemble
A Play of Our Own – Dorothy Miles

The 1970s was a decade when Deaf playwrights came into being. This was most likely due to the heavy influence of the National Theatre of the Deaf and its connections to many world-renowned professional theater artists. These plays have lived long in the minds of the American Deaf community and among Deaf scholars. Video clips of some of these plays can be found in a good number of libraries online. They are mentioned in reputable books on Deaf literature, culture, and history. Some examples are: *Deaf World*, *The HeART of Deaf Culture*, *Pictures in the Air*, *Deaf Heritage*, *Deaf in America*, and *Deaf American Literature*.

Plays Unrelated to Deaf Culture

The King of Spain's Daughter – Teresa Deevy
The Ghost of Chastity Past or The Incident at Sashimi Junction – Shanny Mow
Lost in the Hereafter – Sabina England

The plays in this category do not have any mention of deafness in their stories despite the playwrights' hearing status as being deaf. This follows a similar approach that Obie-award-winning, Chinese-American playwright Henry David Hwang took when he wrote his play, *Rich Relations*, where none of his characters were Asian.

Historical Plays

DEAF SMITH: The Great Texian Scout – Steve Baldwin
Goya – en la Quinta del Sordo (in the house of the deaf man) – Willy Conley

These two scripts deal with aspects of the real lives of two famous people who happen to be deaf and had tremendous influence on people.

Plays Involving Social Justice

25 Cents – Aaron Kelstone
META – Patricia Durr
Profile of a Deaf Peddler – Mike Lamitola

Social issues featuring the struggles of/with deaf panhandlers, and a Deaf Holocaust survivor, figure prominently in these plays.

Domestic Dramas

A Not So Quiet Nocturne – Jaye Austin Williams
WomanTalk – Bruce Hlibok
The Middle of Nowhere – Michele Verhoosky
Reflections of a Black Deaf Woman – Michelle Banks

The characters that populate these plays are everyday Deaf people dealing with their individual problems at home. Sometimes deafness is a factor in their struggles, and sometimes it is not.

Not only do I hope that the plays in this volume will be enjoyed, produced, and critiqued, but that they also help validate, in both the academic community and the public eye, the work of Deaf and hard-of-hearing writers and their contributions. Out in the world, our "voices" may be silent, weak, or unintelligible, but in this collection, we "speak" strongly and clearly, straight from the eye, hand, and heart of Deaf people.

Segments of this introduction were taken from Conley's previous publications:

- Away From Invisibility, Towards Invincibility: Issues with Deaf Theatre Artists in America (Deaf World, *Lois Bragg, ed. NYU Press, 2001; used with permission*).
- In Search of the Perfect Sign Language Script – insights into the diverse writing styles of Deaf playwrights (Deaf World, *Lois Bragg, ed. NYU Press, 2001; used with permission*).
- From Lipreading Ants to Flying Over Cuckoo Nests. *Originally appeared in* American Theatre *magazine, Vol. 18, No. 4 (April 2001). Used with permission from Theatre Communications Group.*

Notes

1 Cohen, Hilary U. "Theatre By and For the Deaf." *TDR: The Drama Review* 33.1 (1989): 68–78.
2 Conley, Willy. "Away from Invisibility, Toward Invincibility – Issues with Deaf Theatre Artists in America." *Deaf World – a Historical Reader and Primary Sourcebook*. Ed. Lois Bragg. New York: NYU Press, 2001. 58–59.
3 Ibid., 59
4 Oliva, Gina and Lytle, Linda Risser. *Turning the Tide – Making Life Better for Deaf and Hard of Hearing Schoolchildren*. DC: Gallaudet University Press, 2015. 42.
5 Conley, Willy. "In Search of the Perfect Sign-Language Script." *Deaf World – a Historical Reader and Primary Sourcebook*. Ed. Lois Bragg. New York: NYU Press, 2001. 147–148.
6 Ibid., 148.
7 Conley, Willy. "From Lip-reading Ants to Flying Over Cuckoo Nest." *American Theatre*. April 2001. 60.
8 Bauman, H-Dirksen, and Joseph J. Murray. "Deaf Studies in the 21st Century: 'Deaf-gain' and the Future of Human Diversity," *The Oxford Handbook of Deaf Studies, Language, and Education*, Ed. Marc Marshark .and Patricia Elizabeth Spencer, New York: Oxford University Press, 2010. 210–225.

1
TERESA DEEVY, *THE KING OF SPAIN'S DAUGHTER*

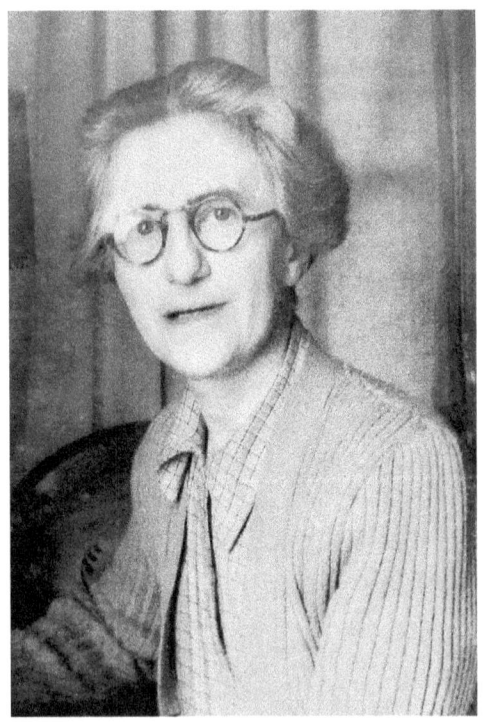

IMAGE 1.1
Source: Teresa Deevy Archive.

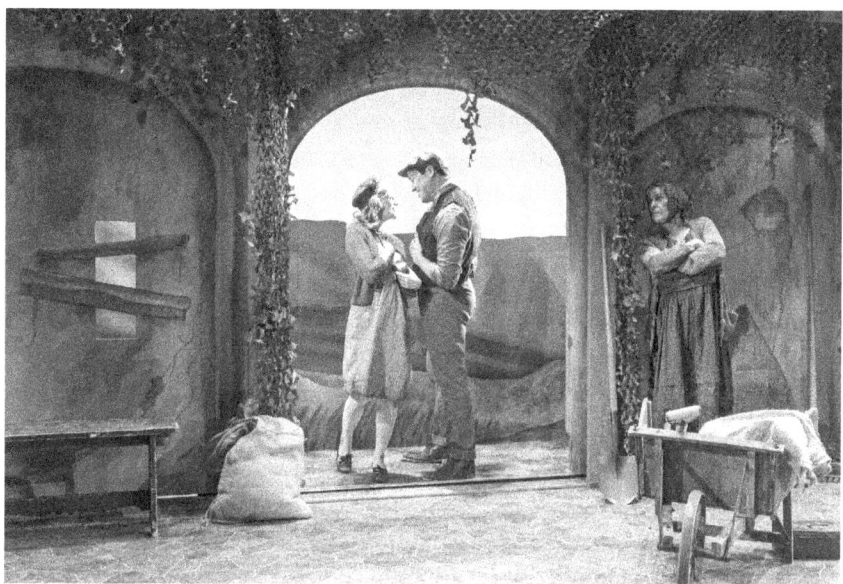

IMAGE 1.2 Actors Sarah Nicole Deaver, Colin Ryan, and Cynthia Mace in Mint Theater Company's production of *The King of Spain's Daughter*, directed by Jonathan Bank.
Source: Photographer: Richard Termine; photo courtesy of Mint Theater Company.

Synopsis

A young, romantic Irish woman named Annie Kinsella dreams of escaping her conservative, patriarchal environment. She happens to see a wedding by the water in her neighbourhood and fantasises about its elaborate nature, picturing herself in it. She is being wooed by a very ordinary, miserly, young man named Jim Harris who proposes to her. Meanwhile, she flirts on the sly with Roddy Mann, a local loafer. She gets snapped back to reality when she is late delivering her tyrannical father's dinner to his job site. As a result, she gets beaten by him and then given the ultimatum of either marrying Harris or enduring five years of drudgery, working at a factory. Ultimately, she makes a surprising decision – a resolution that brings her a sense of liberation yet reveals the depth of the oppression that defines her life and possibilities.[1]

Production History

The King of Spain's Daughter had its original production on April 29, 1935 at the Abbey Theatre. It was produced by Fred Johnson and Abbey Theatre/ Amharclann na Mainistreach in Dublin, Ireland. It was then staged twice more at the same place in 1936 and once again in 1939 in a production that toured that year (Abbey Theatre). The play was broadcast several times by Raidió Éireann

and was also broadcast by the BBC on radio in 1936 and on television in 1939.[2] The cast was as follows:
JIM HARRIS – Cyril Cusack
ANNIE KINSELLA – Ria Mooney
MRS. MARKS – Ann Clery
PETER KINSELLA – John Stephenson
RODDY MANN – J. Winter[3]

BBC Television broadcast a version of *The King of Spain's Daughter* on February 25, 1939. It was one of the 326 live plays broadcast by the station before it closed after the declaration of World War II. Unfortunately, no recordings of the broadcast are known to exist.[4]

Thoughts on the Play

In *The King of Spain's Daughter*, Teresa Deevy effectively encapsulated the conservative, patriarchal society of 1930s Ireland in a rather short play that explores the intellectual, social and political oppression of women. The play reveals how a romantic young woman, who dreams of a happy love life, must accept the reality of her repressive situation. Annie Kinsella – in essence, the title character – is told: "Did you think you needn't suffer like the rest of the world? Did you think you were put here to walk plain and easy through the gates of heaven?"[5] Deevy created a female character who was inherently and perhaps unknowingly an early feminist who resisted societal expectations.

Christopher Morash, a National University of Ireland professor, observed that Deevy's plays displayed:

> an interest in women who seem more comfortable in their heads than in social groups. Perhaps she could relate; losing her hearing in her early 20s because of Ménière's syndrome must have limited her ability to communicate, although she was apparently an accomplished lip-reader.[6]

Morash further commented: "Her plays are about people cut off from the world… [the] plays are marked by colloquial language, with thoughts half-expressed and sentences cut off. They have a very modern, almost post-Pinter sound."[7] When reading (or viewing) Deevy's body of work, one may think she wrote plays about women mired in challenging circumstances and yet were able to find ways to improve their situation or lot in life.

She never let the disability lead to despair, argued Eileen Kearney, a Denver academic whose dissertation on Deevy portrays her as exceedingly resilient: "She wrote quiet plays about women trapped in difficult lives, but they were always trying to make them better."[8] Her writing gives no hint of her profound deafness. Deevy is known to make intended use of silences, which perhaps symbolised the lack of a voice for Irish women during that time.

Despite Deevy's deafness at the time of writing this play, there is nothing in it that involves deaf issues or deaf/hard-of-hearing characters. Various people close to her have claimed that Deevy was a proficient lipreader. In his letter granting permission to reprint this play, Deevy's nephew Jack Deevy wrote, "…my aunt was totally deaf by the time her plays were produced by the Abbey Theatre. She was an accomplished lip reader, but she never heard any of her plays while they were being staged."[9]

It must have been a challenge for Deevy to observe and follow her own work on stage – the quick, back-and-forth dialogue between characters and rehearsal discussions between actors and director in a dark theatre. It would have been intriguing to be a fly on the wall to watch the proceedings of how Deevy and her production team communicated with one another.

Deaf Gain

It is a phenomenal achievement for a woman in the 1930s, let alone a deaf woman, to break through the glass ceiling of the world-famous Abbey Theatre in Ireland and become an established playwright – one who would be the next star of this theatre to succeed Sean O'Casey. According to The Dublin Magazine, Deevy "was one of the most prolific and acclaimed female playwrights in the world" during this time period.[10]

Although they were not part of Deevy's original script, the following poems shed a little light on the origins of the play's title and its connection to the main character, Annie Kinsella.

I Had a Little Nut Tree

I had a little nut tree, nothing would it bear
But a silver nutmeg and a golden pear;
The king of Spain's daughter came to visit me,
And all was because of my little nut tree.
I skipp'd over water, I danced over sea,
And all the birds in the air couldn't catch me.
–nursery rhyme[11]

A Drover

To Meath of the pastures,
From wet hills by the sea,
Through Leitrim and Longford
Go my cattle and me.
I hear in the darkness
Their slipping and breathing.
I name them the bye-ways

They're to pass without heeding.
Then the wet, winding roads,
Brown bogs with black water;
And my thoughts on white ships
And the King o' Spain's daughter.
O! farmer, strong farmer!
You can spend at the fair
But your face you must turn
To your crops and your care.
And soldiers—red soldiers!
You've seen many lands;
But you walk two by two,
And by captain's commands.
O! the smell of the beasts,
The wet wind in the morn;
And the proud and hard earth
Never broken for corn;
And the crowds at the fair,
The herds loosened and blind,
Loud words and dark faces
And the wild blood behind.
(O! strong men with your best
I would strive breast to breast
I could quiet your herds
With my words, with my words.)
I will bring you, my kine,
Where there's grass to the knee;
But you'll think of scant croppings
Harsh with salt of the sea.
– popular Irish poem by Padraic Colum.[12]

Notes

1. Waterford News, review. Waterford Dramatist at Dublin Theatre/New Play by Miss Teresa Deevy. 3 May 1935. *Teresa Deevy – Playwright*. Retrieved from: http://members.tripod.com/waterfordhistory/teresa_deevy.htm. Accessed 23 Aug. 2020.
2. Introductory Essay. "Resisting Power and Direction": The King of Spain's Daughter by Teresa Deevy as a Feminist Call to Action. *Una Kealy, Electronic Journal of the Spanish Association for Irish Studies*. March 17, 2020. Retrieved from: https://www.estudiosirlandeses.org/2020/03/resisting-power-and-direction-the-king-of-spains-daughter-by-teresa-deevy-as-a-feminist-call-to-action/. Accessed 27 July 2020.
3. Playography Ireland. *Irish Theatre Institute*. Retrieved from: http://www.irishplayography.com/play.aspx?playid=31992. Accessed 27 July 2020.
4. The Teresa Deevy Archive, *The King of Spain's Daughter*: Television Production 1939. Retrieved from: http://deevy.nuim.ie/exhibits/show/kingofspain/television-production-1939. Accessed 27 July 2020.

5 Walshe, Eibhear. *Selected Plays of Irish Playwright Teresa Deevy, 1894–1963*. Lewiston, NY: Edwin Mellen Press, 2003.
6 Zinoman, Jason. "An Irishwoman Back From Obscurity." *The New York Times*. Retrieved from: https://www.nytimes.com/2010/08/08/theater/08deevy.html; August 4, 2010. Accessed 27 July 2020.
7 Ibid.
8 Ibid.
9 Deevy, Jack. Letter to the author. 25 Nov. 2004.
10 Zinoman, Jason. "An Irishwoman Back From Obscurity."
11 Halliwell: The Nursery Rhymes of England (4th edition), Class 1-Historical I Had a Little Nut Tree. Retrieved from: https://www.presscom.co.uk/nursery/4_p1.html. Accessed 27 July 2020.
12 Colum, Padraic. "A Drover." *Ireland Calling*. Retrieved from: https://ireland-calling.com/a-drover/. Accessed 23 Aug. 2020.

1

THE KING OF SPAIN'S DAUGHTER

Teresa Deevy

Characters

PETER KINSELLA, *labourer.*
JIM HARRIS, *labourer.*
MRS. MARKS, *a neighbour.*
ANNIE KINSELLA, *Peter's daughter.*
RODDY MANN, *a loafer.*

Notes

The action of the play takes place on a grassy road in Ireland during the dinner hour of a day in April.

Scene

An open space on a grassy road. At each side road barriers with notices, "No Traffic" and "Road Closed." At the back an old dilapidated wall; a small door in the centre of the wall stands open and fields can be seen beyond.

County Council workers have been employed here. Two coats, a thermos flask, an old sack and a man's hat and stick have been left on a pile of stones near one of the barriers.

Peter Kinsella, a heavily built man of 50, comes through the doorway. He carries a pick-axe; his overalls and boots are covered with a fine dust. He stands in the centre, looks away to the left, shading his eyes, then to the right.

Jim Harris comes on, whistling. He is 24, wears a cap and dusty overalls. He leaves his spade against the wall, goes to the barrier at the right side, leans on it, looking away to the right.

JIM: Great work at the weddin' below. Miss What's-her-name getting married.
 The women were gathered at the wharf an hour and a half before time for

the send-off. (Laughs. Peter nods without interest.) Right well it looked from above, with the white launch, an' the flags flyin' an' the sun on the water. Brave and gay at the start, however 'twill go. (Takes his thermos flask.) Come on, man. With the noise of the sirens I didn't hear the whistle, an' I kept workin' five minutes too long. Wasn't that a terrible thing to have happen to me?

PETER: She's late with my dinner.

JIM: (Dismayed) What?! Didn't she come here at all?

PETER: She did not. Late, – the second time in the week.

JIM: 'Tis on account of that weddin'. She'll be up now. They don't feel time or weather when they're waitin' for a bride.

PETER: I'll make her feel something…her father without his dinner.

JIM: (Looking to the right.) Is it at the wharf she is? Or the far side of the river watchin' the start?

PETER: Do I, or anyone, ever know where Annie'd be? Only sisters you have, but they'd give you more thought than that daughter of mine. Oh, she'll be sorry yet.

JIM: It is because of the day; the women can think of nothin' else; they're all the same. Molly and Dot were up at the dawn – would it be a fine day! You'd think they were guests invited. They know her by eyesight so they'll go stand in the crowd and see how she'll look.

PETER: If I knew where to get Annie.

JIM: Annie'll be here now. They're scatterin' away off the wharf, – though I can't pick her out.

PETER: And how would you? More than likely she's off with Roddy Mann. Philanderin' with the like of him – that's all she's fit for – or with any boy she can lay hold of.

JIM: If she goes on a bit aself it's because she must; she's made that way, she can't help it.

PETER: I'll make her help it! You're in no great hurry to have her.

JIM: (Flings round on him.) You know that I am!

PETER: Why don't you marry her so? And stop her goin' on? You're in no hurry.

JIM: I want that, and you know it. How can I force the girl?

PETER: Ay, how indeed. (Laughs contemptuously.) Aw, you're very young.

Goes to the door, stands there looking out across the fields. Jim sits down on the stones and begins his dinner. Mrs. Marks, a big woman of 55 or so, wearing a shawl and with a basket on her arm, comes to the barrier at the right. She pushes the barrier a little aside and comes on.

MRS. MARKS: Can I pass this way? 'Twould be a short cut.

JIM: Are you a motor car, ma'am? (Looks her up and down.) You are not, – 'tis two legs are under you. You can, and welcome.

MRS. MARKS: I thought you had sense in your head, Jim Harris.

Puts down her basket, resting it against a large stone.

MRS. MARKS: There's a terrible weight in that basket there is.

JIM: That was a great send-off they gave the bridal pair.

MRS. MARKS: It was so. I wasn't on the wharf on account of my bad knee, but I seen them from above, an' I met some of them now. I'm glad she had it fine, the poor young thing.

JIM: What "poor" is on her? Isn't it the day of her life?

MRS. MARKS: You could never tell that. It might. They say he wanted the money. They say it was signed and settled before ever he seen her. Well, she'll have her red carpet and all her fine show for her poor heart to feed on. That's the way.

PETER: (Coming from the door.) Fine day, ma'am.

MRS. MARKS: It is indeed, thanks be to God. 'Tis a day of the earth and the sky.

JIM: With the whole month of April floatin' around.

MRS. MARKS: Annie was tellin' me the bride looked like a queen.

PETER: Did you see Annie? She didn't bring me my dinner.

MRS. MARKS: Oh, look at that now! A shame and a sin! She's off across the field with that Roddy Mann.

JIM: (Jumps up) I'll go call her.

PETER: Stop where you are!

He strides off.

JIM: (To Mrs. Marks.) You had a right to keep that to yourself.

MRS. MARKS: To leave her father without his bit! An' she romancin' around!

JIM: He'll have her life.

MRS. MARKS: She earns what she gets. Why don't she settle down? She's a bold, wild thing.

JIM: He treats her cruel; it don't do her any good.

MRS. MARKS: And what would do her good? That Annie Kinsella will be romancin' all her life with whoever she can.

JIM: The way he treats her – it only drives her on worse.

MRS. MARKS: You're too soft-hearted Jimmy Harris. But I have a great wish for you, for the sake of your mother, God rest her soul. You'd be better to give Annie up.

JIM: Give up my life, is it?

MRS. MARKS: You have two good sisters, can't you settle with them, or get a sensible girl? I'm telling you now – that one – her head is full of folly and her heart is full of wile. She'll do you no good.

JIM: You have a lot of old talk.

Silence. Then distant cheering.

JIM: They're not done with it yet.
MRS. MARKS: I was thinking of my marriage day when I was looking at them two. It is a thought would sadden anyone.
JIM: How is that Mrs. Marks?
MRS. MARKS: That's how it is; the truth is the best to be told in the end.
JIM: Haven't you Bill and Mary, and the little place? You didn't fare bad.
MRS. MARKS: Bad. What have bad or good to do with it? That is outside of the question. For twenty years you're thinking of that day, and for thirty years you're lookin' back at it. After that you don't mind – you haven't the feelin' – exceptin' maybe the odd day, like today.

She takes her basket. They hear someone coming. Mrs. Marks puts down her basket again, and waits, expectant.

MRS. MARKS: Annie… and you may be sure she's not alone.

Annie Kinsella is seen in the doorway. She is about 20. She wears a dark shawl, a red dress, black shoes and stockings – all very neat. Her hair is bright gold. With her is Roddy Mann, a big lounging figure, cap pulled low over his eyes.

ANNIE: Now, Roddy, don't come any farther.

Mrs. Marks listens; Jim moves a little farther from the doorway.

ANNIE: (Low tone) Give me the tin.

Roddy hands a tin to her.

RODDY: What did you promise?
ANNIE: (Low, eager.) Wait first till I tell you how she looked.
RODDY: You have told me already; you have talked of nothin' else.
ANNIE: She was like what you'd dream. I think I never seen anything so grand. She was like a livin' flame passin' down by us. She was dressed in flamin' red from top to toe, and (Puts her hand to her breast.) here she had a diamond clasp.
RODDY: And there you have your heart. Now give us a kiss. What did you promise? Leave down the tin.

Annie puts the tin on the ground, slips her hand up about his neck and gives him a long kiss.

ANNIE: That will do now.
RODDY: You have my heart scalded.

He moves off. Annie takes up the tin, wipes her mouth on her sleeve, very thoroughly, turns to wave to Roddy. Comes in.

ANNIE: Jimmy, it was like heaven. She looked that lovely. The launch was all white, and the deck covered with flowers. They had a red carpet—
JIM: You're late with his dinner.
ANNIE: Late! (Alarmed) The whistle didn't go?!
JIM: Ten minutes apast one.
ANNIE: He'll have my life!
MRS. MARKS: An' small blame to him so! Without a bit or a sup! A man wants his dinner. He's gone down to find you.
JIM: Why couldn't you come?
ANNIE: What misfortune came over me? I am at a loss for a word. What will I do now?
MRS. MARKS: Take it down to him, – run.
ANNIE: He'd kill me, he'd kill me dead. I think I'll stop here.
JIM: Here he is now.

All look towards the doorway.

MRS. MARKS: (Turns to Jim) Don't be drawn into it, you. 'Twould be a mistake. Keep your eyes on the ground; 'tis the safest place. You won't see what's happening, and you won't lose your head.
PETER: (Coming in) Is she there? (Sees Annie) Ah-h!
ANNIE: (Nervous, almost perky) I'm a bit late with the dinner, 'tis because of the weddin'. I didn't hear the whistle: I didn't know it had gone on.

Leaves his dinner-tin on the ground, not too near him, and moves away.

PETER: Hand me that tin.

Annie hands it, keeping as far as possible from him. Peter, taking the tin, hits out at her. Annie, dodges and partly escapes, but cries out; Jim springs forward; Mrs. Marks catches Jim by the arm.

MRS. MARKS: 'Tis a terrible misfortune for any man to take the least iota interest in a girl like that!

This flow stops them all.

JIM: (After a silence) What do you want here, Mrs. Marks?
MRS. MARKS: I wouldn't be in it at all but for the sake of your mother, – 'tis well she's in the grave.

PETER: (To Annie) Go down there, you (Gestures towards the barrier at the left) and rake up the few stones I have agen the wall.

Annie hesitates, looks at her father, at Jim, at Mrs. Marks.

PETER: Do you hear what I'm saying?
ANNIE: I don't mind what'll happen; I can take care of myself.

Goes off, left, with a backward look at Jim. Jim would follow but for Peter's forbidding look. Peter goes over to where the coats have been left on the stones. Takes his stick from under the coats.

JIM: This is the best sheltered place for takin' your dinner. You can have the sack on top of them stones.
PETER: Mind yer business.
MRS. MARKS: Steady now, keep steady. Don't let us have anything happen!
JIM: (To Peter) You have your dinner now, can't you leave her alone.
PETER: Do she belong to you? (Pause) Do she? When she do you can talk. (Goes)
MRS. MARKS: Supposin' you were to get a blow instead of herself – what good would that be? It might do you a grievous harm! Great cheer to see her standin' upright if yourself was lyin' low! I wouldn't stir up the embers in a man like that.

Jim walks away from her.

MRS. MARKS: Now I'll tell you this – though I know you won't listen – if you were a man at all you'd make her marry you.
JIM: An' how can I do that?
MRS. MARKS: Ah, you're too soft-hearted for any woman. 'Tis the hard man wins, and right he should. (Confidential now) Annie Kinsella – when I met her down there – was tellin' me how grand the bride looked. "She was dressed," said she, "in shimmerin' green from head to foot."
JIM: What's wrong with that?
MRS. MARKS: Didn't you hear her now to Roddy Mann, "She was dressed in flamin' red from top to toe."
JIM: So she did.
MRS. MARKS: That's the count she puts on the truth! I'm only tellin' you now so's you'll harden your heart! Whatever'll come easy is what she'll say. Now – for the sake of your mother – if you marry that girl, don't believe one word she'll tell you. That's the only way you'll have peace of mind!

A cry. Jim starts forward: Mrs. Marks catches his arm.

MRS. MARKS: Be a man now! Be a man, and don't get yourself hurt!!
JIM: Keep out of my way!

Tries to push her aside. Annie, a little dishevelled, frightened, and with her shawl trailing, runs on. She runs to the barrier at the right side, leans against it, and moans nursing her shoulder.

MRS. MARKS: (To Jim) Now strengthen your heart: quiet your mind. Don't do yourself harm on anyone's account. We get what we merit, and God is good. (Pause) I'll leave ye now.

Takes her basket, does not notice that she has left a small parcel on the stone: moves off. Near the barrier she stops again, looks back at Jim.

MRS. MARKS: Don't be moved to any foolish compassion. The hard man wins. (Goes)

Jim comes a little forward: sits down on an old plank, his back to Annie, takes a small notebook from his pocket, turns the pages, glances over his shoulder in Annie's direction, slips the notebook into his pocket again; waits for Annie to come to him. After a moment she brushes aside her tears, comes over and sits down close beside him.

ANNIE: It was a grand sight, Jim, it was like heaven.
JIM: (Catches her wrist) He hurt you then, —did he do you any harm?
ANNIE: Ah, leave that now! Let us leave that behind us.... The band was playing, and the flags were grand—
JIM: 'Tis a shame you'd madden him. He'll harm you some day, and all your own fault. You won't have any life left. An' what can I do?
ANNIE: Didn't you see the launch at all?
JIM: I saw well from above.
ANNIE: You should have been on the wharf. The cheering an' the music, an' all the sun on the river, an' everyone happy—
JIM: We'd all be happy if you'd have sense.
ANNIE: She looked lovely passin' along, her hand restin' in his, and her body swayin' beside him down the path. The arms of the two families were painted on the launch, the sun was shinin' on it; everything was white or burnin' red, but she was dressed in pale, pale gold and (Hands to breast) two red flowers were crushed up agen her here.
JIM: (Springs up) What lies are you tellin'? I saw her myself: she was dressed in grey; she had no flowers.
ANNIE: (Gentle, bewildered) Jimmy, what's wrong with you?
JIM: She was dressed in grey. Tell the truth!
ANNIE: It was in pale gold I saw her.
JIM: (Furious) An' in shimmerin' green, an' in flamin' red, an' in milk-white when it will suit you! (Silence)
ANNIE: (Gets up slowly) You are a pack of blind owls – all the lot of you! I saw what I saw! (Turns from him)

JIM: But why won't you tell the truth – an' it just as easy?
ANNIE: Stop your fool talk! The truth! Burstin' in where you don't know. Oh, if I could have love!
JIM: Will you leave talkin' of love when I'm tired of askin' you'd come to the priest with me! Are we to be married ever? Are we?
ANNIE: (Quietly.) Whisht, Jimmy, whisht.

Look off away to the right, in the direction of the river.

JIM: Are we? I must know.
ANNIE: (To herself)

> "Then the wet windin' roads,
> Brown bogs and black water,
> And my thoughts on white ships
> And the King of Spain's daughter."

JIM: I'm sick of that thing! Who's the King of Spain's daughter?
ANNIE: Myself.
JIM: Yourself… (A laugh) and the bride beyond!
ANNIE: It is myself I seen in her – sailin' out into the sun, and to adventure.
JIM: Are you going to marry me? Make up your mind.

They hear a sound as of someone coming.

ANNIE: What's that? (Frightened) Is he coming? Jim, he says he'll make me sign on for the factory.
JIM: The factory? In the town beyond? (She nods) That you couldn't stand before?
ANNIE: I was there six months: it would be five years this time.
JIM: Five years! You couldn't do that!
ANNIE: They're only takin' them will be bound for five years. I couldn't face it. (Falters) Every mornin' walkin' the road, every evenin' draggin' back so tired. He has the card: he says he'll come make me sign my name now.
JIM: It was a pity you didn't bring his dinner in time!
ANNIE: It was a great misfortune for me. I am at a loss to explain it.
JIM: And I think he knew that Roddy was with you.
ANNIE: It is that decided him.
JIM: Why do you go with Roddy, and Jack?
ANNIE: It is very unfortunate that I do!…I would face any life – no matter what – before I'd go back to that place.
JIM: Did you kiss Roddy Mann again today?
ANNIE: (Injured) And who else was there for me to kiss?
JIM: When I left you last night, did you go back to Jack Bolger?
ANNIE: Last night…no, I don't think I did last night.
JIM: (Furious) We're all the wan! You have no heart.

ANNIE: So must I go to the factory? Won't you marry me now?

JIM: Annie! —won't I, is it? You well know— (Overjoyed, but checks himself.) Will you come with me tonight and we'll tell the priest?

ANNIE: Is it stand beside you an' you sayin' that? (Insulted) The ground would open under me! Go tell him yourself, let you.

JIM: Would you go back on me then?

ANNIE: I would not.

JIM: You would not? You've changed your mind often.

ANNIE: I'll be in the chapel the day he'll name.

JIM: You will? And come with me then?

ANNIE: What else is there for me?

JIM: Annie! (Checks himself) I'll tell them look out for a place: so they can get a room in the town.

ANNIE: Tell who?

JIM: Molly and Dot. 'Tis I have the house: they knew they'd have to go.

ANNIE: Well, then, they needn't. Let them stop where they are. What would I do without a woman to talk to?

JIM: I want you to myself.

ANNIE: I never heard the like! A good "man" he'd make to begin by turnin' his two sisters on the road! And they after mindin' the place since his mother died.

JIM: Will you go back on me so?

ANNIE: Leave Molly and Dot stay where they are.

JIM: I will not.

ANNIE: What harm would they do?

JIM: They'd be in it – spoilin' the world.

ANNIE: Spoilin' the world! I think you're crazy.

JIM: When we shut the house door I'll have no one in it but you and me.

ANNIE: (After a moment) I think I'll stop with my father.

JIM: And go to the factory?

ANNIE: Maybe I wouldn't do either, –but run away.

JIM: He'd go after you: he'd have you crippled.

ANNIE: I haven't signed yet. I might get on the soft side of him yet if I'd promise—

JIM: What promise would you keep?! (Silence) I have twenty pounds saved.

ANNIE: Where did you get that?

Not greatly interested. Jim takes out his notebook, opens it.

JIM: Four years ago you said I had no money. I have the house now, and besides what I earn I put by two shillin's every week.

ANNIE: Two shillin's….you did! Every week…since that time long ago?

JIM: (Turning the pages of his notebook.) A hundred shillings…that was five pounds the first year…and another five then… and another…and this is the fourth….

ANNIE: (Awed.) You kept it up all along?
JIM: Did you think I'd fall tired?
ANNIE: Let me see. I didn't know you were doin' that.

Takes the notebook, turns the pages. Silence – then.

ANNIE: Oh, 'tis smudged and dirty. Why couldn't you keep it clean?

Angered: throws the book from her. Silence.

JIM: Two hundred weeks, and that's all you'd care.

Walks away.

ANNIE: What would you do with it?
JIM: (Coming a little way back to her.) It would set us up….To buy a few things. I'd have to give the priest some. Then whatever you'd like for the house, and yourself, so's we could settle down right.
ANNIE: Settle down. (A knell to her.) I dunno could I ever get into service in a place in London?
JIM: (In fury) If your father heard you were at the crossroad last night – or if the priest heard tell of it – dancin' on the board, an' restin' in the ditch with your cheek agen mine and your body pressed to me.
ANNIE: It is only in the dark I could do it – for when I'd see the kind you are—
JIM: (Catches her) What's wrong with me now?!
ANNIE: (Holding back) Is it me to go near you– Me?!
JIM: (Crushing her to him.) What's wrong with me?
ANNIE: Jimmy! He's coming! Let go, let me go! Oh-h!
PETER: (Coming on) So that's what you're at!

Annie tries to escape. Jim holds her.

PETER: Stop there, stop there the two of you! (To Jim) You can let her go now.

Jim releases Annie. She stands motionless.

PETER: Was she teasin' you?
JIM: She was.
PETER: Tauntin' you like?
JIM: She was.
PETER: I know…leadin' you on?
JIM: That's it.
PETER: Well, me fine lady, we'll put a stop to your fun. You can do some work now. Stay where you are! Stay there the two of you.

Goes to where the coats have been left, takes a card and a pencil from his coat pocket. Comes over to Annie.

PETER: Write your name there.

Annie looks at Jim: he avoids her look.

PETER: Do you hear what I say? Write your name. We'll have no more cajolin'.

Annie writes her name on the card. Peter, taking back the card, hits at her. Jim knocks aside Peter's blow: they face each other angrily.

JIM: Can't you stop that!
PETER: Oh you'd like to be standin' up for her now, but you have no right! No more than to be kissin' her like you were now. She don't want you. You can go your road.

Wheels round on Annie.

PETER: Will you marry him now, or go to the factory? Five years there, or your life with him?
JIM: I'm not askin' you, Annie, I wouldn't have it like that.
PETER: He's backin' out now.
ANNIE: (To Jim) I might as well have you. (Low) Who would I ever meet would be fit for me? Where would I ever find a way out of here?
PETER: Have ye settled it so?
JIM: We have.
PETER: You'll take her like that?
JIM: I will.
PETER: Well, I'll keep the card, fearin' she'd change.

Puts the card in his pocket. Goes off.

ANNIE: (Softly) You have me ruined. It is all over now. You can go settle with the priest.
JIM: You won't ever regret it. You won't.

But she turns away.

ANNIE: Go on after him now.

Jim hesitates: goes. Annie moves over to the barrier, looks off away to the right. Mrs. Marks comes to the barrier at the left side, shades her eyes, looking on the ground for her parcel.

MRS. MARKS: Well, –look where I left it.

Comes on, takes the parcel she had forgotten.

MRS. MARKS: Well and indeed! My head will never spare my heels! Searchin' high an' low.

Sees Jim's notebook on the ground.

MRS. MARKS: What is that there?
ANNIE: That belongs to Jim Harris. (Takes the book) Jim Harris and myself are to be married very soon.
MRS. MARKS: What?! Is he going to marry you in face of all?! Well, –well, you might talk your head off, or you might spare your breath– it don't make any difference!
ANNIE: Maybe I won't mind it as much as I think.
MRS. MARKS: Be a good wife to him now. Don't give him the bad time you gave your poor father. Often I felt for that poor man when he wouldn't know where you'd be. (More kindly) You have no wish for it? (Annie shakes her head.) And there's many a girl would be boundin' with joy. Is there any other you'd liefer have? (Annie shakes her head.) Well now, well, you'll be all right. A good sensible boy. And you'll have a nice little place. Mind you keep it well, –that'll give you somethin' to do. You won't feel the days slippin'.

Annie moves restlessly away from her.

MRS. MARKS: Well, well, if you could get to care for him that would be a blessin' from God. It might come to you later. Sometimes it do, and more times it don't. It might come with the child.
ANNIE: I dread that.
MRS. MARKS: What's that you said?! Fie on you then! Did you think you needn't suffer like the rest of the world? Did you think you were put here to walk plain and easy through the gates of heaven?
ANNIE: I dread it...dread it.
MRS. MARKS: Would you ask to get in on what others would suffer?
ANNIE: (To herself) I couldn't bear I'd be no more than any other wife.

Distant cheering is heard: Annie listens, looks away towards the river: flashes.

ANNIE: It won't be all they'll say of me: "she married Jimmy Harris."
MRS. MARKS: And what better could they say? You have a right to be grateful. Oh, you're a wild creature!

But Annie is not listening. She has opened Jim's notebook: studies it.

ANNIE: (Turning the pages) June...July...October...November...December...
MRS. MARKS: Poor Jimmy Harris...I hope he's doin' a wise thing.

ANNIE: February, March, April…June, July, August…October – and I was black out with him then – November, December, April, June, August—
MRS. MARKS: A good, sensible boy.
ANNIE: BOY! *(Laughs exultantly)* I think he is a man might cut your throat!
MRS. MARKS: God save us all!
ANNIE: He put by two shillin's every week for two hundred weeks. I think he is a man that – supposin' he was jealous – might cut your throat.

Quiet, exultant, she goes.

MRS. MARKS: The Lord preserve us! That she'd find joy in such a thought!

About the Author

Teresa Deevy, nicknamed Tessa, was born on January 21, 1894 in Waterford, Ireland and was the youngest of 13 children. In 1913, she enrolled in University College, Dublin with the intention of becoming a teacher. She contracted Méniéres disease, which brought on her deafness and forced her to transfer to University College, Cork where she could be treated at a nearby hospital while being close to her family. Her increasing deafness meant that she could not continue with her B.A. studies. She went to London in 1914 to learn lip-reading, and it was there that she developed an interest in drama, particularly in plays by Ibsen, Shaw and Chekhov. At this point, she was totally deaf and read scripts before watching performances and lip-reading actors as they performed.

Under the tongue-in-cheek pseudonym of DV Goode, Deevy began writing her early plays while in London. She also contributed articles and stories to the press, local and national and, in 1925, began submitting scripts to the Abbey Theatre. It was not until 1930 that she had her first success with her three-act play, *Reapers*, which was performed there. This was followed, in 1931, by a one-act play, *A Disciple*. In that year, she and Paul Vincent Carroll shared the honour of the Abbey Play Competition in Dublin with her play, *Temporal Powers*, produced on April 24, 1932. She followed this later with her other plays: *The King of Spain's Daughter* (1935), *Katie Roche* (1936) and *The Wild Goose* (1936). In 1937, the Abbey rejected Deevy's play, *Wife to James Whelan*.[1]

Author Melissa Sihra, who examined Deevy's life, noted that despite an incredible collection of over 25 plays, Deevy was shunned by the Abbey even though she received very favourable responses and accolades from her audiences. "WB Yeats, co-founder and director of the Abbey, did not admire her theatrical voice. More devastatingly, it was the incoming despotic Abbey director Ernest Blythe…who was the death-knell to Deevy's career as a playwright." Blythe's expectations were to produce plays at a national level that served "the conservative Catholic Church and State ethos."[2] This, of course, went against the types of plays that Deevy wrote.

Ironically, she became interested in writing for the radio and, for the following 20 years, wrote remarkably successful radio dramas broadcast on Radio Eireann and BBC Northern Ireland. In 1939, two of her plays were broadcast on the new BBC Television service. While very successful in radio, Deevy never got to see her plays on stage again.

During this period of her life, she moved back to Dublin where she had a wide circle of friends, primarily from within the artistic community. She lived with her sister, Nell, and one friend described the pair as: "Together they were one person – Nell the ears and Teresa the voice."[3] Deevy was elected to the Irish Academy of Letters in 1954. In 1963, she died in Waterford at the age of 68.

After Deevy's death, her plays were neglected by theatres and it seemed that the theatre world had forgotten her, but, in April 1994, the Abbey Theatre revived her play *Katie Roche* to critical acclaim, and her canon of plays has now become the subject of literary conferences and university theses, including more revivals at theatres like the Mint Theater Company in New York City.

Notes

1 Sihra, Melissa. "Power of silence: Teresa Deevy returns to Abbey." Independent.ie. Retrieved from: https://www.independent.ie/entertainment/theatre-arts/power-of-silence-teresa-deevy-returns-to-abbey-36067284.html. Accessed 27 August 2017.
2 Ibid.
3 Waterford City History. 2006. Waterford Dramatist at Dublin Theatre/New Play by Miss Teresa Deevy. Waterford News Review. Retrieved from: https://waterfordireland.tripod.com/the_king_of_spain%27s_daughter.htm. Accessed 16 August 2021.

2
THE NATIONAL THEATRE OF THE DEAF ENSEMBLE, *MY THIRD EYE*

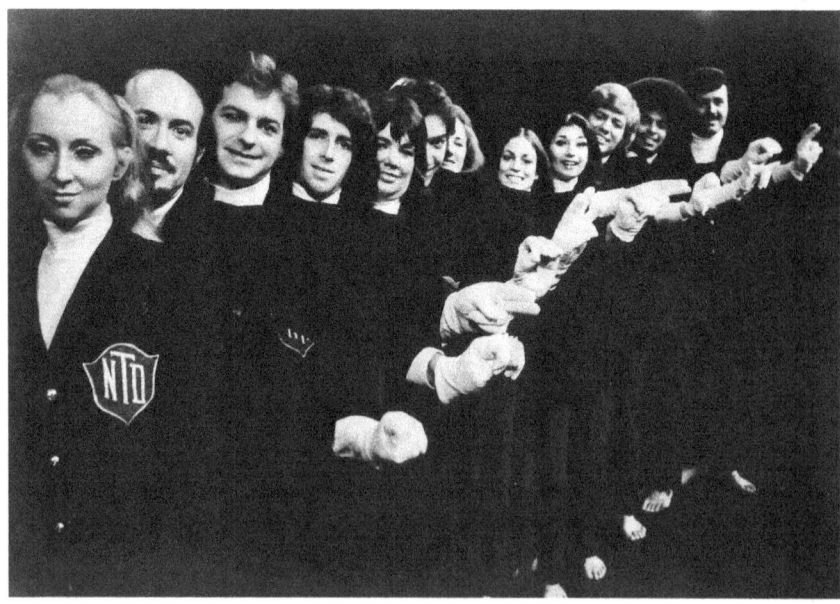

IMAGE 2.1 Ensemble members fingerspelling "See how they run," from the *Three Blind Mice* performance segment of the *Curtain Raiser* in *My Third Eye* (from left to right): Fredricka Norman, Patrick Graybill, Richard Kendall, Timothy Scanlon, Mary Beth Miller, Dave Berman, Dorothy Miles, Linda Bove, Carol Flemming, Edmund Waterstreet, Joseph Sarpy, and Bernard Bragg.

Source: Photo courtesy of the National Theatre of the Deaf.

DOI: 10.4324/9781003112563-4

IMAGE 2.2 From *My Third Eye* when the ensemble expressed the visual-gestural concept of "sunrise" during the *Manifest* segment. Note the symbolic placement of the sun near the position of the third eye.
Source: Photographer: Jay Aare; Photo courtesy of the National Theatre of the Deaf.

Synopsis

My Third Eye is a non-traditional play composed of five comic and dramatic pieces set up in the following sequence:

1 Biography: autobiographical monologues based on the original ensemble members' lives.
2 Sideshow: circus-like exhibits displaying strange inhabitants of the hearing world.
3 Manifest: a creative, show-and-tell demonstration of unique, visual aspects of American Sign Language.
4 Promenade: a poetic exploration into the dreams and fantasies of the ensemble.
5 Curtain Raiser: the play closes with the nursery rhyme, "Three Blind Mice."[1]

Production History

My Third Eye, presented by the O'Neill Theatre Center, was finalized on September 22, 1971. It went on national tour during the 1971–1972 season.

32 The National Theatre of the Deaf Ensemble, *My Third Eye*

The Ensemble

Dave Berman
Linda Bove
Bernard Bragg
Carol Flemming
Patrick Graybill
Richard Kendall
Dorothy Miles
Mary Beth Miller
Fredricka Norman
Joseph Sarpy
Timothy Scanlon
Kenneth Swiger
Edmund Waterstreet

Directors

Remy Charlip – Biography
Joseph Chaikin/Dorothy Miles – Sideshow
Bernard Bragg – Manifest
J Ranelli – Promenade
Joe Layton – Curtain Raiser

Set Design

Alfredo Corrado

Costume Design

Cheryle Conte

Lighting Design

Thomas Markle

Managing Director

David Hays

Production Stage Manager

Guy Bergquist

On October 11, 1971, WTTW Chicago created a videotape of the production. It was titled *Selections from My Third Eye – an expedition created by the company*.[2]

Thoughts about the Play

According to *Deaf Heritage*, *My Third Eye* was the first NTD production that involved aspects of the Deaf experience. Audiences were introduced to "the world of deafness and to sign language and included an amusing 'side-show' where 'strange' people *talked* instead of signed."[3] It was a first to have Deaf company members responsible for directing, designing sets and costumes for a professional national tour. Since the play dealt with Deaf issues, it was more popular with Deaf audiences than with hearing audiences, who most likely had trouble identifying with or understanding Deaf culture. The typical make-up of an NTD audience is about 90% hearing; therefore, many of the plays chosen to be performed throughout NTD's touring history were written by hearing writers for this audience.

This biographical, five-part collection of dramatic and comical sketches drew from the lives, skills, and dreams of the NTD ensemble. The company included Deaf theater luminaries such as Ed Waterstreet (co-founder of Deaf West Theatre), Linda Bove (of Sesame Street fame and also co-founder of Deaf West), Bernard Bragg, Patrick Graybill, Freda Norman, Mary Beth Miller, and Dorothy Miles.

In a videotaped interview, ensemble member Patrick Graybill offered unique insights into the making of *My Third Eye* and its historical context. He recollected that the play surfaced during a time when hearing people didn't know anything about deaf people. To see sign language in public was embarrassing, and deaf people felt like they had to suppress their Deaf identities when told to hide their signs and behave like the hearing. The company's goal was to develop something to present the true colors of Deaf people; to show everyone what they have been enduring in their daily lives, "…witnessing it all through this third eye, and behind the eye we had all these truths, thoughts, and feelings. It was time to expose the audience to all of that." Graybill remembers the shock that people had at how the actors portrayed their experiences.[4]

During NTD's first four seasons of performances (1967–1971), Deaf audiences were proud to see their own kind on stage but admitted they were not able to understand or relate to the plays. When *My Third Eye* went on tour, Deaf audiences absolutely loved the performances, wanting to see more of that type of theater in the future. However, when members of the Alexander Graham Bell Association (staunch believers in an oral education for the deaf) and hearing educators from deaf schools came to see the play, they were very upset that certain parts of the play referred to them. In a letter to NTD, the A.B. Bell Association wrote:

> …we are opposed to any programming which indicates that the use of the language of signs is inevitable for deaf children, or it is anything more than an artificial language, and a foreign one at that, for the deaf of this country.[5]

As a result of the feedback, artistic director, David Hays, became conflicted. He thought that perhaps NTD should go back to performing the classics and

never to return to the type of work like *My Third Eye*.[6] All of this was new, uncomfortable territory for the company because, previously, Deaf people would not dare rebel, talk back or best hearing people. Nevertheless, the company forged ahead and created a collaborative effort that resulted in five separate yet inter-related segments.

Graybill shared further tidbits during a phone interview with this book's editor about the development of the play's five-part structure: Sideshow, Biography, Promenade, Manifest, and Curtain Raiser.[7] The process began with the selection of Joseph Chaikin, founder of the Open Theatre, to develop and direct "Sideshow." Chaikin asked the ensemble to share with him their anger about hearing people. The Deaf actors were a bit stunned by this request coming from a hearing stranger who expected them to suddenly open up and pour out all of their anger about the hearing world. One Deaf actor, who had some residual hearing and could speak well, stood up on behalf of the company and said, "How dare you to ask us to reveal something so deep and personal, especially coming from someone who can hear?" Subsequently, Chaikin quit and went back to New York City. Dorothy Miles, another ensemble member and a relatively new Deaf director, was asked to step in and restore this segment of the production.

For the creation of the next segment, "Biography," NTD hired Remy Charlip, who was more of a choreographer and children's book author rather than a stage director. He guided the ensemble members by having them write about their Deaf experiences. Graybill recalled penning his section in the best possible English he knew so he could impress this acclaimed writer. Charlip's response was that he really liked what Graybill wrote because his English was interesting and different – not written in the way people would speak. At first, this made Graybill feel self-conscious; however, as things progressed, he became pleased with the way the entire ensemble piece came together with each company member performing their experiences. He felt it was akin to group therapy.

Graybill particularly enjoyed the creative process of everyone drawing on a window shade to illustrate their experiences. The shade would be pulled down to display a personal illustration, and then the actor would proceed to share a memory. Everyone's story was fun, quirky, and unique except for ensemble member, Bernard Bragg, who had a serious, profound story about his Deaf parents abandoning him at a deaf institution with no explanation of why he was being left there. Freda Norman, another company member, shared her story of growing up in a Deaf family. She didn't know that there was a hearing world out there until someone came to the door of her family's house. She would watch her mother deal with the hearing stranger and wondered who that was. She asked her mother if there were more of them out there. And, her mother replied, "Yes, lots more, way more than us."[8] (For some reason, this poignant little story never ended up in the script.)

On the section titled "Promenade," Graybill remarked that it was the most difficult to develop. Director J Ranelli wanted the ensemble to record their

dreams at night. Ranelli would watch the actors share their dreams, and then select bits and pieces of the dreams to create what is now Promenade. Graybill could not get a sense of where things were going in the development process, yet he was amazed at how Ranelli was able to weave all of the memory material together and make it aesthetic and successful. According to David Hays, it was Ranelli who suggested the idea of naming the entire production *My Third Eye*.

As for "Manifest," Bernard Bragg, with the help of Dorothy Miles, encouraged the ensemble to play with sign language. The company took pleasure in developing this piece and convinced the audience that Deaf people played with their language just as hearing people played with the English language in songs and poetry.

"Curtain Raiser," the final segment, was paradoxically put at the end of the show as an invitation for the audience to join the "Deaf World" that was presented on stage. Joe Layton, a Broadway director, created a fast, choreographed version of the nursery rhyme "Three Blind Mice" in ASL with movement. Graybill found it challenging to keep up with the quick movement sequences but eventually mastered the steps. Looking at the scope of the entire production, Graybill could see how it moved many audience members to want to either learn ASL or become an actor. His perspective was that *My Third Eye* contributed to a major paradigm shift, helping the world view Deaf people in a more favorable light.[9]

Ensemble member Bernard Bragg commented during a 1972 Gallaudet Today magazine interview that

> some of the reaction was touching. One hearing man came and said, 'You have almost made me ashamed I am hearing.' Another said, 'Where can I learn signs? I have two deaf children.' A woman who attended the performance said, 'I have a daughter being taught orally, and you make me feel it is wrong.' Not all the responses were favorable. One man said, 'Why do you want sympathy?'

Bragg went on to say that he felt that the majority of the audience responses were very enthusiastic, including standing ovations. He noticed that the young, particularly college students, were especially receptive to the show.[10]

During the same interview, Dorothy Miles was asked how *My Third Eye* was conceived. Her reply was:

> Physically, through a three-week experimental session last March when we explored together our own personal thoughts and feelings. We carried those ideas to summer school [NTD's Professional Theatre School] when more thinking was done; then refined our thoughts during our European tour. In the fall, each director went to work on his own section. So, it was a whole year in the making.[11]

Tim Scanlon, another Deaf ensemble actor, mentioned via an email exchange, that throughout his eight years of touring with the company, *My Third Eye* was the most enjoyable performing experience he has ever had.[12]

Dr. Cynthia Peters, a tenured professor of English at Gallaudet University who happens to be Deaf, has done extensive research in Deaf literature. This emerging field involves analysis of literary works by Deaf and hard-of-hearing writers. Peters' deep perceptions in her analysis of *My Third Eye* could only have been written by a Deaf individual:

> This production comes across as more of a musical or variety show than a conventional two- or three-act play. The reason for this may be that it is – more appropriately – an indigenous Deaf American dramatic production. A characteristically indigenous dramatic production avoids the verbalism and the plodding narrative progression of a conventional play, instead responding, consciously or unconsciously, to the visual needs of the Deaf American viewers. To clarify, Deaf American viewers use their eyes and the eye likes visual stimuli – variable visual stimuli. It likes moving objects and it likes variety. The eye also needs a break from time to time. Indeed, the traditional Literary Night, which *My Third Eye* is undoubtedly derived from, is a feast for the eye. A kind of vaudeville production, it is a vehicle for diverse forms, genres, and rhetoric. It first came about when literary societies at schools and clubs for the deaf appropriated English stories and poems and adapted them to ASL and Deaf American viewers' visual needs. Soon, ASL stories and skits as well as other nativist or semi-nativist forms started showing up.[13]

Deaf Gain

NTD won the first Tony Award for Deaf performers in 1977. This is the mother from which all Deaf theater companies around the world were born. One could practically trace the lineage of popular Deaf stage, film, and TV artists and their stories from their past connections with NTD, or from someone once affiliated with this pioneering organization.

Notes

1 Carter, Curtis. "Deaf Prove Deft in 'My Third Eye.'" *Bugle American, Entertainment Section*, 2.35 (1971): 48.
2 WTTW Chicago, *Selections from My Third Eye*, O'Neill Theatre Center, The National Theatre of the Deaf, October 11, 1971; Retrieved from: https://media.gallaudet.edu/media/My+Third+Eye+%281971%29/1_v07ed15g/158896001. Accessed 8 Jul. 2020.
3 Gannon, Jack R. *Deaf Heritage*, NAD, 1981, 354.
4 Christie, Karen and Durr, Patricia. *Patrick Graybill Remembers "My Third Eye."* Retrieved from: https://www.youtube.com/watch?v=GEeYBUnUd74&t=2s. Accessed 16 Aug. 2020.

5 Baldwin, Stephen C. *Pictures in the Air: The Story of the National Theatre of the Deaf.* Washington, DC: Gallaudet University Press, 1992, 21.
6 NTD did return to their ensemble-created, Deaf-centered style once more in their production of *Parade* during 1975–1976.
7 Graybill, Patrick. Interview. Conducted by Willy Conley, 8 July 2020.
8 Ibid.
9 Ibid.
10 Gallaudet Today, *National Theatre of the Deaf*, Spring 1972, vol. 2, #3; 3.
11 Ibid.
12 Scanlon, Tim. Email, 7 July 2020.
13 Peters, Cynthia. *The Poetics and Politics of Deaf American Literature.* Deaf Studies VII, Orlando, FL; 21 April 2001, 6–7; also, *The Deaf Way II Reader: perspectives from the second international conference on deaf culture*, Ed. Harvey Goodstein. DC: Gallaudet University Press, 2006.

2
MY THIRD EYE

The National Theatre of the Deaf Ensemble

Ensemble

Dave Berman
Linda Bove
Bernard Bragg
Carol Flemming
Patrick Graybill
Richard Kendall
Dorothy Miles
Mary Beth Miller
Fredricka Norman
Joseph Sarpy
Timothy Scanlon
Kenneth Swiger
Edmund Waterstreet

Notes

Editor's Note: The pairing of ensemble members' names was indicated in the original script to show which hearing actor was voicing for the Deaf actor. In some places, the following initials are indicated as: BB=Bernard, MM=Mary Beth, RK=Richard.

Around 2000–2001, I requested a copy of the original script of this play. Paul L. Winters, the executive director of NTD at the time, graciously sent me photocopies of the script. Since it has not been verified – due to separated segments (some pages not numbered), faulty record-keeping and vague memories from some living members of the cast – what follows may or may not be the exact

script as performed during NTD's 1971–1972 national tour. It is possible that some pages may be missing or out of sequence. The script reads very much like a "blueprint." The segments were assembled as accurately and logically as possible, including cross-checking with the Selections of My Third Eye video recording. One would have to have seen the show or the video to really understand the context of some scene elements.

> In Kundalini Yoga, the physiological site of the sixth Chakra, the Ajna, is located in the center of the forehead. It is symbolized by an eye — the so-called third eye, the inner eye, or the eye of the mind. When this eye is opened, a new and completely different dimension of reality is revealed....
>
> *(from The Biological Function of The Third Eye by Richard Alan Miller, c1975, 1992)*[1]

Biography

1 Fake Vomit

TIM/DAVID: I was 9 years old then. It was in the springtime. I hated to go to school so I decided to pretend to be sick one day. I thought and thought and thought until I had a good idea. I got a pail and poured in a little water. Then I scattered the pail with Corn Flakes. I had to be very careful because my father is not stupid, so I mixed the ingredients with milk. When I looked in, it looked like vomit, but it didn't smell like it. So, I poured in a lot of vinegar and it smelled terrible. That was what I wanted. Then I put the pail beside my bed and waited under the covers. When my father came in and saw the pail, without any questions, he told me to stay in bed that day. I was overjoyed… inside… that I successfully fooled my father. But then the thought of having to stay in bed made me unhappy. I didn't think ahead that I wouldn't be allowed to go out and play. What a miserable day I had.

2 Cat

FREDA/CAROL: On our way to the hospital to have my tonsils removed, I saw the most darling stuffed cat in a store. "Mom, I want this beautiful, white, soft, furry cat with blue marble eyes and a red felt tongue hanging out. Please." Mom said no. I don't remember much of what happened in the hospital except I was feeling downright sad and unhappy. That cat kept appearing in my mind. When I woke up from the operation Mother was holding the cat. The sheer happiness and relief. That was the surprise Mom was saving for me. (I love my mother.)

3 Baseball

ED/DAVID: We didn't have any T.V. in our home. My three brothers enjoyed listening to the baseball games on the radio, but I couldn't. So, Lester would explain what was happening to me. We'd sit for 2 hours and it was boring and dark inside and sunny outside. We had a great idea! We put a long cord through the window and set the radio on a stool near a field. They would listen, sign to me quickly and we played the game exactly the way it happened. We used specific baseball gestures, for example (sign – safe on first)... meaning safe on first... and invented some (sign – home run)... meaning home run. We would imitate the players we had seen like: (gesture – Mickey Mantle pose) Mickey Mantle. How wonderful my brothers were to me. I really do miss it.

4 First Day of School

BERNARD/KEN: I remember when I was four and a half. I woke up one morning, my mother washed me, dressed me, gave me my breakfast, and then said, "OK, we're ready to go now." And I said, "But where are we going?" She didn't explain, and we went into the subway. We sat there and I was wondering, and I said, "Really, where are we going?" (gesture only – "um... um... just") She wouldn't answer. She was very quiet and I looked at her and... for the first time I felt strange and afraid... and I wondered... my mother always answered every question that I asked but this was the first time that she was very quiet... and I looked at her. When we got off and walked, I was still wondering. Then I saw this old building, it was on Riverside Drive. We went in and I smelled that... school smell. It was very shiny, very clean, and it didn't look like a hospital or any building that I'd ever seen before and then all of a sudden my mother turned me around and said, "This is the place where you will get all of your learning. You'll live here for a while, don't worry, I'll see you again," and she just couldn't seem to talk anymore, and she kissed me, and she left.

5 Oral School

JOE/DAVID: When I was small, my parents wanted me to go to oral school where children are not allowed to use sign language or fingerspelling but had to learn speech and lipreading. My parents are hearing. (They didn't want me to communicate with them in sign language or by passing notes.) They hoped I would be able to learn to talk to them. The teacher said O.K. and tried to teach me how to say different sounds. She held my hand on my throat to feel the vibrations that happen when I made the sound M... M... M... and in my nose when I made the sound N... N... N. And she put a stick to hold down my tongue and it touched my windpipe; the teacher wanted to hear me say Ah... Ah... Ah..., and I almost vomited.

6 Same Stick

MARY BETH/CAROL: My teacher would use the same stick for all of the children.

7 Tie My Hands

MARY BETH/CAROL: I would teach some of the kids who knew no sign language. The teacher would tie my hands together.

8 My Teacher

FREDA/CAROL: A teacher said to me, "Teaching the deaf children through the means of speech training is the best method to adopt because: the majority is hearing and it is up to the minority like you to join them. Being able to speak is likely to help you people to be accepted into the world."

So, I spent my life learning to be like the others and I can speak and read lips. And I wonder, now, how valuable it is that we must always try to be like others. My deafness is… myself. Must it be something that I must fight against, or hide, or overcome?

9 Letter "K"

BERNARD/KEN: My teacher worked with me for weeks and weeks before I finally made my "K" sound right. At the end of the school year, there was a demonstration. Visitors and parents came. When it was my turn, I stood on stage and I made just one sound… "K." My teacher standing in the wings, peeked around and clapped. The whole audience, following her lead, applauded.

10 #152

DOROTHY/CAROL: At my school for the deaf in England, which I entered when I was nearly nine, the children knew each other not by name but by number. The number belonged to the coat hook where girls hung their pinafores, and boys their jackets or caps in their respective playrooms. My number was 152. All my clothes and things were marked RDS 152, "Royal Deaf School – 152." When I was wanted, someone went around signing 1–5-2, or if they used voice, say and sign "one-five-two" (Point to other numbers then sign and say – "I forget!") Many of the kids never knew the others' names, and in that particular town you could go into the deaf club years later and be greeted by people who knew you when as "Ah! 1–5-2!"

11 Ramona

PATRICK/KEN: When I was in the Preparatory #1 class, my curiosity had some control over me, because speech training was so dull. One day I asked the prettiest classmate to ask our very charming but "naïve" teacher to let her go to the girls' room. Ramona said to Mrs. Gulick, "May I go?" and the teacher replied, "Yes, you may." Some teachers tend to teach speech at all times, often demanding that the child's request to leave the room be repeated until spoken perfectly, before permission was granted. If the need is urgent, that could lead to accidents. Anyway… a few minutes later I stood up and said to Mrs. Gulick, "May I go?" She said, "Yes, you may."

Gee, I hastened out of the room and then tiptoed into the girls' room. Of course, I peeked past the door at first to be sure that nobody besides Ramona was there. To my relief Ramona was the only one girl sitting in the wide and large room. She undoubtedly reacted to my brave and heroic act. At first, she shook her head, signing, "No… Mrs. Gulick," or something like that. It must have been my bullheadedness which finally compelled her to show me her private part. Then I ran out of the room to hide in the boys' room for a while, so that I wouldn't get back before Ramona. Later on, when I was back in the classroom, Ramona demanded that I be fair enough to show my private part. A fool was I, for I finally gave in to her pining pleas! I looked around to see if anyone was looking at me. Then I unzipped my pants and showed the tiniest part of me to her. To my frustration, Mrs. Gulick caught me red-handed and then grabbed my hand to pull me into the next room. There she spanked me for a long, long while. I whimpered, feeling angry at myself but especially with Ramona, the Delilah of my class.

12 Laughter

BERNARD/KEN: Spontaneous outbursts of laughter in the classroom were often stilled by scornful reprimands from our fifth-grade teacher because he said they sounded disgustedly unpleasant or irritating – even animalistic. We were given long lectures on the importance of being consistently aware of what our laughter sounded like to those who could hear. We were forced to undergo various exercises in breathing – first without sound then with – repeatedly, with our hands on our stomachs. (Demonstrate)

Compliments were often lavished upon those who came up with forced, but perfectly controlled laughter – and glares were given to those who failed to laugh "properly" or didn't sound like a "normal" person. Some of us have since then forgotten how to laugh the way we had been taught. And there are two or three from our group, who have chosen to laugh silently for the rest of their lives.

13 Cherry Bomb

MARY BETH/CAROL: When I was 15 or 16 – Sam, my brother-in-law, and I were talking in the front room about different kinds of firecrackers he bought In Tennessee. He had regular firecrackers, cherry bombs and TNT. I was fascinated by the TNT. My father was in the living room, but he was busy reading. Then he got up and took the paper with him. I knew instantly that he was going to the bathroom. Because he was deaf, he always left the door open a crack so that we could sign to him "the insurance man is here" or "paper boy is here." Then, Sam and I started talking about the firecrackers again. I asked him all kinds of questions like, "What will happen if I threw a TNT in a garbage can?" He told me that TNT will make dents in the can. He also told me that if I throw a cherry bomb in the toilet, it will split open. Sam asked, "Father in bathroom?" I said, "Yes." All of a sudden, we both got the same idea and smiled. Sam handed me a cherry bomb and said, "Go on." I took it and walked through the bedroom, dining room and kitchen. I paused because I was a little bit nervous and jittery about it. Sam encouraged me and finally I gave in. I moved the bathroom door a little and could barely see my father – although the newspaper and his hands were visible. I lit the cherry bomb, threw it in, and ran to the front room. As I ran, I felt the shock of the explosion. Sam and I sat down and tried to talk about something else. It was very hard to keep a poker face. Sam said that father was coming. His pants were half down and the torn newspaper in his hand. "What happened? What happened?" Then he looked at me and signed, "Don't you ever do that again!" Then he turned and went back to the bathroom. For three days after he was constipated.

14 Sex Class

LINDA/CAROL: When I was 14 years old, I was two classes ahead of the other girls in my dorm. And because I was the smartest, on Wednesdays, I sat in a big chair and the girls sat on the floor around me in a circle. I gave them lectures on sex. Then there was a question and answer period.

One Wednesday, one of the girls asked me what birth control meant. I didn't know the answer.

The following Friday, I went home as usual. On Saturday morning, while my mother lay on a sofa reading a newspaper, I was so nervous that I could hardly swallow. For a while I fought for my courage to get my mother's attention. Accidently she looked at me and said, "What's the matter?" I answered, "Nothing, nothing." I tried again and this time I touched her back and she responded to me. I rapidly asked her what birth control meant.

Then she asked me, "Why do you want to know?" I shyly said, "Well, one of the girls in the school wanted to know what it meant, and I didn't know the answer." She smiled proudly and explained the meaning of it, and what one uses to prevent pregnancy. Then she said that she was glad that I asked her things that I didn't know, because if I asked other people, I might get wrong ideas or have misunderstandings. Whew! I was very much relieved.

On Sunday, when I returned to the school, the girls excitedly surrounded me, asking if I had the answer. I replied, "Yes, I do, but you have to be patient and wait until Wednesday's class."

Choir

RICHARD/DAVID: When I was 7 years old, my friend Garnet Pink and I – both very deaf – decided to join the church choir.

For two or three years we "sang" in the choir. We never went to choir practice but one Friday night we had nothing better to do, so we decided to go. The choir master was ill that evening, so Father Cornish led the practice. It happened he was in foul humor – and naturally, my friend and I happened to be standing in the front row. The priest started with the musical scale.

BAM – he pointed to my friend to begin. Well, with a sickening look, the quickening of the anal muscles, my friend looked at me with a bewildered look.

GARNET: Father, I have a sore throat today.
FATHER: Alright – Richard you begin!
RICHARD: But… sputter, er…
FATHER: (Looking at his watch) Come on, come on! We've wasted enough time.
RICHARD: (Looking helplessly at Garnet) I have a confession to make. I can't sing.
FATHER: What? How did you get by?
RICHARD: We just wanted to be like the others. We simply moved our mouths and everyone thought we were singing.
FATHER: This is preposterous. Get… out…

I was very embarrassed. I would think he would have been a little more understanding.

Mother

DOROTHY/CAROL: I didn't lose my hearing until I was 8, during a three-week coma caused by the fever of meningitis, which destroyed my hearing nerve. My speech and language were already well established, and by chance I was a natural lipreader, so I don't remember feeling any sudden, awful deprivation. I didn't understand what happens when you become deaf for quite a while, in

spite of several incidents that occurred in the weeks after the coma. The one I remember most vividly happened when, still physically very weak, I was moved into a wheelchair and placed where I could see out of the window of my second-story bedroom. It must have been sometime in late March – a real English spring day. I remember the sunshine and my feelings of restlessness and boredom. I remember too feeling very noble and accepting the fact that I had to sit there and be patient. When I began to whisper, very softly, "Mother, Mo-other, Mo-ther." It was with no conscious intention of calling my mother to me. I told myself that since I wasn't calling out loud I wasn't bothering anyone, but just keeping myself amused. "Mother, Mo-ther, Mo—ther."

Then suddenly Mother was there at my side. I remember feeling quite astonished, as if I had conjured her up from thin air. "What do you want?" she asked, and she looked impatient.

"I want something to do."

"You naughty girl."

There I was struggling with a heavy blanket on the line outside… "I thought you wanted to go to the lav." That was the first time she had scolded me since I was ill.

I understood every word she said, but I was helpless to explain away my behavior or describe my confusion. I hadn't called out loud – she had come of her own free will – and now she was scolding me for nothing.

A long time afterwards I understood that I couldn't hear my own voice anymore, but I still hadn't explained to her, or absolved that silly, unimportant, painful, devastating childish sin, when she died thirteen years later.

Sideshow

Curtain opens on dark stage but spotlight immediately lights on Ringmaster in center stage. Roll of drum.

RINGMASTER: Welcome!! Roll up and welcome to the best strangest travelling show in the universe here for first time in this city bringing for your interest, enjoyment, astonishment in spite of many difficult frustrating adventures here tonight the strange and special people from the world of A-ba-ba.

Lights up to reveal three hearing persons, mouths moving continually, heads cocked. Assistant is standing by exhibits, indicating them.

RINGMASTER: You will see these strange people perform. And also, also… to show you the strange many other things we saw in that world we have here the most skillful troupe of actors in our whole country.

Actors enter, pose, then establish line.

RINGMASTER: Here is the exhibit. See... yourselves...
 body shape the same, parts the same, behavior
 – ah – different.
 You and I use our eyes,

Actors show in turn.

RINGMASTER: Hers are blank and weak.
 You and I use our faces,

Actors show.

RINGMASTER: Hers is frozen except around the mouth.
 Notice their mouths will continue to move throughout this performance.
 Hands limp and soft, not used much... why?...

They are not used for communication.
 Compare.

RINGMASTER: Mouth opens and shuts, throat trembles,
 tongue wags, air is emitted, head cocks.
 We saw (and) found that these people make
 signs with their mouths.
 Let our actors show you.

Mouthing.

 1 Orator
 2 Bared Teeth
 3 Spitting
 4 Cigarette

RINGMASTER: That's not all. It seems they see... with their ears – watch! No
 strings, no electric wires.

Claps. Exhibits respond with head cocking. Assistant claps, heads cock back. Repeat at same speed 1–2 then with 1–2–3-fast slaps.

RINGMASTER: We saw that many times.
 They look at their watches...

Sign used is "see" – from ear. Ed's image.

RINGMASTER: They don't have to face each other to sign.

Back-to-back image.

RINGMASTER: They can sign their secrets very close.

Whispering image.

RINGMASTER: And they sign bigger when they are apart.

Duet image.

RINGMASTER: Truly it seems their ears are very sensitive and quick and when they don't want to see they put their hands… over their ears – Watch!

Noise image: crumpling foil or squeaking slate. Balloon squeak and bang.

RINGMASTER: But they are capable of learning simple language!

Lesson image.

RINGMASTER: And now we show strange machines brought back from the world of A-ba-ba.

Rack of devices, demonstration using:

1 Bell
2 Whistle
3 Tape recorder

RINGMASTER: Strangest and most interesting of all – the little dumbbell.

Exhibit.

RINGMASTER: Their means of livelihood is to obey this machine. Let our actors show you what we saw.

Telephone image.

1 One person angry with another then becoming meek to telephone.
2 Person taking orders from phone.
3 Person answering two phones at once.
4 Queue at ticket office, interrupted.

RINGMASTER: Even in the home.

Freda image.

RINGMASTER: See what happens! Nothing can stop her!

Various distractions, including Mary Beth and whip.

RINGMASTER: In that world we saw timidity, fear of touching.

No-touch image.

RINGMASTER: We saw... "affection."

Sex image.

RINGMASTER: We saw many strange things. At the theatre!

Ventriloquist.

RINGMASTER: In a room!

Radio image: group around a radio excited at intervals, attracts deaf person who forces his way to the middle – and is left alone with a radio.

RINGMASTER: We had many strange experiences in the streets!

Laughing at signs. Talk down image.

RINGMASTER: At the movies!

Movie image.

RINGMASTER: And we saw a child... like ourselves – this is what we saw.

Speech teaching image. Fade out on this image.

Manifest

Fox Story

Enter from all directions. Line-up. THE QUICK BROWN FOX JUMPED OVER THE LAZY DOG. *Spoken.*

CAROL: This is speaking.

Fingerspell all words.

CAROL: This is fingerspelling.

Signing.

CAROL: This is signing.

Sign and hold.

CAROL: This is speed reading.
TIM: *slow*
LINDA: *regular*
FREDA: *fast*
ALL: Wrong

Scramble. Dave tries.

ALL: Wrong (surrounded)
DAVE: Stop

Act out in slow motion.

DAVE: This is the fox, he's brown.
CAROL: That's the dog, he's lazy.
DAVE: Jumps
CAROL: Over
DAVE: Quick

Signs:

Mary Beth: Quick… Quick
FREDA: *Brown*
Joe: Lazy… Lazy
Dot: That's the dog.
Ed: Fox

Unison:

Poses: 1. Group
 2. Carol
 3. Dave

Phonetics

DAVE: A game of signs using one finger.

Dot:	Only	Thirsty	Wise
Joe:	Wonder	Disappointed	Black
Linda:	Scold	Speaking	Witch

DAVE: Two fingers

Ed:	Stupid	Blind	Stuck
Tim:	Look	Stand	Foresee
Richard:	Visit	Lobster	Egg

CAROL: Three Fingers

Mary Beth:	Lousy	Sweet	Bug
Pat:	Dressed up	Boats	Champion
Freda:	Rooster	Awkward	Devilish

DAVE: Four fingers

Dot:	Fantastic	Parade	Never
Joe:	Elephant	Walk	Invent
Linda:	Ignore	Worry	Tipsy

DAVE: Five Fingers

Ed:	Gay	Crazy	Dizzy
Tim:	Fire	Love	Nothing
Richard:	Free	Happy	Peace

CAROL: The middle finger

Mary Beth:	Empty	Sympathize	Excited
Pat:	Delicious	Telegraph	Feel
Freda:	Hands off	Depressed	Brightness

Brightness

FREDA: And now we will show you many other ways of saying brightness.

FREDA:	Dress	Candle	Flash bulb
PAT:	Glasses	Hair	Bald head
TIM:	Moon	Snow	Polished floor
DOT:	Lightning	Lighthouse	Firefly
MARY BETH:	Sweat	Airplane light	Mirror
LINDA:	Eyes	Ring	Shiny nose
RICHARD:	Sunrise	Gun	Stars
ED:	Shoes	Cop car	Headlights
JOE:	Water	Gaslight	Idea
FREDA:	Fireworks		

All join – Fall.

Inflections

RICHARD: Inflections (fingerspell)
 CAN'T YOU SEE THAT THE FIREWORKS ARE OVER?
RICHARD: TIMID
FREDA: Sexy
TIM: A la Brando
MARY BETH: Impatient
PAT: Blank

Ed and Joe carry Ken off.

Origins

FREDA: Holland
CAROL: Our signs for countries often show an image, Holland.
TIM: France
PAT: A handkerchief that a gentleman pulls out of his sleeve, France.
RICHARD: England
DOT: Gentleman stood this way with their canes, England.
JOE: No – because England was always grabbing other countries like me, India.
ED: India
JOE: See the red on my forehead?
PAT: Germany
TIM: Because of the eagle, Germany.
LINDA: Spain
MARY BETH: Beautiful shawls, Spain.
DOT: Canada
RICHARD: The Royal Canadian Mounted Police have a saying: "We always get our man," Canada.
CAROL: Scotland
FREDA: Clothes from plaid fabrics, Scotland.
MARY BETH: Italy
LINDA: The letter "I," the sign of the cross of the church, Italy.
JOE: Japan
ED: The letter "J," Japan.
DAVE: Russia
ED: Because of their dances, Russia.
PAT: We have this sign (shows) for America because of the log cabins.

Shows trees cut down, etc.

LINDA: I thought that it showed America as a melting pot.

Shows.

TIM: I thought it came from cattle fences.

Shows.

DOT: England uses this sign (shows) because they saw American G.I.s chewing gum.
LINDA: Our sign for theatre (shows) – maybe it's the costumes.
TIM: In Sweden.

Shows.

LINDA: Sign language is not universal, but when we tour abroad, we communicate easily with European deaf people. We can go more directly to meanings, instead of being stopped by differences in words.
MARY BETH: Bread is an old sign. We used to hold bread like this to cut the slices.
LINDA: And coffee was put into a grinder.
RICHARD: Crackers has a strange origin. In Scotland, it was good luck if you could break a cracker into three pieces. It's harder to cheat using your elbow.

Sign, mime soup.

TIM: Signs change with the times. Telephone (old man, old phone). Now (young man, modern phone).
FREDA: And haircut. In the old days.

Shows haircut

FREDA: But now.

Shows.

DOT: We have fun with sign language.

Fingerspells.

DOT: A falling leaf.

Shows.

DOT: (Fingerspells) A bouncing ball.

Shows.

DOT: Reflections (with Freda)
PAT: This means preach. Why don't you practice what you preach becomes…

Shows.

ED: (Speak and sign, or Dave) We like to invent signs. This means Law – (shows) the letter "L" against the tablets. Now, in the Old West – the Law of the Gun.

Show. Shoot-out – Ed & TIM.

Slang

RICHARD: (Carol) "A little dictionary of slang."
ED: Richard (Carol) "Amusement"

1 The Smile
2 The Chuckle
3 The Giggle
4 The Laugh
5 The Hysterics
6 The Rolling-on-the-Floor

PAT: Linda (Dave) "Crying"

1 The Lump
2 The Choke
3 The Sniffle
4 The Sob
5 The Cry
6 The Weep

DOT: Joe (Dave) "Anger"

1 The Irritation
2 The Restraint
3 The Anger
4 The Slow Burn
5 The Swell-Up
6 The Blow-Up
7 Instant Replay
8 Rewind

TIM: Carol (Dave) "Fear"

 1 The Observance
 2 The Eyes
 3 The Heart
 4 The Jaw
 5 The Hair
 6 The Legs
 7 The Departure

MARY BETH: Freda (Carol) "Love"

 1 The Meeting
 2 The Falling
 3 The Approach
 4 The Response
 5 The Fade-Out

Triad and Four Poems

PAT: In poetry, we can hold signs in a way you can't hold words – TRIAD.
PAT, CAROL, DOT: There be three silent things:
> The falling snow...
> The hour before the dawn...
> The mouth of one just dead.

TIM: (Holding three sign images) Tree, Shadow, Falling on a house.
JOE: "Poetry of deaf children"
> Dreams
> Cowboys and Indians
> Circle in
> My head when I dream

LINDA: (Carol) Twisted
> Jointed, no
> teeth, looking at
> the world through glass
> eyes.

FREDA: (Carol) Because
> Brown grass
> Was green, it had
> Life, it died because
> It stopped growing.

RK: (Dave) Born
> Living, growing
> Constantly growing-up.
> Life is as soft as
> Me.

Sea Battle

RK: When we were children trying to develop our sign language, we told stories like this. Mostly when our teachers weren't looking.

Carol speaks all.

TIM:	Water
DOT:	Lighthouse
ED:	Aircraft carrier
MM:	Fighter plane
LINDA:	Battleship
RK:	Parachutist
PAT:	Helicopter
FREDA:	Rescue
JOE:	Lightning and thunder
RK:	Wind
JOE:	Rain
ED:)
MM:) Sunrise
LINDA:)
PAT:	Peace

Promenade Workbook

First Summary Sept. 10, 1971

 Editor's Note: As much as possible, the large gaps in line spacing in this section of the script were exactly as in the original script. On some pages in the original script, the word "VOID" appeared at the top of blank, numbered pages. It is not clear why these pages were documented in this manner. One possible theory is that it represented the dark void (and some activity or lack thereof) outside of the large cloth that the characters interacted with on stage. Another idea is that this segment may have been an early draft since one company member (Tim Scanlon) remembers that more activities were involved than what is on these pages. The VOIDs might represent a work-in-progress or an undetermined piece of work that were to be completed and inserted later, or perhaps they were never gotten around to in writing. The editor decided to keep them in their original locations to preserve the integrity of the script.

Lines

 Enter
 Where's my mother and father?
 When will it stop raining?
 Hot... I can't stand the heat.

Mother... Father
7 1/4
I can't sleep here.
Will the sun ever shine again?
Oral school
Where's my rainbow?
Can you hear the rain?
Yes, on the window.
Hat
7 1/4
Can you hear?
152... 152
Where's my rainbow?
That's the answer to my question.
Got ya... red, blue, yellow, pink, purple, black
Hanging pantomime... small clapping
Same color as my golf balls.
Hot
The Lord's Prayer.
Mommy... Daddy
152... 152... 152
What time is it?
No... No
I'm scared
Gorilla movement
1–2–3–4–5–6–7–8–9–10
Time... time... time... time
10:45
I can't sleep here.

Choir, choir, it's time to start. We've wasted enough time.
Richard, you start with the musical scale.
Richard, is something wrong?

Father, I can't sing.
1–2–3–4–5–6–7–8–9–10
Can you hear?
What?
Anything
Nothing at all.
Music
What time is it?
Answer
What time is it?
Answer

Operation

BB: Time... Time
DAVE: Chanting
MM: Do you want to hear?
BB: Yes, but I'm not ready.
CAROL: Do you want to hear the rain?
BB: Yes
MM: Relax
BB: What are you going to do? Not now. I'm not ready. No... No

Placed in a sitting position
 MM – Doctor
 Joe – Mask
 Pat – Takes notes
 TIM – Breathing bag
 RK – Indicator light
 Linda – Heartbeat rhythm
 Carol – High-pitched sounds
 Dot – Clock
 MM, Carol, Ed – Pass instruments
 Two basic positions for group: 1. Bandage 2. Noise
 Unwrapping of bandage. Machine-like.

MM: Clap... Can you hear?

Bird chirps.
Development of sound.

RK: Bernard... Bernard
CAROL: Can you hear the rain?
BB: I can... I can hear.

Sharpen sounds, make louder.

BB: Stop... stop... please stop (*Through building sound*)

Collapse in TIM's lap.

	Signs		Words
TIM:	Secret	CAROL:	Secret
RK:	Silence	DAVE:	Silence
KEN:	Noise	DAVE:	Noise
PAT:	Sign	CAROL:	Sign

Sound of these words echo briefly by company as the composition dissolves.

Sun

Works his way to center as group shifts. Tries to cover head with cloth.
Group pulls taut as he tries to cover.
He tries to reach edge of cloth.
He rolls back and forth.
He rolls across cloth and then off.
Lines through-out:
Sun
My hat
He disappears.
Group begins to examine empty cloth.

Cat

MM: Meow... Meow... Meow

Others open a bit so that Ken can be seen crawling for the cat.
He is supported and held back by the group.

PAT: No... No...No
CAROL: Leave the cat alone.
PAT: No... No

Carol pets the cat.
Ken falls through the group.

Void

Carol rides horse around cloth.
Freda steals one of Ed's balls.

Names

Moves across the cloth asking:

LINDA: What's your name?

Slaps, hits, and knocks each person down on each spoken response.
BB fingerspells his name.
Linda hits him hardest and most often.

Void

Knife

Tim *begins to move up from floor.*

Dream walk builds through many peoples' hands.
People drop off as dream walk moves higher.
Dream walk begins to move down.
People come back... lay hands on Tim.
Dream walk sinks into crowd.
Crowd splits as Tim emerges with knife.
Shows knife to individuals in group.
Says each time: K-NIFE
Speech lesson: KNIFE not K-NIFE.
Carol copies this and echoes KNIFE.
Tim sits with Freda behind.
She pushes knife away – he pulls – she lets go and Tim stabs himself.
Freeze.
Applause.
Congratulations.
Tim gradually realizes what happened and accepts congratulations.

Void

Entrance

DAVE: 5 minutes

Group into costumes, make-up, warm-up
 Ad-lib lines with movement to places:
 What are you doing?
 See you later
 Ready for the show? What show?
 The door over there
 It's time.

MM: It's time
DAVE: Places... Places

Group moves to edges and wrap-up in cloth forcing BB to stay in middle.

BB: What... Which is it?

No answers.
 Pat and Ed point at costumes, then several point to audience.
 BB sees audience, realizes he is on.
 And alone slowly begins lines from GIANNI SCHICCHI.

BB: I leave my own young mule for which I paid
 300 florins and which is the best mule in
 Tuscany to my devoted friend, Gianni Schicchi.

> I leave my house in Florence to my dear, most
> affectionate and devoted friend, Gianni Schicchi.
> And the sawmills of Signa go to my dear and most devoted friend, Gianni Schicchi.

At last line group swarms around BB and cover him.
 Entire composition collapses.

Babies

Group starts moving around in clockwise direction.
 Bodies under cloth.
 Freda moves to center of cloth and then to UR corner.
 As she starts to move, others begin to duck under cloth and move to center.
 She picks up corner of cloth and begins to cover herself.

Group comes out one at a time: 1. Pat
 12. Ed.
 Others not set.

Form family picture.
Hold in place.
Freda opens her mouth.
Red ball comes out... rolls down cloth.
Freda falls back and is caught as Ed begins move to ball.

Golfballs

 Tries to capture ball.
 Group moves around cloth and makes waves. Ball jumps.
 Each person throws in another ball.
 Ed tries to catch the red and yellow ones.
 All balls end up off the cloth.
 Ed ends up sprawled on cloth.
 Ed looks around cloth, still searching.
 Faces front.

ED: Give me back my ball(s).

Teaching

 Carol covers herself with cloth.
 Is lifted onto Ed's shoulders.
 Group moves to her.

Linda sitting alone.
Joe bunches cloth as a pail.

CAROL: (Mouthing but no voice… uses 3 hand positions on face.) BUCKET

Linda tries to say the word.
After each try Carol nods to Joe.
He dunks Linda.
After the first dunk,
the group starts with words and sounds:
SPEAK
BUCKET
This builds from:
1. individual
to: 2. group confusion
to: 3. rhythm led by RK
After fifth dunk, Linda collapses.
As Linda starts to collapse the sounds stop
and Carol and Ed fall.
The group moves to catch Carol and Ed.
Linda lying motionless.

Void

Rescue

Group on knees around edge of cloth.
TIM on cloth looking for Linda.

TIM: LINDA… LINDA

Cloth pulled taut as TIM starts to move.
As TIM reaches Linda (slow motion) small waves begin.
TIM picks up Linda… waves become larger.
TIM struggles to keep balance… staggering a bit… waves larger.
TIM falls with Linda.
Linda rolls off cloth left.
TIM rolls off right to places with group.
Cloth goes back to calm, empty.

Void

Discussion

BB: What's wrong?

DAVE: My ears... a little trouble with pressure. It's ok now.
BB: Trouble?
DAVE: It's ok now.
BB: I remember you told us about your experience when you thought you were losing your hearing.
DAVE: Yes, I was on a plane. The pressure changed and my ears hurt for half an hour. It was difficult to hear anything.

Begin development of laughter.

BB: Have you ever imagined what it would be like to be really deaf?
DAVE: I don't really know... if I became deaf... I... well, it's not easy to answer that question.
BB: Right, I can understand that. How do you think you'd feel? Happy? Sad?

More laughter.

DAVE: I don't think I'd be very happy. I don't know. At that time, I didn't think of deafness as a loss. At that time, I was only thinking of the good side. Really a new experience for me. Maybe my first reaction.

Maximum development of laughter.

BB: Go on.
DAVE: (Blank)

Laughter begins to finish.

BB: Go on.
DAVE: (Blank)

Laughter finished. Possible INSERT PAGE here.

BB: Think for a minute. What would you miss most?
DAVE: Losing sound would be important to me. I don't know if I could live without sound.
BB: What would you miss most?
DAVE: Probably music.
 Ensemble begins to leave stage.
BB: That's important to you?
DAVE: Yes, that is important to me.
 Especially the music I make myself.

> Being here has shown me that.
> I can feel a kind of loss.
> *All should be off by line above.*

BB: What is the most important thing to you?
 END.

Possible Insert

BB: Ask me the same question. Ask me how I would feel if I were to become blind. Do you know what I would say?

DAVE: I don't know.

BB: What do you think I would say?

DAVE: I don't think you'd be very happy.

BB: No, you're right. Now if you became deaf, would you be happy?

DAVE: Probably not.

BB: Then say so… it's easy to say.

End of Possible Insert.

Curtain Raiser

THREE BLIND MICE, THREE BLIND MICE
SEE HOW THEY RUN, SEE HOW THEY RUN
THEY ALL RAN AFTER THE FARMER'S WIFE
WHO CUT OFF THEIR TAIL WITH A CARVING
KNIFE HAVE YOU EVER SEEN SUCH A SIGHT IN
YOUR LIFE AS THREE BLIND MICE.
THREE BLIND MICE.
SEE HOW THEY RUN, SEE HOW THEY RUN
THEY ALL RAN AFTER THE FARMER'S WIFE
WHO CUT OF THEIR TAILS WITH A CARVING
KNIFE HAVE YOU EVER SEEN SUCH A SIGHT IN
YOUR LIFE AS THREE BLIND MICE.
THREE BLIND MICE
SEE HOW THEY RUN, SEE HOW THEY RUN
THEY ALL RAN AFTER THE FARMER'S WIFE
WHO CUT OFF THEIR TAILS WITH A CARVING
KNIFE HAVE YOU EVER SEEN SUCH A SIGHT IN
YOUR LIFE AS THREE BLIND MICE.
HAVE YOU EVER SEEN SUCH A SIGHT IN YOUR
LIFE AS THREE BLIND MICE.
HAVE YOU EVER SEEN SUCH A SIGHT IN

YOUR LIFE AS THREE BLIND MICE.
THREE BLIND MICE, THREE BLIND MICE
SEE HOW THEY RUN, SEE HOW THEY RUN
THEY ALL RAN AFTER THE FARMER'S WIFE
WHO CUT OFF THEIR TAIL WITH A CARVING KNIFE
HAVE YOU EVER SEEN SUCH A SIGHT IN YOUR LIFE
AS THREE BLIND MICE
THREE BLIND MICE
THREE BLIND MICE
THREE BLIND MICE
THREE BLIND MICE

About the Author

In 1967, a new era in American theater began with the establishment of the National Theatre of the Deaf. Even though the theater program at Gallaudet University had been doing sign language plays with voice interpretation since the 1890s, it was NTD that helped put Deaf theater on the map. The NTD founders believed that for every NTD show, the audience needs to hear every word and see every word, thus their oft-quoted slogan became "You SEE and HEAR every word." Hearing voice actors were once called "readers." This term most likely came from an old Deaf theater technique at Gallaudet where hearing people sat offstage – usually in the first or last row of the house (sometimes in the catwalk where the lights were hung) – with music stands and scripts, and read the lines of dialogue that the Deaf actors were signing on stage. As Bragg commented during a Gallaudet Today interview,

> … we have had hearing persons as readers since the beginning. It was David Hays' concept to blend speech and sign. Maybe someday we can devise a production which everyone can understand without words. In *My Third Eye* we tried to eliminate the need for readers as much as possible.[2]

NTD's style involved having one to three readers on stage as their own characters while voicing the lines of the signing characters.

Six people bought tickets to see the first performance of the NTD in 1967, most of them out of curiosity. After many years, one Grammy nomination and one Tony Award later, the NTD has brought audiences to their feet across the globe and received rave reviews from New York to New Delhi.

In her book *Signs of Silence*, Helen Powers stated that in 1946, Robert Panara, a graduate of Gallaudet University and newly hired Deaf teacher at the New York School for the Deaf, produced a play with Bernard Bragg, a 17-year-old student in Panara's English class. Later in the 1940s, when Bragg was a student at Gallaudet, Panara left the New York School for the Deaf to teach at Gallaudet.

While both at Gallaudet, Panara and Bragg conceived of the idea of a theater for the deaf.[3]

In 1963, Dr. Edna Simon Levine, a psychologist working in the area of deafness, saw Bragg perform a one-man-show in New York City, and met with him to share her own ideas of forming a professional company of Deaf performers in the 1950s. Arthur Penn and Anne Bancroft, the director and leading actress of Broadway's *The Miracle Worker*, were approached with the idea and, in turn, brought it to their colleague, Broadway set and lighting designer, David Hays. Struck by the beauty and strength of sign language on stage, Mr. Hays persisted in his vision of bringing this powerful form of expression to theater audiences.

A federal grant in 1965 from the U.S. Department of Health, Education and Welfare provided planning funds. In the spring of 1967, a national television program was aired which explored the experimental idea of NTD. With additional funds from the U.S. Office of Education, NTD's annual Professional Training School began that summer, and the company made its first national tour that fall from a home base it shared with The O'Neill Theatre Center in Waterford, Connecticut. The following year, The Little Theatre of the Deaf, an offshoot of NTD providing theater for young audiences, was created and began touring.

In 1983, NTD moved to its own home in Chester, Connecticut. In 1994, the National and Worldwide Deaf Theatre Conference had its inaugural session to facilitate communication, develop techniques, and encourage the work of Deaf playwrights from over the 40 theaters of the Deaf from all around the world that the NTD was instrumental in founding.

NTD later moved to Hartford, Connecticut in July of 2000, to the historic Colt Armory and moved once again in 2004 to the campus of the American School for the Deaf in West Hartford.

During a span of 50 years, NTD conducted 64 national tours with guest artists to all 50 states. In Stephen Baldwin's story of the NTD, *Pictures in the Air*, he noted that: "Overall, NTD has presented more than 8,000 performances in America after touching 30 countries and seven continents (Hays presented a workshop in Antarctica in 1998!)."[4] NTD earned its place in theatrical history as the oldest, continually producing touring theater company in the United States. NTD has received critical acclaim for its adaptations of classic literature (Chekhov, Voltaire, Homer, Moliere, Ibsen and Puccini) as well as for original works by the Company. NTD has put its signature on such creations as a magical adaptation of Phillip de Broca's film, *King of Hearts*, and *Ophelia*. The company has collaborated with artists such as Chita Rivera, Jason Robards, Arvin Brown, Bill Irwin, Alan Arkin, Sir Michael Redgrave, Meryl Streep, Peter Sellars, Tetsuko Kuroyanagi, Colleen Dewhurst, and Pilobolus Dance Theatre. NTD's teleplay of *One More Spring*, produced with Connecticut Public Television and The Learning Channel, was nominated for an ACE Award.

Notes

1 Miller, Richard Allen. The Biological Function of the Third Eye. Retrieved from http://www.nwbotanicals.org/oak/newphysics/thirdeye.htm. Accessed 17 Aug. 2020.
2 Gallaudet Today. "National Theatre of the Deaf." *Spring* 2.3 (1972): 5.
3 Powers, Helen. *Signs of Silence: Bernard Bragg and the National Theatre of the Deaf.* New York: Dodd, Mead. 1972. 72.
4 Baldwin, Stephen C. "American Deaf Theatre from 1993 to 2022," unpublished manuscript.

3
DOROTHY MILES, *A PLAY OF OUR OWN*

IMAGE 3.1
Source: Photo courtesy of Liz Deverill.

68 Dorothy Miles, *A Play of Our Own*

IMAGE 3.2 The Hartford Thespians during curtain call of *A Play of Our Own*, directed by Dorothy Miles. Laura R. Miller, Joyce Horvath (seated), Andy Diskant, Tim Reynolds, Elise B. Burke, Leo Burke, Lilly R. Shirey (seated), Greg Bonin, Jane W. Golightly (left to right).

Source: Photo courtesy of Lilly R. Shirey.

Synopsis

This light-hearted, ensemble-created play provides a look at what happens when a deaf daughter brings home a hearing boyfriend to meet her Deaf family. Domestic scenes of Deaf life in a 1970s household are portrayed with incidents and banter involving TTY telephone calls, doorbell light flashes, plans for attending the Deaf Club, being home from Gallaudet College, sign language semantics, and getting ready for a big dinner gathering. The play's focus on cross-cultural relationships somewhat mirrors that of the classic comedy-drama film, *Guess Who's Coming to Dinner*, where a bride's white parents are astonished to learn that her fiancé is black.

In this case, the Deaf daughter has something important to say to her very Deaf-centric family but does not get to tell them because of family members being too distracted to listen. Amid the chaotic hustle and bustle in the house, the family's Deaf world bubble bursts when a hearing person – the daughter's boyfriend – enters their house for the first time. The situation is exacerbated when everyone learns that the boyfriend's hearing parents do not know that the family they are about to share a meal with is Deaf. The latter part of the play deals with an encounter between the two families, ending with what could be interpreted either as a hopeful start or a troublesome beginning.

Production History

The play had a preview as a fundraiser for the Maryland School for the Deaf before it premiered at the American School for the Deaf in Rockwell Gym in Hartford, Connecticut on June 9, 1973. It was sponsored by the Hartford Club of the Deaf and directed by Dorothy Miles; Stage Manager, Mike Muszynski; Technician, Hugh Farquhar. The cast was as follows:

 Dora Daniels – Lilly Berke
 Edgar Daniels – Leo Berke
 Joan, a neighbor – Laura Rabinowitz
 Peter Daniels – Greg Bonin
 Ruth Daniels – Elise Baris
 Margaret, Ruth's friend – Jane Wilson
 David Bone – Tim Reynolds
 Mildred Bone – Joyce Horvath
 Harold Bone – Andy Diskant

The play had a subsequent production the next day at the Eugene O'Neill Theatre Center on June 10, 1973. Stage Manager, Wesley Miller; Technician, Frank Fradianni. The cast was as follows:

 Dora Daniels – Lilly Berke
 Edgar Daniels – Leo Berke
 Joan, a neighbor – Laura Rabinowitz
 Peter Daniels – Greg Bonin
 Ruth Daniels – Elise Baris
 Margaret, Ruth's friend – Jane Wilson
 David Bone – Tim Reynolds, Ben Birdsell (understudy)
 Mildred Bone – Joyce Horvath
 Harold Bone – Phil Lohman

Thoughts on the Play

To help spread the news about the latest developments of the company as well as their alumni actors, the National Theatre of the Deaf sent out a newsletter in 1973 announcing the production of Dorothy Miles' play, *A Play of Our Own*. It noted that

> for community theatres of and for the deaf, a major problem in the past has been the selection of suitable plays dealing with the problems of deafness, and none at all dealing with everyday life in which most of the characters are deaf. For comedies, murder mysteries, romantic dramas, and so forth, community theatres have turned to plays written for speaking actors and adapted them for sign language presentation.[1]

The script was developed by the Hartford Thespians, a local Deaf community group of actors, under the guidance of Miles who had the dual role of

documenting the improvised dialogue and directing. What is intriguing about Miles' writing is how certain "ASL phrases" – indicated with glosses between quotation marks – were woven into the colloquial English dialogue. In Deaf theater (and in ASL linguistics), glossing is a simple compromise for transcribing ASL into English on a written script. ASL is a visual, three-dimensional language and does not have a written form. Therefore, an English word is merely placed on the page as a code word to the signer to approximate what ASL sign should be employed. It should be noted that ASL glossing is often used where video transcription is not available.[2]

Although some of the lines in *A Play of Our Own* are not written in perfect English, they are still comprehensible. A reader familiar with ASL would most likely recognize the ASL idioms and concepts. In essence, Miles was documenting and/or translating exactly how these lines should be expressed in ASL on stage. It takes good bilingual skills to be able to read Deaf actors signing in ASL on stage (during the exploration and rehearsal phase of the production) and choosing the right glosses in English to record on the page. This is done so when the actors are memorizing and reviewing their lines, they can quickly envision or recall what their ASL lines were or should be.

Other unique features evident in the script are places where lines of dialogue were not written out; rather, stage directions explain a broad situation and give actors the freedom to ad-lib or improvise. Another feature – in numerous places throughout the script, actors are expected to apply visual-gestural communication methods such as universal gestures, body language, pantomime, or Visual Vernacular.[3]

As Miles wrote in her director's notes in the playbill (dated 6/9/1973)[4]:

> This play is the result of a Movement and of an experiment. The Movement is nationwide: a move towards acceptance of deafness and identification with the real life of a deaf person; and a move away from the imitation of hearing persons. The experiment is local; an attempt to develop a full-length play that would allow deaf adult actors to be "themselves" on stage – using their own language and their own everyday environment. To make this a truly honest portrayal of deaf family life, there is no spoken narration. Hearing members of the audience who cannot follow sign language will thus be in the position that deaf people normally are when watching a stage or television presentation performed by hearing persons – much of the dialogue must be guessed.

In his article, *Unmasking Dorothy Miles,* Stephen Baldwin suggests that

> *A Play of Our Own* was an overt declaration of war against NTD. Dot's stage play was an antithesis to the performance style of NTD that adapted and translated mainly English language scripts, following a hearing world

theme, and utilizing two onstage voice actors. Her original play adhered to a bona fide deaf perspective with no onstage or offstage voice interpreter. American Sign Language (ASL) became the norm, not the stylish, sign-mime approach that NTD used.[5]

By coincidence, or from being inspired by NTD's recent release of *My Third Eye*, Miles, who is an alumna of the National Theatre of the Deaf, wrote and directed her play during 1973.

Deaf Gain

One of the earliest Deaf playwrights to have written reality-based, Deaf life on the stage. Miles is perhaps the best-known British Sign Language poet, and the original source of most of the sign language poetry composed and performed today. Along with *My Third Eye, Sign Me Alice* (written by Gilbert Eastman), and *Tales from a Clubroom* (written by Eugene Bergman and Bernard Bragg), this play has become a part of the canon of Deaf Theatre classics.

Notes

1 NTD Newsletter, 1973.
2 American Sign Language Teachers Association. Definition of ASL Glossing. Retrieved from: https://www.aslta.org/gloss/, Accessed: 18 Aug. 2021.
3 As explained in his book, *Visual-Gestural Communication*, Conley stated that Visual Vernacular (V.V.) is an aspect of storytelling in ASL.

> V.V. was created by former NTD actor Bernard Bragg who formally studied mime under Marcel Marceau. Greatly inspired by Marceau, Bragg found a way to apply mime techniques he had learned into a theatricalized form of ASL, which is at once poetic and cinematic. Just by merely standing in place and using the power of gestures, the storyteller can portray film-like elements such as a wide shot, medium shot, close-up, subjective point of view, objective point of view, omniscient point of view, slow-motion, freeze-frame, stop-action, cuts, and zooms. V.V. is also known as Sign Mime; however, there is some difference between the two labels. While V.V. is primarily performed while standing in one location – usually good for compact ASL performances fitting within the TV/film frame or computer screen – Sign Mime is more theatrical, where the performer moves around and uses the stage space with ASL.

4 *A Play of Our Own*. Hartford: Playbill, 1973.
5 Baldwin, Stephen C. "Unmasking Dorothy Miles – The Deaf Bard of England, Wales, and America, Part Two." Deaf Seniors of America/New Horizons; Summer 2020, 21.

3
A PLAY OF OUR OWN

Dorothy Miles

Characters

DORA DANIELS, *deaf. Between 45 and 50. For her first entrance, in Act I, she is wearing some kind of apron or smock over her dress to show that she is doing housework. At the beginning of Act II, she is dressed for going out – something plain but suitable for wearing at dinner later. She should be fluent in sign language but may choose between using idiomatic signs and "Signed English," except where the script calls for specific idioms. She does not speak but can mouth words.*

EDGAR DANIELS, *deaf. A little older than his wife. For his first entrance, he is wearing pajamas with a bathrobe over them, though he may need to be partly dressed under the pajamas for a quick change before his second entrance. At this entrance, he is dressed casually – slacks, with a shirt or sweater – but tastefully enough to be acceptable to the visitors later. He wears bedroom slippers until after his second exit, then changes to socks and shoes. His choice of communication is the same as his wife.*

THE NEIGHBOR, *deaf or hard of hearing. She can be any age from 25 to 60, but preferably over 30. She should be dressed very casually – slacks and sweater, or an old dress, with a jacket over her shoulders – during the first act. She can have her hair in curlers. When she enters during Act II, she has changed to an afternoon dress, and combed out her hair. She should be proficient in the sign language, enough to use the idioms given, but she can have an oral background and mouth words a lot, even using her voice occasionally, except after the hearing characters have entered.*

PETER DANIELS, *deaf or hard-of-hearing. Between 18 and 22. He also is dressed casually but neatly, possibly with a Gallaudet sweatshirt. He should be a good signer and use Signed English most of the time with perhaps several modern variations, such as the "-ing" ending and the "am, is, are" signs. But, he should also be adept with idioms. He*

should be able to speak well enough for David to understand him on stage but does not need to be clear to the hearing audience.
RUTH DANIELS, *deaf. Between 22 and 24. She is dressed comfortably but attractively – slacks, a sweater in pleasing contrast, a scarf or jewelry if desired. She should sign fluently and can use up-to-date modifications; she should also be able to speak, or at least mouth words clearly. When talking with David and with Mildred she may need to sign slower than usual.*
MARGARET, *deaf. Same age as Ruth. She wears neat working clothes – a pants suit, or dress with a cardigan or jacket. She should be a fluent signer but does not speak.*
DAVID BONE, *hearing. Age around 25. He wears a suit. He should be able to sign quite well, using up-to-date variations now being taught in sign language classes, but should not appear too fluent, as he must frequently request interpretation of idioms. He speaks while signing at all times. When talking with Mildred and Harold, he signs only where indicated, otherwise he speaks to them.*
MILDRED BONE, *hearing. Age 45–50. She is dressed for dinner, but not "dressed up" (a pants suit or suit with skirt or cocktail dress will be suitable). She speaks at all times and should seem quite inhibited about using gestures.*
HAROLD BONE, *hearing. A little older than Mildred. He wears a suit. His choice of colors should be more "liberal" than his wife's. He speaks at all times, except during his scene with Mr. Daniels, when he uses gestures very comfortably.*

Notes

The ages given refer, of course, to the characters. Younger or older actors may be selected and made up to fit the parts. In community group, however, every attempt should be made to fit the actor to the character in terms of both age and communication skill. It is especially recommended that hearing actors play the hearing roles, otherwise the honesty of the performance is forfeited.

Place: The living room of the Daniels' home in Hartford, Connecticut.

Time: The Present (Act I – Late morning of a day in April, Act II – That afternoon, Act III – One moment later).

Act I

As the curtain opens, we see the TTY light flashing on and off in synchronization with the ringing of the telephone. After several flashes, Mrs. Daniels enters from the kitchen, drying her hands on a dish towel. She looks at the TTY with mixed surprise and annoyance, goes to it, and begins to operate it. The call is brief – maybe three or four sentences on each side – but we see that Mrs. Daniels is surprised and excited by what she reads. When the call is over, she re-reads the message, then gets up and moves towards center stage, looking around as if wondering what to do first. By this time, Mr. Daniels has entered from the bedroom, tying the cord of his bathrobe, obviously just getting out of bed. He watches her

for a moment, then comes forward so that he is facing her when she turns to go back to the kitchen. She is startled.

MR. DANIELS: What's the idea? "Light-flash" woke me up.
MRS. DANIELS: Sorry, forgot to "turn-off-switch" in bedroom. Busy cleaning. Not expect TTY call early morning.
MR. DANIELS: "Anyway," light woke me up!

He turns away, angry.

MRS. DANIELS: (Trying to soothe him) Guess who called?
MR. DANIELS: I don't know.
MRS. DANIELS: Daughter Ruth called. She—
MR. DANIELS: Ruth? About time! Not much call lately – never write – not come visit.

Mrs. Daniels tries several times to interrupt him during this speech.

MR. DANIELS: Why she have to go work in New York in the first place? I often worry about her. Bad place live "there," New York. Robbery, rape, muggings, "and so forth." Why can't she stay home, work here "in area"… then she not have to call you in mornings, wake me up.
MRS. DANIELS: Silly. You know Ruth has good job in New York. Good experience for her, out-in-the-world, new life, meet people. What you know about New York? You never live there. You always want to stay home, do same old thing.
MR. DANIELS: Well, I'm fine here – good life, nice home, two cars, many friends.
MRS. DANIELS: (Nodding sarcastically) Oh, yes – but you always complain, complain, about money, about your boss, hearing people talk about you at work, no promotion. If you go, go to many different places while young, you not complain like that now.
MR. DANIELS: Stop add, add.

He moves away again. Mrs. Daniels, remembering the phone message, goes after him.

MRS. DANIELS: Oh, Ruth coming home this evening…
MR. DANIELS: Fine…
MRS. DANIELS: …and bring boyfriend with her.
MR. DANIELS: Boyfriend? From New York?
MRS. DANIELS: I don't know.
MR. DANIELS: I forbid it!

He takes several quick paces while Mrs. Daniels shows her exasperation. Then Mr. Daniels turns and comes back suddenly.

MR. DANIELS: Maybe I never go to New York, but I met New York deaf boys at basketball, bowling, "get-togethers" – tough, dress awful, no respect for people. I don't want see Ruth "go with" any New York deaf boy. Why not Ruth stay home, find nice boyfriend here?
MRS. DANIELS: You know Ruth has good judgement, won't pick lousy boy. Maybe boy not New Yorker. Many different deaf "flock to" New York for work – you behind news!
MR. DANIELS: O.K., O.K.

He turns and crosses to the bedroom. Mrs. Daniels watches him go, annoyed with him. After a few steps he turns around.

MR. DANIELS: I will see Ruth after Club tonight.

Mrs. Daniels panics, runs after him, taps his shoulder, then turns towards the TTY.

MRS. DANIELS: No, don't go to Club, Ruth want you stay home meet boy for dinner.
MR. DANIELS: I can't. You know I always regular Club Fridays. Tonight meeting, I have to give Treasurer's report.
MRS. DANIELS: Please – you can give Treasurer's report to President, he will understand, Ruth "specific" want all family "round-the-table" dinner. Look!

She shows him the TTY message. He reads it without enthusiasm.

MRS. DANIELS: You should be happy to see daughter. "A while ago" you complain not see enough. I feel this boyfriend serious, maybe both plan get married, then "responsibility-off-your-shoulder."
MR. DANIELS: (Upset by the idea of "married") Fine, fine – now Ruth plan get married. I let her go to New York, nothing "contribute-to-house." I have to pay heavy TTY bill for you call her. I almost never see her. I have to give up Club meeting tonight for her. Next, I have to pay for her wedding! What do I get "in return"?

Mrs. Daniels has been nodding or shrugging at each of these complaints. Now Mr. Daniels moves away, and Mrs. Daniels follows to argue with him. He turns back abruptly, and they almost bump into each other.

MR. DANIELS: Son Peter, I "pay-out-money" for him at Gallaudet. He comes home yesterday. What happens? He takes my car, goes "traveling-around" without telling me.

MRS. DANIELS: Boys all same...
MR. DANIELS: What's more, I took your car go to work last night. I stopped for gas. Man told me you owe him five dollars!
MRS. DANIELS: I forgot! "Broke." I mean pay today, sorry...
MR. DANIELS: No excuse. All of you money "throw away." Food prices "going up." All prices "going up," I spend, spend....

The doorbell rings and flashes. Mrs. Daniels, annoyed too, is happy to get out of the argument.

MRS. DANIELS: Doorbell.

She crosses past Mr. Daniel who grabs her shoulder.

MR. DANIELS: I go change clothes.
MRS. DANIELS: All right!

She continues on to the foyer. Mr. Daniels exits signing "spend, spend," as he goes. He pauses at the exit to see who is coming in, but when he realizes it is the NEIGHBOR, he exits quickly. Mrs. Daniels and the NEIGHBOR enter from the foyer.

NEIGHBOR: I brought your magazines.

She hands over a pile of magazines.

MRS. DANIELS: Thank you.

She takes the magazines and places them on the little table near the armchair. She is still thinking about her husband, and looks towards the bedroom shaking her head.

NEIGHBOR: What's the matter?

Mrs. Daniels shrugs and shakes her head again.

NEIGHBOR: You had a fight with your husband?
MRS. DANIELS: (Plopping on the sofa) Yes, I don't know what to do.
NEIGHBOR: (Sitting too) Same with me. I had a fight with my husband last night.
MRS. DANIELS: We've been married many years, still fight about big things, little things. He never listens to me.
NEIGHBOR: Me too. When I argue with my husband he always "nod, nod-at-me." I can't get through to him, can't.
MRS. DANIELS: Really men all alike.
NEIGHBOR: Have to accept that fact.

A pause while both women consider that fact. Then Mrs. Daniels looks around the room and starts to get up.

MRS. DANIELS: Excuse me, I have to clean.
NEIGHBOR: Wait. "How come" husband up early? I thought on lobster shift, "all night."
MRS. DANIELS: Yes, still. TTY "light-flash" woke him up. That's why he complain.
NEIGHBOR: TTY "light-flash"? Who call TTY?
MRS. DANIELS: (Forgetting about the cleaning) Ruth called…
NEIGHBOR: Ruth? What she say?
MRS. DANIELS: She will come home for weekend, bring boyfriend…
NEIGHBOR: Boyfriend? What name? Where from?
MRS. DANIELS: I don't know. She not tell me. Short call, "typewrite."
NEIGHBOR: (After a pause) Boyfriend will stay "here-house" for weekend?
MRS. DANIELS: (Surprised) I never thought about that.

She thinks for a moment.

MRS. DANIELS: NO room!
NEIGHBOR: (Casually) Maybe both plan "sleep-together."
MRS. DANIELS: (Jumps up, shocked) I won't accept that.
NEIGHBOR: (Shrugs, trying to be sophisticated) Many young people do that nowadays.

While she is saying this, Mr. Daniels re-enters from the bedroom, now fully dressed except for his bedroom slippers.

MRS. DANIELS: Not in my family!

She turns and sees her husband.

MR. DANIELS: What, not in your family?
MRS. DANIELS: Nothing. Not important.

He still stands there.

MRS. DANIELS: What do you want?
MR. DANIELS: My coffee.
MRS. DANIELS: Coffee on stove in kitchen. Get it yourself.

Mr. Daniels sighs, and exits to the kitchen. Mrs. Daniels turns back to Neighbor.

MRS. DANIELS: What I say?
NEIGHBOR: About Ruth bring boyfriend home.

MRS. DANIELS: Oh – Ruth only talk about dinner. Can't be, stay overnight. She would tell me. No – "specific" dinner.
NEIGHBOR: O.K., dinner. You need any help?
MRS. DANIELS: Let me think.

She gestures, arranging the dinner in the air.

MRS. DANIELS: I have roast beef – really for tomorrow, "put-forward" today. Oh, could I borrow your platter for the meat?
NEIGHBOR: My platter? Sure.
MRS. DANIELS: (Going back to her plans) Potatoes? I have to buy.

She nods.

MRS. DANIELS: Corn? Or peas?

She shakes her head.

MRS. DANIELS: Decide later.
NEIGHBOR: Soup?
MRS. DANIELS: No, That's fattening. Juice!

She thinks over her plans again and nods, satisfied.

MRS. DANIELS: Dessert? Oh, can you make your delicious apple pie that Ruth loves? She will be thrilled!
NEIGHBOR: Apple pie?

She ticks off the items on her fingers, then nods.

NEIGHBOR: Have everything. Can make. When need?
MRS. DANIELS: (Irritated by neighbor's stupid question) This afternoon, of course.
NEIGHBOR: That's right. What time is it now?

She grabs Mrs. Daniels' hand to look at her watch.

NEIGHBOR: Eleven.

Gesturing to herself, she quickly figures out her duties for the day, including making the pie, and how much time they will take. Then she nods.

NEIGHBOR: Can make it. Can.
MRS. DANIELS: Fine. Wonderful.
NEIGHBOR: How many altogether "round-the-table"?

Mrs. Daniels looks at her and starts to speak, but the Neighbor takes over, counting on her fingers.

NEIGHBOR: You, husband, Ruth, boyfriend – four…
MRS. DANIELS: (Pointing to the thumb) Peter.
NEIGHBOR: Peter home? How long for?
MRS. DANIELS: A few days.
NEIGHBOR: Fine, nice.

She goes back to counting.

NEIGHBOR: Five. You have enough?
MRS. DANIELS: I better make enough for seven or eight. Ruth come from New York, may be hungry. And Peter, he always eats like a pig, "big-pile, stuff-it-in."
NEIGHBOR: Must remember, Peter at Gallaudet. I heard Gallaudet food lousy…
MRS. DANIELS: (Skeptical) That's what he says…
NEIGHBOR: …and Ruth in New York, eat out, out all the time.
MRS. DANIELS: That's why better plenty food.
NEIGHBOR: You wise.

A short pause, then Mrs. Daniels looks around the room again.

MRS. DANIELS: (Rising) Excuse me, must "get-on-with" cleaning.
NEIGHBOR: (Catching Mrs. Daniels' arm) "Question," you think Ruth and boyfriend serious?

Mrs. Daniels has already said this to her husband, just to annoy him, but now she really considers the idea.

MRS. DANIELS: Could be. Ruth never made special arrangements like this before. Come on, see "sentences," TTY.

The two women cross to the TTY to read Ruth's message.

NEIGHBOR: You think that means marriage?
MRS. DANIELS: Maybe I wonder…
NEIGHBOR: (Excited) When? You feel when?
MRS. DANIELS: Must admit, would like June.
NEIGHBOR: Why June?
MRS. DANIELS: You never heard "quote" June Bride?
NEIGHBOR: True, true. Where marry? Who minister?
MRS. DANIELS: (Impatient with stupid questions) Church "over-there"; Father Marsh, of course.
NEIGHBOR: That's right. (Pause) What kind of wedding, you feel?

MRS. DANIELS: "Well," I always want big white wedding for Ruth. Myself fail, parents poor, can't afford. I imagine Ruth "long-gown, veil."
NEIGHBOR: (Sentimentally) Beautiful.
MRS. DANIELS: Reminds me of old movie, "Father of The Bride," remember?
NEIGHBOR: Don't remember that.
MRS. DANIELS: Yes, you saw captioned.
NEIGHBOR: Don't remember title. Tell me story, maybe I remember.
MRS. DANIELS: Yes, you know. Father, Spencer Tracy, give bride away, that Elizabeth …
MRS. DANIELS & NEIGHBOR: (Together) T-a-y-l-o-r.
NEIGHBOR: Yes, that…I remember now, good movie, "wow."

Mrs. Daniels describes the wedding scene in the movie, Elizabeth Taylor's face, her veil, her long gown covered with lace, the train, the sleeves, then comes to the bodice, and describes a high collar.

NEIGHBOR: (Interrupting) No, I remember "plunging-neckline."
MRS. DANIELS: No, you're wrong, "High-collar."
NEIGHBOR: No, "plunging-neckline."
MRS. DANIELS: No! I remember, "high-collar." You always forget.
NEIGHBOR: No…

She sees that the argument is hopeless.

NEIGHBOR: ….oh, "concede." Go on.
MRS. DANIELS: "High-collar, slim, long-gown," walk, walk, "glances meet."

She gazes upwards and smiles, as if she were the bride smiling at the groom. Then she comes back to the present day.

MRS. DANIELS: Wow, I can imagine Ruth beautiful.

She crosses to the sofa, thinking about Ruth. Then she turns with a new thought.

MRS. DANIELS: Me, pink "dress. No – green "dress," "big-hat"…
NEIGHBOR: (Interrupting) Peter, usher?
MRS. DANIELS: (Annoyed) Of course. That's why better June, Peter home from college.

Neighbor has moved towards the sofa during the last two lines, and now she sits down. Mrs. Daniels sits also, facing the kitchen.

MRS. DANIELS: Oh, Peter really loves Gallaudet College, wants "go-through" graduate. He decide wants to become leader in deaf world, (Jokingly) "big-head."

NEIGHBOR: Where Peter now?
MRS. DANIELS: Stay overnight with friend. Should home any time, he took father's car that's why mad.
NEIGHBOR: "Oh-I-see." (pause) Did you hear about Mrs. Smith?
MRS. DANIELS: Hear no. "What's up?

****The NEIGHBOR** *describes a tea-party at Mrs. Smith's home, showing the position of the table, of Mrs. Smith, her young daughter and one or two other people. A tea-pot was near Mrs. Smith's elbow. Mrs. Smith, signing excitedly, knocked the tea-pot over, and her daughter's arm was scalded. Mrs. Daniels asks questions about it, e.g., "Badly hurt? Take to hospital?" etc., and the* NEIGHBOR *answers them. Mrs. Daniels comments how careless Mrs. Smith is with her signing, and with her daughter. Both women agree about this. When this topic is finished, the* NEIGHBOR *introduces a new subject "Heard about…?" The women exchange a few sentences about this subject. While they are talking, Peter enters from the foyer and crosses behind the sofa. He greets the women casually, and continues walking. Mrs. Daniels jumps up and waves for his attention.*

MRS. DANIELS: Your father wants to see you about car. He's mad.

Peter sighs and looks at her.

NEIGHBOR: I better go now, see you later.

She exits. Mrs. Daniels watches her go, then turns back to see Peter about to exit too. She quickly moves to him and taps his shoulder.

MRS. DANIELS: I have to clean bedroom, you stay here for a while. Oh…

She is just going to tell him about Ruth's call, when Mr. Daniels enters from the kitchen, now wearing shoes and carrying a cash box and record book.

MRS. DANIELS: Fine! Tell Peter about Ruth.

Mr. Daniels looks at her blankly, thinking about something else. She repeats, impatiently.

MRS. DANIELS: Tell Peter about Ruth.

She exits. Mr. Daniels looks at Peter, remembers the car, and points a finger at him. Then he looks on the table for his papers, doesn't find any, goes to the little table and finds them there, puts his cash box down, sits in the armchair and begins to work on his accounts. During this time, Peter has been standing in the same place, watching his father. When Mr. Daniels is finally settled, Peter comes between armchair and sofa, and looks at his father expectantly. A few moments pass. Peter loses patience. He taps his father's shoulder.

PETER: What's this all about? What about Ruth?

Mr. Daniels stares at Peter for a moment before the question gets through.

MR. DANIELS: Oh, Mother got a TTY call this morning from Ruth. She will come home.

He goes on working. Peter is not satisfied. He taps his father's shoulder again.

PETER: What for?
MR. DANIELS: (shrugging) For dinner.

He looks away. Peter is really puzzled, taps his father again.

PETER: All the way from New York just for dinner?
MR. DANIELS: (Annoyed) I don't know.

He sorts out his papers. Peter looks at him, almost gives up, then taps his father harder.

PETER: I want to know what's going on!
MR. DANIELS: Ask your mother.

Pointing offstage with his thumb.

PETER: She told you to tell me!
MR. DANIELS: Don't bother me. I have to finish this work.

He tries to concentrate on his papers, but Peter is stubborn, too. He taps his father again.

PETER: You can do that at the club tonight.
MR. DANIELS: Oh, I remember now. Your mother says we can't go to the club tonight. Ruth will bring a friend home. We must stay for dinner.
PETER: What! You promised you and John would help me fix my projector at the club tonight.
MR. DANIELS: Don't blame me.

He makes notes in his book. Peter is frustrated, and thumbs his nose at Mr. Daniels, who looks up quickly. Peter looks innocent. Mr. Daniels glares at him, then nods and turns back to his papers. Peter moves to sit on the sofa. He gets an idea, and waves and stamps his foot to get his father's attention.

PETER: Will Ruth stay all weekend? Well, we can go to the club tonight and have dinner with her tomorrow, Saturday.
MR. DANIELS: (Shrugging) Mother says tonight, and seems she means business.

He looks away. Peter waves and stamps again.

PETER: But it can't be that important.
MR. DANIELS: Your mother thinks different. Ruth's friend is a b-o-y.
PETER: Boyfriend? Can't understand how boys become interested in a girl who looks like Ruth.
MR. DANIELS: Stop insult your sister! (Pause) Your mother thinks both plan to get married.
PETER: Ruth, married! Fine! "After-that" you can afford to increase my allowance at Gallaudet.
MR. DANIELS: (Quickly) Think smart, you?

He and Peter glare at each other for a moment, then Mr. Daniels looks away. When his father isn't looking, Peter replies, "Yes" to that question. Then he becomes restless. He gets up and goes to the table for the newspaper. He returns with it, and sits on the arm of the sofa while glancing at the sports page. But he is more interested in talking. He taps his father with the newspaper.

PETER: Imagine, Ruth get married! I wonder if her boyfriend is a Gallaudet graduate. She always likes the smart type.

Mr. Daniels is insulted by implication. He is not a Gallaudet graduate.

MR. DANIELS: That's right. Gallaudet people always think they are smarter than others.

Peter throws the newspaper at Mr. Daniels. If he catches it, he can say "Thank you," and look at the front page. Peter stands up.

PETER: Maybe her boyfriend is hearing.

He moves to sit on the sofa again, still talking.

PETER: I would like that.

Mr. Daniels stares at Peter while he sits down.

MR. DANIELS: Where you get that idea? Ruth has more sense not to go with hearing boys.
PETER: How can you tell?
MR. DANIELS: Ruth has good judgement.
PETER: You think so?
MR. DANIELS: Yes, she has good judgement, like me.

Peter's expression shows that he does not agree.

PETER: What's wrong with hearing boys, anyway? I have many hearing friends, and we get along fine, "associate."

Mr. Daniels feels that his son needs a lecture. He puts his papers down on the little table, and leans forward, facing his son.

MR. DANIELS: Friends is one thing – marriage is another thing. Married people must have same interests, same friends, communicate w-e-1-1.

Peter tries to comment, but Mr. Daniels holds up his hands to stop Peter, and shakes his head.

MR. DANIELS: Not funny!
PETER: You think so?

He moves too, so that he looks directly at his father.

PETER: You've been married for twenty-four years, right. Well, I notice you don't have same interests or friends as Mother, and what's more, you never seem to know what Mother says!
MR. DANIELS: That's enough – cut it out! I remember when you small boy, I watch through window, you play with hearing kids, me "touch-heart-fall," why? Children "run-away, group-together, leave-you-one."

Peter tries to interrupt each of the following points his father brings up, but Mr. Daniels holds up his hands to stop Peter, and goes on talking.

MR. DANIELS: In my work, many years "since," I notice other people promoted, other people raise. So I "meet" my boss, I ask, "Promotion? Raise?" He said (shakes head), "Because you're deaf." More, I know several my friends marry hearing. What happen? Divorce! Through my experience I know that hearing people won't accept us deaf "in" their world, N-O!

He finally lets Peter talk.

PETER: You're old fashioned. Times have changed. Today most hearing people accept deaf people for what they are. And many hearing people now can sign, anyway.

Mr. Daniels gets up towards the end of Peter's lines.

MR. DANIELS: Finish! Enough. I don't want to hear any more about that. Ruth's boyfriend is hearing…

This is a slip of the tongue – or hands – and we must see clearly that Mr. Daniels catches it, or the audience will think it is a real mistake. He should slap his hands, or wave them in the air, stamp his foot, or something like that, then correct himself.

MR. DANIELS: …DEAF, period!

He begins to pick up his papers and cash box. As he does so, Mrs. Daniels enters from the bedroom carrying a mop and duster.

MRS. DANIELS: I have to clean, "shoo, shoo."
MR. DANIELS: I go to President home, "there."

He starts to cross, then Mrs. Daniels taps his shoulder.

MRS. DANIELS: Come back early. I may need you help me shopping

Mr. Daniels nods, and continues past Peter. Peter taps his shoulder.

PETER: Can I go with you?

Mr. Daniels looks at him, begins to nod, then remembers why he was mad at Peter. He points his finger at Peter.

MR. DANIELS: Keys!

He holds his hand out. Peter fishes in his pocket for the keys and hands them over. The two exit through the foyer. Mrs. Daniels begins to clean the room, as the curtain falls.

Act II

As the curtain rises, Mrs. Daniels comes into the room carrying her coat and handbag. She looks annoyed and glances at her watch several times while she puts her handbag on the armchair and puts her coat on. Then she picks up her bag again and crosses in front of the sofa. At the same time, Ruth enters from the foyer, carrying a suitcase. She puts it down close to the sofa.

MRS. DANIELS: Oh, you come early, "what's-up?"
RUTH: Boss "let-me-off" for afternoon.

Mrs. Daniels puts her purse on the sofa, and hugs Ruth.

RUTH: Where you go?
MRS. DANIELS: I have to go shopping. I wait, wait for Father and Peter come home, go shopping for me – not come, I have to go myself. Want come with me?

RUTH: Yes. Oh no, I finish call Margaret from New York, ask her come here. I feel come soon, better stay.
MRS. DANIELS: (Looking at her watch again) "Well," I have to go.

She suddenly realizes that something is missing.

MRS. DANIELS: Where your boyfriend?
RUTH: Gone visit his parents. His parents live not far from here, imagine! Will come later…
MRS. DANIELS: C-o-n-n boy? "What a relief." Your father will be happy. He worried thought boy will be New Yorker, you know. A.S.D. boy?

Beginning now, and for the rest of this scene, we see that Ruth is trying to find the courage and the opportunity to tell her mother something important. Each time she seems to have a chance, her mother cuts in.

RUTH: No, because…
MRS. DANIELS: Anyway, not New Yorker. What name?
RUTH: Name, D-a-v-i-d B-o-n-e.
MRS. DANIELS: I don't know who?
RUTH: No, you don't know who.

She takes her mother's arm and points to the sofa, wanting to sit down, but Mrs. Daniels moves away, inspecting Ruth.

MRS. DANIELS: You too thin! "What's-the-matter?" You not eat properly? You sick lately?
RUTH: No, I'm fine. Nothing wrong with me. Sit down.

She tugs at her mother, but Mrs. Daniels shakes her head and taps her watch.

MRS. DANIELS: No time. Is your boyfriend nice?
RUTH: Yes, very nice. Really wonderful person, but…
MRS. DANIELS: "What's-the-matter?" Is he hippie?
RUTH: No, not hippie. Will explain…
MRS. DANIELS: Oral?

Ruth is confused by this question, and does not answer quickly. Mrs. Daniels thinks it is the right answer, and nods her head.

MRS. DANIELS: Oral!
RUTH: No, no – he thinks signs are fine. I want…
MRS. DANIELS: He have good job?

RUTH: Yes, fine job. He works in Media Center "connected-with" New York University…
MRS. DANIELS: Media, what's that? Never heard.
RUTH: He works with television, films, photographs, slides – like that, you know – for education and public service.
MRS. DANIELS: Sounds interesting. Media, new to me.

She looks at her watch.

MRS. DANIELS: Oh, I must go. See you later.

She grabs her purse from the sofa and crosses in front of Ruth. Ruth grabs her arm, frantic.

RUTH: Mom, I must discuss with you. David plan bring his parents here tonight, meet you. I told him bring for dinner.
MRS. DANIELS: What! I'm not ready! You give me lot of trouble. You "know-that" food cost rising, your father complain about spend money…

Sees that Ruth is upset.

MRS. DANIELS: Oh, all right. Good thing I go shopping now, buy extra.

Mrs. Daniels shakes her head, looking puzzled.

MRS. DANIELS: Parents deaf?
RUTH: No. I want to tell you about that…

Mrs. Daniels is really puzzled and upset.

MRS. DANIELS: "Well," boyfriend come, hearing parents come, all family "round-the-table." "What's-up?" Looks like you plan get married next week.

She shakes her head.

MRS. DANIELS: Silly me.
RUTH: (Meekly) Yes, we plan get married next week.
MRS. DANIELS: What! No! Why?

She gives Ruth a brief, all-over glance.

MRS. DANIELS: Are you…?
RUTH: No, I'm not pregnant. Silly, finish. You want to know why I get married – well, my boyfriend got new job in…

She stops, and decides not to tell her mother where. She covers up quickly.

RUTH: …"over-there," must move next week. While time "come-closer," we realize can't "let-go," want marry so I can move with him.
MRS. DANIELS: Why not tell me before?
RUTH: Last minute decide.
MRS. DANIELS: You give me no time plan, reserve church, send invitations, buy dress…
RUTH: You not have to worry, we only want small wedding.
MRS. DANIELS: Oh, you "upset" my plans. I always want you have big white wedding.
RUTH: (Apologetically), I "know-that," but really not important. Right?

Mrs. Daniels sighs and grows quiet. She gives her daughter an anxious, motherly look, and puts her hands on Ruth's shoulders for a moment.

MRS. DANIELS: You really love your boyfriend?
RUTH: Yes, really.
MRS. DANIELS: How long you know him?
RUTH: Almost one year.
MRS. DANIELS: One year. You never tell-us family.
RUTH: Oh, no! Really start see each other often about six months. Up-to-now, I thought Just good friends. Happen two months ago start regular out-out, good time, sit talk-talk, share, join-together love…but…

She tries to continue.

MRS. DANIELS: (Nodding in exasperation) Love!

She lifts her hands up, then notices her watch and panics.

MRS. DANIELS: I'm off. Really I'm confused. I better go, shop, bring food, prepare dinner. Then tonight we will sit down, really discuss everything.
RUTH: Yes, but one thing I MUST tell you…
MRS. DANIELS: (Frantic) Later!
RUTH: …REALLY IMPORTANT…
MRS. DANIELS: I'll be back.

She kisses Ruth's cheek and rushes out. Ruth grabs at her but misses. Ruth makes a suitable exclamation. She stands frustrated and anxious. Then she slowly picks up her case, and carries it near the bookcase. She looks on the bookcase for letters. Finding some, she takes them to the sofa. She looks at the letters without interest, then picks up her handbag. She takes some pictures from the handbag and looks at them, smiling. While she is doing

this, Margaret enters from the kitchen and stops. When she sees Ruth, she tiptoes and taps Ruth's arm.

RUTH: Frightened, me. How you get-in?
MARGARET: Round the back. Kitchen door not locked, same always. I opened-it, came-in.

They hug.

MARGARET: Well, why you TTY me from New York? What's-up?
RUTH: I want inform-to-you news. Really exciting.
MARGARET: What? Tell-me.
RUTH: No, you guess.
MARGARET: (Suitable exclamation; thinks) You move-back live with parents?
RUTH: No, I can't do that.
MARGARET: Job promotion?
RUTH: No. Come on, you can do better than that.
MARGARET: Ah-h-h, I know. New boyfriend.
RUTH: Yes.

Margaret laughs and shakes Ruth's shoulder.

MARGARET: Fine! Found your i-d-e-a-l man?
RUTH: (Embarrassed) NO – "off-the-track."

She hesitates, then decides to go ahead.

RUTH: I must tell you I plan get married next Saturday.
MARGARET: Next Saturday! Fast work! Wow!

She holds Ruth's hands.

MARGARET: Do I know him?
RUTH: No, you don't know him.
MARGARET: Yes, I know many deaf from New York through bowling, basketball, conventions. Remember I came to New York last year, you introduce me to several boys there…

Margaret nods, Ruth gestures "There-you-are."

RUTH: His name is David Bone.
MARGARET: Don't know.

She shakes her head. Ruth gestures "There-you-are" again.

RUTH: "Well," you know "since" we discuss marriage, I always say I want marry tall, dark, French-Canadian "type" deaf. "So" – I "off-the-track," what? I will marry short, blonde, and hearing.
MARGARET: (Shocked) Hearing – hearing…?

Ruth sits on the sofa and pulls Margaret down with her.

RUTH: I tried tell Mother "just-now," but she "kept-on" talking, won't listen to me, left. Now I tell you, I feel better. I have pictures.

She turns and gathers up the pictures she was looking at before. Margaret is still shocked. When Ruth turns and gives her the portrait, Margaret takes it but does not look at it.

MARGARET: Hearing, really – really?

Ruth nods. Margaret looks at the picture, not really seeing it, then puts it down.

MARGARET: How "you-two" communicate?
RUTH: He can sign. I met him at sign language class. Not expert, true, but "good-enough." I can't wait for you to meet him tonight, you will see what I mean.
MARGARET: Tonight? I can't make it; I have dinner date.

Ruth makes a gesture of disappointment.

RUTH: Why? You must meet him.
MARGARET: You not say, tonight. You tell me, come after work. I have that date "since."
RUTH: But you must meet him. You come tomorrow morning?

Margaret is not very enthusiastic.

MARGARET: Tomorrrow? Fine. Have no appointments.
RUTH: Oh, happy. When you meet him you will see why I like him.

Margaret is still upset.

MARGARET: Your boyfriend mix with deaf, like go meetings, "and-so-forth"?
RUTH: No – but he accepts my friends, same I accept his friends. I interpret for him if necessary, some he interpret for me if necessary.

Margaret shakes her head, not satisfied.

MARGARET: O.K. You ever "join-in" group all hearing "round-the-table?"
RUTH: Yes.
MARGARET: You follow them one hundred percent?
RUTH: Of course not! But many people there really sweet, "ambitious" learn fingerspell. I "get-along" fine. David, "we-two" agree, anyone worth keeping as good friend will find some way communicate with me – or with him.

Margaret says nothing. Ruth hesitates, then goes on.

RUTH: Anyway, we will leave, go California right after wedding.
MARGARET: (Jumping up) California! You mean for honeymoon?
RUTH: No, we will move there. He has new job.

She pulls Margaret to sit down again. Margaret is really stunned now, and stares blankly at Ruth.

RUTH: Anyway when we arrive there we will make new friends, so naturally we will choose people who accept us both. Maybe more deaf than hearing, who knows.
MARGARET: What job "over-there" California?
RUTH: Really good job. He will become Assistant Director in Media Center there; will work with deaf children
MARGARET: "Wow," I think you really brave move far from home with new husband.
RUTH: Many people do that.
MARGARET: Yes, but – hearing, deaf. Hope you won't be mad at me – don't want to see you make any mistake. I notice that hearing/deaf marriage very difficult, because most hearing people have no patience with deaf.
RUTH: Most deaf people have no patience with hearing, too. True, all marriages are difficult, not only deaf/hearing. If two people really want to live and work together at their relationship, it can succeed. Important thing, really communicate. We finish discuss possible problems "ahead."

Margaret shows that she is weakening.

RUTH: Come on! You know me. Trust me.

She shakes Margaret's shoulder a little. Margaret gives a little smile. Ruth encourages her again. Margaret's smile becomes broader, and finally she nods her head. The two girls laugh and hug each other.

RUTH: You will like him, he's different. You will see when meet him.
MARGARET: O.K.

She accepts Ruth's word, and becomes her normal curious self.

MARGARET: How "you-two" become interested in each other? What happen?
RUTH: That really interesting story. I tell you.

**Ruth tells her love story from the first meeting to the proposal of marriage, which happened the previous night.*

RUTH: "So" we discuss "what-to-do," decided come home today, make arrangements, inform families. He never told his parents about me, same I never told my parents about him. I thought "worthless." "Well," I succeed tell Mother about marriage, but not tell he's hearing. She left. I hope Mother come home first before Father, because if Mother accept, Father not so bad.
MARGARET: True, you're right.
RUTH: I hope you don't have a dinner date for next Saturday.
MARGARET: Dinner date!

She looks at her watch, and starts to get up.

MARGARET: Wow, I have to go.
RUTH: "Wait" – you don't have a dinner date next Saturday.
MARGARET: Dinner date next Saturday – what you mean?
RUTH: I reserve you next Saturday.
MARGARET: What – what for?
RUTH: For my bridesmaid, of course.
MARGARET: Me? Really?
RUTH: You think I would ask any other girl? Silly.
MARGARET: I never thought…Fine with me,

They hug.

MARGARET: What you want me wear?

**They discuss style and color of Margaret's dress. After a few sentences, there is the sound of a door slam. Margaret looks offstage, and gets up.*

MARGARET: Your father!
RUTH: (Still looking at Margaret) "What-to-do?"

She gets up and turns as Mr. Daniels enters. He sees her and comes to hug her, then greets Margaret.

MR. DANIELS: (To Margaret) How are you? (To Ruth) "What's-up?" "Lately" you no write me…

RUTH: Busy!
MR. DANIELS: Busy?

He nods, with a sarcastic expression.

MR. DANIELS: Where's your boyfriend?
RUTH: Gone visit his parents. They live near here, over-there." Mother told me you worry about me go with New York boy, but he's not – you don't trust me.

Mr. Daniels smiles, embarrassed.

RUTH: Boyfriend will come later, bring his parents here for dinner tonight.
MR. DANIELS: Deaf parents?
RUTH: (Ruth looks at Margaret, decides to tell her Father, and starts to answer his question before looking back at him.) No, really all "three-of-them"…

Mr. Daniels cuts in after Ruth says "No."

MR. DANIELS: "Well," why bring tonight?
RUTH: We want "you-four" meet – because we plan get married.
MR. DANIELS: What's hurry? Plenty time.
RUTH: No, soon….

The doorbell rings. Ruth gives Margaret a frantic look. Mr. Daniels turns to go to the door, but Ruth stops him, gestures "Me," and exits Mr. Daniels turns to Margaret.

MR. DANIELS: Really plan marry soon?
MARGARET: Seems…

Ruth enters followed by the NEIGHBOR, who is carrying a platter and a cloth-covered pie. The NEIGHBOR puts them down on the sofa.

NEIGHBOR: Your mother just arrived, outside.

She hugs Ruth.

NEIGHBOR: I brought you pie. In New York, not eat enough, thin – now "gain, fat." How you feel – how like New York…?

Peter enters carrying a bag of groceries. He waves to get Mr. Daniels' attention.

PETER: Mother want you, "there."

He gestures "Hi" to Ruth, then crosses to table to put the bag down. The Neighbor picks up the platter, etc. from the sofa. Mr. Daniels, who has been trying to speak to Ruth again all this time, gives up, and exits.

NEIGHBOR: I put in kitchen.

She exits.

RUTH: (To Margaret): "What-to-do," how tell them…?
 She breaks off as Peter comes to hug her and greet Margaret.

****Ruth and Margaret comment on his appearance, and tease him about Gallaudet or girls. After a few sentences, Peter goes back to the table, and takes things out of the grocery bag to find a box of cookies. Mr. Daniels enters with another grocery bag and six packs of beer and soft drinks. He goes to the table and puts them down too. During this action, Ruth and Margaret continue to discuss the problem.*

RUTH: Can't tell them now. Too many people…
MARGARET: Better wait, Mother in…
RUTH: Where Mother?

Mrs. Daniels enters. She nods at Ruth and waves "Hi" to Margaret, says "Late," and, rushes to the table. As she passes, Ruth grabs Margaret and they move downstage facing the audience.

MRS. DANIELS: (To the men) Not put there! "Put-away," kitchen.

She supervises Peter and Mr. Daniels while they re-load the bags and take different items into the kitchen. The NEIGHBOR comes out to help, too. The four of them should make a big job of this, so that there is constant activity going on between the table and the kitchen. However, this should not distract the audience too much from the conversation between Ruth and Margaret.

RUTH: Help! I don't know what to do.
MARGARET: Better tell them now.
RUTH: I can't – too busy "moving-around."
MARGARET: You have to "tough" get attention. I must leave. Please, "go-ahead." Good luck.

She kisses Ruth's cheek, then pushes her towards the group. As she moves towards the foyer still looking at Ruth, and gesturing encouragement, Ruth moves slowly towards the group. David Bone enters from the foyer, hesitatingly. He sees the front door open, and walks in. Margaret, walking backwards, bumps into him, looks at him, then turns to Ruth who at that moment turns her head to look at Margaret again. Ruth sees David.

There is a brief moment of panic, then she crosses to him, smiling, and they hug. Ruth turns and indicates Margaret, then all three look at the group. Margaret crosses to get the family's attention. Mr. and Mrs. Daniels and Peter come forward to meet Ruth and David in front of the sofa. They group in a half-circle, so that the order from right to left is David, Ruth, Mrs. Daniels, Peter, Mr. Daniels, Margaret, and the Neighbor, all behind the sofa.

RUTH: (To the family) This is David Bone. (To David) This my Mom, this my brother Peter, this my Dad.

Mr. Daniels and David shake hands across the group.

MR. DANIELS: Happy meet you.
DAVID: (Signing) Happy meet you.
MR. DANIELS: I see you before? "School" where from?

David does not know the sign Mr. Daniels uses for "school" – the old sign for "institution." He imitates it wrongly, using the sign for "liquor," with a questioning expression. Ruth steps forward, and gently pushes David back. She looks at her family.

RUTH: I try to tell you before – he's hearing.

Mrs. Daniels puts her hand to her mouth and falls back on to the sofa. At the same time, Mr. Daniels crosses behind Peter to bend over his wife, gesturing "what's this?" Peter, smiling triumphantly, turns to where his father was standing before with a gesture "There-you-are." He finds his father gone, turns to where he is now, taps him on the shoulder, and gestures "There-you-are," again. Quick curtain.

Act III

One moment later. The scene is exactly the same as at the end of Act II. As the curtain opens, Mr. Daniels pushes Peter out of the way and turns again to Mrs. Daniels.

MR. DANIELS: You not tell me.

Mrs. Daniels jumps up, defending herself.

MRS. DANIELS: Not me! Ruth never told me.

Both look at Ruth.

RUTH: (To Mrs. Daniels) It's your fault. I try tell you this afternoon. You won't listen.

Everyone looks at Mrs. Daniels. She is upset, and decides it is her husband's fault.

MRS. DANIELS: (To Mr. Daniels) You always blame me for everything.

She turns and exits quickly to the kitchen. Mr. Daniels, the NEIGHBOR, and Peter follow her out. Margaret goes towards the kitchen exit, then stops and looks back at Ruth and David, who remain in the same place.

RUTH: (To David) Sorry, I didn't have time tell them.

Noises offstage. A chair or cupboard door banging, Mrs. Daniels sobbing. David looks in that direction. Ruth and Margaret look to see what he is looking at. Margaret can see into the kitchen, offstage. She turns to Ruth.

MARGARET: Mother cry.
RUTH: (To David) I better go comfort Mom. You don't mind stay here – relax.

She persuades David, who is not happy about it, to sit on the sofa. Then she crosses to Margaret.

RUTH: Don't mind, talk to him.

She exits. Margaret is uncomfortable. She looks at David, but he is not looking at her. She looks towards the kitchen again, looks back, and this time meets David's eye. They both smile politely. David looks away again. Margaret takes one or two steps towards him, looks offstage again, and this time sees help available. She waves and beckons.

MARGARET: Come on, help, talk.

Peter enters from the kitchen.

PETER: Crazy house, "there" (points with thumb) I can't do anything.
MARGARET: Talk to him.

She pushes Peter towards the sofa. When Peter moves, she feels more confident and crosses to sit on the sofa, left of David. Peter stands between the sofa and the armchair.

PETER: Sorry about that. Parents don't understand.
DAVID: That's O.K. They were surprised.

He looks past Margaret and Peter to the kitchen, then looks away, perhaps adjusts his tie or wipes his hands.

MARGARET: (Aside to Peter) He really good signer.
PETER: Deaf parents?
MARGARET: No, family all hearing, Ruth told me.

Peter decides to ask, anyway. He waves and makes a sound to get David's attention.

PETER: Are your parents deaf?
DAVID: No, why?
PETER: You sign good.
DAVID: Thank you. I learned to sign in class. (Pause)
PETER: How did you become interested in the deaf?
DAVID: I work at a Media Center. I made a captioned film for deaf children.

Noises offstage – Ruth shouts "Mom," pans rattle. David is distracted.

MARGARET: (To Peter) Really interesting, many hearing people become "involved" in deaf world, learn sign.

David looks back at Margaret in time to catch the end of her sentence.

DAVID: What did you say?

Margaret starts to tell him, but stops and turns to Peter.

MARGARET: You tell him.
PETER: She said it's interesting how hearing people become involved in the deaf world.

Peter does not pronounce "involved" right, and David does not know the sign. He imitates it, awkwardly.

DAVID: What's this?
PETER: Involve.

David shakes his head, repeats the sign. Peter fingerspells. I-n-v-o-l-v-e. David says each letter while Peter spells it, then says the word.

DAVID: I-n-v-o-l-v-e, involve. Oh, involve.

He signs it again. Peter and Margaret repeat it with him until he has it right.

DAVID: Why is it signed like this, "involve?"
PETER: (Shrugging) It's like "diving (MIME)." The two fingers (holds up two fingers) are your legs. (He taps both legs) And you dive in (mimes diving) and get "involved."
DAVID: (Laughing) Sign language is fascinating.

He speaks the last word, tries to think of a sign but fails, so fingerspells. F-a-s-c-i-n-a-t-i-n-g. Margaret now finally feels free to talk directly to David.

MARGARET: That sign, "fascinating."
DAVID: (Imitating her) "Fascinating." Really?
PETER: (Nodding) You get your nose pulled in, "fascinating."
MARGARET: (To Peter) Same principle, "interesting." Tell him.
PETER: It's the same principle as "interesting." Your chest is pulled in, "interesting." Your nose is pulled in, "fascinating."
DAVID: (nodding and laughing) Yes, I see. Crazy sign.

Noises offstage. A chair scraping or a pan banging. David looks off, Peter and Margaret look too; then they all turn back to look at each other, but there is nothing more to say. Margaret looks at David, at Peter, then glances at her watch and jumps up quickly. David rises too.

MARGARET: (To Peter) Have to go! Tell Ruth goodbye for me, will see her tomorrow. Don't want bother them.

She points to the kitchen. Then she turns to David and shakes his hand, points to her watch and gestures "Late!"

MARGARET: Nice to meet you. Bye.

She exits quickly. David and Peter look offstage, watching Margaret go out of the front door. Then they look at each other. David looks off to kitchen. Peter turns to look too. Then they look at each other again. A pause.

PETER: You said you work in a Media Center?

David nods.

PETER: What exactly do you do?
DAVID: I do – everything. Plan films, write captions, fix machines, splice tapes...
PETER: You said you fix machines?
DAVID: Yes.
PETER: I have a projector upstairs.
DAVID: You do?
PETER: Can you fix it?
DAVID: Oh, it's broken?
PETER: Yes, can you fix it?
DAVID: Maybe...
PETER: Let's go upstairs and look at it.

He takes David's arm. David pulls back, and points to the kitchen.

DAVID: What about them?

PETER: "Never mind" them.

He uses the slang "don't care" sign. David does not know it. He imitates it.

DAVID: What's that?

Peter repeats the word, then fingerspells it.

PETER: Never mind. N-e-v-e-r...
DAVID: "Never"?

He uses the regular sign for "never." Peter shakes his head and his hands, and starts again.

PETER: N-e-v-e-r...

He mimes holding the word "Never" while he spells the next word.

PETER: ...m-i-n-d.
DAVID: Oh, "never mind."

Peter pulls his arm again. He holds back.

DAVID: Are you sure?
PETER: Come on.

Ruth enters from the kitchen, looking back over her shoulder. David turns to her in relief. Ruth smiles at David, looks around for Margaret, and speaks to Peter.

RUTH: Margaret gone? "Oh-brother."
PETER: She will see you tomorrow.
RUTH: O.K. Please go help Mom prepare dinner. She wants use that table.
PETER: Not enough chairs.
RUTH: I "know-that." We have to use kitchen chairs, "make-the-best-of-it."

These two lines can be omitted if there are enough chairs, and enough room for the dining area. Peter can exit after Ruth's previous line. IF not, he now shrugs and exits. Ruth turns to David.

RUTH: Sorry. They're alright now. They prepare dinner.

They hug each other in relief.

RUTH: Are your parents coming?

DAVID: Yes.
RUTH: What time?
DAVID: I told them to come early.

He looks at his watch.

DAVID: They should be here any time now.
RUTH: I better tell Mom.

She turns to go back to the kitchen, but suddenly remembers an important question. She turns to David again.

RUTH: What did your parents say?

David hesitates. Ruth adds to her question: When you told them I'm deaf? David is a little uncomfortable with the question.

DAVID: Well – I told my mother we were getting married, and…
RUTH: Yes, but how did you explain about me being deaf?

David chooses his words carefully.

DAVID: I told them…you were – special.
RUTH: "Sweet."

She kisses his cheek. David's face shows that he is more uncomfortable now.

RUTH: They accept me?

David doesn't answer. Ruth persists.

RUTH: That I'm deaf.
DAVID: Well – I didn't exactly tell them that…
RUTH: You mean you didn't tell them that I'm deaf?

She sees from his expression that she is right.

RUTH: You stupid!
DAVID: Who's stupid? You didn't tell your parents that I was hearing.
RUTH: But there's a difference…
DAVID: It's not different…

Peter enters from the kitchen with a tablecloth. Ruth and David stop talking, and look angrily at each other and at Peter, while he – not looking at them – moves the table out from the wall, puts the cloth on, and exits again.

RUTH: I tried to tell my mother this afternoon but she won't listen to me.
DAVID: Well, my mother wouldn't listen to me either. She was upset because we are getting married so soon.
RUTH: But why did you give up and leave?
DAVID: (Speaking only) Give up and leave? (Signing too) It was hard enough to persuade them to come here and meet you. What more do you want?

Ruth begins to answer, but Peter and the NEIGHBOR enter with dishes and cutlery, and go to the table. Ruth goes to them and gestures "I'll do that, you go away." They leave everything and go out. Ruth comes back downstage.

RUTH: Fine way for us to start our wedding plans. I feel like you pushed me in the water, "over-my-head."
DAVID: You want to call the whole thing off?

He moves away. Ruth runs after him and takes his arm.

RUTH: No David, it's just that it's much harder for your parents to accept me, than for my parents to accept you. They are alright now – but how will I face your parents? I won't know what to do, I will feel so "awkward."

She uses the sign for "clumsy." David does not know the sign. He repeats it – incorrectly – and taps Ruth impatiently for a translation. Ruth repeats the word, then shouts it.

RUTH: Awkward – awkward – nervous, upset!

David now understands the word, but still gets the sign wrong.

DAVID: Awkward! You think hearing people don't feel awkward too? How do you think I felt when you all went out. I felt awkward!

He walks away. Ruth is shocked into silence. The idea that hearing people can really feel as helpless as deaf people in situations like this is new to her, and she realizes she has been unfair. And this is their first serious quarrel. They stand apart for a while, then David moves back towards Ruth and touches her. They embrace.

RUTH: Sorry.
DAVID: I'm sorry too.

They embrace again, and kiss.

DAVID: It will be all right. We knew we would have problems.

Ruth nods shyly. They cuddle a little, smiling at each other. Then Ruth looks at the dining table, and points.

RUTH: Help me?

David nods. They go to the table and begin to arrange the plates and cutlery, pausing once to smile at each other. Then the doorbell rings and the light flashes. David, who has his back to the door, turns to look, then turns back to Ruth with a question on his face. Ruth nods.

RUTH: Doorbell. It must be your parents.

David gestures for Ruth to go to the door. She shakes her head and gestures for him to go. The doorbell rings again. Mr. Daniels enters from kitchen, points to the lamp and the door, and gestures "What's going on?"

RUTH: (To Mr. Daniels) I think his parents.

She encourages David again, and this time Mr. Daniels gestures encouragement too. David braces himself, and goes to the door. Ruth asks her father, urgently.

RUTH: How's Mom now?
MR. DANIELS: Your mother's alright. Now she's blaming me.
RUTH: Sorry. Fetch Mom, meet…

Mr. Daniels exits. Ruth smooths out her clothes. Mr. and Mrs. Bone (Mildred and Harold) enter with David. Mildred is already talking when she enters, and continues while David helps her out of her coat.

MILDRED: I hope we haven't kept anyone waiting. We stopped for gas and your father was worried about the oil filter or something.
DAVID: No, you made good time…
HAROLD: Yes, that's what I told your mother…
MILDRED: ….this is really nice. Oh, that must be Ruth…

She crosses in front of the sofa to meet Ruth, holding out her hand.

HAROLD: (To David) You didn't tell us she was so pretty…

Mildred takes Ruth's hand and holds it while she talks.

MILDRED: …hello, Ruth. I must say when David told us he was Getting married, I really…

David has put his mother's coat on the sofa, and now runs around the sofa to place himself between Ruth and Mildred.

DAVID: She can't hear you, Mom.

He uses a sign only for the word "hear" using the hand on Ruth's side. Mildred doesn't notice it.

MILDRED: Can't hear me? (To Ruth) I'm sorry I'll talk louder. When David told us he…
DAVID: No, Mom, you don't understand. She's deaf.

He signs only the word "deaf."

MILDRED: Deaf? Oh, oh…

She shrinks back a little, smiling nervously at Ruth as if Ruth had changed into a strange animal. Then she turns her head quickly to look at her husband, saying "Harold." The NEIGHBOR enters, looking back into the kitchen and beckoning to the Daniels. Mildred turns back, and sees the NEIGHBOR.

MILDRED: Oh, this must be her mother.

She crosses to meet the NEIGHBOR, taking her hand.

MILDRED: How do you do, this is something of a surprise…

David has moved to come between them.

DAVID: No, Mom. This…

Ruth has moved towards the kitchen. She waves to David.

RUTH: She's our neighbor. She's deaf too.
DAVID: (Translating) This is a neighbor. She's deaf too.

Mildred looks from David to the NEIGHBOR to Ruth, eyes opening wider. The NEIGHBOR taps David's shoulder and points to Mildred.

NEIGHBOR: Tell, happy meet you.

David nods, not really paying attention. Mildred shrinks back, and with a cry of "Harold," goes back to her husband. Ruth and the NEIGHBOR, meanwhile, have persuaded Mrs. Daniels to enter. She is followed by Mr. Daniels and Peter.

DAVID: Mom, Dad, these are Ruth's parents.

Mildred has been frozen since returning to Harold. Now she rushes forward, smiling frantically.

MILDRED: Please forgive me. It's so nice to meet you, but I can't quite get used to the idea.
HAROLD: (At the same time) We weren't told that your daughter was—ah—ah…
DAVID: Mom, they are deaf too.

There is a frozen moment. Then Mildred turns to Harold.

MILDRED: O-o-oh, Haar-old. They're all deaf.

She bursts into tears and clings to Harold, who with David, persuades her to sit on the sofa. He sits too, so that he is on Mildred's right and David, standing, is on her left. Ruth moves to David's other side, watching Mildred. The rest of the Daniels family, with the NEIGHBOR, groups together in such a way that the audience has a clear view of both groups. From right to left is Mrs. Daniels, Mr. Daniels, the NEIGHBOR, Peter. While this movement is going on, Harold is speaking.

HAROLD: Why didn't you tell us this before?
DAVID: I tried to tell you this afternoon, Dad, but Mom was so upset.

During Mildred's following speech, Mrs. Daniels and the NEIGHBOR "whisper" in signs: "she cry, upset, what-to-do?" "She talk, me understand no," etc.

MILDRED: What are we going to do? They're all deaf. What kind of wife will she make for you, David? She'll be utterly dependent on you. How can she work? Why, she won't even be able to get up in the morning if she can't hear the alarm clock. And of course she can't help with the driving – you'll be killed by a truck because she can't hear it coming. Oh, Harold – how can we put a stop to this?

On this cue, Ruth turns from Mildred to see what her family is doing. Mildred, David, and Harold continue to talk, but lower their voices, so that the focus shifts to the other group. Ruth moves to her mother's side.

MR. DANIELS: See, they won't accept deaf.
PETER: "Normal." "Face-to-face," – shock. Will "fade-vanish" later.

Ruth turns back to the other group. Mildred raises her voice again.

MILDRED: But what about children. You can't have children.

Harold makes a disapproving sound. Mildred turns on him.

MILDRED: They would be our grandchildren, Harold.

She puts her hand to her forehead.

HAROLD: (To David) I think your mother is going to have one of her headaches.

Ruth taps David's shoulder.

RUTH: What she say?
DAVID: Later.

He turns back to Mildred.

DAVID: It so happens, Mom, that only ten per cent of deaf people have deaf children.

Ruth has turned again to the other group, and this time moves to the front.

RUTH: Come on, help!
MR. DANIELS: I "know-that, those-two," think deaf stupid, can't do anything. (To Ruth) Seems they will oppose your marriage.
PETER: (To Mr. Daniels) What about yourself? (To Mrs. Daniels) Go on, offer them a drink.
RUTH: Yes, come on.
MRS. DANIELS: I never thought of that.

Ruth and Mrs. Daniels turn and move towards the other group. The NEIGHBOR goes behind the armchair. Mr. Daniels and Peter stay where they are. As soon as this movement begins, David starts his next line – shouting the first word then speaking and signing the rest.

DAVID: Mom! Deaf people live like everyone else. You don't have to worry about us.

Mildred is shocked into silence.

MRS. DANIELS: (To David) Would they like something drink?
DAVID: Would you two like a drink?
HAROLD: Yes, I could do with a beer.

Mildred hasn't answered.

DAVID: Want a drink, Mom.
MILDRED: No, no, I don't want anything. (To Harold) Let's go home. I think I'm starting a headache.
DAVID: Have some coffee, Mom. (To Mrs. Daniels) Do you have any coffee?
MRS. DANIELS: Yes, should be ready. Black?
DAVID: Yes, black, thanks.

Mrs. Daniels exits to kitchen.

MILDRED: (Plaintively, but with curiosity) Do they cook their own food?
DAVID: Of course they cook their own food, Mom!

Ruth taps David again.

RUTH: What she say, "since"?
DAVID: She's worrying about how we will live, if you can work, if you can drive, if we can have children…

Mr. Daniels makes a sharp movement of exasperation.

MILDRED: (To David) Why are you waving your hands about?

She waves her hands in the air to illustrate.

MILDRED: Where did you pick that up?
DAVID: (Talking to Mildred, but signing too) That's how deaf people communicate best. I learned it for my work.
MILDRED: Well, I can't wave my hands around like that. Do you expect me to learn—

Ruth kneels at the side of the sofa, near Mildred, and speaks and signs, slowly.

RUTH: I can read your lips.
HAROLD: She can speak!
DAVID: Yes, she can speak.
HAROLD: (To Mildred) Well, it's all right then. She can speak and he can hear, so there's no problem.
MILDRED: That's fine – so together they make one person.

She ends in a wail. By this time, Mrs. Daniels has arrived with coffee. David takes it and offers it to his mother. She tries to push it away.

MILDRED: NO, I don't want any coffee.
HAROLD: (Firmly) Now, Mildred…

Mildred knows from experience that when Harold gets stubborn it is time for her to cooperate. She takes the coffee, and begins to sip, looking up only at Harold the first two times. Then she looks at the others, and sees that they are all watching her.

MILDRED: (In a scared voice, to Harold) Why is everyone looking at me. I feel like some kind of a freak.
HAROLD: Now, Mildred…
DAVID: Oh, Mom…
MILDRED: (begrudgingly) It's good coffee.
DAVID: She says it`s good coffee.
MRS. DANIELS: Thank you.

Mildred smiles weakly, sips again, then with a brave smile, looks around the group. The TTY rings, light flashes.

MILDRED: What's that?

Peter, who is nearest, sits down and starts to answer the TTY. Mr. Daniels moves so he can read over Peter's shoulder. Harold gets up and stares. Mrs. Daniels and the NEIGHBOR discuss who they think is calling. It is one of the Club members calling about the meeting tonight. Ruth moves closer to Harold, and uses speech and gestures.

RUTH: That's telephone.

Harold imitates her gesture.

HAROLD: Telephone?

He crosses to where Mr. Daniels is standing and looks at the TTY. David and Mildred are talking in low voices, and continue to do so throughout this scene. David sitting on the arm of the sofa. Harold gestures to Mr. Daniels.

HAROLD: Telephone???

Mr. Daniels nods, "Yes," and gestures too, explaining how they operate the machine. Harold is impressed, and turns back to Mildred.

HAROLD: Mildred, you should see this thing. They put the receiver on a little box, and push a button…

While he is talking, Peter and Mr. Daniels discuss the message and the answer. Harold turns back with another question, and gestures to Mr. Daniels.

HAROLD: "You have this machine here, and type your message. What about the other end of the line?"

Mr. Daniels gestures that the other person has a teletypewriter too, and they type back and forth. Harold turns to Mildred again.

HAROLD: Mildred, this is really amazing. They have this machine here, and the other person has a machine there, and they type their message back and forth.

Mr. Daniels and Peter have discussed the message again, and Peter completes the call by hanging up. Harold turns back to Mr. Daniels, and speaks.

HAROLD: Where did you get the machine?

He feels this is too complicated to gesture, and turns to David. David, ask him where he got this whatsitsname. David signs and speaks to Mr. Daniels.

DAVID: Where did you get the TTY?
MR. DANIELS: Oh—

He starts fingerspelling to Harold. A-g-. Then he realizes it is useless, drops it, and leans past Harold to get David's attention.

MR. DANIELS: Tell him, I got from a-g-e—

He never finishes. Harold grabs Mr. Daniels' hand and hits his own forehead.

HAROLD: I know how to do that.

He speaks, but gestures to Mr. Daniels at the same time.

HAROLD: When I was a little boy, in Boy Scouts, I used to do that. Wait a minute…

He thinks, then begins to spell, speaking his comments.

HAROLD: A, you just did that, it reminded me. B. Then C, that's an easy one. D—

He gets this wrong, making an F-shape first then bringing two fingers down so that the middle finger sticks up. Mr. Daniels corrects him.

HAROLD: Yes, that's right. My name—uh, hum—H, A…R, R?

He can't remember the hand shape for R, and calls to David.

HAROLD: David, how do you say R?

David, teasing his father, says R without spelling it.

DAVID: R.
HAROLD: Oh no, I mean on your fingers.
DAVID: (Showing the letter too) R.
HAROLD: Yes, R, O – I remember that – L – that's another easy one – D, oops, D.

Harold is very pleased with himself. Mr. Daniels nods at him in a long-suffering way.

HAROLD: (Speaking very distinctly) I must go and tell my wife.

He crosses to the sofa and sits. He speaks to Mildred.

HAROLD: See, Mildred, I can spell my name. It's really very easy. I remember from Boy Scouts. Look – H-A-R-O-L-D....

He makes the same error again, and Mildred slaps his hand, shocked.

MILDRED: Harold!
HAROLD: Oops!

He corrects himself, with the help of almost everyone in the room. They are all smiling now. A basis for communication has been established. Mildred is just a little bit jealous of Harold's accomplishment. She straightens up.

MILDRED: Well, that's very nice. Maybe you can teach me.

Mrs. Daniels feels it's time to play hostess again. She leans forward.

MRS. DANIELS: More coffee?
RUTH: (Signing and speaking) Coffee?
DAVID: Coffee?

Ruth takes the cup. Harold starts to imitate the sign, but grinds the wrong way. Mildred looks at all the different hands signing the word at her, takes a deep breath, and tries it herself. Her sign comes out more like "necking," but at least she has tried. Ruth and David hug each other. Mrs. Daniels takes the cup and turns to leave. Peter crosses past Mr. Daniels to tap on his father's arm, and points to the group at the sofa.

PETER: See! O.K. now.

Mr. Daniels holds his hand up to cut Peter off, and turns so that he is facing the audience. He speaks deliberately.

MR. DANIELS: Trouble's just beginning!

About the Author

Dorothy Miles, "Dot" as she is familiarly known, is the author of the books, *Bright Memory: The Poetry of Dorothy Miles*, *British Sign Language – a beginner's guide*, and *Gestures: poetry in sign language*. Born hearing in 1931 in Gwernaffield, near Mold in North Wales, Miles became deaf at the age of eight and a half from cerebrospinal meningitis.

She was especially taken by the use of sign language in the NTD. According to European Cultural Heritage Online, Miles once said,

> When I first saw the National Theatre of the Deaf in 1967, I saw what they were doing with sign language, things I had never dreamed of. And I went home and started writing poetry that combined English language and signs. That was my first real honest to goodness poetry. Before that I wrote, well, just verse and it was all so exciting for me.[1]

Miles was a key figure in the British Deaf Community. In a letter to her sister, she remarked on the irony that her deafness should have been the factor that set her onto her career. She reasoned that if she had not become deaf, she should never have had the grammar school education she received at Mary Hare, she should never have had the bursary from the British Deaf Association and the scholarship to go to Gallaudet, nor would she have worked for the NTD. Had she been hearing, she said, she would have been what her mother would have called, "just another ten-a-penny tin-pot office girl."[2] After her death in 1993, the UK Council on Deafness established the Dorothy Miles Cultural Centre to carry out her vision of deaf and hearing people learning, developing, and working together. In 2010, the centre evolved to Dot Sign Language with the goal of bridging the gap between the Deaf and hearing worlds.

Notes

1 Sutton-Spence, Rachel. Dorothy Miles. European Cultural Heritage Online (ECHO). Retrieved from: http://sign-lang.ruhosting.nl/echo/docs/Dorothy%20Miles.pdf. Accessed 8 February 2021, 2.
2 Ibid., 4.

4
SHANNY MOW, *THE GHOST OF CHASTITY PAST OR THE INCIDENT AT SASHIMI JUNCTION – A KABUKI WESTERN*

IMAGE 4.1
Source: Photo by Willy Conley.

112 *The Ghost of Chastity Past or The Incident at Sashimi Junction*

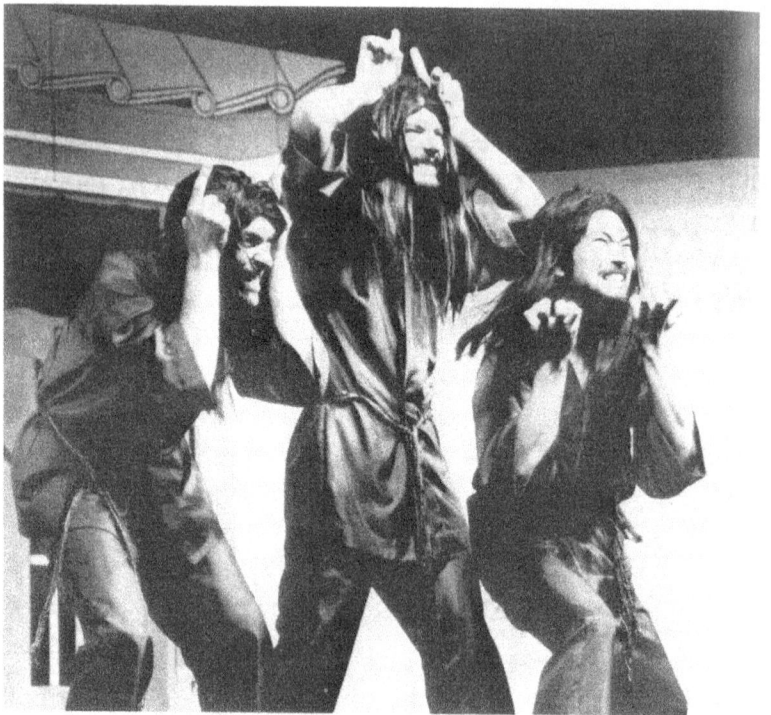

IMAGE 4.2 NTD actors Andy Vasnick, Michael Lamitola, and Akihiro Yonaiyama (left to right) as the demons in *The Ghost of Chastity Past*, directed by Peter Sellars.
Source: Photo courtesy of the National Theatre of the Deaf.

Synopsis

In a Japanese pagoda/saloon, the geisha Sweet Chastity finds herself loved by two gunslingers. This leads to a hilarious duel at high noon in the annals of the west or east. The dueling cowboys face off in a sumo wrestling match complete with six-shooters. In the meantime, the Japanese propmen forget their "invisible" duties and get involved, complicating matters that end in an uproarious climax. The underlying theme is a tongue-in-cheek combination of universal struggle between Good and Evil and the eternal love triangle.

Production History

The National Theatre of the Deaf company consisted of ten actors, of which eight were deaf. They used American Sign Language, while two hearing actors, playing MUSICIANS, voiced their lines and provided musical accompaniment. The play opened at Paul Mellon Arts Center, Choate, Wallingford, October 2, 1981.

Director: Peter Sellars
Set by Chuck Baird
Costumes by Fred Voelpel
Movement by Sahomi Tachibana
Music by Peter Sellars
Lighting by David Hays
With the following cast:
MUSICIAN 1– Jody Steiner
MUSICIAN 2– Charlie Roper
PROPMAN 1– Howie Seago
PROPMAN 2 – Chuck Baird
SHERIFF – Carol Aquiline
GAMBLER, DEMON, INDIAN – Mike Lamitola
STRANGER – Carole Addabbo
GEISHA 1, DEMON, INDIAN – Andy Vasnick
GEISHA 2, DEMON, INDIAN – Akihiro Yonaiyama
SWEET CHASTITY – Nat Wilson

This play was part of a twin bill that toured the USA and Japan. The other half of the bill was GILGAMESH, adapted by Shanny Mow after Larry Arrick's adaptation.

Thoughts on the Play

This play is one of most satirical and farcical pieces of theatre that the National Theatre of the Deaf has performed in its 50-year history. This travesty combines the solemn dramas of Japanese theatre with the bawdy Wild West of Hollywood. Its brief, minimal style is a director's dream. It is no wonder that world-renowned stage director, Peter Sellars, seized the opportunity to stage it.

According to theatre critic Eliott Norton,

> the setting is a barroom furnished in Japanese style, except for brass spittoons. The characters, dressed magnificently in robes that are at once Oriental and Hollywood western, include Japanese cowboys who fight for the hand of Sweet Chastity, a demure beauty, and are vanquished by black-clad property men who turn into hallooing Indians.[1]

In a review of the play, Steve Marks observed that Mow's play was

> a Western horse opera in the manner of the stylized Kabuki theatre. The narrators, called 'hooters and pickers,' sign and play the banjo using Oriental melodies and chords, but not without a cowboy drawl. The delight of this piece is in how well the ancient Japanese theatrical style fits into the Western motif…how much difference is there between John Wayne and a samurai? Now, imagine the Duke in satin pajamas and the hilarity is apparent.[2]

In traditional Kabuki theatre, only men perform, including female roles. The NTD production of the play observed this trait with a twist of its own: Female actors played the male roles of the tough sheriff and rough cowboys. Another traditional aspect of this type of theatre is music. For this integral part, Sellars composed the samisen music, developing beats with snare drums to punctuate the playwright's text. Mow once commented that since Sellars grew up and studied in Japan, he was the perfect collaborator for this play. Mow also added that he wrote the script in verse even though he didn't have the properly trained ear for it. Yet, to his surprise, Sellars did not change, add or subtract a single word of his text; he looked at the text and developed the music accordingly.

In retrospect, Mow seemed to underestimate his playwriting talent: "Did I really write that? Was I that good then? Did Peter take nothing and make something out of it?" The one question Mow raised is one that all collaborators might want to consider. Do we achieve the ideal collaboration when we couldn't discern who collaborated on what?[3]

Deaf Gain

Shanny Mow is the first Deaf playwright to have his plays produced by the National Theatre of the Deaf. Furthermore, he is the first – and perhaps only one to date – to have worked with Broadway-caliber stage directors, one of whom was Peter Sellars. Mow was prolific in creating a total of ten plays for NTD and the Little Theatre of the Deaf, the offshoot company for young audiences.

Notes

1 Norton, Eliot. "Deaf Theatre in Happy Epic." *Boston Herald American*. October 20, 1981.
2 Marks, Steven. "A Tribal Rite." *Sunday Bulletin*. 11 October1981: 19.
3 Conley, Willy. "In Search of the Perfect Sign-Language Script – Insights into the Diverse Writing Styles of Deaf Playwrights." *Deaf World – a Historical Reader and Primary Sourcebook*. Ed. Lois Bragg. New York: NYU Press, 2001. 54.

4

THE GHOST OF CHASTITY PAST OR THE INCIDENT AT SASHIMI JUNCTION – A KABUKI WESTERN

Shanny Mow

Note

This script includes some minor changes to bring it up to date.

Scene

At rise, the musicians enter, bow and settle on a Music Box DSL. Musician 1 works the clackers: House lights go black. Another clack: Curtain rises. Clacking continues until curtain is completely raised. Propman 1 and 2 enter from opposite wings and meet at CS.

PROPMAN 1 & 2: (Signing together) Where hell's winds blow,
 Where vultures rule the sky,
 Where tumbleweeds drink alkali,
 There's a place forgotten
 By time and historians,
 A saloon in Sashimi Junction
 Once lively, bawdy and mad.

While they sign, they get carried away with themselves, tumbling around. They remember their proper function as Propmen and cease and desist. Flutes.

PROPMAN 1 & 2: The ghosts remember.

They hold open the batwing saloon doors as Sheriff, Gambler, Stranger, Geisha 1, Gunfighter, Geisha 2 and Sweet Chastity enter as ghosts.

GHOSTS: (To the audience) Ghost.

Sink to their knees and turn their backs to audience. Sweet Chastity remains standing and facing the audience.

SWEET CHASTITY: Sweet Chastity remembers.

Chastity stamps on the floor. Everyone rises as the Living in real time. Gunfighter and Stranger exit through the saloon doors. Sheriff and Gambler cross to the bar. They perform the tea ceremony with beer mugs. Animated Japanese music. They burp and complete the tea ceremony. Geisha 1 flirts with Sheriff DSL while Geisha 2 does the same with Gambler at DSR. Enter Gunfighter brandishing six-shooters. He walks downstage. With each step everyone jumps. Chastity reacts visibly.

PROPMAN 1: She was the prettiest girl
 Ever seen in these parts.
 And her heart belonged
PROPMAN 2: To a Gunfighter,
 A man of great skills,
 Who killed for a living.

Gunfighter offers Chastity his arm. He embraces and kisses Chastity. Chastity swoons. Propman 1 catches her.

GUNFIGHTER: Love me, Chastity baby?
CHASTITY: I love a man who's strong.
 I love a man who's unafraid.
 I love a man who's fast.
 I love a man who's hungry.
 I love a man who's a man.

Propman 1 kisses Chastity. Gunfighter calls for a deck of cards. Everyone gathers in a semi-circle with Gunfighter in the middle. Propman 2 joins the game, ignoring everyone's annoyance. Everyone cheats; Propman 1 assists Propman 2 from behind. Gunfighter and Chastity make out. Everyone peeks at Gunfighter's cards. Japanese music. Gunfighter notices his cards have been switched, looks menacingly at Propman 2 who points to Gambler who in turn begs for his life. Gunfighter shoots the guns out of Gambler's hands. Gambler dies dramatically. Noises and painful twangs. Propman 1 tries to catch falling Gambler but misses. Propman 2 blows smoke away from Gunfighter's guns. Geisha 1 weeps over dead Gambler.

GUNFIGHTER & SHERIFF: Cheater! Cheater!

Lights change, turning the scene surreal. Gunfighter and Sheriff transform into coyotes. They circle Gambler's body. Stranger as silver coyote appears on top of the bar.

PROPMAN 1 & 2: Theirs was a rugged land
 Of coyotes, rattlesnakes,

Prairie dogs and scorpions,
Death ever present in their shadows.

Form themselves into a moon. Coyotes howl.

PROPMAN 1 & 2: That fateful day
The Stranger came.
From parts whereof
Nobody knew; nobody asked.

Stamp on the floor. Lights return to normal and humans are humans again as silver coyote disappears. Geisha 1 sets to commit hara-kiri, but fusses over her hair instead. Gambler raises his head and finishes the suicide for Geisha 1. Geisha 2 weeps over their bodies. She turns into a demon, hovers over the bodies and exits.

SHERIFF: In accordance with Section 73.103e, Public Health Regulations as set forth in the Municipal Code provision 589, any dead body, human or otherwise.... Dump the bodies!

Propmen hold a black curtain in front of bodies. Bodies disappear. Stranger appears through hidden door in the bar, brandishing guns. Sheriff cowers behind the bar. Stranger swaggers to the bar. Chastity takes notice of Stranger and lets go of Gunfighter who falls to floor unceremoniously.

PROPMAN 1 & 2: Sweet Chastity looked
At the Stranger,
At his chiseled chin,
At his white teeth,
At his deep blue eyes.

Chastity does a sensual dance. Gunfighter rises, his arms up in rage. Enter demons. Loud music.

PROPMAN 1 & 2: From the gulch of Hades
Sprang the Demons
To comfort the betrayed heart.
DEMONS: Pride,
Lust,
Greed,
and Envy.

Demons surround Gunfighter, comforting him. Gunfighter orders them to attack Stranger who easily fights them off. Demons exit. Gunfighter and Stranger face each other in a High Noon showdown. Chastity tries to dissuade them.

PROPMAN 1: By the code of the land
They lived and died.

PROPMAN 2: By the code of the land
 They lived and died.
PROPMAN 1 & 2: By the code of the land
 They lived and died.
PROPMAN 1: Only room
PROPMAN 2: For one man.
PROPMAN 1: Only room
PROPMAN 2: One man.
PROPMAN 1: Only room
PROPMAN 2: For one man.
PROPMAN 1: Only room
PROPMAN 2: One man
PROPMAN 1 & 2: Only room for one man
 With the fastest gun
PROPMAN 1: Fastest gun
PROPMAN 2: Fastest gun
PROPMAN 1: Fastest gun
PROPMAN 1 & 2: Fastest gun
 Fastest gun
 (to each other) Fastest gun
 (to audience) Fastest gun.
 By the code of the land
 There was only room for one man.
PROPMAN 1: (Simultaneously with Propman 2) Only room
PROPMAN 2: (Simultaneously with Propman 1) for one man
PROPMAN 1: (Simultaneously with Propman 2) Only room
PROPMAN 2: (Simultaneously with Propman 1) for one man
PROPMAN 1 & 2: Only room for one man in the heart
PROPMAN 2: (Simultaneously with Propman 1) One man
PROPMAN 1: (Simultaneously with Propman 2) in the heart
PROPMAN 2: (Simultaneously with Propman 1) One man
PROPMAN 1: (Simultaneously with Propman 2) in the heart
PROPMAN 2: (Simultaneously with Propman 1) One man
PROPMAN 1: (Simultaneously with Propman 2) in the heart
PROPMAN 1 & 2: Sweetheart
PROPMAN 2: (Simultaneously with Propman 1) One man
PROPMAN 2: (Simultaneously with Propman 2) in the heart
PROPMAN 1 & 2: Sweetheart
PROPMAN 2: (Simultaneously with Propman 1) One man
PROPMAN 2: (Simultaneously with Propman 2) in the heart
PROPMAN 1 & 2: sweetheart
 sweetheart
 sweetheart
 sweetheart

The Ghost of Chastity Past or The Incident at Sashimi Junction

 Sweet
 Sweet
 Sweet
 Sweet
 Sweet
PROPMAN 2 & 1: (alternately) Sweet
 Sweet
 Sweet
 Sweet
 Sweet
PROPMAN 1 & 2: (Simultaneously) Sweet
 Sweet
 Sweet
 Sweet
 Sweet
 Chastity

Stranger and Gunfighter go through sumo pre-match rituals. Drums. They tie their sleeves, Japanese style. Propmen bring guns but have a little fun playing with them first before surrendering the guns. Gunfighter and Stranger draw and fire their guns. Propmen throw dinky rubber darts. Pause. Gunfighter and Stranger inspect the darts.

GUNFIGHTER & STRANGER: (Holding the darts in front of Propmen's faces)
 Do you call this a bullet?
 Do you call yourselves Propmen?

Hurl the darts at Propmen, rip their Propmen masks off and stomp on them.

PROPMEN: You want bullets, you'll get bullets.

Exit. Sheriff intervenes. Gunfighter and Stranger punch Sheriff. Stranger grabs a broom and sweeps Sheriff away. He raises broom to hit Sheriff on the floor. Propmen enter carrying giant bullets, the size of buoys, hanging from fish poles. The bullets move slowly toward each other. Sheriff is caught in middle and gets it in the head. Propmen exit.

SHERIFF: (Dying) Chastity!

Chastity approaches Sheriff and recognizes something vaguely familiar. She cradles Sheriff's head in her lap, wipes his forehead and accidentally pulls his moustache off.

CHASTITY: Mother!
SHERIFF: My sweet baby, I dressed myself as Sheriff so I could watch over you in this wretched place... A saloon is no place for a self-respecting lady... Only way I could protect you from these evil men... Men! Chastity, promise me you will always be gentle and sweet... Avenge me...

Offers his gun to Chastity and dies. Gunfighter and Stranger turn away in shame. They make grand displays of shame and remorse.

CHASTITY: For mother! For mother!

Points the gun left and right. Musicians don a piece of obviously Native American garb. Propmen enter garbed as Native Americans. They each carry a wildly colored, inflated long balloon like a spear. They slap the butts of the Stranger and Gunfighter who drop to the ground, "slain" by the balloons. Drums. They approach Chastity, balloon-spear in hand, to slay her. She deftly averts them. They perform a comedy routine before accidentally slaying each other and dropping to the ground. Chastity rises slowly and inspects the carnage. She exits through the swinging doors. Suddenly she returns with a balloon through her body. We see that the long balloon is simply tucked under her arm in the classic manner of a fake body stab. More Native Americans enter with long balloons, dance around and taunt her. Dance music and drums. Mortally wounded, Stranger shoots the Native Americans dead. He shoots the Musicians dead. He crawls toward Chastity. They reach for each other's hand. Everyone except Chastity, Stranger and Propmen becomes a ghost again, rises and exits. Chastity and Stranger reach out for each other again.

PROPMAN 1 & 2: (to music) The horror of life
 Is the glory of death
 And love is...

Pulls Chastity's and Stranger's hands apart.

PROPMAN 1 & 2: eternal.

Blackout. Curtain.

About the Author

Shanny Mow, whose parents were originally from Canton in the Guangdong province of China, was born in 1938 in Stockton, California. He became deaf at the age of five from meningitis. After acquiring his B.S. in education from Gallaudet University, he went on to California State University at Northridge to receive an M.A. in Educational Administration. Early in his professional career, he taught at schools for the deaf in Montana, New Mexico and Hawaii. He was often associated with the NTD as an actor, director, and resident playwright.

 Also, during summers when the company was on break from tours, Mow served as acting and playwriting instructor for NTD's Professional Theatre School, and administrator of the Deaf Playwrights Conference. Being a Sign Master was one of his primary roles with NTD as well as with other theatres.

Mow adapted Homer's *The Iliad – Play by Play*, which was directed by Ed Waterstreet, making it NTD's first mainstage production written and directed by Deaf artists. He also adapted *The Odyssey* as well as *Gilgamesh* and *Parzival, From the Horse's Mouth* (co-written with David Hays), which was performed at the Kennedy Center. As former artistic director of Cleveland Sign Stage Theatre, he wrote and directed *Counterfeits*, which was nominated for 1995 American Theatre Critics Association New Play Awards. His other works include *The Cat Spanking Machine*, *Squanto Spoke English*, *Love Thy Neighbor*, *Letters from Heaven*, *Shakespeare Unmasked*, and *Bell in Hell*. He wrote over 27 plays that were produced, including a dozen short plays for youth theatre such as *La Legenda De La Llorona*, voted the Best Play at the 1990 Very Special Arts Festival for Deaf Students. In 2015, he passed away in his beloved, adopted "hometown" of Santa Fe, New Mexico doing what he always loved during a good part of his life – traveling, cooking, and hanging with close friends while freelancing as a writer and theatre artist.

The following are excerpts from "Can You See What He's Saying?" an insightful interview Steven Marks conducted with Mow: "My biggest problem in writing, is often a line looks good on paper, but does not sound good. I don't always have a good feel for words and how they sound." If it seems like sound should not be the concern of a deaf playwright and a company of actors who use sign in their performances, it is because many people are unaware of the fact that NTD plays before hearing and deaf audiences at the same time. The language problem, because that is what it finally comes down to, is solved by "interpreters" on the stage who speak the lines while the deaf actors sign the dialogue…. By simply incorporating the "interpreters" into the action of the play, an NTD performance becomes a synchronized unveiling of two linguistic interpretations.

"I'm a few years behind in contemporary slang," Mow explains. "I have to read a lot of popular novels…to get a feel for it. It's a problem trying to keep up with the flow of information that comes so easily through sound devices."

"I try for something intelligent to say. When I write, I worry about the story line; how it is done in sign and voice comes from the actors and director." The two-language problem is not a great problem after all, according to Mow. Even though the two languages (sign and English) are linguistically different, any written line can be translated into sign language.

"When I put words on paper, I think in English. If I wrote in sign language, I couldn't put it onto paper without it looking like broken English."

Mow depends on his eyes for contact with the world. He says after working with the NTD he developed a feeling for the visual aspects in theatre. For this reason, he writes to the company's strengths which are physically oriented. Anyone who watches a conventional play after attending an NTD performance can't help but notice the absence of physical interactions.

By contrast, the NTD company uses every theatrical "trick" in the book to create a dramatic evening. It's this total use of dance, gesture, mime and even the spectacular that Mow and the NTD delivers. Mow believes that in some areas the entertainment world is too much in love with the oral.[1]

Note

1 Marks, Steven. "Can You See What He's Saying?" *Sunday Bulletin*. 11 Oct.1981: 19.

5
STEPHEN C. BALDWIN, *DEAF SMITH*
The Great Texian Scout

IMAGE 5.1
Source: Photo courtesy of Stephen Baldwin.

IMAGE 5.2 Deaf Smith, the title character – in the play directed by Timothy H. Haynes – is famously portrayed in this 1886 painting by William Huddle. At the lower right corner is Deaf Smith kneeling and leaning forward with his hand up to his ears as if trying to listen. The painting, hung in the Texas State Capitol in Austin, depicts the end of the Texas Revolution and shows Mexican General Santa Anna surrendering to the wounded Sam Houston after the Battle of San Jacinto in 1836.
Source: Wikimedia Commons.

Synopsis

Deaf Smith's story is told mostly through flashbacks from the perspective of Hendrick Arnold, a trusted member of his spy company. The play opens with the president of the Texas Republic, Sam Houston, addressing senators and representatives, imploring them to hear about the tremendous value and sacrifice of his most reliable scout, Erastus "Deaf" Smith, who died less than a month ago. At Houston's behest, Hendrick Arnold shares highlights of his battlefield experiences involving Deaf Smith. Flashback re-enactments show the machinations of Mexican Generals Santa Anna and Cos; Deaf Smith's relationship with 'Lupe, his Mexican wife; his torn loyalty between the Mexican culture he loves versus standing up against the cruelty of the Mexican Army; and his talent at spying and deception. At the end, Arnold pleads with the Texas Republic House of Congress to honor Deaf Smith and grant his family land and a pension that he so well deserves.

Production History

The play premiered at the Texas School for the Deaf in Austin on May 25, 1985 as part of the Texas Association of the Deaf's Centennial Convention hosted by the Austin Association of the Deaf. It was produced by Southwest Collegiate

Institute for the Deaf and Howard College. Director, Timothy H. Haynes; Assistant Director, Jeffrey Donnelly; Stage Manager, Maureen O'Keefe and Cast; Lighting, Ron Shipley and Crew; Set Design, Timothy H. Hayes; Music, Adolph Labbe; ASL Translation, Minnie Mae Wilding. The original cast (in order of appearance) was as follows:

 Jeff Donnelly – Sam Houston
 Mike Walker – Hendrick Arnold
 Haden Lambert – Mexican Soldier #1
 Rodrigo Zapata – General Cos
 Luis Duos – Male Dancer #1
 David Bledsoe – Male Dancer #2
 Martha Fischer – Female Dancer #1
 Yvette Gaytan – Female Dancer #2
 Jacklene Giacona – 'Lupe Smith
 James Dees – Deaf Smith
 Martha Fischer – Mrs. Dickinson
 Kenneth Long – Texian Soldier #1
 David Bledsoe – Texian Soldier #2
 Haden Lambert – Mexican Soldier #2
 Luis Duos – Mexican Soldier #3
 Jeff Donnelly, Dora Garcia, Maureen O'Keefe – understudies
 Cecilia McKenzie – offstage interpreter
 Richard Fendrich – offstage interpreter[1]

Thoughts about the Play

This straightforward drama for youth and family audiences is based on historical accounts of a Texas Revolution scout named Erastus "Deaf" Smith. The original production, staged before a deaf and hearing audience, involved a predominantly Deaf cast of student actors who signed their lines, even though all of the characters were hearing (except for Deaf Smith). As written, the play could very well be produced primarily with a hearing cast and (hopefully) one deaf or hard-of-hearing actor playing the title role. Then, a director would have to decide whether this character uses sign language since Deaf Smith in real life was hard-of-hearing, used speech and lipreading, and probably didn't know sign language.

Deaf Gain

Baldwin is the first writer in this collection to have written a biographical play about a real-life deaf American. The play spotlights a deaf man who was so valuable to the Texas Revolution war effort that they printed his likeness on the Republic of Texas Five Dollar Bill. In addition, one of the largest counties in Texas was named after Deaf Smith. If one walks into the entrance of the state capitol building in Austin, Deaf Smith can be seen featured in a large painting

by William H. Huddle titled "The Surrender of Santa Anna" (see above picture). He is the one with his hand up to his ear, kneeling in the lower right corner of the painting.[2]

Notes

1 Deaf Smith. *The Great Texian Scout*. Austin, TX: Playbill, 1985.
2 "Surrender of Santa Anna" by William Henry Huddle from Wikimedia Commons. Retrieved from: https://commons.wikimedia.org/wiki/File:SantaAnnaSurrender.jpg. Accessed 2 Jun. 2020.

5
DEAF SMITH
The Great Texian Scout

Stephen C. Baldwin

Characters

ERASTUS (DEAF) SMITH, *daring guide, scout, and spy for the Texian Army.*
HENDRICK ARNOLD, *a free Negro and member of Smith's spy company.*
PRESIDENT/GENERAL SAM HOUSTON, *commander-in-chief of the Texian Army.*
GUADALUPE (LUPE) SMITH, *Deaf Smith's wife; woman of CastiIlian birth and culture.*
GENERAL COS, *Mexican officer who offered $1,000 for Smith's head.*
MEXICAN SOLDIER NO. 1
MEXICAN SOLDIER NO. 2
TEXAS ARMY SOLDIER NO. 1
TEXAS ARMY SOLDIER NO. 2
1ST MALE DANCER
2ND MALE DANCER
1ST FEMALE DANCER
2ND FEMALE DANCER
MRS. DICKINSON

Notes

Two female dancers needed only for second scene; their male dance partners will later change into Mexican and Texas Army soldiers.
　Lupe interchanges with Guadalupe Smith.
　One of the female dancers can change to Mrs. Dickinson.
　Scene breakdown:
　Scene 1: Texas Republic House of Congress

Scene 2: Plaza of LaVillita of Bexar (Old San Antonio)
Scene 3: Houston's Headquarters
Scene 4: Vince's Bayou Road
Scene 5: Texian Army Campfire
Scene 6: Mexican Army Campfire
Scene 7: Battle of San Jacinto
Scene 8: Houston's Headquarters (Capture of Cos) and (Dream encounter with 'Lupe)
Scene 9: Back to Texas Republic House of Congress (End of Arnold's speech)

Scene 1

Gradual light on President Sam Houston who is standing in front of a low wooden podium and pounding the gavel to get attention while looking directly at the audience.

HOUSTON: Order! Order! As President of the Texas Republic, I expect silence among you senators and representatives. You cannot adjourn this legislative meeting without first hearing about our deceased friend, Erastus "Deaf" Smith. Even though Deaf Smith died 19 days ago, I am still in mourning! Why? From the first shot of our glorious Revolution to the victorious Battle of San Jacinto, Deaf Smith was always my stay in the darkest hour! Therefore, my friends, I ask you to pay attention to a fellow scout and spy of the Texian Army.

Stepping aside.

HOUSTON: Mister Hendrick Arnold.

Enters Arnold in a lone light; Houston exits.

ARNOLD: (Takes off Texas hat in respect) I thank thee Mr. President Houston. Good evening busy gentlemen. It is truly a great honor to appear before you. But I was far more honored to have served alongside old scout Deaf Smith. Resting in an unmarked grave while his family is starving, I beg you to release his long-overdue pension you promised for veterans. All I ask is this liberty to share with you a dilemma of a man who first sought revenge then changed his mind. Not because he was an angry deaf man, not because he was a true Texian, but because he was human. For those of you who are not quite familiar with his incredible exploits, let me begin with the Siege of Old San Antonio where Mrs. Smith danced in the plaza. Yes, it all began with music, so to speak…

Cross-fade to Scene 2.

Scene 2

Three soft white eight-foot flats or Masonites are placed on stage: the stage right flat has the large painting of the San Jacinto flag; the center stage flat has the Texas state seal, and the old Mexican flag is seen on the stage left flat.

Lights up on two pairs of dancers dancing to the end of a Mexican folk song (La Posta); then, they line up for a second dance called "La Bahia." (Note: any appropriate folk music will do.)

The ending of the dance is interrupted by the entrance of General Cos in full military attire along with a Mexican Soldier carrying a rifle, and a rolled sheet of paper tucked under his belt.

MEXICAN SOLDIER NO. 1: (Shouting) Alto!

No response.

MEXICAN SOLDIER NO. 1: Stop in the name of Mexico and General Santa Anna! Alto!

Still no response. He gets approval from General Cos to use his rifle. Cocks rifle and shoots directly in air. Music and dancers stop abruptly.

MEXICAN SOLDIER NO. 1: When I say stop in the name of the Republic of Mexico and General Santa Anna, I need only say…alto…once. (Pause) It is my pleasure to introduce your military governor…General Cos.
COS: My humble apologies for interrupting your last dance on this beautiful but hopeless plaza. General Santa Anna has instructed me to take your town and declare martial law. My presence is a consequence of your rebellious behaviour. Either you need a thrashing or face banishment from Texas forever! And before we disperse this unlawful assembly, I must know the whereabouts of…El Sordo! Yes, the deaf one.

Instructs the soldier to nail "Wanted" poster on stage left flat. Poster says: WANTED: DEAD OR ALIVE! EL SORDO $1,000 REWARD.

COS: After this war began, I started to hear a great deal about El Sordo. Mexicans and Anglos praise his scouting ability. He shall not stand in my way – no matter how good he is.

He throws a leather bag of Spanish Reals on the ground in front of the startled crowd.

COS: There is the bag filled with the reward, $1,000, for telling me where I can capture El Sordo, the Deaf One, or known by some as Erastus "Deaf" Smith. (Pause) Still no takers?

Walks up to 1st Male Dancer.

COS: What about you?
1ST MALE DANCER: I've never heard of him, General Cos. El Sordo does not strike a bell with me.
COS: (Throws dancer's hat off) Won't tell me?

Turns to 2nd Male Dancer.

COS: What about you?
2ND MALE DANCER: In Texas, there are many men who are called Smith. I cannot recall anyone whose name is Erastus. What a strange name.

Cos pushes him down; walks up to Arnold.

COS: Are you just another amigo who wishes to deny his friendship with El Sordo?
ARNOLD: (Walks up to poster) I will not deny being his friend, but I find it hard to believe he's worth all this money.
COS: His knowledge of the lands of Texas is worth much more. He can be a valuable guide for the Texas Army. Since we are at war with you rebels, I'll do anything to take away your best scout!
LUPE: (Stepping out of crowd) But Sir, Deaf Smith has not joined the Texian Army. He is proud of his new Mexican citizenship.
ARNOLD: He's made it clear he would take no sides.
1ST FEMALE DANCER: He's always minded his own affairs.
2ND FEMALE DANCER: So there is no reason in the world for you to hate him or punish him.
COS: I hated him the first time I heard his name! My spies tell me that the whole Texas Army is relying on him for scouting services! Your leaders like Austin, Travis, Fannin, Bowie, and Sam Houston all want Deaf Smith on their side! My spies tell no lies! Deaf Smith is being groomed as the…eyes of the Texian Army! So, I must do away with him before he joins the Texian Army against us.
LUPE: (Walking up to General Cos) My husband will not tolerate your cruel animosity. (Pause)
COS: (Delighted) Mrs. Smith?
LUPE: I'm proud to be the wife of a man who loves peace. 'Rastus shall find it rather flattering when he learns of his value on both sides.
COS: (Motions for Soldier to hand money bag to Mrs. Smith) Tell me where your husband is and the reward is yours. You'll live comfortably for the rest of your life.
LUPE: (Tosses bag back to Soldier) Money will not buy my loyalty; I shall never betray my husband.

COS: Such blind loyalty! You are a fool, so are you all! Deaf Smith is my enemy and he shall be mine alone!
ARNOLD: You are creating a crime before it starts. You're a good-for-nothing coward!

Soldier hits Arnold with rifle butt.

COS: Any further insults? You are all a hopeless lot. I'm wasting my time and I shall begin with a complete confiscation of the property of Deaf Smith... El Sordo!

Cos and Soldier exit. Everyone gathers around Arnold who is given water and a head bandage.

DEAF SMITH: (He enters wearing a weather-beaten sombrero, dingy buckskin, ragged pants and old brogans. He is carrying his Kentucky rifle, powder horn, and a Bowie knife in a leather sheath. He carries a bunch of dead rabbits. Sees poster with dancers.) $1,000 for my head! 'Lupe!....

Kisses and hugs her then…

DEAF SMITH: (Looking at Arnold) What happened to you?
ARNOLD: I challenged General Cos and his intentions.
2ND FEMALE DANCER: They struck him with a rifle for standing by your innocence.
DEAF SMITH: (He and his wife hug) Why are you crying?
LUPE: You will have to leave San Antonio again!
DEAF SMITH: Because of that ridiculous poster? Must be a mistake. I've done nothing wrong!
2ND MALE DANCER: General Cos is serious. You must run for your life!
1ST FEMALE DANCER: General Cos wants you dead. Leave now!
DEAF SMITH: I'm innocent! Why does he want my head?

Lupe takes him aside while rest of group moves to the opposite side.

LUPE: Yes, you are innocent, but General Cos is serious.

Points to poster.

LUPE: He says the Texian Army will enlist you. He got his information from his spies.
DEAF SMITH: His spies are wrong! I just told General Austin and General Houston not to count on me. I can't believe this is happening to me!
LUPE: What will you do now?
DEAF SMITH: I'll go to General Cos and tell him the truth.

ARNOLD: (Interrupting) He will slit your throat on sight!
DEAF SMITH: (He sees something in the distance, looking beyond the audience. 1st Male Dancer exits suddenly. Everyone gathers around Deaf Smith. He puts his arm around Lupe. Onlookers ad lib what they see in the "distance.") Lupe, they are burning our house and farm.
2ND MALE DANCER: They scatter your horses…
1ST FEMALE DANCER: and cattle…
2ND FEMALE DANCER: and take your arms.
1ST MALE DANCER: (Enters, breathing heavy) General Cos is coming back!

Lupe moves to hug Deaf Smith. The dancers exit. Arnold, Lupe, and Deaf Smith stay behind.

DEAF SMITH: I shall slit his throat first!

Takes down the poster and throws it on the ground.

LUPE: You are adding kindling onto a fire. It is not good. Leave revenge to God.
DEAF SMITH: If he can turn my land into waste, I can take his life. If General Cos wants war with me, I will punish him. It's him against me alone.
LUPE: Please, 'Rastus, run and hide until this war is over.
DEAF SMITH: No. I will not hide from anyone. My dignity is at stake.
ARNOLD: You cannot fight a one-man war.
LUPE: Please flee! (Pause)
DEAF SMITH: I'm going back to see General Houston.
ARNOLD: If you're joining the Texian Army, I'm going with you!
DEAF SMITH: If they'll take me…
ARNOLD: They'll celebrate having the best scout in Texas!
DEAF SMITH: No celebration for me until I kill General Cos.

Arnold is on a quick lookout while Lupe and Deaf Smith have one final moment together.

LUPE: (Taking him aside) Remember, everywhere you go I go with you in spirit. Take with you what I said. Revenge does not belong to you.

They embrace. Offstage gunshots. Only Arnold and Lupe duck. Then both men flee while Lupe waves goodbye. Blackout. Lone light on Arnold as in Scene One.

ARNOLD: …it was the beginning of a war within a war. Two men seeking revenge without even knowing each other. Mrs. Smith kept trying to get her husband to desist, but to no avail. However, the bigger war with Mexico kept both men busy for awhile. News of Deaf Smith joining the Texian Army brought great rejoicing at General Houston's camp…

Blackout.

Scene 3

Two soldiers and General Houston stand in front of the center stage flat which has the state seal. They're standing around a campfire. A bridge is seen protruding from stage right. Everyone greets each other.

HOUSTON: I am sorry to hear that the Mexican Army destroyed your property. General Santa Anna shall pay for this.
DEAF SMITH: You take care of him and I'll take care of General Cos.
ARNOLD: My companion thinks of nothing but Cos!
HOUSTON: Well...Mr. Smith, I have good news for you. The Provisional Government of Texas has authorized me to appoint you head of my spy company. It was not easy to convince them of your ability. If not for the support of Austin and Travis, I might have failed. Speaking of Colonel Travis, I have some bad news.

Takes out a letter from inside his coat.

DEAF SMITH: Is it about the Alamo?
HOUSTON: Yes.

Begins to read letter. Sentimental background music begins. Suggestion: Timed version of "Green Leaves of Summer."

HOUSTON: "To the People of Texas and all Americans in the World: I am besieged by a thousand or more soldiers under Santa Anna. The enemy has demanded a surrender. I call on you in the name of liberty, of patriotism, and everything dear to the American character to come to our aid. If this call is neglected, I am determined to die like a soldier who never forgets what is due to his own honor and that of his country. Victory or death..." William Barret Travis, commander of the Alamo Garrison. (Pause)
DEAF SMITH: Have you sent reinforcements, Sir?
HOUSTON: No. The Alamo has fallen.
ARNOLD: Any survivors? Our families are there too.
HOUSTON: I need you to go back to Bexar and find out. Godspeed my friends.

Smith and Arnold exit via the bridge.

Scene 4

Mrs. Dickinson enters in dim lighting. Deaf Smith and Arnold trek along the road until they meet Mrs. Dickinson who carries a staff. She is exhausted and soiled with dirt and blood. They recognize each other but the greeting is subtle and low-keyed. After a brief hug...

DEAF SMITH: Are you all right, Mrs. Dickinson? General Houston sent us to check on the Alamo.
MRS. DICKINSON: No need. They are all dead.
DEAF SMITH: (Stunned) I, I, can't believe, it.... What about my wife and family?
MRS. DICKINSON: She has fled safely along with Mr. Arnold's family. Only mothers and children were spared.

Sobs quietly.

MRS: DICKINSON: Everyone was killed...everyone was....

Fainting a bit.

ARNOLD: Come with us Mrs. Dickinson, we'll take you to General Houston's camp.
DEAF SMITH: Yes, go with Mr. Arnold. I'll catch up with you shortly.

Arnold and Mrs. Dickinson exit.

DEAD SMITH: (Sotto voce) If all 200 at the garrison are dead, then my revenge is 200 fold!

Gradual light appears on an isolated Lupe who talks to her husband in a dream. Deaf Smith folds his arms and bows his head amidst the fog in his lonely spot.

LUPE: You are adding kindling onto fire. That is not good. You were taught that revenge belongs only to God. Nothing is gained in life when someone tries to get even. Deep inside you know you'll never be at peace with yourself, even after you perform your evil deed. Please channel your anger and hatred into the nobler things in life. Please, I speak from the heart because I love you. I never stop caring for you.

Blackout.

ARNOLD: (Lone light on Arnold as he narrates) Deaf Smith was determined to exact his revenge. Nothing seemed to deter that old soldier. When the morale of the Texians was real low, there was Deaf Smith, bringing up everyone's spirits with his unusual encouragement and positive outlook. He told everyone not to give up hope, to keep on trying and trying...

Scene 5

Two Texas Army soldiers are sitting around the campfire; they welcome Deaf Smith and Arnold who join them.

ARNOLD: Will this war ever end?

TEXAS ARMY SOLDIER NO. 1: I wonder if the enemy is asking the same question.

TEXAS ARMY SOLDIER NO. 2: They are too busy celebrating their victories.

TEXAS ARMY SOLDIER NO. 1: But the time will come when the tide shifts in our favor.

DEAF SMITH: Let's not give up hope. The war is not over. We must keep trying, never giving up, and improving with time and experience, then the war turns in our favor. A few battles lost does not include the war itself. We are on home territory. There is much at stake for us. I know we can win.

ARNOLD: I believe that too. One decisive victory will give us back our freedom, our land, and our happiness. Beyond that victory is the preservation of those hard-fought liberties.

TEXAS ARMY SOLDIER NO. 1: That's why I feel this win in my heart. The desire is to fight for everyone's rights, not just the rights of one person. We are fighting for all of us.

TEXAS ARMY SOLDIER NO. 2: Once we achieve independence, the killing stops.

General Sam Houston enters. The soldiers stand but Houston makes them sit in their original places.

HOUSTON: Santa Anna and his troops are hiding near Richmond. His generals are flanking him on all sides. We need to know their destination. I want Smith and Arnold to go into their camp.

TEXAS ARMY SOLDIER NO. 2: How can a deaf man learn anything in the lion's den?

HOUSTON: He has never failed me. What he gets done is more important to me.

DEAF SMITH: Getting into the camp of the enemy is my specialty.

Getting up.

DEAF SMITH: Mr. Arnold and I will return with the whereabouts of different troops.

TEXAS ARMY SOLDIER NO. 1: Are you really deaf, Mr. Smith?

DEAF SMITH: Sometimes I hear, sometimes I don't. I can talk but people think I'm from Russia.

ARNOLD: And he knows Spanish quite well.

DEAF SMITH: In the midst of gunfire, the sound of whizzing bullets never bothers me, and I can concentrate better on the battle. I always feel the barking dog's bite first.

ARNOLD: (Gets up) But I get to hear the whizzing bullets and the barking dog.

Deaf Smith and Arnold exit quickly to...

Scene 6

Two Mexican soldiers are standing by their campfire. Arnold puts clothes on Smith from stage right then hides behind the set. In comes Deaf Smith, wearing a poncho and sombrero and holding a flask. He is acting like a drunkard. First, they push him away, then he offers them a swig of his flask.

DEAF SMITH: My toast to the winning army!

Drinks.

DEAF SMITH: Death to General Houston and his dirty Texians!

Toasts again. Each soldier takes a quick swig and toasts.

MEXICAN SOLDIER NO. 2: Gracias, Amigo. Where are you from?
DEAF SMITH: Bexar, LaVillita. I was born in Russia.
MEXICAN SOLDIER NO. 1: Let me see your papers.

Deaf Smith hands him his citizenship papers. After reading.

MEXICAN SOLDIER NO. 1: You're cleared. Where are you heading?
DEAF SMITH: First to Bexar then to Mexico City to fetch my wife and children.
MEXICAN SOLDIER NO. 1: Does she have a great shape?
DEAF SMITH: (Nods) You two coming to Mexico too?
MEXICAN SOLDIER NO. 2: Wish we could. General Santa Anna wants us near the bayou soon.
DEAF SMITH: Oh, you mean Vince's Bayou.
MEXICAN SOLDIER NO. 2: Si.
DEAF SMITH: Watch out for those sneaky Texians!
MEXICAN SOLDIER NO. 2: One more victory is all we need and we'll catch up with you in Mexico City.
DEAF SMITH: (Toasts) Viva La Mexico!

Passes flask around.

DEAF SMITH: You don't look like a soldier.
MEXICAN SOLDIER NO. 1: (Showing his saddle bag around his shoulder) At twilight I leave with this…our final military plans.
DEAF SMITH: Well, here's a toast to a very brave courier!

Passes drink around again.

DEAF SMITH: Tell me, amigos, do you fight for hate?

Both shake head in the negative.

DEAF SMITH: No? Then why do you fight?
MEXICAN SOLDIER NO. 2: I was drafted. At least I'm allowed to travel. Nothing personal against Texians or Americans. It's a duty that must be done.
MEXICAN SOLDIER NO. 1: I'm in it for adventure. The thrill of being a courier is better than being a sloppy soldier.

Takes a quick swig.

MEXICAN SOLDIER NO. 2: Sloppy? Soldiers are sloppy? Huh?

Pushes Mexican Soldier No. 1.

DEAF SMITH: Easy, amigo! Peace!
MEXICAN SOLDIER NO. 1: (Using Deaf Smith as a shield) I didn't mean you!
MEXICAN SOLDIER NO. 2: We have more courage than sissy couriers!

Tries to take a swing.

DEAF SMITH: (Hands his flask to Mexican Soldier No. 2) Here! Keep it all! It'll cool you down! (To Mexican Soldier No. 1) You had better come with me! Come, quickly!

Smith picks up the dispatch quickly. Deaf Smith and Mexican Soldier No. 1 flee. Arnold enters and knocks out Mexican Soldier No. 1, puts a rope around him, and exits with him and Deaf Smith.

MEXICAN SOLDIER NO. 2: (Shakes fist and drinks) Keep him away from me! Couriers are cowards!

Drinks whisky.

MEXICAN SOLDIER NO. 2: Hey, who was that Russian man, anyway?

Blackout. Cross-fade to Scene 6... the bridge. Lone light on Arnold as in Scene 1.

ARNOLD: That's right! He managed to bring back the most important news of the war. The dispatch gave us the break we so desperately needed. Every war had its great breaks, and Deaf Smith gave us ours, and more.

Scene 7

Arnold leads the courier by a rope. Following the courier is Deaf Smith, sans pancho and sombero. As they come off the protruding bridge, Deaf Smith gets Arnold's attention before the latter moves SR where two Texians are waiting.

DEAF SMITH: Wait. Vince's Bridge is the only way in or out, right?
ARNOLD: If we battle here, yes. Come. We must hurry!

All three men cross to SR where soldiers are standing, and they call Houston out.

DEAF SMITH: (Hands dispatch to Houston) Here's the dispatch we found. Take care of this courier.

Houston motions to Texas Army Soldier No. 1 to take away Mexican Soldier No. 1. They exit.

HOUSTON: (To Texas Army Soldier No. 2) Search this.

Hands saddlebag.

HOUSTON: What information do you have, Mr. Smith?
DEAF SMITH: General Santa Anna and General Cos are near us now. They are separated from the main army; it's our chance to end this war.
TEXAS ARMY SOLDIER NO. 2: (Showing map he took out) Look at this map! Santa Anna's plans. Like walking right into our camp.

All gather around to view the map.

HOUSTON: No question about it. It's our chance to confront them.
DEAF SMITH: What about Vince's Bridge? Don't you think we need to destroy it?
ARNOLD: Yes, I agree! What do you think, General Houston?
TEXAS ARMY SOLDIER NO. 2: What will that do for us? How do we get out?
DEAF SMITH: No one gets out. No reinforcements for Santa Anna and no escape for anyone. That goes for General Cos, too!
HOUSTON: A fight to the death?

Smith nods.

HOUSTON: Very well, so let it be destroyed! Do it now...

Instructs Soldier to hand them axes.

HOUSTON:... Go my friends, go!

Deaf Smith and Arnold head toward bridge.

HOUSTON: Alert the army, prepare to fight.

Texas Army Soldier No. 2 exits.

HOUSTON: At long last we fight. This is the battle!

Offstage sounds of bugle call and rolling of drums. Quick switch to bridge where Smith and Arnold are chopping down the bridge in haste. They throw away the remaining parts in the bayou. Dismantling the bridge should be shown dramatically. Background flute music plays of "Will You Come to the Bower?"

DEAF SMITH: The battle is beginning!

Pointing to the destroyed bridge.

DEAF SMITH: The bridge is gone!
ARNOLD: No one can escape! It is a fight to the death!
DEAF SMITH: The time has come! General Cos is mine! I shall find him!

Red lights dim. Drum get louder. Flag carrier rushes by. Texas Army Soldier No. 2 fires rifle, cannon sounds, and flashes everywhere. Mexicans and Texians are fighting and fencing in silhouette. More battle sounds and flashes and smoke and shouting. Sudden spotlight on…

DEAF SMITH: (Swinging saber) The bridge is destroyed! Fight for your lives!…

Lights out, then quickly back on.

ARNOLD: (Waving the battle flag) Remember the Alamo!

Light out, then suddenly back on.

HOUSTON: (Firing pistol) Fight for Texas! Our Texas!

Light out. Battle sounds begin to abate. There is an eerie silence then we see shadows of wounded and weary soldiers, all gathering near center stage. As the lights come up, we see from left to right the following: Deaf Smith, Arnold, Texas Army Soldier No.1, Mexican Soldier No. 1, Cos, Mexican Soldier No. 2, Texas Army Soldier No. 2, and Houston. Everyone is battle weary and marked. Houston has a bandage around one leg, and Smith has his stomach bandaged.

Scene 8

HOUSTON: (To the Mexican Soldiers) Santa Anna has surrendered nobly. You may take your men and go back to your country in peace. May we be good neighbors.
COS: (Stepping forth) Yes, we leave in peace… May it last as long as it can.
HOUSTON: Gracias, General Cos.

Deaf Smith and Arnold look at each other.

HOUSTON: Mr. Smith, is something wrong?
DEAF SMITH: I caught him but did not know who he was! He is not dressed like a general.
COS: Are you…El Sordo!

Everyone spreads out a bit as Deaf Smith moves next to Cos.

DEAF SMITH: What took you so long to find me?
COS: And what took you so long to find me? Your desire to destroy me is well known.
DEAF SMITH: I had a job to do for Texas first. But you were never off my mind!
COS: The war is over. We are no longer enemies. What do you plan to do now?
DEAF SMITH: (Looking at Houston) With your permission, General Houston, I wish to cut his throat!

Taking out his Bowie knife.

HOUSTON: The battle is over. No more killing!
DEAF SMITH: My private battle is not!

Grabs Cos.

ARNOLD: (Knocks Cos aside, interrupting Smith) Killing him won't do any good, put the knife away. Think of what your wife said. Think about her. Think about life.

All freeze at this point as Smith looks toward stage right where his wife, Lupe appears.

LUPE: 'Rastus! What good will revenge do? Be at peace with yourself. Hate and anger are not necessary. Spare Cos and you spare yourself. Come home in peace.

Exits.

HOUSTON: Mr. Smith, what is wrong? Are you all right?

DEAF SMITH: (Putting knife in sheath) The war is over. I no longer feel the urge to kill you, General Cos. You may live. Now go!

All four soldiers, plus Cos, exit.

ARNOLD: (To Smith) You are wiser my friend.
HOUSTON: Yes. By the way, Mr. Smith, would you like to form a Ranger group and protect the border of freed Texas? In return, you get free food, arms and horses. Will you do it?
DEAF SMITH: As long as Texas needs me, I'm willing to be of service...just make sure I get my army pension.

Smiles and shakes with Houston who smiles. Houston exits.

ARNOLD: (Pointing to the stomach bandage) You are still bleeding?
DEAF SMITH: It is nothing. But I no longer feel this pain of revenge. It was never good for my soul.

Stage lights begin to dim and Deaf Smith fades in the background.

ARNOLD: Better start taking good care of yourself. When you return from border patrolling, let's sit by the fire and talk about our old fighting days.

Moves away and slowly into the spotlight.

Scene 9

Arnold looks directly at audience as he finishes his speech before the Texas Republic Congressional meeting.

ARNOLD: That was a year ago and he never returned to share our war memories by the fire. The stomach wound killed him. Mrs. Smith and I went to Richmond but could not find his grave...an unmarked grave is an unforgivable disgrace. (Pause) My good brothers, Deaf Smith sought revenge and changed his mind. What does that tell you? Is he not worth the pension promised? Thank you.

Puts hat on and steps out of the spotlight as Houston enters.

HOUSTON: (Pounding the gavel) All in favor of giving the family of Deaf Smith land, pension, and honor immediately, please raise your right hand! The motion carries. Our meeting now adjourns.

Shakes hands with Arnold. Blackout. End of the play.

About the Author

Stephen C. Baldwin is a retired educator who enjoyed teaching in five states across the country. From 1968 to 1989, Baldwin earned three degrees: BA in History, MA in Deaf Education, and Ph.D. in Theatre History, Theory, and Criticism. Before he retired from teaching in 2008, he was a twice-elected president of the Texas Association for the Deaf, newsletter editor, writer, and photographer. He won the National Association of the Deaf's Greenmun Leadership Award as well as the Literary Award. He is also proud of his 2015 Laurent Clerc Award (GUAA) for his social contributions in Deaf history, cable television (Silent Network), and documentaries (Davideo Productions). Baldwin is also the president of his favorite nonprofit organization, Deaf Television Foundation, which espouses theater, literature, and endeavors in long-distance running.

He began writing plays in 1980 and has had 26 of them produced, most related to Deaf culture and history. He even wrote a West Texas rodeo melodrama for a hearing community theater. His most recent play, an original story about a Deaf Tejana woman, had a public staged reading at the Santa Cruz Theater in Austin, Texas, on February 8, 2020.

Baldwin's first book, *Pictures in the Air: The Story of the National Theatre of the Deaf*, was published by Gallaudet University Press in 1994. His first novella, *Backspace*, was published by Savory Words Publishing in 2015. Baldwin hopes to release a modern deaf theater history book (1994–2022) in 2023. He currently lives in retirement in Austin with his wife Rosie Serna.

6
BRUCE HLIBOK, *WOMANTALK*

IMAGE 6.1
Source: Photo courtesy of the Hlibok family.

DOI: 10.4324/9781003112563-12

144 Bruce Hlibok, *WomanTalk*

IMAGE 6.2 This image was used on the promotional flyer for *WomanTalk*, directed by Bruce Hlibok. Originally from a February 20, 1897 issue of the National Police Gazette – The Leading Illustrated Sporting Journal in the World. The caption was: "PUNCHED THE NEW SOUBRETTE – Hot fight in a dressing room at New Orleans, LA over a bald-headed 'angel'."
Source: National Police Gazette.

Synopsis

Molly, a frumpy Deaf housewife, barges into the kitchen of a stranger's house and helps herself to a cup of coffee (a recurring motif of comfort and domesticity). Sandra, a spunky Deaf woman home from work as a stripper, is absolutely flabbergasted by this abrupt intrusion. She demands that Molly leave at once but is ignored. Molly blurts out a confession that her husband, a professional hitman, abuses her. Sandra reluctantly sympathizes and offers blunt advice. After some time, Molly also shares her own history of abuse. After learning that they have much in common in the way of domestic violence, the two women form a friendship. Sandra suggests that Molly seek revenge by murdering her savage husband. Sandra ends up helping Molly dispose of her dead husband's body. The play closes with a phone call from Sandra's brutish ex-husband. Molly – coming up with a reversal of schemes – recommends that Sandra invite him over.

As one of the play's promo materials stated, with tongue in cheek: "Sometimes it gets noisy when Deaf strangers meet."[1]

Production History

The play was presented by Handstone Productions at Entermedia's Second Story Theater. It was directed by Bruce Hlibok; Neil Johnson, set designer; and the actors were Ellen Roth and Linda Herenchak. The play opened on October 23, 1984 and ran for two months.

(Hlibok chose the name "Handstone" because the hand is the symbol of the first method of communication between people – hands were used to gesture. The word stone was used because it was the first method of recording a written word.)[2]

Thoughts about the Play

Darkly humorous and cartoon-like, this is a deliberately provocative feminist work from a Deaf gay male point of view. This tragi-comic, kitchen-sink play explores madness and rationality under patriarchy. Underneath an overlay of comic strip scenes, it deals with the serious problem of spousal domestic abuse in the Deaf community. This is often concealed because of shame as the Deaf world is reputedly small; many people know each other.

During a video interview in *On and Off Stage – The Bruce Hlibok Story*, playwright Bruce Hlibok said that *WomanTalk* was created primarily for a Deaf audience but that the Deaf audience – after watching the play – would discover that the subject of domestic violence involving Deaf people was not a Deaf subject but a "hearing subject." They could not identify with Deaf people in this hearing situation.[3]

Hlibok instilled moments of hilarity such as the annoying and persistent obscene phone calls. This may seem ordinary to the hearing reader/audience, but the humor is in the fact that the obscene calls came through the teletypewriter (TTY), a telecommunication device for the deaf, where the caller types out a message over the line. One would probably think that deaf people wouldn't get obscene calls (heavy breathing, sexual noises and statements) since it is primarily a convention of the hearing world. The coup de grace happened when one of the characters, in a fit of anger at the constant calls, unscrews and throws out the lightbulb from the phone-flash alert device, which is the equivalent of pulling a ringing phone off the wall and chucking it.

It is interesting to note that only one character breaks the fourth wall by exchanging remarks and looks with the audience. In Deaf performances, it is not unusual to find performers involving the audience to some extent. Most likely, this is because for Deaf actors performing in a play with a fourth wall, there is no opportunity to receive a "vibe" from the audience to feed on. Hearing actors can hear audience reactions or movements without having to look at the audience,

whereas Deaf actors cannot; therefore, any opportunity to talk or share with the audience is seized upon.

The script was subtitled "A Play in Six Scenes." However, according to The Village Voice review of the stage production, there was a more fitting subheading used, presumably in the program: "a real cartoon in six scenes." Alisa Solomon, a Village Voice critic, wrote:

> A performance in sign language can teach a hearing person a lot about the nature of the theater. Watching a play in a verbal language you don't understand simply heightens the theatricality and transforms the passive reception of semiotic information into active pursuit; a show in sign, though, challenges the theater's very dimensions. It fills space with a new kind of meaning, elongates time, and makes silence, the stage's third dimension, irrelevant. I wish *Womantalk* didn't have voice interpreters sitting downstage right, speaking the words that the actresses were signing, so that I could have delighted even more in its beautiful crystallization of theater.[4]

Ellen Roth, one of the actresses from the original production, recalled that Hlibok was a frustrated artist because he had to form his own production company at a time when no one else was interested in producing his work.[5] *WomanTalk*, Hlibok's first professional production, turned out to be his most controversial work as it dealt with domestic violence in the 1980s. The New York Deaf community was shocked, and not ready to embrace this topic. Despite that hesitancy, Roth remembered performing consistently to a full house during the play's two-month run.

In the *On and Off Stage* video, Roth commented that Deaf women from Boston liked the play. She surmised this was because they were more progressive in their thinking, having come from a multi-university city aware of the feminist movement. They could identify with the issues that women faced when battered. Because domestic violence was a taboo subject, many women kept their maltreatment a secret. Hlibok, who endured domestic abuse in a past relationship, brought this issue out in the open with his play. He was ahead of his time on a matter that the Deaf community was afraid to address.[6]

The following is an excerpt from a 1985 Deaf Mosaic interview on video with Bruce Hlibok that offers some insight on his writing process:

INTERVIEWER: Are all of your plays performed in sign language or are they spoken?
HLIBOK: It depends on the play. If I feel the play needs vocal interpretation, I would put in voice interpreters. If not, I'll let the play "speak" for itself.
INTERVIEWER: The plays that you write are performed in sign language, yet sign language is not a written language. How do you handle that process?
HLIBOK: My background is in the English language. Even though my parents are deaf, I was still raised in an English background. I write in English

because I think in English. I allow my actors and actresses to translate the script into their own signing style. If I tried to force them to use a certain sign style, it wouldn't look right, it would be awkward, so I prefer that they do the translation. If their translation doesn't match my English script, then we would sit down, discuss it, and work on it until it's right.[7]

Deaf Gain

WomanTalk is the first play – written and directed by a Deaf theater artist – to be produced off-off Broadway.

Notes

1. Hlibok, Bruce. *"WomanTalk" Promotional Handout*. New York: Handstone Productions, 1984. Print.
2. Deaf Mosaic, Video Interview: Bruce Hlibok, #108, 1985. Retrieved from: https://media.gallaudet.edu/media/1_5bnhufm7. Accessed 18 Jul. 2020.
3. Bryan, Anne Marie Jade. *On and Off Stage – The Bruce Hlibok Story*, 2002, DVD, Disc 1 & 2.
4. Solomon, Alisa. "Womantalk." *The Village Voice* vxxix.43 (Oct. 23, 1984): 113–114.
5. Roth, Ellen. Email, 1 December 2004.
6. Bryan, Jade. *On and Off Stage – The Bruce Hlibok Story*. DeafVision Filmworks, 2002.
7. Deaf Mosaic, Video Interview: Bruce Hlibok.

6
WOMANTALK

Bruce Hlibok

Characters

SANDRA, *happy-go-lucky, JAP-type of a feminist. Learning how to belly-dance for a living. Lives alone in a big house. Always wearing "Flashdance" type of clothing. Dances whenever there's space. Has a hot temper and a quick mind.*

MOLLY, *frumpy-go-bad, scaredy-cat type of a woman. Always cooking for fat, demanding husband. Lives next door to Sandra. Always using "schoolmarm" clothing. Drinks coffee whenever there's trouble. Has potential to be a great beauty.*

Notes

Setting: The whole play takes place in the kitchen of Sandra's house. The kitchen is gaily painted in pink with orange cabinets and green counters. It's all very "New Wave." There is a porch door to the side. All entrances and exits happen through the porch side with the exception of several moments when the basement door on the opposite side is used. There is an ironing board and a radio present throughout all six scenes. There is a kitchen table and two chairs, one which is tipsy. There is a TTY light on one wall, and a phone and TTY under a counter. There are dishes in the sink and an ever-present urn of coffee.

Scene 1

Lights go up on Sandra. She is doing a dance routine and ironing at the same time. She finishes ironing one shirt and neatly folds it, puts it down on the kitchen table and picks up another shirt. Molly looks through the window and starts waving in Sandra's direction. Sandra does not notice until she holds up the shirt. Molly appears at the door. Sandra goes to the door.

Molly hands Sandra a note. Sandra reads it and looks for a pen. Molly follows Sandra into the kitchen. Molly hands Sandra a pen.

As Sandra writes on a pad, Molly looks around the kitchen, lifting things.

SANDRA: She's got some nerve!

Hands pad to Molly roughly.

MOLLY: You – you're deaf?
SANDRA: (Astonished) You're deaf?

Turns away.

SANDRA: My God, a deaf person!

Sits down.

SANDRA: The first deaf person I've seen in a long, long time!
MOLLY: I'm shocked, too. Could I have a cup of coffee?

Sandra doesn't answer. Molly pours herself a cup of coffee and sits down.

MOLLY: (All smiles) I saw you dancing. You were WONDERFUL!

Thinks.

MOLLY: You're not really deaf!
SANDRA: Oh yes, I'm deaf!
MOLLY: I don't believe you. You have the radio on!

Points to radio.

SANDRA: Oh, really? Let me show you something.

Sandra goes to radio and picks it up. It is not plugged in.

SANDRA: See?

Slams down radio.

SANDRA: I like dancing! Sometimes you don't need music for dancing!
MOLLY: Oh.
SANDRA: You seem to know something about me? How'd you know I was dancing?
MOLLY: Well, it wasn't me. It was my husb—

Freezes.

SANDRA: Your what? Your husband?
MOLLY: No, no. Just that—
SANDRA: Explain to me or I'll call the police!
MOLLY: (Resigned) Well, he's been staring at you with binoculars—
SANDRA: What? WHERE?
MOLLY: From over there. Where we're staying.
SANDRA: Over there? At that dump of a motel?
MOLLY: Yes. We moved in a week ago.
SANDRA: You have some nerve! NERVE! NERVE!
MOLLY: What?
SANDRA: NERVE! NERVE! Spying on me.
MOLLY: No, no! We just wanted to find out who our neighbor was before we approached them. You seemed so nice. I didn't even know you were deaf. And you were wonderful dancing.
SANDRA: Dancing?
MOLLY: Yes! I don't know how to explain – I'll show you.

Gets up and does a bump-and-grind that rocks the kitchen table.

MOLLY: Oh, sorry!
SANDRA: Oh, you saw that! I'm embarrassed!
MOLLY: (All smiles) Well, my husband loved it.
SANDRA: Get out! GET OUT OF HERE! I don't like the idea of you both spying in here!
MOLLY: (Sits down quickly) Could I finish this coffee? I'm trying to be nice!
SANDRA: Oh, all right. I can't do anything about it!

Sits down.

MOLLY: OH, thank you! What's your name?
SANDRA: Sandra.
MOLLY: I'm Molly. You can call me Moll.
SANDRA: Yeah? Sounds like a gangster's whore.
MOLLY: What?
SANDRA: Never mind. Nice to meet you.
MOLLY: Yes! Are we friends? I'm lonely.
SANDRA: Oh, really? Well…I must be getting back to work. I'm sorry, but I don't think I can be your friend. You'll have to do it yourself.

Gets up and moves to ironing board.

SANDRA: Good-bye.

Molly doesn't see the last statement. She keeps sipping coffee.

SANDRA: (Crossing over to table) Molly, it was nice meeting you, but do I have to…THROW YOU OUT BEFORE I MAKE MY POINT CLEAR?

The TTY light flashes. Sandra goes and answers. Molly pours herself another cup of coffee. Sandra hangs up and sees Molly.

SANDRA: You're still here?!
MOLLY: Who was that?
SANDRA: That was an obscene call.
MOLLY: Wow!

Looks off dreamily.

SANDRA: Wow?
MOLLY: Yes! WOW!

Runs to TTY.

MOLLY: It's been a long time since I got any attention from a man.
SANDRA: (Looks Molly over) I can guess why.
MOLLY: You're lucky!
SANDRA: Well, I don't like obscene calls!

Molly grabs the pad from kitchen table, scribbles on it, and hands it to Sandra.

MOLLY: Then, next time when you get an obscene call, give him my phone number. I think I will enjoy it. I've never gotten an obscene call before!

Sandra tears up the paper.

SANDRA: No. I will not. I am not interested in doing anyone any favors. Especially you.
MOLLY: You seem to be so selfish! You won't even share your calls with me! I'm just trying to be friendly and share things with you! You really seem to be very selfish!
SANDRA: (Outraged) That's your problem! Ever since you arrived, I feel like I've aged ten years! You're interfering, interfering with everything I'm doing! I'm doing the ironing, for heaven's sakes! And you just walk in, help yourself to a cup of coffee and sit there like a queen! And you expect me to get friendly with you about our phone numbers, our favorite things, our problems, our….
MOLLY: I'm sorry! I'm sorry!
SANDRA: And you expect me to shake your hand and fall all over you and be friends for the rest of our lives!

MOLLY: I'm sorry!

SANDRA: And that husband of yours! If he enjoys jerking off when I dance, that's HIS problem! And if he does it again, I am definitely CALLING the POLICE!

MOLLY: Please don't. I didn't mean it! (In tears) I just wanted to be friends. It's not easy being friends!

SANDRA: Not when you barged in like you just did.

MOLLY: You tell me what I should do!

Sandra notices the iron on her dress. She runs to it and saves her dress. She holds it up. There is a hole in it.

SANDRA: Look at what you did!

MOLLY: I didn't do that! You were the one who put the iron down!

SANDRA: WHO made me put the iron down? You! YOU!

MOLLY: I don't like your attitude!

SANDRA: You're damn right! You shouldn't like my attitude after you shoved yours down my throat!

MOLLY: I was just trying to be nice!

SANDRA: This is getting boring. Why don't you and I save time by both of us saying goodbye and you getting OUT OF HERE!

MOLLY: I'll leave now. You've not been as nice as I'd hoped you'd be.

Molly snatches coffee cup on her way out and drinks it. Sandra yanks her back.

SANDRA: Don't make me feel guilty. I'm not feeling guilty at all. You screwed it up. Goodbye!

MOLLY: (Exiting) Goodbye. And I'm sorry.

SANDRA: About time that bitch left!

Sandra looks around and finds the burned shirt, shaking her head. Sandra throws the shirt down and looks at the audience.

SANDRA: I hate people who interfere in your life before they know who you are! That bitch!

Blackout.

Scene 2

Sandra is clipping coupons from the newspaper. Molly sticks her head through the doorway. Molly is wearing a pair of sunglasses.

MOLLY: Hi!

Sandra pretends not to notice. Molly walks into the kitchen.

SANDRA: (Looking up) What do you want?
MOLLY: (Takes the initiative and pours herself a cup of coffee) Mmmm! That's good!
SANDRA: You have some nerve doing that. What do you want?
MOLLY: I wanted to apologize.
SANDRA: For what?
MOLLY: For yesterday morning. I wanted to come last night to say I was sorry, but you weren't home.
SANDRA: That's OK. I was not looking forward to seeing you again. I accept your apology...
MOLLY: I was really sorry about what happened yesterday...

Looks away.
 Sandra says the following line at the same time as Molly's previous line.

SANDRA: ...and would like you to leave now.

Sandra stares at Molly.

MOLLY: Well, I'm happy you accepted my apology and now we can go on and be friends.
SANDRA: Friends? Didn't you see what I said?! I said...
MOLLY: You said you accepted my apology. Am I wrong?
SANDRA: No, but I also told you to leave.
MOLLY: Oh. I didn't see you say that.
SANDRA: Of course you didn't. Not with those fashionable sunglasses.
MOLLY: I have a good reason! It's a black eye.

Shows Sandra.

SANDRA: What happened?
MOLLY: I don't want to say.
SANDRA: (Intrigued, and then suddenly realizing) You know, I'm busy cutting out food coupons, so...
MOLLY: Ooooh! Food coupons! I love to exchange...
SANDRA: Look at me. I said I was busy and will you GET OUT OF HERE! If you don't I will give you another black eye and I won't be responsible for my actions! I wouldn't be surprised you got that from your husband! He's stuck with you and I wouldn't blame him for punching you! You deserve it! GET OUT!
MOLLY: (Standing up, in tears) You're RIGHT. My husband did this to me. I was trying so hard to clear up any misunderstanding between the three of us...

SANDRA: There is no "Three of us." I am NOT involved with your husband!
MOLLY: Let me finish! I came here hoping to find someone who wanted to be friends. This place is nothing but a dump. I was trying to make things better by telling my husband not to spy on you anymore. He got mad. Real mad that I told you. He belted me and then started kicking, kicking, KICKING!

Collapses into chair.

MOLLY: It's always my fault! I'm just trying to do something good! I'll leave now. I'm sorry I bothered you!

The TTY light flashes. Sandra goes and answers. Molly stops at door and turns back and pours more coffee. Sandra hangs up and turns. She doesn't see Molly, then looks the other way.

MOLLY: I poured you some coffee.

Shoving cup in Sandra's hands. Sandra looks heavenward despairingly.

SANDRA: I might as well as accept it and be friends with…her.

Molly sees Sandra's statement, rushes over and hugs Sandra. Sandra pushes Molly away.

SANDRA: Calm down. I think I'll be nice (Smiles a phony smile) and talk with you for a short while and then you can leave. Is that all right?
MOLLY: Yes! Yes! I really appreciate it!
SANDRA: (All phony smiles) And will you be my friend and leave me alone while I'm doing something?
MOLLY: Yes! Yes!

Sandra sits down and clips coupons. Molly paws through the coupons and knocks a coffee cup over.

SANDRA: Damn! You bitch! What were you trying to do? LOOK at THAT!
MOLLY: I'm sorry, I'm sorry!

She puts the coffee-soaked coupons in the sink.

SANDRA: WHAT are you doing?!
MOLLY: I'm washing the coffee off the coupons.

Holds up the mess.

MOLLY: Seems I made it worse.
SANDRA: Yes. You did.

MOLLY: It's all my fault! It's all my fault!

Starts crying and cleaning up at the same time. Sandra sits down and watches Molly.

SANDRA: I guess I should pay some attention to her.

Turns to Molly, and asks, like Show-and-Tell.

SANDRA: Your husband really punched you?
MOLLY: Yes.
SANDRA: Did you ever get punched before?
MOLLY: Yes.
SANDRA: You should punch back.
MOLLY: I'm afraid to! I did once and I ended up in the hospital. See the stitches on my head? He took my head and slammed it through a window.
SANDRA: And you're still with him?
MOLLY: I guess I still love him.
SANDRA: Who's he, anyway?
MOLLY: I don't know anymore. I don't know anymore. When we first got married, I was the happiest girl in town. He was handsome. I was pretty. I thought I'd be happy for the rest of my life.
SANDRA: Then how did he turn out to be someone who hurts you?
MOLLY: He told me he would make my dreams come true. I always wanted to be a dancer, but my mother said I couldn't because I was deaf. He said I could. I believed him. But…
SANDRA: Who's your husband?
MOLLY: I don't know now.
SANDRA: I mean, what kind of work does he do?
MOLLY: Um, he's a killer. People pay him to kill other people. He's a professional hit man.

Sandra is shocked.

MOLLY: I never knew that when he married me. He wanted a woman. He married me because I was good for him in bed, and because I'm deaf, he feels he can trust me not to say anything because nobody would believe me. You know – the world in general doesn't listen to deaf people, really. I can't even go to dance school because we're always running from the law!
SANDRA: I see. And you're still with him – you let him have sex with you even though he abuses you?
MOLLY: I have to. If I won't, he'll squeeze my… and not stop until it hurts. He doesn't care.
SANDRA: Don't you care?! (Outraged) You're a woman! You're a human being! Why can't you divorce or run away from him?
MOLLY: He'll kill me if he catches me.

SANDRA: You shouldn't be afraid! You're being negative. You're letting him treat you like a nobody.
MOLLY: You shouldn't say anything like that!
SANDRA: You should defend yourself! Not him! Why're you both here in this town?
MOLLY: Well – we're hiding out.
SANDRA: The cops after your husband?
MOLLY: Yes. He killed a cop.
SANDRA: WHY, why are you with a man who abuses you, kills people for money, and kills cops – WHY?
MOLLY: Because I don't know what else to do! (Scared) I think I better leave. I'm sorry I told you.

Starts moving toward the door.

SANDRA: Wait! Let me share with you something I learned. You know the most sensitive part of a man's body?

Molly nods.

SANDRA: Good. Now, let's pretend I'm you and you're my husband. Do what your husband would do – OK?

Molly nods, and starts reaching for Sandra's bosom.

SANDRA: Just don't touch my breasts!

Molly moves to do so, and Sandra kicks Molly between the legs.

MOLLY: (Jumping back) Wow – where did you learn that?
SANDRA: From a friend.
MOLLY: Ever do it to someone before? How'd you know if it'll work?
SANDRA: It works. I did it to my ex-husband. He had to go to the hospital.
MOLLY: Your ex-husband? You were married before?
SANDRA: (Realizing her mistake) Yes. I'd prefer not to talk about it.
MOLLY: Oh, please… I'd like to know!

Sandra looks out of the window.

SANDRA: Looks like someone out there looking for something.

Molly looks out of window.

MOLLY: Oh no, it's my husband. He's probably looking for me. He doesn't know I'm here. He'll kill me if he finds out!

Rushes to door.

SANDRA: Kick him if he hurts you! Kick him! Kick him!

Molly rushes out, leaving the door ajar. Sandra goes to close it, and Molly pushes door open, throwing Sandra off balance.

MOLLY: Thank you!

The door slams shut again. Sandra looks at the audience, slowly shaking her head. Blackout.

Scene 3

Sandra is doing calisthenics. Molly limps in, stares at Sandra, puts a bag on the table.

SANDRA: What happened?
MOLLY: It's all your fault.
SANDRA: (Pointing at Molly's bandaged knee) How can that be my fault?

Molly goes to the coffeepot and pours a cup of coffee and sits down.

MOLLY: Remember yesterday you told me to kick him between the legs if he touched me. I did that.
SANDRA: So, he beat you up?
MOLLY: He tried to squeeze my breasts and I lost my temper. I kicked him but he was wearing a hockey jock strap with a cup. And that hurt. I fell to the floor screaming. And he said to me, "You bitch, you deserve that!" And he went out for a drink.
SANDRA: That's mean!
MOLLY: Yes, that's mean! You don't know what it feels like to be beaten up all the time!
SANDRA: I do.

Notices Molly wearing a heavy sweater.

SANDRA: Why're you wearing that heavy sweater? Take it off before you become sick from the heat!
MOLLY: No.
SANDRA: Why not?
MOLLY: Just because.

Stares into her cup of coffee.

SANDRA: Are you hiding something?

No reply.

SANDRA: I don't want you to get sick. I know! The perfect idea!

Sandra gets a fan from under the counter. She plugs it in.

SANDRA: There! How's that?
MOLLY: Oh – thank you. (Pained) I'm not wearing this because I'm cold, or hot. I'm wearing this because of these.

Pushes up sleeve, shows cigarette burns on forearm.

MOLLY: Promise you'll not say anything. My husband did this, too. With a cigarette. When I kicked him, he was still smoking, and….
SANDRA: That's sick! I'm angry! I'M ANGRY!
MOLLY: Oh no. Don't make a big thing out of it. It's happened before. Sorry I told you.

Covers up arm.

SANDRA: It's not RIGHT! You're not a piece of property! You're a PERSON!

Molly says nothing. She grabs the bag and offers it to Sandra.

MOLLY: (All smiles) I saw this yesterday in the store. I thought you'd like it. Let's forget this whole thing. Go on, open it.
SANDRA: For me? You didn't have to!

Opens the bag and looks inside.

MOLLY: You like them?

Sandra pulls out a pair of hideous bunny slippers, examining them from a distance.

MOLLY: You like them?
SANDRA: (Looks quickly at Molly) Ah, yes. They're very – unusual.
MOLLY: Good! I bought myself a pair, too! Next time I come over, I'll wear mine. Let's see you put them on!

Sandra puts them on quickly.

MOLLY: They look very nice!
SANDRA: Thank you.

Sandra walks around and looks at Molly.

SANDRA: I'm going to help you. (Pause) You cannot let your husband do this to you. It happened to me before.
MOLLY: I don't understand?
SANDRA: Remember what I said yesterday morning? I mentioned my ex-husband.
MOLLY: Yes, I remember. He beat you up?
SANDRA: (Nods) Not as bad as yours. You should leave him and make a new life for yourself.
MOLLY: (Alarmed) No! I can't!
SANDRA: You don't need a man to be a woman!
MOLLY: I can't! I don't know how!
SANDRA: I didn't know how, too, until I left my husband. I realized I didn't need a man to be a woman!
MOLLY: How'd that happen?
SANDRA: I'm from a deaf family. I haven't been in touch with them for years. I don't want to. Know why? I grew up in a school for the deaf, had many friends who were deaf. I married my childhood sweetheart and found out one thing. (Pause)
MOLLY: What? What?
SANDRA: Deaf people never mind their own business! They gossip and gossip. Just because they're deaf and I'm deaf doesn't mean they have the right to know everything about me!
MOLLY: Hold on, hold on. I don't understand.
SANDRA: I'll explain. I married Jim – my ex-husband – and I thought life was going to be beautiful and we would be happy together. But that never happened. I mean – after the first few months – Jim's mother– Jim's family was also deaf – she couldn't mind her own business. She started bothering me about having children. I tried ignoring her, but she kept asking me over and over: "When will you have children? When will you have children?" She wanted me to settle down and be a happy woman. I had different ideas. I don't need children to be happy. I told my husband I didn't want children. I knew I could never be a good mother. It's not in me. He told his mother and that was the end of it all.
MOLLY: I'm sorry.
SANDRA: It's okay. I'm a grown woman.

TTY light flashes. Sandra answers it, reads the message, and slams the receiver back on the phone.

SANDRA: Damn you!

Turns to Molly.

SANDRA: It's that guy. He has some sex hangup on me! Now about your husband. You must save yourself! You must stand up for yourself!
MOLLY: I can't. He'll search me out and kill me. I know too much about his work! And I'm committed to him. It's the rule of marriage.
SANDRA: But why him?
MOLLY: My family's all gone. He's the only family I have.
SANDRA: You sure you're not strong enough to leave him?
MOLLY: I'm not strong enough. (Pause) And it's against my religion.
SANDRA: How can your religion support a man who gets paid for killing?
MOLLY: Well, I follow the marriage vows. To love and care for him, for good or bad, till death do us part. So, I must honor that.
SANDRA: (Excited) What did you say?
MOLLY: I follow the marriage vows. To love and care for him, for good or bad, till death do us part.
SANDRA: (Jumps up and down) That's it! THAT'S IT!
MOLLY: What? What?
SANDRA: You gave yourself the answer to the problem! Death!
MOLLY: (Confused) Death?
SANDRA: Yes! If your husband dies, you'll be free! Right?
MOLLY: Yes. But I'm not sure what you mean. He's as healthy as a horse.
SANDRA: I know. We can make sure it happens.

Beckons Molly.

SANDRA: We blast him away.

There is a silence. Molly looks frightened.

SANDRA: We kill him.
MOLLY: No, no, I can't do that.
SANDRA: We can!
MOLLY: No, no, I must go! I don't want to get involved in a murder.
SANDRA: You are already involved. Your husband – if he's ever caught, you'll be in jail too as his accomplice.
MOLLY: No. NO! NO! Stop telling me these things! Just forget it! I don't want to kill my husband! GOOD-BYE!

Runs out. Sandra shrugs and rips off her slippers, looks at them, puts them back on, looks at the audience.

SANDRA: Murder. Perfect murder.

Blackout.

Scene 4

Sandra is sitting at the kitchen table, picking up different kitchen tools. Molly walks in.

SANDRA: Hi!
MOLLY: Good morning.
SANDRA: Everything OK last night?
MOLLY: Oh, everything's fine. He didn't touch me.

Notices kitchen tools.

MOLLY: What're these for?
SANDRA: Different things you can use to kill your husband.
MOLLY: No. I will not do it.
SANDRA: Come on! Just look.
MOLLY: NO. I will not do it. Period!
SANDRA: Just look, that's all.

Sits down, ignoring Molly. Molly looks at the pile and picks up a potato peeler.

MOLLY: This won't help.
SANDRA: Oh, that! That's to stab his eyes – and he won't see when we attack.
MOLLY: STOP IT!
SANDRA: Sit down! I'll explain.

Sandra gets her a cup of coffee.

SANDRA: We could both attack at the same time.
MOLLY: Why both of us?
SANDRA: He should get twice as much pain as you've gotten.
MOLLY: I haven't really been hurt.
SANDRA: You're lying.
MOLLY: How dare you say I'm lying!
SANDRA: I don't understand why you need him. You're not a D-O-G! You're a woman! A woman! Women don't know how to stand up for themselves! If you don't stand up for yourself, how can you be proud?
MOLLY: I'm not proud to be a WOMAN! I'm proud to be a human being!

SANDRA: Proud to be a screwed-up human being?! I lived life as a screwed-up person. People were always telling me how to live my life. I should do this, I should do that. I was always afraid to say my own thoughts, my own feelings. Now I'm happy I decided to tell the world to keep their hands off my life and my happiness. I'm happy for the way I am! You should do the same!

MOLLY: What did you do?

SANDRA: Everything. I experimented with sex, drugs and fun. I wanted to find out what I'd been missing. I even had an abortion.

MOLLY: (Astonished) You're like my husband? Killing people?

SANDRA: (Realizing her mistake) No. I'm not!

MOLLY: Oh, yes! You are! You killed your own child!

SANDRA: I did not! I had the abortion a week after I found I was pregnant. Remember I told you my mother-in-law was bothering me about having children? The real reason – I told my husband I had an abortion because I trusted him so much. His first reaction was…do you want to guess?

MOLLY: Tell me.

SANDRA: He beat me up so bad that I ended up in the hospital with a cracked skull and broken legs. He told his mother about what happened and his mother convinced him not to see me again. I never heard from him again. My family disowned me, too. (Pause) The only thing that came out of all of this was an anonymous greeting card – with divorce papers – a sympathy card. I opened it and someone had written "You bitch – you got what you deserved!" And it was unsigned.

MOLLY: That's terrible!

SANDRA: But I survived. When all this happened, I lost all my friends and I decided to move where no one knew me. I realize that people are worse than animals. Animals don't destroy each other's lives, but people do!

MOLLY: You're wrong!

SANDRA: Animals don't kill each other because of emotional abuse!

MOLLY: You're right!

Both are silent, then break out laughing.

MOLLY: That's the first time all week I've seen you so mad!

SANDRA: Yes. You made me think of things I didn't want to think of.

MOLLY: (Stares at Sandra) Well, I'm living things I don't want to think about.

SANDRA: When you face something bad, it's like a truck hitting you. You can't run away from it. It's like being in front of a huge truck. You can see it coming fast. The headlights hurt your eyes, and the truck keeps coming towards you, and the only thing you can do is close your eyes and hope the truck will hit you so fast that there is no pain. Without spattering any blood on the street. But that never happens. That truck keeps hitting you throughout your life and you feel the pain so slowly. And one day, the truck is bigger

than any other truck you've ever seen – it appears so suddenly and before you know it, you're dead!

Molly shudders.

SANDRA: So, instead of being in front of that truck all the time, we should be standing away and watching it hit someone else, like your husband!
MOLLY: I hope you come up with a different idea besides killing my husband.

Sandra is not paying attention. She suddenly pounces on Molly. Molly shrieks.

SANDRA: How many people know about your husband?
MOLLY: The cops. But they don't know where he is.
SANDRA: And you and me.
MOLLY: And the motel owner. He doesn't know about my husband. He thinks I'm traveling alone.
SANDRA: So, he knows only about you?
MOLLY: Yes.
SANDRA: So, the motel owner knows only about you and you can move out any time you want?
MOLLY: Right. Why are you asking me all those questions?
SANDRA: I'm teaching you how to survive.
MOLLY: Why?
SANDRA: Because—

TTY light flashes. Sandra goes to the TTY light, unscrews it and throws it out of the window.

SANDRA: There! Now he'll bother me no more!
MOLLY: Wow! You threw that lightbulb good!
SANDRA: (Modest) I used to play baseball when I was a kid.
MOLLY: That's just great!

Both start to laugh. Molly gets up and refills her cup. She goes over and looks at the TTY light socket.

MOLLY: It's funny! All this planning about murder.
SANDRA: It's not murder! It's freedom!
MOLLY: Murder, freedom, whatever! It's fun to fantasize.
SANDRA: We're not fantasizing.
MOLLY: You can't be serious.
SANDRA: Yes. I'm "dead" serious.
MOLLY: You're nuts.

SANDRA: I'm not.

MOLLY: I won't do it. He's my husband.

SANDRA: Do you know how many times you've said, "My husband, my husband"? You're making me sick.

MOLLY: (Scared) I'm sorry.

SANDRA: Now you're starting again?

MOLLY: I'm sorry that I said I'm sorry.

SANDRA: You're always sorry and scared shitless to kill your husband!

MOLLY: (Standing up, angry) Oh, am I? Let me tell you one thing – you're a bitch for coming up with all this!

SANDRA: Me, a bitch? How dare you call me that? You have no right!

Slaps Molly. Molly is shocked, and then slaps Sandra. They start to fight. Molly shoves Sandra into a chair.

MOLLY: Now you listen to me. I will not kill my husband. But there's one thing I've learned, thanks to you, is to be stronger. I just realized that! Damn you! Damn you!

Rushes off.

SANDRA: (Astonished, looking at audience) Wow!

Stares offstage. Blackout.

Scene 5

Sandra reads the newspaper, checking the clock. Molly walks in, dressed up and chomping on a grilled cheese sandwich.

SANDRA: (Standing up) Well? You're late.

MOLLY: Were you expecting me?

Sits down.

SANDRA: Well – I wasn't sure after what happened yesterday morning.

MOLLY: You expecting me! Thank you!

All smiles, stands up and starts dancing around the room.

SANDRA: What's going on? What?

Follows Molly around.

MOLLY: I'll tell you.

SANDRA: Tell me! Tell me! Your husband treat you OK?
MOLLY: Who?
SANDRA: Your husband.
MOLLY: Him? Forget him.
SANDRA: What happened?
MOLLY: (Stops dancing) I just decided this morning to change my life. You were right.

Hands Sandra half of her sandwich.

MOLLY: I got angry at myself and decided to change.
SANDRA: Good.

Bites into sandwich.

SANDRA: This is cold.
MOLLY: No sense in wasting it, so I brought it to share with you.

Sandra nods, and takes another bite.

MOLLY: My husband's dead.

Sandra chokes. She looks at Molly who is looking outwards, chewing.

SANDRA: Your husband's really dead?
MOLLY: (Smiling) Yes. He's dead.
SANDRA: I see. That's why you're happy?
MOLLY: Uh-huh. I think so.
SANDRA: How and when did this happen?
MOLLY: Well, this morning my husband pushed me out of bed and told me to make him a grilled cheese sandwich and then to pack up because it was time to move on. I went to the kitchenette and turned on the stove. He got up and sat at the table. I was thinking, thinking about what you said, and he was sitting there. I looked at my bunny slippers, and I realized I didn't want to keep on running anymore, and that my life was going nowhere with him and that there was only one way out. The sandwich started to burn and I put it on a plate and put it in front of him. He looked at me. I didn't look at him. I walked back to the stove, picked up the pan and put it in the sink. I looked at the pan. It was greasy and dirty. I looked at him, at the back of his neck. It was dirty, greasy like the pan. Before I knew it, I'd smashed the pan down on his head.
SANDRA: My God! Where's he?
MOLLY: Back there. On the floor. In a pool of blood.
SANDRA: I see.

Picks up sandwich half.

MOLLY: I went into the bathroom and changed into my good outfit. My bathrobe and slippers were all bloody. Then I came out and saw that my husband still had the grilled cheese sandwich in his hand. I thought I might as well as finish that up, so I took it and came over here.

Sandra looks at her sandwich half, and realizing what she's holding, gives a slight scream and throws it at Molly.

SANDRA: How could you do that?!
MOLLY: How could I? You encouraged me!
SANDRA: I know, but not like that!
MOLLY: (Picks up sandwich half from floor) It was just that I was thinking I was playing the role of "poor deaf me" and that it was time to start telling myself – the "poor old deaf me" side – to go to hell and to start living in the real world and accept whatever punishment I deserve!
SANDRA: Punishment?
MOLLY: Yes. After all, I did kill him.
SANDRA: Yes, but it was in self-defense.
MOLLY: The cops won't believe that. When they find the body, they'll be looking for me and get me – for being his wife and book me as an accomplice—
SANDRA: Accomplice... accomplice. You and I are in the same boat!
MOLLY: Huh? That's right. You know all about this.

Sandra nods.

MOLLY: So, we have to save ourselves.

Sandra and Molly look at each other. Sandra puts a cup of coffee in front of Molly.

SANDRA: I want to tell you I'm sorry for slapping you.
MOLLY: It's all right.
SITS DOWN.
SANDRA: It really hurt – my husband. He slapped me a lot. I think that's how I learned. I've been a little defensive ever since.
MOLLY: I think I understand.

Both are silent. Molly looks up.

MOLLY: What will we do with the body?
SANDRA: Hide it, clean up the mess.

MOLLY: But the body—
SANDRA: There's a large freezer downstairs. We could use that.
MOLLY: Freezer?
SANDRA: Dump him in it. Freeze it. I'm not sure what'll happen next. First, we have to see the body.
MOLLY: I'll show you.

Sandra and Molly stand up and walk out. A few seconds pass. Both walk back in.

SANDRA: I see. He's a big man – and in more ways than one.
MOLLY: Aren't all men like that?

Sandra gives a slight "no."

SANDRA: That's a shame. Wasted on such a man.
MOLLY: Well, what do we do then?
SANDRA: We won't be able to fit all of him into the freezer. We'll have to cut him up.
MOLLY: Cut him up? With what?

Sandra goes to the counter and gets an electric knife.

MOLLY: Cut him up with that?
SANDRA: It'll be a little messy, but it'll work.

Sandra looks around for more items. She finds aprons and gloves.

MOLLY: We need some plastic wrap, too.

Sandra finds a roll.

MOLLY: Good. Let's go.

Both exit. Lights dim for several seconds. Both return, lugging a big plastic bag. Sandra is holding a smaller bag the shape of a head.

SANDRA: (Puts bag on table) There!

Puts electric knife on counter.

SANDRA: There!
MOLLY: Whew! That was hard!
SANDRA: The worst part was cutting him apart. Nearly wrecked my knife.
MOLLY: I never realized there was so much of him.

Examines big bag.

MOLLY: I think something fell out of here.

Sandra leaves the room and comes back holding a severed hand. She drops it into the big bag.

SANDRA: Eech! This is a nightmare!

Lugs the big bag to the counter.

SANDRA: Now – clean up the mess.

Gets cleaning supplies from under the counter. Sandra and Molly head for the door when Sandra stops Molly.

SANDRA: You know, I'm happy I met you. My life has been dull lately. At least you have some excitement running from the cops. I just stand there, remove my clothes, and all these men look at me like a piece of meat. Cutting up your husband reminded me of that – pieces of meat.
MOLLY: Thank you. I'm glad I met you – but what was that about taking off—
SANDRA: Never mind. Not now. I'll tell you later.

Pulls Molly out of the door with her. Blackout.

Scene 6

The lights go up on Sandra. She is fast asleep in her kitchen chair. She looks all mussed up having slept in her clothes all night. Molly sweeps in through the door in a freshly pressed dress and is carrying a cosmetics bag in her whitegloved hand. She is the image of urban sophistication, although outdated. She notices that Sandra is asleep and becomes very quiet in her movements. She sets the bag down on the table, goes over to the stove, and pours herself a cup of coffee. She also pours another cup for Sandra and puts the cup next to her. She then goes over to Sandra's side of the kitchen table, sits down, opens her bag, takes out a cigarette pack, removes a cigarette, lights it, and chokes suddenly, doubling over. Sandra wakes up and in doing so, knocks the coffee cup off the table.

MOLLY: (Coughing) So sorry – I've never smoked before….
SANDRA: (Looking at the dripping coffee) And this?
MOLLY: You did that. (Coughs)

Sandra says nothing. She cleans up the mess. Molly keeps coughing and sipping her coffee.

SANDRA: Well?
MOLLY: I'm all finished. All packed, all dressed, all here!
SANDRA: You're looking good. I haven't had a good night's sleep!
MOLLY: Why not? We were so worn out yesterday?
SANDRA: Ever try spending the night in the same house with a dead body?
MOLLY: No.
SANDRA: You should have the experience. Spending all day cutting up your husband and then working half the night away. I was hoping for a good night's sleep – but that man of yours is still keeping me awake! I didn't know whether he was going to rise and...
MOLLY: It was your idea to offer the use of the freezer. It's not my fault it's in this house.

Sandra says nothing. She goes and fills her cup of coffee.

MOLLY: Anyway. I'm not living there anymore. I told the agent I was moving out. I told him I was moving in with you.
SANDRA: You what?
MOLLY: I thought that I could stay here for a while now that I have no money....
SANDRA: You have some nerve!
MOLLY: What do you expect me to do? Walk the streets alone?
SANDRA: That's not a bad idea.
MOLLY: What? What?
SANDRA: Never mind. You can stay here for a while. There's another bedroom upstairs. You can have it.
MOLLY: Ohhh, thank you. And the motel owner asked me for a date!
SANDRA: Oh, really?
MOLLY: Yes. Lucky me. Lose one man, get another man.
SANDRA: That's fine. Just don't expect me to help out.
MOLLY: Who's asking for help? Now that I've got a date, I'm getting you one.
SANDRA: No thanks. I know your taste. And I don't trust men.
MOLLY: Oh, come on. Just let me help!
SANDRA: No.

Sandra and Molly say nothing for a moment.

SANDRA: Now that you decided to live here, how will you be able to pay for all this?
MOLLY: I hadn't thought of that.

Begins to get upset.

SANDRA: We'll figure out a way. I just realized you dance well. How about joining my work? The other girl quit two nights ago.
MOLLY: Yes. Yes! You were supposed to tell me about your work! What do you do?
SANDRA: I work in a bar. I dance. I take off....
MOLLY: You're a stripper? Wow!
SANDRA: Yes. It's good money.
MOLLY: But...then why did you say all those things about me being cheap then! Look at yourself!
SANDRA: I'm not going to defend myself.

Sandra stands up and goes to the counter.

SANDRA: I'm not defending myself at all. I just didn't want to do what all other deaf people I knew did. Printers, clerks, mechanics – locked into the system of this society. I knew I could do something different. I said to myself one night, "Why not?" And I applied. I got the work. And it pays well. And the men don't touch me. I won't let them.
MOLLY: That sounds interesting.
SANDRA: I find myself in control. And I like that.
MOLLY: But don't people here look down at you?
SANDRA: No. I work in another town – it's an hour's drive. That way I preserve my reputation!
MOLLY: I see.
SANDRA: And the people around here like me. They know me as the "nice divorced deaf woman." It was a nice quiet life...until you arrived.
MOLLY: I'll take the job. I was thinking I could do the same thing as you do, and when I've saved enough money, I could go to dance school!
SANDRA: And pay your rent here. Remember—
MOLLY: I know – nothing's free.
SANDRA: Right.
MOLLY: Fine!
SANDRA: Now what about your things?
MOLLY: I already put them upstairs.
SANDRA: Huh? How...? What...?
MOLLY: You were sleeping. I came in earlier this morning and brought my two bags. The motel owner helped me carry them upstairs. And you know, he said some real nice things to me. He's happy I'm staying here. He said he feels safe now that I'm not alone.
SANDRA: Aaarggghh! I just can't win!
MOLLY: Don't worry. We'll get along just fine. I promise I'll stay out of your affairs and you stay out of mine. We will have to work on our act.
SANDRA: Act?
MOLLY: Yes. Now that I'll be working with you in that bar...?
SANDRA: I didn't say anything about both of us dancing together.

MOLLY: Why not? We could call our act "The Silent Dancers!"
SANDRA: "The Silent Dancers?"
MOLLY: Sure – why not?

Looks in her bag and brings out a lightbulb. She crosses over to the counter and screws in the bulb where the TTY bulb used to be.

MOLLY: There! Now I'll be able to get those obscene calls!
SANDRA: All of this is happening too fast. Just wait – hold on a minute!
MOLLY: Am I doing anything wrong? I'm sorry—
SANDRA: Stop it! Stop it! I don't like the idea of all—

TTY light flashes. Molly answers it. She excitedly types on the TTY, but as she reads the message, she becomes obviously upset.

MOLLY: It's for you. He doesn't want to talk with me.
SANDRA: It's that guy?

Molly silently nods, on the verge of crying. Sandra goes over to the TTY.

SANDRA: I don't want to talk with him!
MOLLY: He wants you.

Sandra types on the TTY. She has an inspiration. She types furiously. In the meantime, Molly is crying. Sandra calls Molly's attention and gestures for Molly to come over to the TTY.

SANDRA: It's for you.
MOLLY: For me?

She rushes over to the TTY, smiling. She furiously types and then hangs up triumphantly. Meanwhile Sandra is smirking.

MOLLY: Guess what?

Sandra shrugs.

MOLLY: I got you a date with him.
SANDRA: You what?!
MOLLY: It'll be nice. Me with the motel owner, you with the guy!

Sandra collapses into her chair.

SANDRA: Why, why, why?
MOLLY: Because I can't go out with two men at the same time.

Sandra stares at Molly and then sighs.

SANDRA: Ok, ok, ok. Do I have a choice? No. I don't even know his phone number. W-h-e-n-s t-h-e d-a-t-e?
MOLLY: I didn't promise anything. I've no idea.

Sandra starts to laugh. Molly joins in a second later.

SANDRA: You know – I was wondering about your dancing yesterday. Before you said anything about hitting your husband – where'd you learn that if you never went to dance school?
MOLLY: Oh. I watch "Solid Gold" on TV every night.
SANDRA: I see.
MOLLY: I was wondering – what are we going to do with the body?
SANDRA: I've no idea. Open a restaurant? Throw it to the dogs? Keep it frozen? I really have no idea.
MOLLY: Me, too. No idea.

Molly refills her coffee cup. Turns to Sandra.

MOLLY: Want some coffee?
SANDRA: Yes, please. Thank you.

Molly places coffee cup on table for Sandra.

SANDRA: About the body – I really have no idea. We'll worry about it tomorrow. After all, someone did say once, "Tomorrow's another day!"

As she gestures, she knocks the coffee cup off the table. Sandra and Molly look at the coffee cup, and then at each other and start to laugh. The TTY light goes on and off. Sandra and Molly reach for the phone. Molly gets there first. Molly answers, reads the incoming message and looks at Sandra.

MOLLY: It's the guy again! He says he wants to speak to you.
SANDRA: No.

Molly types Sandra's answer and reads the TTY message.

MOLLY: He WANTS to speak to you.

Looks at TTY.

MOLLY: Says his name's Jim – says he's your ex-husband.

Sandra reacts.

MOLLY: He wants to see you…he wants to come back.
SANDRA: Now, that's a really obscene call! I'm not speaking to him!
MOLLY: (Still reading) Says he knows where you live. He'll come by…

Sandra shoves Molly out of the way and starts typing furiously. Molly looks around, not knowing what to do, and then spies the electric knife lying on the counter. Molly picks it up and starts to rub it. Sandra looks up from the TTY and does a double-take, glancing at the TTY and back to Molly. Sandra smiles when Molly looks at her. Molly nods.

SANDRA: I think he should come by….

Molly starts to laugh and caress the knife as Sandra keeps typing… Fadeout.

About the Author

Bruce Hlibok (1960–1995) was a playwright, director, and the first Deaf actor to play a Deaf character on Broadway performing in the 1978 hit musical, *Runaways*. His plays *Going Home, The Passion of Rita H*, and *WomanTalk* were produced off-off Broadway. Also, he appeared on television at the Tony Awards in 1978 as a guest performer, ABC's 20/20, CBS' The Equalizer, an HBO Christmas special, and two PBS productions. He is the author of the children's book, *Silent Dancer.*

7
AARON WEIR KELSTONE, *25 CENTS*

IMAGE 7.1
Source: Photo courtesy of NTID Dept. of Performing Arts.

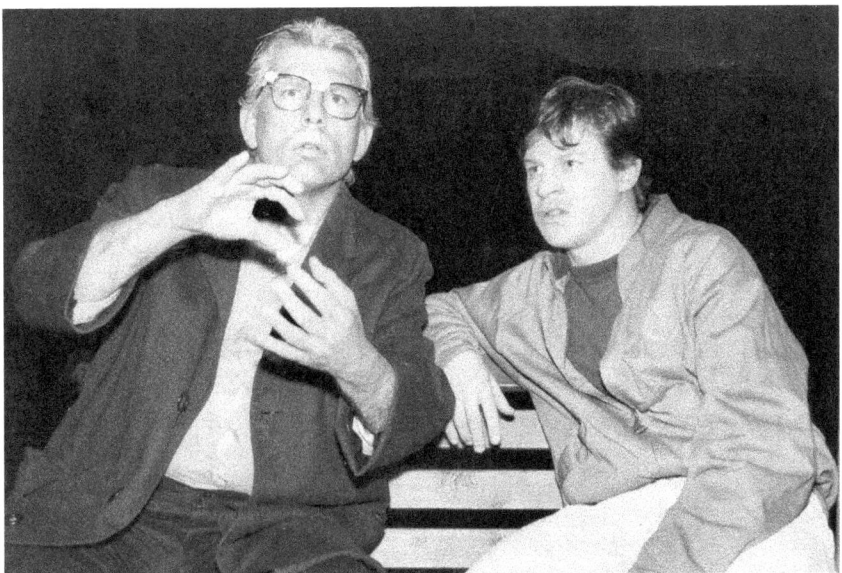

IMAGE 7.2 Actor/director Alan Barwiolek (left) and Jeff Bravin perform in a scene from Aaron Kelstone's *25 Cents*.
Source: Photo courtesy of NY Deaf Theatre, photo by Tony Allicino.

Synopsis

Even though an old Deaf peddler warns his friend Brian otherwise, Brian stays around for his stories. Harry sees Brian with the peddler, whom he doesn't accept as a Deaf person. Their confrontation reveals different points of view on the peculiar institution of Deaf peddling. Age-old questions of pride and shame arise as they try to untangle themselves from cultural labels.

Production History

25 Cents was presented as part of a twin bill, *Two One Act Plays by Two Deaf Playwrights* [the other one-act was *The Hearing Test* by Willy Conley], by New York Deaf Theatre (NYDT) as part of their 14th anniversary season. It ran from December 4 to 19, 1993 at the Judith Anderson Theater in New York, NY. It was directed by Alan R. Barwiolek; set design, Richard Harrison; costume design, Irene Bartok; lighting design, Michael Appel; sound design, Nicole Bernadette and Richard Rose. The cast was as follows:

 Old Man – Alan R. Barwiolek
 Brian – Jeff Bravin
 Harry – Troy Kotsur
 Kelly – Genie Gertz
 Voice – Daniel Hahn

Voice – J. Patrick[1]

It is important to point out the incredible value and existence of NYDT. This small, Deaf-operated theater organization in New York City has been a long-time supporter of producing original works by Deaf and hard-of-hearing playwrights.

> Besides the obvious goal of providing theatrical productions to deaf and hard-of-hearing audiences – and giving deaf actors, writers and stage technicians a rare showcase for their talents – the NYDT is also looking to 'enlighten and educate hearing audiences about our culture,' says *25 Cents* actor and director, Alan R. Barwiolek, in the article *Deaf Theatre Wins Resounding Approval*. "The not-for-profit company does that by simultaneously performing in both ASL and spoken English, with onstage actors serving as the 'voices' of deaf actors who perform in sign language."[2]

Jackie Roth, NYDT's artistic director at the time, commented that

> While it's a complicated staging technique, … [it is seen] as a challenging alternative to simply having an ASL interpreter sitting off to the side of the stage. Deaf people derive information from the visual. And since theatre is a visual medium, it's a nice method.

Roth stated further that

> our mission is to give a deaf perspective to our work at the same time we're bringing our culture to audiences…. NYDT's biggest problem has been reaching out to potential young writers. We need to find these people and get information out to them. Deaf kids need to know there are opportunities out there. If we can get them to start writing younger, we can nurture them along so they can compete on equal ground with other artists…and hopefully, a production by one of our writers will someday go to Broadway.[3]

Thoughts about the Play

25 Cents won an award in the one-act category in the Sam Edwards Deaf Playwrights Competition in New York City and was produced off-off Broadway. This play, with a philosophical bent, deals with the controversial issue of deaf peddlers who are an embarrassment to hard-working members of the Deaf community who feel they make an honest living with "regular" jobs. Aaron Kelstone gave his lines of dialogue some cadence and essence of American Sign Language (ASL) with special arrangements of English glosses and word repetition. He drew upon the two-beat and sometimes three-beat rhythm of ASL expression and portrayed that by repeating specific English words, as seen in his script. While

the dialogue is readily comprehensible to a reader unfamiliar with ASL, the emotional charge of the content is very likely to be missed.

There is a strong moment early in the play when characters wear masks. The use of masks in Deaf theater is not very common as they tend to cover the face, which blocks communication by hiding facial expressions and non-manual markers, grammatical elements crucial in ASL. However, when masks are used in purely visual, nonverbal ways, then they can become very effective on stage.

Deaf Gain

This one-act play was originally published in 2003 by the Tactile Mind Press.[4] There are incredibly few plays by Deaf writers that get published in a professionally bound book as an individual script. This is a real inspiration for future Deaf and hard-of-hearing writers in getting their plays published.

Notes

1 New York Deaf Theatre. *25 Cents*. New York: Playbill, 1993.
2 Dominguez, Robert. "Deaf Theatre Wins Resounding Approval." *Daily News*, December 15, 1993, 49.
3 Ibid.
4 Kelstone, Aaron Weir. *25 Cents*. Minneapolis, MN: The Tactile Mind Press, 2003.

7

25 CENTS

Aaron Weir Kelstone

Characters

OLD MAN, *a Deaf manual alphabet card peddler who never finished residential school. His signing style is what is called "strong ASL" or "very Deaf."*

BRIAN, *a Deaf man, graduated from a residential school and now a college graduate. His signing skills are what is often described as a "Gallaudet signer."*

KELLY, *a Deaf woman, who was mainstreamed in public schools. She discovered Deaf Culture later in life and sometimes is more radical than a native Deaf person about deafness. Her ASL is not native, and she mouths her words often while she signs.*

HARRY, *a Deaf man, graduate of the residential school, a skilled tradesman and confident about his identity and values as a Deaf person. Sees the world clearly along black and white boundaries.*

Scene

Late afternoon. A few trees, a park bench, a trash container, and a birdbath are in place. Litter is scattered about like in a typical inner-city park. Old Man appears, walking along the park path. He acts out the action of selling something to invisible people passing by him. His face and body language indicate the results of his actions, sometimes with success, but more often with failure. Three people appear: their faces hidden behind masks similar to those used in the presentation of mime. Each mask bears an expression of disgust or rejection. The three people menacingly surround the old man. Their actions are aggressive, consisting of pushing and pulling motions, which wear the old man down. His face and body language gradually conveys rejection, despair, and exhaustion. He sees the park bench. As he moves toward it, the three masked persons fade away. The old man slumps down onto the park bench.

OLD MAN: Ahh. How long we suffer? So many years—wait-wait-wait. No Moses come to save Deaf. Deserve hope… Yes… deserve hope. All deserve hope.

Brian appears, sees Old Man signing to himself.

BRIAN: Hey, old man. Is it so boring you have to sign to yourself for entertainment?

OLD MAN: Ah, life drives me crazy. Push-push. Pull-pull. Never right answers anywhere.

BRIAN: What's wrong with you today? You're not yourself.

OLD MAN: Nothing… tired, that's all.

BRIAN: Old man, I worry about you. I think someday I will come here and find you dead. You know how city parks are now? Children kill for fun!

OLD MAN: Me always come here. Many memories here. I never stop visiting this place. If I die, who cares? This old bench my friend, together we share many dreams, many thoughts. Many sights we see together. Time pass— I become wrinkled, bench paint peel. Knees shake, bench wobbles. Every day people pass, but who notices old things?

BRIAN: Oh, come on. Tell me one of your stories. Maybe that will cheer you up.

OLD MAN: What for?

BRIAN: Because I like the old Deaf stories. When you tell the stories I feel like our Deaf past is real. Something that proves to me that I'm less of a freak. Something beautiful happens when I listen to your stories.

OLD MAN: Beautiful? Sometimes I not understand you. I old, and worst, I A-B-C card peddler. All Deaf they happy if me gone, but I survive. HA! They hate me… they reject me. Don't you ever feel that? Awful will happen to you if they see you with me. What true reason you come here?

BRIAN: Loneliness mostly.

OLD MAN: You, lonely? I believe not. Lonely, what do you know about it?

BRIAN: It still happens. No matter how smart or successful or independent we are… Sign or no sign, college or no college, it remains the same. Only difference between you and I is you've been rejected two times. Hearing people reject you, Deaf people reject you.

OLD MAN: What about you? Why not you same like others?

BRIAN: Like I said before – we're not that much different.

OLD MAN: No, true business, different! All my life reject, reject. You not the same. You lucky than I. You have TTY; have R-something….

BRIAN: Relay service.

OLD MAN: Yes, that. Now sign language accept everywhere. Not like when I young. You have chance. Too late for me.

BRIAN: Don't give me that pity-pity-pity stuff. I'm Deaf too, remember? Sure I have a chance, but it hasn't really changed that much. Hearing people still say, "Sign Language is so beautiful," or "Do you know how to drive a car?" or "Can you have children?"

Laughs.

BRIAN: Wait… wait, this is one of my favorites: "Have you seen 'Children of a Lesser God?' Such a nice movie!" You'd think they would have figured it out that I've lived it.

OLD MAN: Hey, pity-pity-pity, remember? We both can talk-talk-talk. Nothing changes.

BRIAN: Until you tell your stories and then for me it's different. They're good and for a moment I can almost bear it. It's important! What you remember is important and we should know it. There is a past worth being proud of and hope is possible.

OLD MAN: (Chuckles and shakes his head) Before I hope like you. I sit very, very quiet here. Look long, long time across the park. Sometimes if I look hard enough I see ghosts. They all complain. Grieving and crying for what we lost…our signs bastardized, no love for one another, our culture destroyed by mainstreaming. Ghosts cry and cry, but I want to believe that someday I look hard enough I see past them, see our Moses.

BRIAN: I want to believe.

OLD MAN: Now I only cry. We like silly clowns. The hearing they laugh, laugh, laugh. We good clowns.

BRIAN: It's worth the wait. Someday it will happen. It will, old man, it will.

OLD MAN: Maybe not worth wait. They win anyway.

BRIAN: Maybe that's why I come, old man? To convince you to keep on believing. If you give up your dreams, maybe you still breathe or eat, but the truth is you're already dead. Deep down you know that, don't you?

OLD MAN: Same-same. Your hope, my Moses. Happen? Never!

BRIAN: Please don't say that.

OLD MAN: All I know I wait long time for my Moses.

Harry and Kelly enter. Harry sees Brian and Old Man, and points them out to Kelly.

HARRY: Look at that. The college whiz kid and the old peddler together. I can't believe it. Let's check this out.

KELLY: Harry! What about the movie? We just have enough time to get there.

HARRY: Kelly, this won't take more than a minute.

KELLY: Harry, with you nothing takes just a minute.

HARRY: Hey – trust me – this will be fun and maybe cheaper than the movie.

KELLY: Trust? You? Ha!

HARRY: Ah, come on.

Pulls Kelly along and goes behind Old Man and lightly taps him on the shoulder.

OLD MAN: Moses?

Turns to see who it is.

OLD MAN: Oh, it's you.
HARRY: Well, well, well. What do we have here? Teaching some tricks of the trade, old man? What's up, Brian? College not enough for you? Have to add some on-the-job training?
BRIAN: Look, we're just talking.
HARRY: Talk! About what? There's nothing this old man knows that's worth talking about.
BRIAN: Oh, that's right! I forgot. Harry, the big "D." You've figured out everything.
HARRY: I don't need a college education to know what to do about Deaf peddlers.
KELLY: This is not what I call fun. Let's go.
HARRY: Not yet. The whiz kid thinks he's got all the answers. Let's give him a real education.
KELLY: Here's what's real. We are going to the movies. Now we can do it together or I can do it alone. Which is it?
BRIAN: Hey, Harry, that's easy enough to understand. You should be able to figure out the answer to that quick enough. I'll give you a hint: turn left and keep going straight till you get to the movies. Better yet, just follow Kelly so you don't get lost.
HARRY: Know what your problem is? You think just because you get to go to college you can forget where you come from. Well, I'm here to remind you.
BRIAN: Remind me of what? That you can't keep your nose out of other people's business?
HARRY: Now look who's having problems communicating. How about if I just become a quick study and tell you right now what the problem is.

Looks over at Old Man and smiles.

HARRY: But first, we need some visual aids for the college kid here. We'll keep it simple just like they do on Sesame Street.

Goes over Old Man and frisks his pockets.

OLD MAN: Hey!
KELLY: Harry!s

Harry finds what he is looking for and takes it from the Old Man's pocket.

HARRY: Okay, class: Life 101 is now in session.
BRIAN: Looks more like Mugging 101 to me.

HARRY: Now, now, children. Please observe what the professor has discovered. Ah, yes, the famous A-B-C cards.

Acts like he is adjusting a pair of glasses on his nose.

HARRY: Let's see, yes, here we are. We'll take some class time today to make sure Brian can follow along. We'll read the material real slow now: HELLO. I AM A DEAF PERSON. I AM SELLING THIS DEAF EDUCATION CARD TO MAKE MY LIVING. WILL YOU KINDLY BUY ONE? PAY ANY PRICE YOU WISH. THANK YOU. My! That's certainly polite of you, old man. Now, if I recall correctly, we just turn the card over and here we are: our cherished ASL alphabet.

Goes to all three and shows them the A-B-C cards up close to their faces.

HARRY: Now if you look real close, we can see that the basic message spells out W-H-O-R-E!

Throws A-B-C cards at Brian.

HARRY: How can you socialize with scum like this? When I was little I would see him beg for 25 cents. (To Old Man) Every day I live with the shame of your begging. What do you beg for now, old man, one dollar? Two dollars?
OLD MAN: Not your damn business.
HARRY: It IS my damn business. You shame me; you shame all of us.
OLD MAN: Shame? Because me use SSDI. Shame because me use English like foreigner. Shame because me sign ASL. Shame because me fail state school. Shame because me not think same as you. (To All) Well, shame same for— (To Harry) You! Why? Because you always depend on parents, I know it! (To Kelly) You! Because you voice like foreigner. I see the faces! (To Brian) You! Because you not listen to Harry. He knows what is right. (To Kelly) Shame because you mainstream. (To Harry) Shame because your mind is closed!
HARRY: B-S!
KELLY: Let's go. We don't need to do this. We are just wasting our time.
HARRY: What do you know? You'll never understand. You're just hard of hearing.
KELLY: Just. Just! You think that's all it is, that my life is easy! Can you imagine what it is like to be alone? In class expected to use your voice with no choice and then see the faces full of laughter? Or if they don't laugh they smirk. And if they don't then it's the other way around. The minute they realize I'm not "normal" then it just happens like magic—

Snaps fingers.

KELLY: Suddenly I'm an alien popping out to devour them. How many times do I have to see the shocked look on their faces or watch them retreat quickly down the hall. I didn't ask for rejection then and this old man isn't asking for it now.
HARRY: Fine! So you support him. Go, whore in the streets just like him. Be my guest. Go on.

Pushes Kelly away. Brian steps between them.

BRIAN: What do you think you are doing now? I don't remember shoving women around as being a Deaf culture thing.
HARRY: As if you know anything about Deaf culture. The best thing you can hope for is that a hearing person might mistake you for a Deaf person.
BRIAN: You take that back.

A shoving match starts. Kelly tries to intervene and it quickly gets out of hand. Brian, Kelly, and Harry become a confusion of arms and legs and soon fall to the ground in a tangled mess. Old Man goes to pick up a discarded cup and heads to the birdbath to scoop up some water. Then he walks over to the others and throws water on them. All sputter in reaction to being doused with water.

BRIAN AND KELLY: Hey!
HARRY: He's lost his mind for sure.
OLD MAN: No, I celebrate.
KELLY: Celebrate what?
OLD MAN: I celebrate like hearing people if they could see you now.
BRIAN: What do you mean?
OLD MAN: DEAF POWER!
HARRY: Deaf Power?
OLD MAN: Yes, DEAF POWER!

Moves about the stage celebrating.

OLD MAN: DEAF POWER! They be so happy to see. DEAF POWER! Deaf have the power to fight each other. DEAF POWER! Deaf people have then power to hate each other. DEAF POWER! Deaf people have the power to beat up on each other. (To Harry) Stab-in-back. (To Kelly) Oh yes, stab-in-back. (To Brian) Oh yes, DEAF POWER, DEAF POWER, DEAF POWER!

Harry finally has enough of this and starts to angrily chase down Old Man. He catches up with him and grabs him by the elbow.

HARRY: Stop it! Shut up! You mock me. You mock all of us. You're wrong to make fun of Deaf Power that way. It makes it a lie!
OLD MAN: No lie. I tell the truth.
HARRY: Lies!
OLD MAN: You see what you want. You not see me because I am a simple truth you fear. It never changes. None of you change. All my life I meet Deaf person they think I walk away because I ashamed? No, I walk away because their minds, and yours too, are already too deaf. You are just scared of me because you know. If no 504, no ADA, no TTY, no interpreters, then you no different, you same me.
HARRY: In your dreams, old man. You're right, Kelly – this is a waste of time. Let's go.
OLD MAN: No, you listen! I have courage.
HARRY: Courage? You? As far as I'm concerned, you're the biggest kind of coward. You don't have the guts to get a REAL job.
OLD MAN: What I do takes more courage than you. Every day I go out and look at the world face to face. I stand right here. Many not look me eye to eye. But, some, they look at me and they know. They same as me. I not need to say one word; not use one sign – they know. THEY KNOW! They owe me. You owe me! You'll never understand that. You think this is easier? What little they give me will never replace what I lose.
HARRY: I will never accept you.
OLD MAN: Still true.
HARRY: Still lies! Nothing you can say will change that.
OLD MAN: I'm telling you, what I do and what I get will never replace what any of us lose.
HARRY: I said lies! You just don't get it. Deaf culture has already decided. Period!

Harry pushes Old Man away and he stumbles and falls. He then pulls out a knife and opens it up. He points it toward Harry.

HARRY: You better know how to use that, old man.

Harry menacingly approaches Old Man. As he does so Old Man turns the knife around and offers Harry the handle.

HARRY: What the… you gone crazy on me, old man.
OLD MAN: Go on, take it!

Old Man tosses the knife on the ground to Harry, who carefully reaches down and picks up the knife.

HARRY: I don't understand.
OLD MAN: I make it easy for you. Go ahead: one stab, right here and it's all over. No need feel shame anymore. Go ahead. You already reject me. I'm nothing. You think me nothing. So, go ahead. Now finish it!

Sees that Harry is not making a move toward him. There is a pause as they eye each other.

OLD MAN: Oh, excuse me! I forgot. I forgot the Deaf culture rules. It hard to stab someone when you are face to face. Easy to talk-talk-talk. Now we do it right way – copy traditional Deaf way. I turn around so you can stab me in back. It called backstabbing. It should be easy.

Turns back to Harry. Harry has a look of fury on his face.

KELLY: I think this has gone far enough. Give me the knife now before something really goes wrong.
HARRY: What for? You think he is worth saving?
KELLY: He is human. Don't forget that.
HARRY: No, he stopped being human to us a long time ago.
KELLY: If you believe that then you are the same.
BRIAN: (To Harry) Leave him alone. He's earned his bit of truth.
HARRY: Truth! He's nothing but an old man crying for things he never had. He chose this life. No one forced him to be a peddler. He made the decision.
KELLY: What about me? I'm a woman, a Deaf woman. First, I am rejected for being a woman. Then I am rejected for being Deaf. Then I am rejected for not being Deaf enough. When did I choose, Harry? When?
HARRY: It's still his problem. He has to live or die with it.
KELLY: Yes, you're right… he can live with it or he can die with it.
OLD MAN: Choose? We are like wood floating in water – sooner or later we all in the gutter – down sewer. Pah! Who remembers?
KELLY: Who remembers? No that's not right.
OLD MAN: Right, Wrong? No matter, it's true. No one remembers us. Period!
BRIAN: It is always easier to hate, isn't it? Who taught us to hate like this? Who, Harry?
HARRY: All I know is what I see. Deaf culture makes it clear. Ah, what's the use. You have to be deaf to understand.

Goes to sit on the wood bench.

BRIAN: It's our Deafness that blinds us and binds us, all of us at the same time.
KELLY: We just need to be loved. For who we are.

Old Man picks up the cup and goes to the birdbath. He scoops out some water and goes over to Harry. He gently drips some water on Harry.

HARRY: Now what?
OLD MAN: I'm celebrating!

Tosses water high in the air; it comes down gently dousing all of them.

BRIAN AND KELLY: Not DEAF POWER again?
OLD MAN: Yes. DEAF POWER NOW!

Moves about the park in a jovial mood.

OLD MAN: We be so happy to see – Deaf communicate: can!

Pulls Brian behind him followed by Kelly. They forget the tension of the previous moment. The joviality of Old Man rubs off on them and together they begin to chant.

BRIAN, KELLY, OLD MAN: Deaf power now! Deaf power now! Deaf power now!

This continues until they collapse around the park bench in laughter and exhaustion. One by one they slowly notice that Harry had not joined them in the celebration.

HARRY: I do not understand any of you.
KELLY: What?
HARRY: The three of you hopping around yelling chants. You think that wins the war?
OLD MAN: Who knows?
HARRY: That's a brilliant answer.
BRIAN: Well, there's always Moses.
HARRY: Moses?
OLD MAN: Yes, Moses: true. Long ago Jewish people stuck in Egypt for 400 years. No answers for them even though like us they asked why? Then Moses come and show them their promised land. Why God not send Deaf their Moses too?
HARRY: Four hundred years! Who in their right mind wants to wait 400 years?
BRIAN: He means hope. When he talks about Moses, I think of the word "hope." Someday there will be hope for us too.
OLD MAN: Yes, we find our promised land.
KELLY: It could be wonderful.
BRIAN: A Deaf president.
HARRY: Sign language in the movies.
KELLY: A Deaf mayor too!
OLD MAN: And we not discriminate. Our land open to all.

BRIAN: Yes! Oral, late deaf, born deaf, hard of hearing. It makes no difference. Everyone finds a way.
HARRY: No need to read lips. No cued speech.
OLD MAN: Throw away paper and pencil.
BRIAN: Right!
KELLY: I wish it were here. I wish we were in our promised land right now.
HARRY: Listen to us. What do we think we are talking about? The old man just said before it will never change. Now you dance around and act like silly dreamers.
BRIAN: Wait a minute.
KELLY: What?
BRIAN: Maybe it's already here.
HARRY: What's already here?
BRIAN: Our promised land!
OLD MAN: Promised land? Where?

Looks around trying to see what Brian seems to see.

OLD MAN: I don't see anything. What are you looking at?
BRIAN: Right here! Right in front of us. The four of us sitting here. Look at us. Laughing and joking and dreaming! Trying together to find solutions instead of whining. Maybe this park bench is the beginning of our promised land.
KELLY: Because for this moment we're just four ordinary people. No labels. Just us.
OLD MAN: Four ordinary people.
HARRY: Ordinary.
BRIAN: Yes, not impaired and not defective.
KELLY: Nobody needs to fix us.
OLD MAN: Or save us like Moses.
BRIAN: Harry, maybe that's it. We stopped hating long enough that we could see each other for who we are. We've kept looking for someone to take care of it and it was ours to take care of all along.
HARRY: Wait a minute. It's just not that easy. Just now, old man, you were saying we all end up down the gutter. For God's sake, we were all tumbling in the grass fighting with each other till you threw water on us. Just a while ago, so as far as I am concerned it's nothing but B.S.
OLD MAN: B.S.? Real things start where? Dreams. Just like when Moses helped bring Jewish people out of Egypt.
HARRY: Yeah and then they spent 40 years lost in the desert.
BRIAN: But at least they had hope.
HARRY: Hope is one thing. Real world is different. Hearing people will not change. Same for me. All my life what I know I know from my culture. Deaf culture. I can't and we can't change overnight. This old man, we cannot accept. Period.
KELLY: We? Why not?
HARRY: That's the way it is.

BRIAN: And that's the way it always has to be?
HARRY: For now, yes, that's the way it has to be.
BRIAN: I can't accept that.
OLD MAN: He right, that way always be. Same-Same. Nothing you do will change anything.
BRIAN: Maybe Harry thinks things have to stay the same. But I don't have to accept that. NO WAY!
HARRY: You do what you gotta do. I'm done with this discussion. I gotta go.
KELLY: Go? What about me? You just going to walk off now?
HARRY: What?
KELLY: We were going to the movies, remember?
HARRY: Oh that.... Can we do it another day? I'm not in the mood, sorry.
KELLY: Fine, you do what you have to do. I'll talk to you later.
HARRY: Okay then, thanks. You're ok with this, right?
KELLY: Whatever. Just go, we'll talk later.
HARRY: Yeah, right. Later.

Departs.

KELLY: Well, isn't that something?
BRIAN: What?
KELLY: I've been stood up a few times before but never on the way to the movies.
BRIAN: Oh, yeah. Guess there's a first time for everything.
KELLY: Yeah, well I guess it's home for me, there's always laundry.
BRIAN: You want me to walk you home? It's on my way.
KELLY: No thanks. I think a walk by myself will be good for me.
BRIAN: Hey, I'm a good listener. Sure you don't want me to come along? Like I said, it is on my way.
KELLY: Good try, Brian, but I'd rather not. See you some other time.
BRIAN: Never hurts to try. Take care.
KELLY: You too. (To Old Man) Bye.
OLD MAN: Bye. See you again, will?
KELLY: Maybe.
OLD MAN: Maybe, that fine.

Smiles.

OLD MAN: Walk home, careful you.
KELLY: I will. Bye.

Departs. Brian watches Kelly depart. After a bit he goes to the bench and sits down.

OLD MAN: Well, see me talk right.
BRIAN: Yeah.

OLD MAN: Easy not, right?
BRIAN: No, I thought it was just a simple thing, really. Just coming here to listen to an old man tell me some old stories. Who you are didn't seem that big a deal to me. I mean, really, in the end who cares?
OLD MAN: Deafies, yes, it is hard to accept.
BRIAN: Then why not do something about it? Why not you change?
OLD MAN: Me? Change, now? Train, gone, sorry.
BRIAN: No, no, no joking. I am serious. I think you can change.
OLD MAN: Think, one thing. Do, different story.
BRIAN: It still doesn't seem right to me. There has to be a better way. There just has to be.
OLD MAN: For you, I think so. For me, not.
BRIAN: That's it?
OLD MAN: For now, yes.
BRIAN: Hard to accept that. It goes against what I believe. There's always time to change, to make the world a better place.
OLD MAN: I only know what I see. We wait, see-see. Maybe you right.
BRIAN: I am right. You make me angry how you act right now. I don't like how I feel.
OLD MAN: Angry, nothing new. Maybe we stop angry, solution will find.
BRIAN: Let go of the old ways before we find something new?
OLD MAN: Like Moses say, let people go.
BRIAN: Even if it means being lost for 40 years along the way?
OLD MAN: Maybe.
BRIAN: Don't know about that. Something to talk about the next time.
OLD MAN: Time to go, eh?
BRIAN: Yeah.
OLD MAN: You like the girl?
BRIAN: Huh, oh Kelly… I do.
OLD MAN: Maybe you start there. Connection important always.
BRIAN: Depends. I don't think she was interested.
OLD MAN: Give it time. Hurry, hurry not need.
BRIAN: Okay, see-see.
OLD MAN: You back soon?
BRIAN: I think so. I want to, but you know…
OLD MAN: Confusing?
BRIAN: Don't get me wrong.
OLD MAN: Worry not, you know where to find me.
BRIAN: I do… well, okay then. I will be around one of these days.
OLD MAN: Sure, home careful you.
BRIAN: You be careful too.
OLD MAN: Will, will, bye.
BRIAN: Bye.

Exits. Old Man is left alone on the park bench. In a bit he looks down and sees some of his A-B-C cards on the ground. He reaches down and picks up a few. He looks out across the park into the audience and slowly smiles. He gets up and begins to approach imaginary people again, showing them the A-B-C cards. Lights fade to a spot on Old Man. He turns to the audience, offers a card. Lights fade to black.

About the Author

Aaron Weir Kelstone has been an actor, director, playwright, an artistic director, and business administrator for various theater organizations over the past 15 years. Originally from Kansas, he has worked in Missouri, Arizona, and Ohio before settling in New York. He was the former Artistic Director and General Manager of Cleveland SignStage Theatre located in Ohio from 1995 to 1999. He has an MA degree in English Literature from Cleveland State University. He also has an EdD in Education from Northeastern University. He also majored in business and theater for three years at Arizona State University. He has been a Principal Lecturer at the National Technical Institute for the Deaf for the past four years teaching theater, deaf studies, literature, and social studies courses. He currently serves as the Program Director for the NTID Department of Performing Arts and also serves as the Development Officer for Performing Arts with the NTID Office of External Affairs.

8
PATRICIA A. DURR, *META*

IMAGE 8.1
Source: Photo courtesy of Patricia A. Durr.

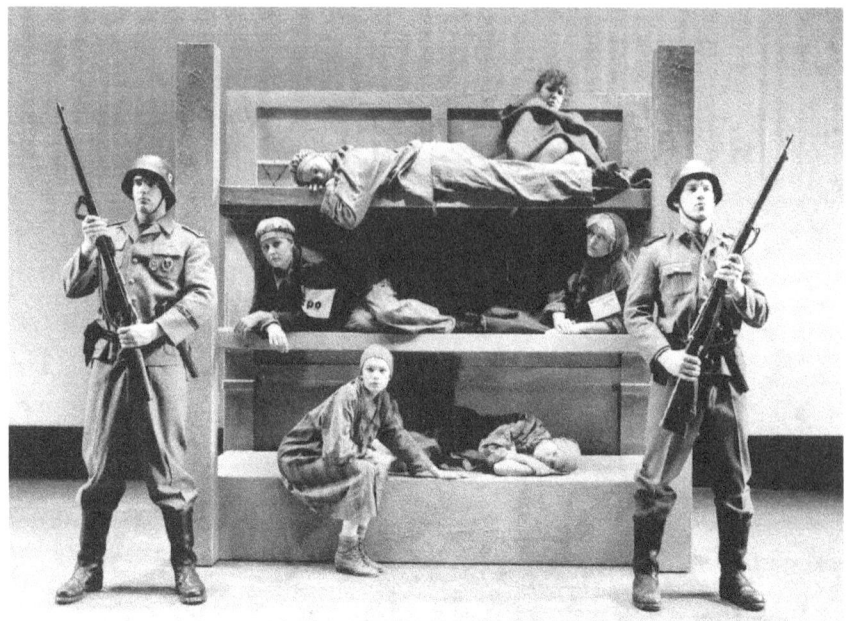

IMAGE 8.2 Scene from concentration camp barracks in *META*, directed by Dennis Webster. Actors: Paul May, Matt Daigle (SS guards, left to right); Cindy Millard, Sophie Bleiweiss, Annie M. Yeager, Michele Bontrager, Lisa Holbrook, Teresa N. Thiry (clockwise, from sitting position on the bunk).
Source: Meta, 1993, Lights On! Deaf Theatre records, RITDSA-002, RIT Archives, Rochester Institute of Technology.

Synopsis

Set in the late 1980s, we follow Kemba, a Black Deaf college student, as she unexpectedly develops a friendship with a Jewish Deaf Holocaust survivor named Meta. Initially, Kemba is not keen on having to interview Meta for a history class. Over time, she begins to see parallels between her own life and the horrors of anti-Semitism and bigotry. In the process of retelling her story, Meta finds peace. At the same time, as Kemba records and shares Meta's story, she learns acceptance – discovering how we are all interconnected and have a responsibility to love and protect one another.

Production History

META, originally directed by Dennis C. Webster, was co-produced by LIGHTS ON! Deaf Theatre and the National Technical Institute for the Deaf (NTID) Performing Arts Department on April 15–18, 1993 at RIT's Panara Theatre. The scene design was by Jenny Geller, Daniel A. Lunt, and Tracey Salaway; "Meta's

Flashback" settings were designed by Dennis C. Webster; lighting design by Dennis C. Webster; costume design by Michele McLean and Alice J. Parker. The cast was as follows:

 Old Meta – Della Gorelick
 Young Meta – Michele Bontrager
 Kemba – Tracey Washington
 Marc – Roger Vass Jr.
 Janna – Tara Petrites
 Neighbor, Deportee – Colleen Geier
 Mother, Kapo – Erika Koza
 Brother, Prisoner – Andrew Rubin
 Sister, Prisoner – Michelle Johnston
 Friend – Annie M. Yeager
 SS Doctor – Peter W. Wollenhaupt
 Soldier – Paul May
 Solier, Young SS – Matthew W. Daigle
 Female SS – Cynthia C. Barrett
 Female Kapo – Lisa Holbrook
 Baby – Jessica L. Miller
 Female Prisoners – Sophie Bleiweiss
 Patricia Mace
 Cindy Millard
 Gina I. Switalski
 Teresa N. Thiry
 Anna Wania
 Kathleen Wania
 Christine Wania
 Mel Westlake
 Male Prisoners – Robert Cagle
 Frank Kimmes
 Donald R. MacDonald

Voicing Actors for the April 15, 17, and 18 performances:
Meta – P. Gibson Ralph
Kemba – Keayva Edwards
Janna – Susan R. Quinlan
Marc – Matthew Knapp

Thoughts about the Play

This is perhaps the first play produced in the Deaf community that deals with the disturbing issues of eugenics and genocide; more specifically, it addresses the holocaust of Deaf people in Nazi Germany. The play in which a Black Deaf college student befriends a Jewish Deaf survivor also briefly deals with the cochlear

implantation controversy – as some consider it a modern-day cultural and linguistic genocide. Unique to this production is its style; Deaf experiences are revealed through shadow play depicting the survivor's experiences in concentration camps as silent, sign-less flashbacks. In addition, to illustrate how Meta received information, all characters (except for Meta) are shown just moving their mouths and not speaking vocally.

Patricia Durr based the play on her experiences bringing Holocaust survivors to speak in her classes as well as interactions she had with her students at the Lexington School for the Deaf in Queens, NY and at NTID, a college of Rochester Institute of Technology. In particular, she was deeply moved by Meta Noveck, a Jewish Deaf survivor of four concentration camps. While the script was inspired by Meta's perseverance and hardihood, it is a composite of several survivors' stories.[1]

Durr intentionally included an anti-Semitic joke to illustrate the anti-Semitism that exists in the Deaf world. She sought input from Black and Jewish Deaf people in the development of the script; and again before publication. Written and produced more than 25 years ago, Durr remarked that the play attempted to explore intersectionality and simultaneity but admittedly is constructed from a White lens as she is a White, non-Jewish, partially Deaf, cisgender woman.[2]

Deaf Gain

The play contributes to the contemporary framework of Deaf Gain via its subject matter, production style, and comprehensive involvement of Deaf artists in all aspects of the production. The direction, set design, flashback shadow play, lighting design, poster design, and projected Holocaust artwork were done by Deaf creatives. Although numerous Holocaust dramas and films are written and directed through a hearing male lens, *META* introduces to the world the first Deaf-created dramatization from the perspective of a Deaf woman's Holocaust experience.[3]

Note

1 Brando, Carlos. "META: A Celebration of Spirit." *Reporter*, 4 September, 1993, 19.
2 Durr, Patricia A. *Meta Introduction*. Rochester, NY: 2020. Email.
3 Ibid.

8
META

Patricia A. Durr

> Injustice anywhere is a threat to justice everywhere.
>
> – Martin Luther King, Jr.

> Several years ago, I met a Deaf German Jewish woman who had survived several concentration camps. Her experiences inspired me to write this play. This is not a biographical piece but rather a collection of the many images I have heard, seen, or read about. Knowledge of these atrocities is invaluable especially in light of the growing xenophobia and anti-foreigner activities by Neo-Nazis in Germany and the genocide in Yugoslavia, Iraq, and Sudan during the time this play was set. The name of the play is in honor of the woman who inspired it so we may all bear witness.
>
> – Patricia A. Durr

Special thanks to:
 Fred Beam
 Shannon Bradford
 Diane Brooks
 Dr. Simon Carmel
 Dr. Karen Christie
 Dr. James Graves
 Patrick Graybill
 Stephen Jacobs
 Zoe Durr Jacobs
 Adrian Noveck
 Dennis Webster

DOI: 10.4324/9781003112563-17

Characters

META, *Jewish German Deaf woman, Holocaust survivor, 70s, mouths some German words while signing nervously in American Sign Language. She has arthritis and wears a housecoat and slippers.*

YOUNG META, *Deaf, late 20s, she occasionally uses German signs but mostly mouths German and uses mime and gestures. She has long auburn hair. In later scenes, she will be shaved bald or with a head covering.*

KEMBA, *an African-American Deaf, middle class, Northeastern, female college student (early-mid-20s), uses American Sign Language. She is dressed casually, in jeans and a nice shirt. She carries a knapsack with a "silence = death" pin.*

JANNA, *Kemba's roommate, middle class, West coast, Deaf White female college student, 18–25.*

MARC, *Kemba's roommate, middle class, Midwest, Deaf White male college student, 18–25.*

Note: All other characters are hearing but do not speak verbally. They just move their mouths to illustrate what Meta receives as information. Voicing can be provided for hearing audience members who do not understand American Sign Language when Meta and Kemba are conversing. To portray Meta's experience, there is no voicing during the reenactments.

META'S MOTHER, *50–60 years old, Hearing. She gestures and uses German mouth movement.*

META'S BROTHER, *mid-20s, Hearing. He gestures and uses German mouth movement.*

META'S SISTER, *late teens–early 20s, Hearing. She gestures and uses German mouth movement.*

META'S FRIEND, *late 20s, Hearing Jewish Woman.*

Actors can play multiple roles:
 Deaf man #1
 Deaf man #2
 Male Prisoner
 Soldier
 Male SS Doctor
 Female SS #1
 Female SS #2
 Expectant Mother
 Woman with baby
 Grandmother
 Female prisoner #1
 Female prisoner #2
 Female Prisoner #3
 Neighbor *(elderly Hearing woman in U.S.)*

Extras:
 Deaf people, blind people, elderly, crippled
 Five Extras: Female *(To play various roles including Kapo)*
 Two Extras: Male *(To play various roles including Kapo)*

Notes

SS and Gestapo are used here to mean any Nazi working for the German government.

Four stage areas – stage left (Kemba's apartment), stage right (Meta's apartment), center stage (hospital room), in front of the scrim and behind the scrim (Meta's reenactments). Sets should be minimal with a versatile unit for the flashback scenes that can serve as barracks, bunk beds, tower, crematorium, and train.

Scene 1

Stage left couch with coffee table. Janna is sitting on the couch watching TV. Enters her roommate, Kemba.

KEMBA: Do ya mind if I watch a videotape?

Looks at watch.

KEMBA: I want to start it before Marc shows up and wants to watch Wheel of Fortune.
JANNA: He's in love with Vanna White.

Mimes.

JANNA: Anyway, you can watch the tape any time. It's not Marc's TV.
KEMBA: I know but I just want some peace. He's always looking for a fight with me. No offense but I prefer a Black roommate like John. He was a great roommate, cool. But then he moved and now we are stuck with Marc.
JANNA: He's fine, just a little immature.
KEMBA: Little???

Starts to take out videotape.

JANNA: What's the movie?
KEMBA: It's not a movie – it's for my history class.
JANNA: What's the tape about?
KEMBA: H-o-l-

Looks at the tape for the correct spelling.

KEMBA: o-c-a-u-s-t. You know during World War II when Hitler killed all the Jews.
JANNA: Why do you have to watch it?
KEMBA: I have to research this and then interview a person who survived. The teacher says I must read a lot and watch videotapes first. She's afraid I'll go in there and ask really stupid questions. I told her I wanted to research Malcolm X and she said "no" right in my face. I call that discrimination.
JANNA: Malcolm X – why him?
KEMBA: You know Malcolm X – come on man. You know with all the shirts and hats.
JANNA: Yeah, but what's the X for? What's it mean?
KEMBA: "X" is NOW. "X" is…

Can't explain.

KEMBA: "X" – oh it's a Black thing. "X" is for pride. Proud to be Black. It's for our people – Black people. "X" is because Black people are pissed off. Whites pushing us around, controlling us for money all the way from slavery times to now. Right, right. I remember. Since enslaved people were often given their master's last name, Malcolm rejected that and used X. Understand?
JANNA: (Nods)

Marc runs past the TV room and then runs backward.

MARC: Kemba (Use sign name), your mommy's on the phone.
KEMBA: I'm not here!
MARC: No way. I already told her you're here.
KEMBA: (Stares at Marc)
JANNA: She already told you – she isn't here!
MARC: (Takes off imaginary glasses – wipes them – looks in the room again, flashes light switch or just waves to get Janna and Kemba's attention as they are chatting on the couch. Sign name for Janna.) I'm looking for Kemba – I can't find her. If you see her, tell her to call her stupid mother so I don't have to play this phone tag – OK?
KEMBA: (Gives him an OK – "F" handshape with a wink then adds an index finger to sign asshole.)
JANNA: He is a big jerk, but you owe him. We can't keep telling your mom you're not here. You're gonna have to talk to her soon.
KEMBA: I know, I know.
JANNA: Before you were talking about Black people being slaves, well Jews were slaves long, long ago and in WWII.
KEMBA: What are you, Jewish?

JANNA: No. I watched the movie with Moses – you know the Jews had to make the Pyramids.
KEMBA: Slaves! Jews! No way. Jews are supposed to be rich.
JANNA: And Black people have good rhythm.
KEMBA: Move over. Let me see that, man! Jews slaves. Hmm…well, we'll see what the video shows but later I'm gonna check out Malcolm X.

Scene 2

Lights shine down on stage right, which has a slightly elevated platform with a big armchair and a small wooden chair. Meta is seated in the armchair. Wheel of Fortune is on TV.

META: (Walks around tidying up. Sits down, straightens out her dress, and fusses. Picks up clock on table to see it better. Looks at strobe light. Starts to get involved with the TV.)
 Meta is participating in trying to figure out the missing letters on the Wheel of Fortune.
META: THEW RST F ohhhh 0 O. Come on.

Shaking her head, drops pencil. Gets on knees to find pencil – freezes. Lights dim stage right and come up on center stage.

YOUNG META: (Kneels in the same position as Meta. Plays with an ant. Shadow of soldier appears. She responds by running to catch bread. Eats it hurriedly but savoring each bite. Climbs on cot, stands on tippy toes to peer out of window. Lights fade.)
META: (Doorbell light stage right flashes on and off. Lights go up to find Meta startled from the position of staring out the window in same position of young Meta. She shakes herself out of the memory. Straightens up her clothes and hair and goes to answer the door. She looks through the peephole, looks around surprised – slight smile. Opens the door a crack because of chain lock.)
META: (Fingerspells) K E M B A.

Closes door, unhooks lock, and opens door.

KEMBA: Hello, I'm Kemba. Thanks for seeing me. I gotta do this history project Friday so.

Brings in video camera and tripod, bumps into many things. Busily sets up camera.

META: Coat?
KEMBA: Yeah, thanks.
META: (Takes coat and hangs it up. Points to where Kemba should sit.)

KEMBA: Nice apartment.

META: Thank you.

KEMBA: Thank you for agreeing to see me. I know it is hard to talk about this. I saw the videotape about Hitler and the... Killings... really gross.

META: That is why when you called and asked, I said, "Yes, I will tell you about my experiences in the camps." But it is hard. I watch the news and see so much badness. Always against other races. Fire in LA and I see camps again in Europe – Yugoslavia. That gives me strong, strong memories.

KEMBA: You know about LA and all that stuff?

META: Yes, I watch TV.

KEMBA: Cool. Honestly, I wanted to research about Malcolm X so I could understand my people better. Ya know, imagine – I'm Deaf Black and a woman – wow! So, I don't really know much about this topic but for history class, ya know we have to study this stuff.

META: Yes, I remember when I moved to the U.S. and in the 1960s, I saw on TV all the problems in the South – I was very surprised. Here in America the Black and Jewish people are same.

KEMBA: What do you mean?

META: I see the police and dogs attack people in the streets, and I saw the people in white robes with hoods. The burning crosses. The hangings. I couldn't understand why and then a friend explained about all the slaves in the South before working on farms and so the White people there have very strong feelings of hate. Ghettos, forced to leave town, persecution and oppression – this Jewish and Black people have shared. That is why so many Jews worked with Black people to fight for equality.

KEMBA: Jewish people worked with Black people?

META: Yes, with the one group – oh, I forget the name.

Tries to fingerspell but can't recall the name.

META: Many many Jewish lawyers and teachers and Rabbis work together. But now the problem is much worse like in Brooklyn, no?

KEMBA: Hmmm. I didn't know all that stuff. Well, in Brooklyn it was just the Hassidics and Black people. But you see what I mean. Why I'm really interested in Black history.

META: Yes, that is very good you should know all.

KEMBA: Well, I guess your time was bad too. It must have been terrible.

META: My time with Hitler. You can never understand – I pray you will never really know. Never again.

KEMBA: Will the camera bother you?

Without waiting for the answer finishes setting it up.

META: You don't have to make it so high.

Kemba looks at the tripod and at Meta.

META: Do you need help?
KEMBA: No, no. You just sit down. I'll be ready in a minute. Ok, I think we all set. Why don't you start from the beginning? I mean why don't you start with explaining about what Germany was like when Hitler took over.
META: Light?
KEMBA: Light? From the camera?
META: Red light? Should have red light mean on?
KEMBA: Yeah.

Looks over the camera. Can't find it – starts to show frustration.

KEMBA: Ok go ahead.
META: (Deep breath, looking and reading from two sheets of paper, she signs) In 1941, I was deported from my small hometown with Jews to a bigger town. We were then marched by the SS commandant to the train. The SS were very rough. They put us all into cattle cars and we traveled many days to Poland. We saw many Jews from all over Germany and Austria. We were tired and cold and cried. Some people got sick and the SS separated them into another line. We don't know what happened to them.

We were hungry and became thin and weak. Two month later, January 1942, SS called all the children, handicapped, sick and old to go another place. But me, I was still in the same place. The SS did not know I am deaf. My heart was beating fast...

Scene 3

Kemba's apartment TV room with papers and some books scattered on table. Janna is watching TV. Marc enters stealing a remote control from her and chasing her around the room climbing on furniture along the way. They both run out the door. Kemba enters carrying a glass and shaking her head at her roommates.

JANNA: Whatcha doing?
KEMBA: Working on my paper. I met the Jewish lady today – old!
JANNA: Yeah, hard to understand?
KEMBA: Y-E-S, sometimes she seems to mouth German words and some signs are not clear.
JANNA: Did she grow up oral in Germany?
KEMBA: Yes. I tried to ask her some questions, but she just read me her story from when she was captured and freed.

JANNA: Read?
KEMBA: Yeah.

Imitating Meta – "in 1941 I was captured…." Explains how Meta had the paper in her lap and retold the paper.

KEMBA: Yes, and it's weird. See the last sentence: "Thank God. I am alive…." She wrote G - D. Looks like she is afraid to type the whole word.
JANNA: Oh, yeah. I heard different religions won't print their God's name out of respect.

Enters Marc.

MARC: What's up?
KEMBA: Ignores him.
JANNA: Talking about Kemba's research project. She is interviewing an old deaf Jewish lady about WW II.
MARC: Ah, I heard a great joke – wanna see it?
JANNA: NO.
KEMBA: NO!
MARC: OK, a woman is pregnant…

Actor should exaggerate the story.

MARC: After hours and hours of pushing, the baby won't come out. So, the doctor finally says, "You're Jewish right?" And the pregnant woman pants "yes," so the doctor takes out a $10 bill and holds it under her vagina—
KEMBA: STOP – time out. That's not cool.
JANNA: (To Marc) You're such a fool!
MARC: (While Kemba and Janna are objecting) Take it easy, let me finish. It's really funny!
KEMBA: Funny, got any good "Black" jokes?
MARC: S-U-R-E.

Teasingly and starts to re-tell a joke when he sees that Kemba is really angry.

JANNA: (To Marc, mouths and signs small why signaling towards Kemba. Light flashes.)
MARC: It's for you (pointing at Kemba) and runs out of the room.
KEMBA: (Looks at Janna and shakes her head no, and then starts reading from her book.)
JANNA: Ignore him. If it's your mom…
KEMBA: Tell her what? Her daughter is still DEAF!

Scene 4

Center stage lights go up to show two guards with guns on watch as four prisoners slowly pass by. One falls down and the guards start to beat on him as the others carry him away. The guards taunt and then light cigarettes as the lights dim.

Lights go up on Meta's apartment. Kemba is seated with camera already set up and directed at herself.

KEMBA: (Looking at her notes) OK you said you were captured in 1941. What was your life like before that? Did you go to a deaf school?

Jumps up, startling Meta and turns camera to point at Meta.

META: My school was the Hebrew School for the Deaf Mutes in Berlin. It was oral. I graduated and was working. After the war, I found out the SS stormed the school and took all the children to Auschwitz. All 146 children were killed.

KEMBA: (Again, moves the camera) They were killed because they were deaf right?

META: (Waits for her to move the camera back) No. Because they were Jewish. German deaf children, non-Jews, they were not taken. They were just sterilized.

KEMBA: What? What for?

META: Hitler wanted a perfect race. No one should be diseased or ill. He had a special place to kill the retarded and the mentally ill. For the deaf Germans, he just cut them to make sure they never had any more deaf children. He also had a special institute with perfect German girls, and they were had by the best SS and when they gave birth, they had to give their baby to the state for the Nazis to raise. The Nazis had many plans. Sometimes the doctors would sterilize the deaf boys and girls – little, without any anesthesia. Sometimes they would experiment on the deaf to try and find out how to cure them. They poured hot oil down their ears, stuck instruments inside, cut them.

KEMBA: Wow, sounds like cochlear implants. You know…

Gives an exaggerated explanation of cochlear implants and how they work. She is obviously against them.

KEMBA: That is how hearing people are trying to make deaf people into a perfect race. Germany's worse – sterilization – children! Killing the Jewish kids. Didn't the parents and teachers protest?

META: I found out one headmistress at our school (M - sign name) escaped with 12 Jews away in 1938 or 39 but most of the teachers and parents felt to be deaf was bad and agreed with the Nazis about disabled and the Jews.

KEMBA: Did they experiment or sterilize you?
META: No, no! They would kill deaf, Jews right away. They did not know I was deaf. I had to hide it. Many of my friends – non-Jews. Deaf. They have no children. There is no strong deaf family in Germany.
KEMBA: Did you ever have any children?
META: After the war, I moved to the U.S. and met my husband. He is also a deaf Jew – from Russia, but he moved when he was a boy before the war. We have two sons… They are hearing. I'm chilly. Do you want tea?
KEMBA: (Looking impatient) Yeah, sure.
META: (Goes to turn on stove and gets out the teacups.)
KEMBA: (Turns off video camera. Notices Jewish star on table. Meta has returned. Kemba gives Meta a draft of her paper.) Here is some of the information I have written out for my paper. I'll get the tea while you read it.

Kemba returns with two teacups and bends over near Meta to set down the cup.

KEMBA: What is it? Is it the wrong cup? Is this your good china – I'm sorry, I'm sorry.
META: It's nothing. It's just the smell – your hair, the burning.
KEMBA: What? My hair.

Grabs and smells it.

KEMBA: I reached down for a tea bag I dropped – oh, I must have burnt a little of my hair on the stove I guess.
META: Reminds me of the smell of the dead – of the burning. And babies too. Babies. Fire. Once I was working and everyone stopped. I looked and saw a big fire and the SS were throwing in babies – alive. They were screaming. The smell.

Points to Kemba's hair and shudders.

KEMBA: (Kemba reaches out to hold Meta's hand.)

Meta looks out window and Kemba eyes the camera and realizes it is off – Kemba expresses her disappointment to herself.

META: The snow is very pretty, yes?
KEMBA: (Nods her head as she sips her tea. Stares at Meta in awe.)

Light fades stage right and comes up on center stage where we see Young Meta digging an invisible trench in the snow. There are a few people working around her. Friend is directly across from her digging.

SS: (Enters stage left and starts to order some prisoners around. Seeing Meta, he shouts to her.)

YOUNG META: (Keeps working away.)
SS: (Shouts again and starts walking towards her in the snow.)
FRIEND: (Motions to Meta to turn around and face the SS guard.)
YOUNG META: (Responds and turns around.)
SS: (Gives her instructions and walks away.)
YOUNG META: (Stands shaking a little and looks back at Friend.
FRIEND: (Mouths instructions to Meta.)

Scene 5

Kemba is working on a map in the TV room of her apartment. Janna is watching TV.

JANNA: (Waves) You're working too hard. Makes me feel guilty. Knock it off! (Laughingly)
KEMBA: (Laughs) Strange – I'm trying to plot out all the different labor camps Meta was in and when, and it's really confusing. The Germans kept shifting her from one place to another.
JANNA: Maybe she was lucky. If she stayed in one place for a long time, they'd find out she was deaf. Hey, let me watch the tapes. I got goose bumps from the one about sterilization. Horrible – not a bad idea for people like Marc but…
KEMBA: Hmm. I don't have any more tapes. I stopped taping her.
JANNA: Why??
KEMBA: It just happened by accident. I don't feel right using all this fancy high-tech equipment. It's really awkward dragging around on the subway and all the people stare at me like it's "hot" or something. No way a Black person could have a camcorder in NYC if…
JANNA: You're paranoid. Anyway, she is old, right? We need the tapes to remember her story.
KEMBA: I'll remember her. I'm keeping careful notes and writing it out after each time we meet.
JANNA: Not everyone will want to read it – rather to see it.
KEMBA: It's the videotape. It makes me feel like… how can I make you understand? When I was little, I used to have to go to the audiologist a lot. My hearing was really strange. It would fluctuate from DEAF to hard of hearing. I remember EVERY time my mother would take me out of school to go downtown. And I always missed the best activities – coloring or birthday parties. And then they would put me in the room. You know – with all the dots on the wall and the big cold headsets and a crowd – I mean a crowd of white people stood outside observing me through the window. At first, I just sat there and they had to make it louder and louder and louder until I heard a sound. But right away all those people in their white coats their faces got whiter and whiter and they would start looking really concerned and whacked out, so I'd immediately raised my hand to make them happy. Always being afraid that they had turned off the machine and I'd get caught. I feel like the camcorder is the same for her. I don't want to do that to her.

JANNA: But if she doesn't mind it…
KEMBA: When I don't have the camera on, it's more comfortable. We can just chat. It's not like an interview or a test.
JANNA: What did she talk about then – since I can't watch it? You'll have to tell me.
KEMBA: Oh, I was asking about her family and she explained that her father died before the war and her mother was really sick. She had older brothers and sisters – they were married with kids. All the members of her family were hearing. She said that many people did not know what was happening to the Jews in the beginning. They really thought they were just being relocated. Also, it was very hard for Jewish people to escape. Her brothers and sisters all got papers. They got her papers too, but her mom was really sick, and she refused to go. (Pause) Then she said something strange.

Looking at her notes.

KEMBA: "Understand a daughter comes from her mother. This bond cannot be broken. We are the same. It was not hard to decide to stay. She gave me life – I must do the same…." Then she started to explain.

Scene 6

Lights fade on stage left and center stage is illuminated showing three chairs and a wooden table. An oil lamp is lit on the table. Meta's mother is laying down. Young Meta is trying to understand everyone in this dimly lit room. Note: all is done with gestures and mouth movement – no voicing.

BROTHER: We must go to America now. Hitler will kill us.
YOUNG META: (Points to mother.)
SISTER: Papa is gone. Mother is too sick to travel. You're deaf-mute. If they catch you, they will kill you.
BROTHER: Or maybe they will rape you, or experiment on you first.
YOUNG META: No.

Points to mother and gestures "stay together."

BROTHER: Meta, Meta, we must go. They will kill us.
YOUNG META: Why? Why? I don't understand!
BROTHER: (Points at Star of David on Meta's dress) JUDE + DEAF.

Mimes deaf then slitting throats. Gives her the papers.

BROTHER: Come with us?
YOUNG META: (Looks at brother, sister, mother. Puts arm around mother.)
BROTHER: (Blows out the oil lamp.)

Scene 7

Lights up on stage right. Light flashes. Meta walks to answer door slowly. Kemba enters and hugs Meta. She offers her a loaf of bread. Meta looks out into the hall half expecting Kemba to have the video camera.

KEMBA: How are you feeling today?
META: Old, old (with a little giggle). You?
KEMBA: Young, young.
META: You are in time to help me light the first Hanukkah lights.
KEMBA: I am sorry I didn't bring anything… Umm..am I supposed to bring any presents?
META: (Holds up the bread.) The bread is my present. Bread is my life.
KEMBA: I'm not Jewish.
META: But you can share the experience. Because you're Black – because of your history you understand. Hanukkah is the Festival of Lights. Long ago the Jews were conquered and had no temple to worship but they fought back and won. When they entered the temple there was only a little bit of oil – tiny but they decided to light it and it lasted for 8 days. That is why we have the Festival of Lights to thank G-d for his miracle.
KEMBA: Oil being lit for eight days is the big miracle!
META: The Jews are a simple people. We got back our temple and could celebrate our religion again and we were free. If we wanted many big signs of his love, we would not have survived the camps. Small things can be the biggest things.
KEMBA: (Nods her understanding and picks up a picture on table.) Are these your sons? Do they live in NYC?
META: Yes. Now they are all grown up. One is married and has two sweet boys. The other, not yet. I wish he could find a nice girl like you.
KEMBA: But I'm not Jewish.
META: You can convert like that little man, the dancer.

Imitates tap dancing.

KEMBA: Who? Oh, Sammy Davis Junior. Well, with all you're teaching me, maybe I'll convert to be Jewish. Who knows?
META: (Smiles) Now, you ask me about my family. What about yours, hmm? Do you see your family much?
KEMBA: Oh, no not much.
META: Not even your Mamma?
KEMBA: No. No.
META: Problem?
KEMBA: Yeah, she doesn't accept I'm Deaf. She wants me to get a cochlear implant. Remember that machine I told you about before that they cut your skull and put in your head – that!

META: And you are fighting this.

KEMBA: Yes.

META: Good for you. But you can still see her. You can always fight the bad but still love. She is always your mother.

KEMBA: Maybe. Anyway. You were telling about your decision to stay with your mother. Your brothers and sisters escaped to America and you stayed behind with your mother – remained in Germany?

META: One brother – he did not make it.

KEMBA: How come? I thought you all had papers.

META: Yes, but he had the city of Jerusalem on his face – he looked very strong like a Jew. So, he waited till all his family get through then he tried. He could not hide he is a Jew. All the SS need to do to the men is tell them to drop their pants and then they are gone. His wife saw from the boat. And he was taken away. No one ever saw him again.

KEMBA: Pull down their pants – why?

META: Jewish men are circumcised so they would look and see who was a Jew and who was a non-Jew. Simple.

KEMBA: What happened to you?

META: My mother and I tried to live quietly so no one would notice us. I wore the Star of David as ordered and obeyed curfew but soon all Jews in my town were forced together at the synagogue. There was a queue of us. We were to be deported. Everyone looked frightened. By then we heard rumors of the death camps. I tried not to look at our neighbors because some feared me.

KEMBA: Feared you, why?

META: They knew I was deaf. If I approached them and later a guard found out I was deaf, he would punish them for not reporting me. Many mentally slow, elderly, blind, etc., already disappeared so they knew.

KEMBA: Oh, I see. Then what?

META: We were moved to many different places, but one was the worst. Long, long train ride – you know, box for animals? It was horrible. Pitch black so I could not communicate at all. I felt for my mother's face. It was wet with tears. Crying. I talked to her "where are we going?" Remember I was oral. And she writes out the letters in my hand.

Takes Kemba's hand.

META: POLAND.

KEMBA: Poland?

META: Yes. We were very scared. So many. Dirt, Death, and Darkness. Hell there. For my mother – it was worse.

KEMBA: Why? Because she was sick?

META: No, because she was hearing. She could hear the moaning, crying, vomiting, fighting, dying, insanity.... She press her ears so hard. I was lucky to be deaf. For me there was only the darkness, smell, and heat. Sometimes a person would fall and cling to my leg trying to pull themselves up to not

get crushed. Many days on the train. Can't keep track because always dark. Don't know if it is night or day. Felt like one week in transport. Sometimes train stop and SS open door throw bread. All the people go wild. Fight and claw. The SS would stand, watch and laugh. Such animals. Once I saw a young man from my town. His father caught the bread and the boy beat his father and stole his bread. Such horror to see this – his own father. One person very nice gave bread to me. I gave it to my mother. She is so sick. Before they gave us bread, we must work first. We must turn out the dead bodies. This give us more room, but the smell is all the urine and waste and death.

KEMBA: (In trance almost – then shakes it off.) Where did you arrive?

META: To Poland. When the doors opened, I thought I would be blind. It was so piercing bright and I could feel a breeze. But soon I could see, and I wished I was blind.

KEMBA: What? Why?

META: Right in front of me the chimney stacks. So many, with the souls/smoke going up into the air. The smell! I didn't know what it was yet, but I was frozen with fear.

Scene 8

Stage right dims as center stage becomes illuminated to show two wooden doors opening with people being pushed and pulled out. "146" is written on the door in chalk. Guards and Kapos pass by mouthing orders and mocking some of the passengers. A group of deaf, blind, and elderly people are stage left. A table with an SS doctor is center stage with his back to the audience. Several prisoners pass by in striped uniforms.

YOUNG META: (Rubs eyes and stares ahead with fear. She is pushed out and falls. She quickly gets up to find her mother.)

META'S MOTHER: (Thrown from the car, but almost smiling to be away from the sound of the cattle car.)

YOUNG META: (Catches Mother, looks around, sees deaf people stage left and looks excited. She starts to make a step towards them forgetting the danger of being disabled.)

DEAF MAN #1 AND 2: (A deaf person in the group points at the smokestacks and another deaf person signs fire.)

MALE PRISONER: (Sees Young Meta, nods towards the group and then nods at the smokestack chimney as he passes by indicating that the group will be killed and to stay away.)

YOUNG META: (Freezes in her tracks, realizing all of these people will soon be sent to their deaths.)

SOLDIER: (Forces new arrivals to form a line, separating women and men.)

DEAF MAN #1: (Realizing the danger, starts moving away. A Kapo with a Brown Triangle badge sees him and starts mocking him and pushing him back with the handicapped group).

YOUNG META: (Stares on with disgust.)
META'S MOTHER: (Looks frightened for Meta after making the connection.)

Kapos and Guards take the handicapped group away to their death, off left. New women arrivals are inspected by the SS doctor, who points left and right.

WOMAN WITH BABY: (Watches and sees that left is for death. A prisoner whispers to her.)

She hands her baby to her mother knowing any woman with a child will be killed and her mother will be killed anyway since she is old.

GRANDMOTHER: (Takes baby.)

Line moves up with the young women going right; old, sick, or with children going left.

WOMAN WITH BABY: (Goes right.)
GRANDMOTHER: (Goes left.)
META'S MOTHER: (7th from the front.)
YOUNG META: (8th from the front. She watches as people pass right and left. She realizes right is for the young and healthy. Left is for the old, sick, and children.)
FRIEND: (9th in line.)
PRISONER #1: (Passes by the line and mouths something.)
YOUNG META: (Looks back after him to understand. She taps her mother and shows on her face she does not understand what the man said.)
SOLDIER: (Tears open the coat. Buttons fly and he laughs.)
MOTHER: (Touches Young Meta on the shoulder to calm her down, and moves behind Meta.)
YOUNG META: (Stands in front of SS doctor and tries to lipread his command.)
SS DOCTOR: (Points to Soldier to hold open Meta's coat.)
SOLDIER: (Holds open coat and leers at her.)
YOUNG META: (Stands humiliated and terrified.)
SS DOCTOR: (Points to his left.)
YOUNG META: (Goes stage right clutching her coat around her, holding back tears and shows relief. Looks back to see Mother.)
SS DOCTOR: (Points to his right.)
META'S MOTHER: (Goes stage left, head held high, never looks back at Meta.)
YOUNG META: (Starts to turn to run for Mother.)
PRISONER #1 AND FRIEND: (Grabs her and brings her off stage right.)
META: (In frozen pose like Young Meta.)
KEMBA: (Rubs arm – goose bumps.) Did you see her again?
META: (Looks numb) She went left!

Pause – really talking to herself.

META: Nowhere to put the stone – nowhere.

KEMBA: Stone?

META: Jewish people visit grave – put stone there so the dead know they came. They are not forgotten. Where to put the stone for Mama – where? The guilt. The woman who gave her baby to the grandmother, later she hung herself. Many survivors after they are freed kill themselves – the guilt is too great.

KEMBA: (Long pause, shifts in seat) What happened after the selection (gestures right, left)?

META: We were stripped of our clothes and searched everywhere. I was so ashamed and scared. I became truly numb. No thoughts, nothing – like an animal. Gave us the zebra clothes – it didn't matter what size – no underwear and no bras. Later we don't need bras because our breasts shriveled up to nothing. Then they shaved our heads because of the lice – we were treated like dogs – and if we escaped then the villagers would recognize we were prisoners. Also, use hair for mattress and sell. I had long auburn hair. Beautiful. Every night my mother brushed it. Stroke after stroke. When I was in line to have my head shaved, I remembered my mother walking left. She was proud, no weeping. I cannot cry for my hair. I told myself pretend orthodox and it is the day after my wedding. I watched my auburn hair fall to the floor with a smile.

KEMBA: Wedding?

META: Orthodox Jewish women shave head after marriage – not attractive to other men.

KEMBA: Oh, then did you get a number tattooed on your arm?

META: Yes, for three years that became my name and the appellee – that was my panic 3 or 4 times each day, morning, midnight, hot freezing, didn't matter. I slept on the bottom bunk with my hands pressed to the floor wood to feel the vibrations if the guard came in to announce roll call. I had to fight horrible for bottom bunk but some there knew I am deaf so they give me the bottom bunk.

KEMBA: (Looks at the note she scribbled on her pad.) Appell/Roll Call panic?

META: I am deaf and they never called the numbers in order because people changed every day: some died, were sick, taken. Always I panicked. What if they catch me? I will disappear…

Scene 9

Lights fade stage right, lights up on center stage. Line of women in prisoner uniforms with hats are standing in the cold. Lighting is dim to show early a.m. hours. Women move feet to keep warm, all stare straight ahead. Stage left SS female guard holds paper with numbers. Other male guards pass by.

FEMALE SS #1: (Mouths number/name as if shouting.)

FEMALE PRISONER #1: (Steps forward, holds, then steps back.)

FEMALE SS #1: (Mouths number/name as if shouting.)
FEMALE PRISONER #3: (Steps forward, holds, then steps back.)

Young Meta has been trying to lipread the SS guard but finds it impossible. Prisoners step forward.

YOUNG META: (Taps prisoner on her left, shows her number, imitates SS shouting number, then indicates prisoner should nudge her.)
FEMALE PRISONER #2: (Looks confused.)
YOUNG META: (Puts hand over her ear to show she is deaf then points at her number again, the whole time looking forward.)
FEMALE PRISONER #2: (Stares ahead with a very stern face of disgust.)
YOUNG META: (Taps prisoner #3 on her right, shows her number, imitates SS shouting number; then indicates prisoner should nudge her; her face shows panic.)
FEMALE PRISONER #3: (Looks around, afraid of being caught, and finally nods.)
FEMALE SS #1: (Still calling numbers with prisoners stepping forward; when a number is called and no one steps forward, guard circles the name.)
FEMALE SS #1: (Calls Prisoner #3's number) Prisoner #3.
FEMALE PRISONER #3: (Steps forward.)
YOUNG META: (Almost stepped forward thinking it was her signal.)
FEMALE SS #1: (Calls Young Meta's number.)
PRISONER #3: (Gently nudges Meta.)
YOUNG META: (Steps forward, stares ahead; the spotlight shines on her shaking like a leaf.)

Scene 10

Center stage goes dark, stage right lights up.

META: Always panic, every single time, never know. Person next to me might decide to report me to get more food. Maybe other person afraid to help me because she might get caught. Another person might think deaf people are a disease and should die. Always panic… Lucky, I had a friend. I must never be noticed. Must be very, very small.
KEMBA: You never got caught?
META: I'm still alive, no?

Stage right light fades; center stage spotlight on Young Meta, shaking. Behind her are prisoners with lighter clothing, different order and different female SS reading the numbers. Lighting is bright to show hot summer afternoon.

YOUNG META: (Steps back into line looking relieved.)
FEMALE SS #2: (Calls number.)

FEMALE PRISONER #1: (Steps forward.)
FRIEND: (Nudges Young Meta.)
YOUNG META: (Steps forward into light shaking lightly with frightened face as light fades.)

Center stage goes dark, stage right lights up.

Scene 11

Stage right shows Meta sleeping in her chair with dim light next to her. Stage left is Kemba's apartment. Kemba is lying on the couch poring over a book on the Holocaust. She drifts into sleep. Lights up on center stage. Young Meta with Friend in a bunk.

FRIEND: (Signing/miming poorly while coughing – she is deathly ill). Please kill me. Please. I don't want to die like the baby. Remember. Please, I want you to do it.
YOUNG META: (Caressing the woman and gently rocking while shaking her head "no.")
FRIEND: (More begging to be killed.)
YOUNG META: (Looks around – sees one woman from another bunk watching)
FEMALE PRISONER #2: (Gestures at shoes.)
YOUNG META: (Looks and understands. Takes off Friend's shoes while fighting tears. Holds them to her chest. Looks lovingly at Friend and then gives them to the prisoner.)
FEMALE PRISONER #2: (Gets out of bunk – puts on shoes and hides old ones. Does a little jig and then turns to Friend. Taking a strip of cloth and wrapping it up. Crazy look in her eyes.)
YOUNG META: (Stops her and motions for her to be gentle. Prays it will be quickly over. Friend then bends down to kiss her. Motions for Prisoner to kill Friend as she looks away.)
FEMALE PRISONER #2: (Somewhat touched by the prayer. Kills Friend but has in her eyes a gleam of pleasure.)
YOUNG META: (Cradles her dead friend harder and harder while rocking.)

Lights out center stage and lights on for stage right and left to show Meta and Kemba tossing in their sleep. Suddenly Kemba wakes from her nightmare panting as Meta continues to toss and turn in her continual hell.

Scene 12

Center stage lights go up to show a guard on a tower with a spotlight. He moves the spotlight across the stage and through the audience. Three prisoners try to escape undetected. A doctor emerges from behind the tower zippering up his pants. Young Meta

crawls behind him back toward her barracks. On stage right, Meta with Kemba watch the end of a soap opera.

KEMBA: Oh, I knew they would have to kill her when they brought her husband back after being missing for 10 years.

META: Yes, but what about the little boy? Remember after they declared her husband dead she remarried and then that guy was killed by the spy. But before that they had the little boy.

KEMBA: Oh, yeah what will happen to him? Soap operas! Do you want some of the bread I brought you?

META: Yes please.

Kemba goes out to get bread. Meta naps a little.

KEMBA: (Sets down bread, hitting Meta's arm. She jumps.)

META: Oh, oh. I thought you were – oh.

KEMBA: Thought I was the spy from the TV show.

Wiggling her eyebrows.

META: (Giggling, eats bread.) Ah this is much better than the camps. Ha – the camp bread was so hard and old. One piece every day that is all.

KEMBA: I heard some husbands tried to throw bread over fence to their wives to help them survive...

META: Bad, bad.

KEMBA: Bad??

META: Yes, how do I explain? If you eat good, you will have period. Little food, you will stop period. Guards watch us in bathroom. If see woman have period, will pull out and be gone because it means she stole the food.

KEMBA: (Shocked. Reaches for knapsack to pull out pad and pen. She has a Silence = Death with Pink Triangle pin.)

META: (Reacts and reaches for the Pink Triangle pin on the bag.)

KEMBA: Oh, that's for AIDS. Pink Triangle means—

META: Gay.

Uses old NYC sign.

KEMBA: What?

META: Boy with boy, girl with girl.

KEMBA: Right. (Surprised) I want the government to pay attention to AIDS and help people who are sick. That's why it says Silence = Death. Your time – deaf and Jewish=Death and parallels how today people are quiet about AIDS and that leads to death.

META: Pink triangle from Hitler.

KEMBA: W-h-a-t? No, this is new.
META: Nazis hated many groups. Jews, handicapped, gays.... So, they made them wear badges too. Yellow Star for Jews.

Takes from chair and holds up star.

META: Pink Triangle for homosexuals.

Uses NYC sign and points to pin.

META: Red for Political. Brown for...

Thinking.

META:...Gypsies. Purple...much, much hate.
KEMBA: (Looks from Meta, the star, and to her pin with a puzzled expression, confused by how much she does not know. Long pause) Why did they hate so much? It's so insane. All planned out like that – badges tattoos, trains. It's so crazy.
META: There is no "why." We can't explain it. The SS were animals, but they tried to make us into their image. They would make us kneel on broken glass for hours. They would hang children and make us watch. They would have young men burn their own fathers and mothers in the oven. They were the animals. When the Americans freed us, they forced the SS to bury our dead. They forced them to fix the railroads so we could go back to our homes. The SS were working for the Jews. It is very strange how G-D can change it all in one day.
KEMBA: A whole bunch of the top SS guys killed themselves when they knew the Americans and Russians were getting close, right?
META: Yes, and some, some SS tried to be good – to show G-D.

Long pause...

META: One SS knew. I was moved again because the Russians were very near. We had to walk very far, and it was freezing. People thought we would be saved soon. They heard bombing and the SS looked scared. We were so cold. My clothing froze and I could not move my clothes to go to the bathroom. Once I fell in the snow and started to cry and an SS came and hit me with a whip on my face. I had a horrible headache. I thought I would faint and then freeze in the snow. Many did, freeze like statues. I got up. I don't know how. We finally arrived at the next camp and we had to stay in tents. Many, many were dying: sick, beaten. What were we talking about?

Very tired.

KEMBA: Not being caught. You said one SS knew you were deaf.

META: Yes, I was always very careful and quiet – small like a mouse. Never wanted to make a mistake or they would catch me. Many SS were escaping, and others were panicked. I was working in the compound moving rocks with the wheelbarrow and...

Meta nods off to sleep. Kemba debates if should she should wake her. She decides to let her sleep. Picks up her backpack, looks carefully at the pin and back at Meta.

Scene 13

Stage right dims, center stage lights up. All characters look cold and worn out.

YOUNG META: (Pushing a load of rocks in a wheelbarrow to unload at the next location. One rock has fallen out without her noticing.)

YOUNG SS: (Enters, see the rock fall in his path and calls out to Meta to come back and pick it up.)

YOUNG META: (Unloads rocks stage right.)

YOUNG SS: (Comes up behind her and shouts at her back. No response. He spins her around with his stick and shouts in her face while pointing at the forgotten rock.)

YOUNG META: (Spins around, looks at the soldier terrified, sees the fallen rock. She looks at his face and then to the rock, seems puzzled and then starts to move for the rock.)

YOUNG SS: (With the stick he holds her still, looks her up and down, then looks around puzzled at how she could exist there undetected. Gives her a look of disgust at his discovery and storms off.)

YOUNG META: (Shaking, touches her pants to feel them damp with her urine. Other workers pass as if nothing happened; several refuse to look her in the eye. Meta begins to work by mistakenly loading rocks back into wheelbarrow and looks over shoulder constantly.)

Black out, spotlight on center stage.

YOUNG META: (Stands alone in roll call position. She gets an imaginary nudge and steps forward, ready to be taken away or shot on the spot. She shakes but stares straight ahead, then steps back and trembles.)

Black out on the spotlight.

YOUNG META: (Sleeping in the bunk, alone, with hand pressed to floor. She wakes up constantly, looking in the darkness for the soldier to come take her away when there is nothing there.)

Black out, lights up center stage.

PRISONERS: (Pass by carrying things)
YOUNG META: (Pushes wheelbarrow, while looking over shoulder.)
YOUNG SS: (Sees no one watching, steps in her path. Mouths exaggeratedly/orally to her "Gut Morgen," which means Good Morning in German and walks away.)
YOUNG META: (Frozen, follows him with her eyes, looks around and starts to tremble as soon as the SS has left.)

Center stage light fades; stage right is illuminated to show Meta deep in sleep and slightly trembling.

Scene 14

Stage left, TV room. Kemba is working on paper while Marc is watching TV. Marc becomes bored and throws a pillow at Kemba.

KEMBA: (Jumps – scared, she looks up, Marc turns his head quickly and then looks back. She shows her middle finger then with her other hand uses the "F" hand shape with the circular part of the "F" going in and out of the middle finger as if screwing.)
MARC: Oh, what's that a Black sign?
KEMBA: No, it's universal. I think it should become your sign name – Marc.

Speaking to an imaginary person.

KEMBA: Meet my roommate "Marc."
MARC: (Laughing) I threw that at you cuz I'm curious. I wanna know – what's the problem with your mom?
KEMBA: My mom. My mom wants me to get a Cochlear Implant.
MARC: No, way! Your mom can afford a Cochlear Implant?
KEMBA: Yes—my mom's high up in this company. She earns a really good salary. Not all Black people are on welfare – for your information.
MARC: I know. Why she want to waste her money for an electronic gadget to make you into a robot?
KEMBA: She's paranoid. She's worried I won't be successful in the work world: Deaf Black woman, who signs without speaking!

Imitates shocked look of employer.

MARC: Man, your mom should know better; she's Black herself. We're Deaf not dumb. We can do anything. I mean would your mom paint you white cuz it would get you a job more easily?

KEMBA: She doesn't understand. She wants what's best for me but she doesn't understand that the best thing is to accept me.
MARC: That's bullshit. I mean she's Black right? She should be able to understand easily.
KEMBA: Yeah, but you're Deaf right, and you go around making all your racist jokes and being real stupid on Jewish and Black people. And here you be Deaf – you're supposed to understand better...
MARC: That's different... I'm just shitting around. That's not the same as telling you to put a machine in your head and...
JANNA: (Enters; to Kemba) Didn't you hear?
KEMBA: What?
JANNA: The news. A group of Neo-Nazis set an apartment building on fire in Germany.
KEMBA: What?
JANNA: The news – a group of Neo-Nazis set an apartment building on fire in Germany.
KEMBA: WHAT! Jews there?
JANNA: I don't know. Two people dead.

Kemba runs out of the room.

Scene 15

Center stage; Kapos come out pushing female prisoners. They all get in formation facing the gallows with their backs to the audience.

YOUNG META: (In back row. Taps Friend for an explanation.)
FRIEND: (Indicates she does not know what is going on.)
FEMALE SS: (Comes up and begins shouting – no voice.)
ALL PRISONERS: (Respond with a jerk except Meta.)
FEMALE SS: (Calls two soldiers to bring another prisoner.)
PRISONERS: (Get up on the gallows.)
FEMALE SS: (Continues to lecture to the women showing that they all must watch, and no one is to turn their heads.)
SOLDIERS: (Put the noose around a woman's face.)

Spotlight on Soldiers' faces and Young Meta's. The hanging victim stares proudly ahead. Young Meta turns her head away. Stage right; Kemba runs up to pound on Meta's door and hits the doorbell. No answer. Neighbor opens her own apartment door and comes up behind Kemba.

NEIGHBOR: (Moves mouth only.) What's wrong?
KEMBA: (Very upset, trying to be clear, mimes) Worry – no answer...
NEIGHBOR: (Looks her over.) Wait.

Then goes back to her room.

KEMBA: Call someone to come open the door – please – call.
NEIGHBOR: (Takes key and opens the door.)
KEMBA: (Bursts into Meta's apartment; the TV is on. Eight Hanukkah candles are burning. Meta enters from bathroom, startled to see Kemba.)
KEMBA: I was worried. You didn't answer the door, so your neighbor let me in.
META: I was in the bathroom. I have no light flasher there. What's wrong?
KEMBA: I was worried about you. Germany – the news.
META: Yes, see it happens again, again. They call us liars – they ignore our tattoos and our dead – and it happens again.
KEMBA: I know, I know. But it won't be like before. Everyone saw it on TV. It will be in the newspapers and people will stop it.
META: It is a horrible thing. It makes me so sick. Because I know some Germans will say "Whew, only Turks, they are not coming for me." I know the feeling – it is so sick. Remember – I told you of my mother going left. I am sick every time I think of it. Why because I am glad for one short second. I am glad this old sick woman is not around me anymore and there will be less risk of me getting caught. Oh, when I thought that, I cried out. I cried so loud. I cry for my momma – no, I cry for me, for the loss of my soul.
KEMBA: You could not help it. All the fighting for food, shoes, survival. They made you inhuman – it is not your fault.
META: My friend. She was a good one. She sheltered me and when she begged me to help, I could not. It is so sickening. Why do I live and they are all gone. And now again.
KEMBA: No, no. It won't happen again. Too many people know about it now.
META: Oh, we survivors are old and dying. No one left to remember. Some say it is a made-up lie. It was all a hoax.
KEMBA: I will remember. I know it is true.
META: But you do not know it all. What I saw. It was so horrible.

Takes a deep breath – this is hard for her.

META: After I was freed and arrived in America, I met my husband. I put the camps out of my mind. The memories would pop up but I would fight them out until I was pregnant, then I had the worse dreams. I would wake up shaking, my pillow soaking. My husband would hold me to calm me down but he could never understand – never. It is hard for the men; they cannot forgive themselves for what happened to us. I could never tell my husband the shame, the pain, the changes my body experienced. It was so pitiful – women who looked like starved men.
KEMBA: You never told him? You never told anyone?
META: Yes, I told my family, but it is not the same. They are all men. As I am older, the memories are stronger. I see my Papa and Mama's faces. I see the

faces in the camps. I relive it. I had to watch everything. No ears to hear. So, everything is burned into my mind. I wonder if the hearing people have such memories. Everything clear. We are the same. And you are my daughter now. We are bound to what war can do to us. It can never do this to a man. On the news a grandmother and her granddaughter killed in Germany. They are our family.

KEMBA: You said your memories were worse when you were pregnant. Why?

META: Yes, this is what I am speaking of. When I was pregnant with my first son. Oh, I would wake up screaming night after night after night. My husband thought this is a woman thing. He did not know it was of the camps. My heart was racing so hard. I tell you now, so you really know. One night I was sleeping with my hands on the floor wood always....

Scene 16

Stage left lights fade as center stage lights come on dimly. Bunks are shown with several women sleeping close together on the bottom and top bunk. Young Meta has her arms stretched out, so she is touching the floor with her hands.

EXPECTANT MOTHER: (Walks from stage left and falls near Meta and clutches her stomach.)

YOUNG META: (Wakes, rubs eyes to see.)

FEMALE PRISONER #1: (Moves in her sleep.)

FRIEND: (Climbs down from upper bunk to comfort Expectant Mother. Expectant Mother starts to scream in pain, not audible.)

FEMALE PRISONER #1: (Starts to wake up.)

FEMALE PRISONER #2: (Looks to see if guard is coming, puts her hand over Expectant Mother's mouth to stifle the screams.)

EXPECTANT MOTHER: (Crying, kicking, panting.)

YOUNG META: (Reaches out to hold her hand while keeps other on the floor to "listen.")

FRIEND: (Face shows pain from Expectant Mother biting her hand.)

FEMALE PRISONER #3: (From bunk, she sadly gives her shoe to Friend.)

FRIEND: (Puts shoe in Expectant Mother's mouth and moves to crotch area.)

WOMEN IN BUNKS: (Watching as baby is being born.)

YOUNG META: (Holds hand up as she sees baby come out.)

WOMEN IN BUNKS: (Faces light up.)

EXPECTANT MOTHER: (Collapses.)

FRIEND: (Cuts cord, begins to hand baby to Expectant Mother.)

YOUNG META: (Slow motion – feels vibrations, drops Expectant Mother's hand, waves to friend.)

FEMALE SS#1 AND KAPO: (Enter quickly as lights go on in the barracks.)

FRIEND: (Slow motion – gets up to run stage left.)

BUNK WOMEN: (Cover ears from screaming baby and stamping feet. Many hide their faces.)
FEMALE SS #1: (Slow motion – grabs baby from Friend.)
FRIEND: (Falls to knees sobbing.)
EXPECTANT MOTHER: (Slow motion – grabs at female SS as she passes by with baby. SS almost falls.)
FEMALE SS #1: (Slow motion – motions to other guard to beat Expectant Mother.)
FEMALE KAPO: (Bends over Expectant Mother to hit her with baton. Women in bunk look on in terror.)

Scene 17

Black out center stage, stage right lights up. Meta is clinching her left hand from the memory of Expectant Mother holding it.

META: The mother never even looked at her. It was a very small baby girl – from mother to daughter – life. It would have died but better to die in its mother's hands than theirs. In America, during my pregnancy, safe in my bed thousands of miles away and thousands of years later, I woke to sweat and my heart racing. I dreamt they came for my child. They took everything from us: our hair, our period, our breasts, our virginity, our daughters.
KEMBA: How did you survive?
META: We were numb. Animals and cruel. But when the baby was born, we were all awaken for a few minutes. We were alive until the pain came back and we went numb again. Up went the wall. The baby was taken from us like our mothers were. Every day I wanted my mother. Every time I thought they'd come to take me to the chimney. I'd pray, and pray, and pray.
KEMBA: You still believed in God? You still have faith.

Points at the Menorah.

META: Without faith – no life.

Pointing at necklace pendant.

META: Chai is because of faith. How to explain? I sometimes passed near the gas showers and once I saw a group of people, old women and children waiting, waiting. The children's bare feet were frozen to the grounds and their mothers had to tear them up as the line moved on closer to their deaths. The women knew. Lipreading I saw they were singing. All together they sang. Hebrew. The guards saw they could not take OUR God. God was there. God was there. And guilt. Not me? Go numb again – no pain. Secretly proud of surviving.
KEMBA: I wonder if that's what slaves felt like?

Scene 18

Center stage lights go up halfway to show a building with two young guards with guns near the entrance. Young naked women are pushed into a line and forced to enter the building. Young Meta pushes a wheelbarrow by, and one guard starts shouting at her and pushes her away. She is shocked by what she sees and runs from the scene. The naked women begin to fight more. Stage right lights go up. Kemba appears at Meta's apartment ringing bell. Neighbor comes out.

KEMBA: (Signs and mimes) I got an A on my paper. I want to show it to her. She knows I'm coming. She's probably in the bathroom.
NEIGHBOR: She went to the hospital.
KEMBA: (Shakes head – I don't understand. Gives paper with pencil to neighbor.)
KEMBA: Hospital! Where?

Writing.

NEIGHBOR: (Writes back.)
KEMBA: (Starts to leave but returns and asks Neighbor for a key, and pantomimes wanting to light the Menorah. Neighbor lets her into Meta's apartment. Kemba lights all the candles on the Menorah, sits in chair, puts hand in seat and finds an envelope and the Star of David.)

Scene 19

Black out. Lights up on center stage. Meta hooked up to a monitor in a hospital bed. Enters Kemba stage left. She is carrying her research paper.

KEMBA: (Looks around, then looks lovingly at Meta. Crumples up paper. Holding Meta's hand. Opens the letter she found in the armchair.)
KEMBA: Long ago there was an old, old woman
 who'd hid her soul
 (It was hidden deep in the core of her bones)
 She met a young woman
 with eyes of brilliant innocence
 (who bore out the old woman's soul with her kindness)
 The old woman never intended to
 reveal so much pain
 and confide so much shame
 But no cameras or paper could capture the truth
 This must go from:
 Eye to eye, mind to mind, heart to heart, soul to soul.
 After the horror stories were told,
 the silence broken

The young girl brought her peace
She reminded the old woman –
The bond from mother to daughter
can never be broken
Keeping the faith, G-D keep you Shalom,
Meta Goldstein

Kemba puts down the letter and lights the Menorah in the hospital room. She lights all nine candles and turns to Meta.

KEMBA: Happy Hanukkah!

Heartbeat flatlines on the monitor; slow black out.

Scene 20

Center stage; dim lights show female bodies all over floor as male prisoners pick up and move them around. They start to take a lunch break in the room when the SS doctor arrives. They stand at attention and he orders them to start loading the crematorium. Two prisoners open the door of the oven. Bright red lights flare in the background on a canvas, which is waved to create the feeling of flames. The prisoners react to the heat as the other prisoners begin to load the body into the oven. Lights dim out. Stage left, TV Room.

JANNA: (Reading poem) Beautiful. Maybe she knew she was going to die.
KEMBA: No, they found it in the chair with the Star of David. She was waiting for me to come again so she could give it to me.
JANNA: Do you have the star?
KEMBA: No, I gave it to her oldest son at the funeral. He should have it to give to his children.
JANNA: I still think she was waiting. You know, they say people wait until the right time to die. But now she's dead and she doesn't know that people in Germany are fighting the Neo-Nazis. She probably thought it was happening all over again.
KEMBA: She knows it won't.
JANNA: Why?
KEMBA: You gotta have faith.
JANNA: In what? Millions of people were killed and for her to die after seeing it start again.
KEMBA: No, no – you don't understand. Her dying shows she has faith. A soul that strong can't die.
JANNA: Are you going to give her sons a copy of your paper when you're done?
KEMBA: Yeah, I think so. It will take me a long time to write down her whole story. I can give it to them at the stone setting ceremony.
JANNA: What?

KEMBA: On the first anniversary of a Jewish person's death they put down the tombstone.
JANNA: One year – why??

Phone light flashes. Janna looks at Kemba. Enters Marc.

JANNA: (To Kemba) Want me to get it?
KEMBA: (Nods her head.)
MARC: (Looking around) Ah, you know it's your mom. You gotta face her some time. Just give her a piece of your mind. Either she accepts you as a deaf person or fuck off.
KEMBA: (Looking through a book of Holocaust artwork.) I know. I'm just waiting for the right time. I want to tell her as clearly as possible so she can really understand me.
MARC: What good is being silent. You never.... What ya looking at?
KEMBA: These are artwork from a Deaf survivor from Dachau – David Bloch.
MARC: A Deaf man painted these?
KEMBA: Yeah, and they have special symbols see...the cross?

Kemba and Marc flip through the book. Slides are projected onto the scrim showing the artwork of David Bloch: slide of hanging and tower; slide of quad; lights come up on center stage to show concentration camp scene recreated from slide of the prisoners; slide of prison cell; slide of prisoners at fence and woman with child. Center stage lights come up to show prisoners behind barbed wire as in the slide. Spotlight on woman and child.

KEMBA: (Affected) I have to call my mom now.

Marc gives her a thumbs up and keeps looking at the pictures. TTY conversation is projected on the screen while Kemba types at a TTY in the apartment.

KEMBA: Hi mom. Did you get my letter Q GA
KEMBA'S MOM: Yes. I talked it over with your dad and we agree. The cochlear implant is your decision. GA
KEMBA: Really!!!!! GA
KEMBA'S MOM: Yes. I still want you to have the best and a good life and I worry. But I don't want you to feel like I don't love you as you are. I never wanted to make you feel that way. GA
KEMBA: Mom I'm so happy. I felt so sad this issue was really hurting our relationship. GA
KEMBA'S MOM: Your letter really helped me understand why you stopped being in contact with me. So tell me about this project you are working on. I enjoyed learning about your new friend Meta GA

Lights fade out on Kemba and TTY screen – lights up slightly on Marc looking at pictures as they are projected on screen. Artwork by David Bloch: slide of woman and child and prisoners at the fence is shown again. Slide of roll call with SS and folded uniform in place where prisoners are gone. Lights up to show prisoners in position with Female SS taking roll call, guard present, Kapos with clubs, doctor inspecting, and uniforms folded in places where prisoners are gone.

Black out. Lights up slowly on center stage. Tombstone with carving. Fall leaves are scattered about. Kemba looks one year older and has on a different fall jacket. Her hair is different.

(Text on tombstone)
Meta Goldstein
Beloved Wife and Mother
Survivor 1941–1945
1922–1992

About the Author

Patricia A. Durr was a founding member of LIGHTS ON! and for a number of years its artistic director, and a member of the board. This community theater company was dedicated to producing plays about Deaf experiences and proudly produced a couple of the plays featured in this anthology (*Tales from a Clubroom* and *A Play of Our Own*). Under her direction, LIGHTS ON! secured a large grant from the U.S. Department of Education for their *Theatre Arts in Education* program and ran play-creation and acting workshops for three years.

Durr has written, directed, and produced educational videos for national distribution – *The Grey Area: His Date/Her Rape, HIV/AIDS Prevention for Deaf Students,* and *Me Too* and short documentaries on Deaf Holocaust survivors, *Exodus* and *Worry*. These films and her dramatic short *Don't Mind?* have won awards. Durr is also a visual artist whose works are exhibited and sold nationally. She worked with the Memorial Art Gallery and NTID's Dyer Arts Center to co-curate the exhibition *De'VIA: The Manifesto Comes of Age*. Durr holds a MS in Deaf Education from the University of Rochester/NTID and a BA in Sociology from LeMoyne College. She is a retired professor of Deaf Cultural Studies and social sciences at NTID in Rochester, New York, and considers herself an ARTivist – committed to using the arts to contribute to social justice. Durr is currently working on a series of children's books for Surdists United.

9
MICHELE MAUREEN VERHOOSKY,
THE MIDDLE OF NOWHERE

IMAGE 9.1
Source: Photo courtesy of Michele Verhoosky.

IMAGE 9.2 Painted collage of scenes from *The Middle of Nowhere*, directed by Aaron Kelstone.
Source: Painting by Michele Verhoosky.

Synopsis

The Middle of Nowhere is a coming-of-age drama of inner journeys, family secrets, and – ultimately – triumphs. Jessie, a 15-year-old (hearing) girl, longs to move beyond the farm she lives on in "the middle of nowhere," Ohio with her deaf Nana and mother, Emily. Jack, a stranger she meets while waiting for a bus not expected to arrive for a few days, turns out to be not only well-versed in the ways of the world outside the middle of nowhere, but fluent in sign language as well. Could all this lead *somewhere* for this young girl looking for her own ticket out?

Production History

The Middle of Nowhere was presented as a showcase production on July 26, 1997 during the National and Worldwide Deaf Theatre conference held at the American School for the Deaf in Hartford, CT. It was directed by Aaron Weir Kelstone. Other members of the production team were Robert DeMayo, Dramaturg/ASL

Translator; Alan Neece, Stage Manager; and Lisa Dennett, Voice Interpreter. The cast was as follows:

Nana – Stella Antonio
Jessie – Jody Drezner
Jack – Alek Friedman
Emily – Anne Tomasetti[1]

Thoughts about the Play

This play handles the tricky sign language-voice conundrum – as all plays involving sign and voice do – by incorporating the use of two departed family members (Stashu and Leah) as spiritual guides who double as interpreters. If two hearing characters are speaking to one another, the spiritual interpreters sign the spoken lines. Conversely, if two deaf characters are signing to one another, the interpreters voice their lines. This is done to create communication access for the deaf and hearing members of the audience. This communication approach on stage is similar to "shadow interpreting" where a sign interpreter shadows a speaking character on stage. In essence, the audience is hearing the spoken lines and simultaneously seeing the lines interpreted in sign language. During the play, Stashu and Leah are not mere shadow interpreters but also real characters who sign and speak their lines.

For hearing audience members not familiar with the signing/voicing conventions of Deaf Theatre, it usually takes about the first five minutes of a play to become accustomed to hearing the lines from a deaf character being spoken by another person.

Deaf Gain

As of this writing, Michele Verhoosky is perhaps the world's only living Deaf female playwright whose plays have been widely produced.

Notes

1 Program for *Michele Verhoosky's The Middle of Nowhere at the American School for the Deaf*. West Hartford, CT: Playbill, 1997.

9
THE MIDDLE OF NOWHERE

Michele Maureen Verhoosky

Characters

STASHU, *age late 60s–early 70s, (hearing)*
 Nana's departed husband. He acts as a spiritual guide and a voice and sign interpreter.
LEAH, *age early 20s, (previously deaf, now hearing)*
Nana's departed daughter. She acts as a spiritual guide and a voice and sign interpreter.
JESSIE, *age 15 (hearing)*
Nana's great-granddaughter, Emily's daughter, a tomboy, and a CODA (child of deaf adults), she is weighed down with heavy responsibilities.
JACK, *age mid-30s, (hearing)*
Jack is a rugged, mysterious stranger, well-versed in the ways of the world and ASL.
NANA, *age late 70s, (deaf)*
Nana loves her life on the farm – and her memories. Age and circumstances have not defeated her.
EMILY, *age mid-30s, (deaf)*
 Nana's granddaughter, Jessie's mother. Radiantly beautiful, but repressed, sorely wounded by life experiences.

Notes

Setting: 1966. Rural Ohio. A combination farmhouse kitchen with a bench set off downstage left to designate the bus stop and Jessie's bedroom, and a wicker couch set off downstage right to designate the farmhouse porch.

DOI: 10.4324/9781003112563-19

Act I, Scene 1

Early afternoon. The lights come up to reveal Jessie. Feeling trapped between romantic longings and encroaching depression, she sits reading a bus schedule in front of the drug store which doubles as the local Greyhound stop and bears the sign, "New Rome, Ohio." Dressed in pale blue cut-off jeans with the cuffs neatly rolled just above her knees and a short-sleeved pinstriped Oxford shirt, she leans forward and looks anxiously down the road, trying to glimpse the future she so longs for. Behind her are Stashu and Leah who – as departed members of Jessie's family – are clearly worried about Jessie.

LEAH: (speaking & signing) I want to get closer to her, Papa.
STASHU: (speaking & signing) This is as close as we can get, Leah. And here my name is Stashu now.
LEAH: But to me you'll always be Papa.
STASHU: Look at her, Leah – your granddaughter.
LEAH: The one I never knew. She looks so alone.... Oh, how I wish I could've stayed! Things would've been so different! First for my daughter, and then for hers. Even Mama's life would've been different... if I had stayed.
STASHU: Stay? Leah, you couldn't. The choice wasn't yours. You were called away.
LEAH: I've missed them! So much. Papa... Stashu, haven't you?
STASHU: Yes... oh yes.
LEAH: But this! Seeing them, but they not seeing us? Oh, why were we sent here?
STASHU: To try to help.
LEAH: But how? They can't see us!
STASHU: Leah, child... there's seeing...

He touches his eyes.

STASHU: ... And there's seeing.

He touches his heart.

LEAH: Will they see, Papa? Will they ever?
STASHU: We have to be patient. Trust, hope, pray, and be patient.
LEAH: Oh Papa, Stashu... this is so hard!
STASHU: Yes, Leah, it is. Waiting is always the hardest part.

Leah and Stashu look at Jessie.

JESSIE: (speaking, Leah signing to end of scene) Twenty dollars! That's what it takes. More than twenty dollars to get out of the middle of nowhere.

She digs wadded up cash and coins from her pocket and counts.

JESSIE: (speaking, Leah signing) 4.25... 50... 75... 76... 77... 78...

She sighs, leans back, closes her eyes. Enter Jack, a new stranger in town. Dressed in a pair of jeans and a tight t-shirt with the arm sleeves rolled up and worn cowboy boots, he has a dusty denim jacket and a duffel bag slung over a shoulder. With his long hair blowing beneath a battered Stetson, Jack looks expectantly down the street, sees Jessie, and nudges her foot with the toe of his boot. Jessie opens her eyes and sits up, dazed.

JACK: (speaking, Stashu signing to end of scene) This here where I grab the Greyhound?

Jessie dumbly nods "no."

JACK: It running late?

Jessie dumbly nods "no."

JACK: (Frowns, checks watch.) You sure? Thought it was supposed to leave at two.
JESSIE: (voice cracking, Leah signing) Thursday.
JACK: What's that?
JESSIE: Thursday.
JACK: (puzzled) Thursday?
JESSIE: That's when it comes.
JACK: Wh-a-a-t... you tellin' me the bus only stops in this town *once-a-week*?
JESSIE: (nodding nervously) Mmmm-hmmm.
JACK: Are you kidding me?

Jessie dumbly nods "no."

JACK: *J-e-e-e-e-s-s-s-us!*
JESSIE: Sorry.
JACK: (Barks a rueful laugh and throws himself on the bench next to Jessie.) Ha! Yeah, that makes two of us.
JESSIE: Were you heading far?
JACK: Far enough. *Je-e-e-s-s-us!*

Jessie cringes.

JACK: Sorry. It's just that, goddamn, I can't believe she didn't tell me!
JESSIE: Cora?
JACK: That her name? The old lady behind the counter in there? Took her ten minutes to count me back my change. Bet she thought if she'd waited long enough I'd forget I had it coming.

JESSIE: She has rheumatism.
JACK: Yeah? Well she doesn't have all her marbles, selling me a ticket for a bus that don't leave 'til the middle of the week, that's for sure.
JESSIE: Everyone knows the bus only comes Thursday.
JACK: Everyone, huh?
JESSIE: Well, everyone from around here.
JACK: Yeah, well I sure ain't from around here.
JESSIE: Are you from Texas? You look like you're from Texas. I mean, your boots, and your hat, and… I bet you're in a rodeo!
JACK: A rodeo? You think I'm a *cowboy*?
JESSIE: What do you do? Rope steer? Break horses? You ride, don't you? You walk like you ride.
JACK: (misunderstanding, Stashu signs "motorcycle") Yeah, I ride…
JESSIE: Is it hard? Staying on for the count, I mean? What do you have to do? Really dig in with your knees?
JACK: (bewildered) Well, yeah, I reckon.
JESSIE: (delighted) Really? Huh! I watch tv a lot. You know, Bonanza, Stony Burke, n'all. I watch what they do, then I go out and try it on Big Blue. He's our horse. He can get really mean—he hates the saddle! Mama rides him bareback, but I keep telling her maybe that's okay on the farm, but you can't ride a horse in a show like that. Do you have to bring your own saddle?
JACK: You live on a farm?
JESSIE: Mmmm-hmmm. Me 'n Mama. Oh, and Nana of course. My grandma. Well, Mama's grandma actually. She brought Mama up after her parents died… and now she's bringing up—I mean *brought up*—me.
JACK: She did, huh? Why, what's wrong with your Mama?
JESSIE: (defensively) Nothing's wrong with her! She's just…
JACK: (curious) Just?
JESSIE: Nothing!
JACK: Hmmmph! What about your daddy?
JESSIE: I don't have one. I mean, I have one, but…
JACK: Oh… sorry.

She clamps her jaw shut, turns away.

JESSIE: It's all right. I mean… I never knew him, so I guess it doesn't really matter… does it?
JACK: No. I guess not.
JESSIE: Where you heading?
JACK: Colorado.
JESSIE: *Colorado*? For real?
JACK: Well… yeah!
JESSIE: Oh, wow! I'd love to see Colorado! Mountains, and blue sky, and eagles! They have eagles in Colorado, don't they?

JACK: (He removes his hat, scratches his head, bemused.) Yeah, I suspect so.
JESSIE: Oh, I'd do anything to see all that!
JACK: You would, huh?
JESSIE: Ohio's flat. The soil's clay, full of arrowheads, and shale and flint. You cook in the summer…
JACK: Yeah, I can vouch for that.
JESSIE: And freeze in the winter. If it's not snowing, it's raining—a hard, cold rain from a dark grey sky. It just goes on and on until you think the sun's never going to shine again. But, oh!!!

She rises, caught up in her vision.

JESSIE: Colorado! Oh, if I could only go to Colorado! There'd be room to breathe! There'd be places, wide open places where people wouldn't know me! Wouldn't matter who I was, I could be anything I wanted! I could ride horses, real horses, not mean and hard like Big Blue. Be a rodeo queen. Have my own spread, just like the Ponderosa! I'd have ranch hands working for me. They'd call me *Miz Jezz* and ride behind me when we go out to do cattle runs, cut timber, string fences. I'd meet up with Stony Burke and Little Joe…
JACK: (alarmed) Little Joe?
JESSIE: And his Pa. I love Ben Cartwright, don't you?
JACK: Well, I—
JESSIE: I'd be sitting there on my horse, a Palomino, in my buckskin skirt, my hat slung around my neck and my hair streaming down my back. And they'd look at me and know I was a force to be reckoned with.
JACK: (with a low whistle) Well, that's sure a pretty daydream.
JESSIE: Daydream?
JACK: You had me going right up until… The Cartwrights aren't real, y'know.
JESSIE: (flustered) Oh. I know that! 'Course I know that. But that doesn't mean I wouldn't meet someone like them, does it? I mean, nothing like that ever happens here. But stuff like that happens in places like Colorado – all the time!

Jack rises with a rueful laugh and slings his bag over his shoulder.

JESSIE: (alarmed) Wh-a-a-t? Where you going? You're not leaving, are you?
JACK: Can't stay around here, not with the bus not leaving 'til Thursday. I'm just gonna go inside and ask Cora is it, for my money back. Find me a motel tonight, then hit the road tomorrow. Get me a hitch.
JESSIE: A hitch?
JACK: A hitch! Hitchhiking! How'd ya think I got here?
JESSIE: You can't!
JACK: Sure I can! There's nothing to keep me here, that's for sure.
JESSIE: No, I mean, you can't! There's no motel around here…

JACK: No motel?
JESSIE: Nearest one's in Cedar Grove.
JACK: Yeah? And where's Cedar Grove?
JESSIE: Next town over.
JACK: That all? Shoot, I could walk that.
JESSIE: It's twelve miles.
JACK: (sputters) Twelve... Goddamn!

He angrily storms back and forth in front of Jessie.

JACK: You know how long it took me to get a ride here? An *hour*, that's how long! A whole dang hour! Stood right in the middle of that road with my thumb stuck out for a solid hour before a truck finally stopped.
JESSIE: People don't hold with hitching 'round here.
JACK: What do I look like—a robber? A crook? A *murderer*?
JESSIE: Do, do you have to be in Colorado real soon?
JACK: What?
JESSIE: I mean, do you have, well, folks waiting for you? Or a job or something?
JACK: You ask a lot of questions, kid, you know that?
JESSIE: I'm not a kid!
JACK: You're not, huh? What are you? Twelve? Thirteen?
JESSIE: I'm fifteen!
JACK: Huh! All of that, huh? Not even jailbait.

Jessie looks at him blankly.

JACK: Jailbait. Sixteen? Oh, forget it!

He hoists his bag, eyes the long road.

JESSIE: I was thinking... that if... well, I mean, if you didn't have to be in Colorado real soon, and seeing as you got no place to go – until Thursday that is – that you could, well, maybe come stay with me.

Jack looks sharply at Jessie.

JESSIE: It'd only be a few days. Until Thursday.
JACK: Stay with *you*?
JESSIE: Yeah, I mean, oh, no, I mean, not with *me* but, well, out on our farm. With my mama and nana. It's no place special. I mean, it's nothing fancy, but... well, there's lots of room, and it wouldn't cost ya anything.
JACK: It wouldn't, huh?
JESSIE: Well, not money. 'Course, Nana might put you to work. Fixing screens and chopping wood. That kinda stuff. Nothing you couldn't handle.

Jack stares at Jessie taking her measure. Jessie, though flushed with embarrassment, stands her ground and doesn't look away.

JACK: You make a habit of this, kid?
JESSIE: A habit?
JACK: Pickin' up strangers?
JESSIE: (blushing) Oh. No! I've never done this before in my life!
JACK: Huh! Well… *Dang it!*

He slaps his knee. Jessie jumps.

JACK: All right.
JESSIE: (with disbelief) All right?
JACK: You talked me into it.
JESSIE: I did?
JACK: I don't know how, and I don't know why I'm going along with this. Well, shoot, I know why. Where the hell else am I gonna go in this godforsaken town? But… well, you look harmless enough.

He slings the bag over his shoulder.

JACK: So, which way we heading?

Jessie stares at him, dumbstruck.

JACK: Hey, you're the boss lady here. I'm just the ranch hand riding behind ya, remember?
JESSIE: (points right) That way.
JACK: That way?
JESSIE: Follow me.

She leads the way. Jack falls in line, then suddenly halts.

JACK: What am I supposed to call you?

Jessie looks at Jack perplexedly.

JACK: Hey, I can't call you "jailbait," and I'll be danged if I'll call a fifteen-year-old kid, "Boss." So, what's it gonna be?
JESSIE: Oh! Uh, ummm… Jessie.
JACK: Jessie? Why, that's a *boy's* name. Sure you don't prefer "Jessica?"
JESSIE: No. Just Jessie. My name is Jessie.
JACK: Okay, Jessie.
JESSIE: What's yours?

JACK: Jack.
JESSIE: Jack? You want me to call you Jack?
JACK: Yeah. Jack. Just Jack.
JESSIE: (with a delighted grin) Okay… Jack.

Exit Jack and Jessie.

Act 1, Scene 2

Later that afternoon. The light comes up to reveal the farmhouse kitchen. Nana sits at the table, folding laundry. Dressed in a shapeless housedress and scuffed slippers, an apron dangling from her neck and tied loosely around her waist, she bends painfully and selects the next item from a wicker basket by her feet.

With her is Emily, in shorts and a summer blouse, who sits folding laundry at the table. She pauses to pour Nana a glass of iced tea. Nana accepts with a smile, but keeps an eagle eye on Emily, correcting her method of folding as she drinks.

Enter Jessie, trailed by Leah and Stashu, who hover nearby, voicing the words the others sign.

JESSIE: (signing only, Leah voicing) Mama, Nana, I brought someone home.
EMILY: (signing only, Stashu voicing) Who? A friend?
JESSIE: Uh, not exactly. He's, he's someone I just met… at the bus stop. This afternoon.
EMILY: This afternoon? But the bus doesn't leave until…
JESSIE: Thursday. I know, but he didn't. That's why I said he could stay with us.
EMILY: Jessie, you want to bring some man – a *stranger* – here? No, Jessie. No. No.
JESSIE: It's too late. He's already here.

Enter Jack. Nana and Emily look at him with much dismay.

EMILY: Jessie! What have you done?
NANA: (signing only, Stashu voicing) Who is this man?
JESSIE: He's a cowboy, Nana.
NANA: But what do you know about him? Where is he from?
JESSIE: I don't know. I just know he's going to Colorado.
NANA: Is he married?
JESSIE: Married? What? Nana, why should you care? He doesn't wear a ring.
NANA: No?
JESSIE: (flushing) I checked.
NANA: That doesn't mean anything. Many men don't wear rings.
JESSIE: Why is it so important to you?
NANA: Is important to know who you bring into my house!

JACK: (speaking & signing) I'm sorry. This isn't working out. Maybe I'd better leave.

Jessie, Nana, and Emily stare at Jack, incredulous.

EMILY: (signing only, Leah voicing) You can sign?
NANA: (signing only, Stashu voicing) Are you *deaf*?
JESSIE: (signing only, Leah voicing) No! He's *hearing*!

She furiously turns to Jack to hold a fierce, private spoken conversation.

JESSIE: (speaking, Leah signing) Wh-a-a-t? You can *sign*? Why didn't you *tell* me you could sign?
JACK: (speaking, Stashu signing) Why didn't you tell me your family was *deaf*?
JESSIE: (still speaking only) Because, because you wouldn't have come then. Would you?
JACK: (still speaking only) So, what... you thought you'd just *spring* it on me and let me flounder?
JESSIE: (still speaking only) You're not floundering!
JACK: (speaking & signing) That's because I know sign!
EMILY & NANA: (signing, Leah voicing) Where you from? How you know sign?
JESSIE: (speaking & signing) Well, I guess I'd better introduce you. Mama, this is *Jack*.
EMILY: Jack?
JESSIE: (speaking & signing) Yeah. That's what he told me to call him. This is my mother, Emily.

Jack nods, eyeing Emily appreciatively. Emily flushes slightly.

EMILY: What's your sign name... Jack?

She signs a "J" near her eye.

JACK: (speaking & signing to Emily) Well, I thought 'bout that, but it's a bit plain, don'tcha think? So it's Jack.

He signs a "J" across his chest with a flourish.

JACK: You know... King, Queen... Jack...

Emily, startled, copies the sign.

NANA: (signing, Stashu voicing) Ahh! Poker.

She laughs gleefully, miming the Joker from a pack of cards, the dealing of cards, the fanning of a good hand.

JESSIE: Jack, this is Nana.
JACK: (speaking & signing) Nice to meet you...

He eyes Emily appreciatively.

JACK: Both.
NANA: (signing, Stashu voicing) How you know sign? Where you learn?
JESSIE: (speaking & signing to Jack) She says...
JACK: (speaking & signing to Jessie) I know what she said.

Jack turns back to Nana and Emily.

JACK: (signing only, Stashu voicing) From a friend.
NANA: (signing only, Leah voicing) A friend?
JACK: (signing only, Stashu voicing) Yes ma'am. A good friend. Her mother was deaf. Grew up with her. Always hung around, did things together. So, I just kinda picked it up, y'know?
NANA: Your *good* friend. Why you not married to her?
JACK: Well, she *asked* me, but... well... it wouldn't have worked out.
EMILY: (signing only, Leah voicing) It wouldn't? Why not?
NANA: Were you ashamed?
JACK: Ashamed?
NANA: Of her mother?
JACK: Oh! Oh, no! No, not at all.
NANA: Then why?
JACK: Well, I guess... I just, I just wasn't ready. To settle down. In one place.
EMILY: One place?
JACK: Back East.
JESSIE: (speaking & signing to Jack) East! You're from the *EAST*?
JACK: (signing only, Stashu speaking) I was... *restless*. I just thought there had to be more to life than just *there*.

Signing only, Stashu speaking.

JACK: So, one day I just packed up and hit the road. Did some construction. Oil rigging. Even worked at a golf course once, selling overpriced clubs to folks who couldn't play for beans. Been to Carolina, Georgia, Tennessee... even the Gulf of Mexico. But Margaret...
JESSIE: (speaking and signing) *Margaret?*
JACK: (signing only, Stashu speaking) That was her name. Margaret. Margaret Mary. She never wanted to go any further than her own backyard. She

thought I was crazy to give up such a good job. She told me flat out she couldn't leave… the job or her mother.
JESSIE: (speaking and signing) Job? You mean, you *worked* together?
NANA: Where you work?
JACK: At a school. A school for the deaf. Back East.
JESSIE: (speaking) *Oh geez*!
EMILY: What, Jessie? What's wrong?
JESSIE: (speaking & signing) *Everything*!

She confronts Jack, holding a private, spoken conversation with him which Leah and Stashu sign as depicted in bold type.

JESSIE: (speaking only, Leah signing) A schoolteacher? A schoolteacher from the East?
JACK: (speaking only, Stashu signing) Something wrong with that?
JESSIE: I thought you were a cowboy!
JACK: I've been a lot of things, but I never said I was that.
JESSIE: I thought you were from Texas! You talk Texas!
JACK: Now how would you know what Texas sounds like?
JESSIE: I, I just know.
JACK: From tv?
EMILY: (signing only, Leah voicing) Jessie? What's wrong? What's going on here?
JESSIE: (speaking & signing to Jack) This was a bad idea. You better leave. Now.
NANA: (vehemently to Jack) No. No. It's getting late. You stay. You stay here!
JACK: (speaking & signing) No, really. This isn't fair to you.
NANA: You hungry?
JACK: Hungry? Well…
NANA: Yes, big man like you, of course you're hungry.
JESSIE: (speaking & signing) Nana! What are you doing?
NANA: (to Jack) You like fried chicken? Mashed potatoes? Gravy?
JACK: (speaking & signing) Yeah. Yeah! Shoot, they're my favorite. But…
NANA: You know how to chop?
JACK: Chop?

He mimics dicing vegetables.

NANA: Chop!

She mimics axing a tree.

NANA: Wood. You know how?
JACK: (speaking & signing) Yeah. Sure. I can chop wood.
NANA: Good. Then you stay.
JESSIE: (speaking & signing) Stay? Oh, Nana!

NANA: Eat dinner. Chop wood. Stay here, with us. Until Thursday.
JACK: (speaking & signing) Well, sure, I mean, if that's all right.
NANA: Jessie? Emily?
EMILY: (shyly, nervously signing, Leah voicing) It would be... nice... to have a man in the house again?
NANA: Jessie?
JESSIE: I don't have anything to say about it, do I? Yeah... Sure... I mean, where else has he got to go?
NANA: (to Jack) Good! Then is all settled! Come! I show you around before supper. Show you the porch. It where you going to sleep.
JESSIE: (speaking & signing) The *porch*! But Nana, *I* like to sleep on the...

Emily yanks Jessie back into her seat.

NANA: (to Jack) You will like the porch. It's nice and cool out there.

She takes Jack's arm, guides him outside. Exit Nana and Jack.

Act 1, Scene 3

A few minutes later. Farmhouse kitchen. Jessie sighs and slumps in her chair at the kitchen table. Emily studies her thoughtfully.

EMILY: (signing only, Stashu voicing to scene's end) Well... Jessie... well.
JESSIE: (signing only, Leah voicing to scene's end) Don't, Mama. Just... don't.
EMILY: (curious) Why did you bring him—a *stranger*—here?
JESSIE: I don't know! I just thought... I thought... I thought he was *nice*, okay?
EMILY: Thought? You changed your mind? Why did you change your mind?
JESSIE: Oh... I don't know! You should've seen him, Mama! Back there, in town. I mean, I was just sitting there, out front, and I'm *dying*, you know?
EMILY: Dying?
JESSIE: From the heat, from... oh, from *everything*!
EMILY: Oh, Jessie! Honey, you're not dying.
JESSIE: And then, the next thing I know, I look up, and there he is! Just standing there, right in front of me! For a minute, I didn't think he was real. I thought, I thought...
EMILY: What? What did you think?
JESSIE: I don't know. I thought he was somebody I made up.
EMILY: (musingly) He has a nice face.
JESSIE: He needs a bath!
EMILY: He's just dusty. From traveling.
JESSIE: You think he has a nice face, Mama?
EMILY: Yes. I do. An honest face.
JESSIE: *Honest*? He told me a pack of lies!
EMILY: Did he? Did he really?

Jessie, flustered, looks away. Emily grips Jessie's chin, turns her back, refocusing her attention.

EMILY: Honest people look at you when they talk. In the eyes. They don't look away, like they are nervous, or hiding something… or dreaming up schemes.
JESSIE: You mean… like I do.
EMILY: Oh, Jessie… you are honest!
JESSIE: Really?
EMILY: Painfully honest! But… oh, Jessie, you just have so much imagination! So many dreams!
JESSIE: I just don't want to… I just don't want to be like, like… *Margaret Mary*! I don't want to be stuck in *one place* all my life!
EMILY: I know that, Jessie… I know… that's why you brought your Jack here.
JESSIE: He's not *my* Jack.
EMILY: Yes, he is, Jessie. Yes, he is.
JESSIE: (confused) What? Mama, how can you… I thought he was *different*!
EMILY: He is.
JESSIE: I thought he *knew* stuff! Been places! Done things!
EMILY: He has.
JESSIE: And now I find out he's not who I thought he was at all!
EMILY: No, but he might be someone better. Did you ever think of that?

Jessie stares at Emily, stunned. Suddenly, she leans across the table, and hugs Emily awkwardly. Emily strokes Jessie's hair with one hand, and Jack's battered hat with her other.
Stashu and Leah look at each other with stunned expressions and bewildered smiles. They clasp their hands and bow their heads. Lights fade to black over Jessie and Emily.

Act 1, Scene 4

Few minutes later. Farmhouse kitchen. Enter Nana. She senses Stashu and Leah and her departed loved ones and addresses her conversation to them all. Leah voice interprets for Nana.

NANA: Well, Mama, Papa… we have guests again.

She pauses, as though listening.

NANA: What? He reminds you of Stashu? My Stashu? Leah, what do you think? Does this guest, this Mister Jack here, remind you of your daddy? You were taller, weren't you, Stashu? My arms always remember you taller.

Nana raises her arms, closes her eyes. Stashu's arms raise, hovering mere inches around her as both move in a slow, dreamy waltz, their bodies never quite touching. Finally Nana stops, nods her thanks, and slowly lowers herself into her rocking chair with a small sigh.

NANA: Yes. You were taller, Stashu. You were taller.

She cocks her head, listening.

NANA: He *does* have a good appetite, Mama. Is a pleasure to cook for someone who likes to eat. We still have them, Papa, the tomatoes you planted. Cuttings from your vines. But somehow, they just don't taste as *full*. You must have a secret, Papa.

She mimics fingering fine cloth.

NANA: Leah, the lace cloth. What do you think? Hmmm, well, you are probably right. This Jack seems to like to keep things simple. Still, it's been such a long time since I've had the lace out… Remember all those Sunday dinners, Stashu? Ahh, but how I wish you were still here to carve! Hams, roasts, turkeys I can still cook. But carve? Ahh, Stashu, if you could see my hands, you would not know me now.

She flexes her stiff fingers, then pushes herself upright.

NANA: Well, you are right. It *is* time I took myself off to bed.

She shuffles stage right, pauses, and turns back with a smile.

NANA: You can come too, if you'd like. You're welcome. You know that, don't you? You're always welcome.

Leah and Stashu freeze, staring at each other in hopeful amazement. Nana chuckles to herself, shakes her head, and shuffles off. Exit Nana with Leah & Stashu trailing her.

Act 1, Scene 5

Later that night. The porch. Jack, clad only in his jeans, is stretched out on top of the sheeted roll-out bed. Behind him is Stashu.

Enter Emily, gently prodded by Leah. Emily wears a soft, white cotton nightgown beneath a simple open robe. Nervous, she clutches a pillow and blanket to her chest.

JACK: (signing, Stashu voicing) Emily! Something wrong?
EMILY: (signing, Leah voicing) Are, are you comfortable, Jack? Do, do you like it here? I, I brought you an extra blanket. It can get cool out here.
JACK: Feels good though. Today was a scorcher.
EMILY: Yes, it was. But tomorrow will be worse.
JACK: Worse?
EMILY: It's July. And this is Ohio.

Jack groans. Emily starts to leave. Leah blocks her path. Emily pauses, turns back to Jack.

EMILY: It doesn't get hot, back East?
JACK: Oh, no! It gets hot. And humid too. It's just that, well, when you're away from something you just remember the good stuff, y'know? The bad stuff you just sorta forget.
EMILY: That's strange, isn't it?
JACK: What's that?
EMILY: Memory. How it works.
JACK: (intrigued) Why? What do you remember?
EMILY: (elusively) Oh, lots of things. Sometimes, if I close my eyes? I can almost taste them... smell them... feel them! Sometimes I wonder if I'll ever feel them again!

Emily shivers. Leah longs to embrace her, but Jack rises first.

JACK: (concerned) Are you cold?
EMILY: A little.

Stashu tries to nudge Jack into action, is pleased when Jack responds with little prompting.

JACK: Here. Maybe you'd better take this.

He picks up his jacket and drapes it around Emily's shoulders. Emily closes her eyes, savoring the contact.

EMILY: Thank you.

Jack stares at Emily, stunned by the intensity of his own feelings.

JACK: (gruffly) You're welcome.

Jack backs away, stands behind the wicker couch. He and Emily exchange glances, then nervously look away. Jack clears his throat and motions to the couch.

JACK: Would you like to sit?

Emily, after a pause, accepts, her body stiff and prim. Jack joins her, his body language more open and accessible.

EMILY: You'll be going soon.
JACK: Thursday.
EMILY: (sighing) Yes... soon... We don't get much company out here.
JACK: Why's that?

EMILY: Well... we're all alone, way out here, on the farm.
JACK: What do you do?
EMILY: Do? Why, we, we work. And talk. To each other. Jessie has school and... and her tv. She's not deprived.
JACK: Do you ever go to the movies?

Stashu's face lights up at the notion.

EMILY: (taken aback) Movies?
JACK: Yeah! Movies. You have movies, don't you? Please tell me you have movies!
EMILY: Yes.
JACK: (afraid to hope) Yes?
EMILY: We have movies. But I don't go.
JACK: Why not?
EMILY: (dejected) I can't understand... what they're saying.

Stashu and Leah both sag slightly in defeat.

JACK: (newly fired up) Well why the hell can't you? You're not blind!
EMILY: What?
JACK: (taking charge) And Jessie's not deaf! Do you have a car?
EMILY: No.

Jack groans, sorely disappointed.

EMILY: We have a truck.

Jack sits up, hopeful once more.

EMILY: It's not working. Sometimes it's hard to start.
JACK: Hmmm. Could be the battery. Maybe the carburetor.
EMILY: You know how to fix trucks?
JACK: Well, sure I know how to fix trucks! You gotta know trucks! First thing in the morning I'll take a look, get it running, and then we'll take off, to the movies.

Emily nervously rises, putting distance between her and Jack.

EMILY: I'm not sure this is a good idea.
JACK: Emily! Don't tell me you want to live your whole life without seeing a movie!
EMILY: I, I've never been! I wouldn't know what to do!
JACK: Do? What's to do? You sit in a nice, plush, cushy seat.

He steers Emily back to the couch.

JACK: And stuff your face with popcorn.
EMILY: Popcorn?
JACK: Dripping with butter. And salt! Lots and lots of salt!

He broadly pantomimes this.

EMILY: Oh my God!

Jack hurries around, sits next to Emily, pantomiming still.

JACK: Wash it down with ice-cold Coke…
EMILY: Coke?
JACK: Or do you prefer Orange Crush?
EMILY: No, no, Coke is fine.
JACK: Then you whip out your hanky.
EMILY: My hanky?
JACK: Because you're gonna cry.
EMILY: I am?
JACK: It's not a good movie if you don't cry. Even comedies. They're not really funny until you laugh *and* cry. So, what do you say, Emily? Is it a date?
EMILY: (excitement overcoming doubt) I, I… *yes!*
JACK: (pleasantly surprised) Yeah?
EMILY: Oh, yes! Wait until I tell Nana!
JACK: (with a grin) Think she'll be excited?
EMILY: (elated) Oh yes! And Jessie too!
JACK: (sobering) Jessie. Oh, yeah. Jessie.
EMILY: (perplexed) You want Jessie to come, don't you?
JACK: Yeah, I mean… she's gotta come! To help me out.
EMILY: Oh Jack!

She touches Jack's arm.

EMILY: I'm really glad Jessie brought you home, Jack!
JACK: You are, huh?
EMILY: Yes. Really. Good night.

Emily leans forward to kiss Jack's cheek. He surprises her by turning his head, kissing her lips. Emily immediately breaks away, rises, obviously shaken, as is Jack by the intensity of his emotions.

JACK: (gently) Good night, Emily.
EMILY: Good night, Jack.

Emily turns away, begins to leave, realizes she still has Jack's jacket. She turns back to Jack, hands him the jacket. Both of them hold their ends, each reluctant to let go, to break their contact. Finally, the jacket slips through Emily's fingers. She breathes deeply, turns, and heads back inside. Exit Emily.

Jack grins, shakes his head, and leans back, hugging his jacket to his chest. Leah and Stashu look at each other hopefully. Lights fade.

Act 1, Scene 6

Next morning. Lights come up on the porch. Stashu watches as Jack pulls a clean shirt out of his duffel bag. Enter Jessie, still in her night shirt, trailed by Leah, absolutely furious.

JESSIE: (speaking only, Leah signing) What the hell do you think you're doing?
JACK: (speaking only, Stashu signing) Better not let your mother hear you talking like that.
JESSIE: Don't tell me how to talk to my mother! Who the hell do you think you are?
JACK: At least your mother had a robe.
JESSIE: A robe?... *Ohhhh!*

Jack finishes buttoning his shirt and begins combing his hair.

JACK: You better go get ready.
JESSIE: I'm not going anywhere! Not with you!
JACK: The first show is at ten.
JESSIE: I'm not going!
JACK: And then I thought I take y'all out for lunch. They got a nice restaurant in town?
JESSIE: Where do you think you are? New York City?

Jack looks at Jessie sharply. She flushes, hangs her head, mutters.

JESSIE: Big Boy.
JACK: Don't be fresh.
JESSIE: That's the name of the restaurant!
JACK: Big Boy?
JESSIE: They have chili, hotdogs, hamburgers 'n stuff.
JACK: (dryly) Stuff.
JESSIE: You know, sandwich platters. French fries. Hot fudge sundaes. *Jello.*
JACK: They got flowers?
JESSIE: (sputtering) Flowers! They've got *booths*! Paper placemats and *booths*! Okay?
JACK: But the food's good?
JESSIE: What? Yeah! I mean, the kids from school go there all the time!
JACK: You ever go with them?
JESSIE: What? No! I mean...

Jessie breaks off, embarrassed, then erupts in fresh fury.

JESSIE: We were doing just fine until you came here!
JACK: You invited me, remember?
JESSIE: We didn't bother anybody, nobody bothered us. We were happy!
JACK: (quietly) Were you?
JESSIE: YES! We were doing just fine! And now you want to go and, and…
JACK: And what, Jessie? What do I want to do?
JESSIE: (yelling furiously) MESS EVERYTHING UP!
JACK: (with a sad shake of his head) And you're the one who wants to go to Colorado. When you're afraid of your own shadow.
JESSIE: (yelling, dangerously close to tears) I'M NOT AFRAID OF ANYTHING!
JACK: (with compassion) Oh, Jess…
JESSIE: *Jessie*! My name is *Jessie*!
JACK: (soothingly) It's okay, Jessie… it's okay.
JESSIE: (angrily, defiantly) No, it's *not* okay. It was *never* okay! Growing up out here, with Mama, with Nana, with no *father*! Having to be *responsible* for everything! Having to do all the *talking*! Do you know what my first memory is? I'll *tell* you what my first memory is! My first memory is Mama holding me up to the phone and signing to me to tell the operator to send help.
JACK: Help?
JESSIE: For Pop-Pop. My great-grandfather! He had a heart attack!
JACK: Oh, Jessie…
JESSIE: The only other person in the house who can talk, and he goes and dies!
JACK: How old were you?
JESSIE: Four! I was four years old! But I did it! I made that call! Just like I did all the rest! Nana, Mama and me, we take care of each other! We don't need you or anybody else coming in here and messing things up!

Stashu and Leah stand stricken, unable to touch Jessie, who stands rigid, quivering with emotion. Jack reaches out and clasps Jessie in a fiercely protective hug. Startled, Jessie momentarily stiffens, then, with a tearing sound, throws her arms around Jack and sobs. Jack hugs her close, rubs her back.

JACK: You never were a kid, were you? You weren't allowed to be.

Stunned, Jessie pulls back. Jack wipes her tears.

JACK: I'm gonna be leaving soon, remember? Another day, and you'll never see me again.
JESSIE: (crestfallen, pulling away) Oh. Yeah… to Colorado…
JACK: I'll remember you.
JESSIE: (fighting fresh tears) Oh!

JACK: Hey! Jessie? Hey, it's nothing to cry over!
JESSIE: I'm not crying!
JACK: Your mama and I? We thought the movie would be a real treat – for all of us.

Jessie looks at Jack wonderingly.

JACK: What d'ya say? Will you help me make this day special? For your mama and Nana?
JESSIE: A *movie*? You want me to sign a whole damn *movie*?
JACK: (with a teasing grin) Think you're up to the challenge?
JESSIE: (with a shrug) I don't know…
JACK: Come on, Jessie. It wouldn't be the same without you.
JESSIE: It wouldn't?
JACK: Naw… wouldn't be half the fun!

Jessie snorts, swipes at her eyes, her nose, and nods her head "yes."

JACK: (feigning deafness) What's that?

Jack cocks his ear by Jessie's mouth.

JESSIE: (shouting in Jack's ear) Yes! I said yes!
JACK: You'll go?
JESSIE: I'll go.
JACK: You're all right, Jessie.
JESSIE: (self-deprecating) Oh, yeah… I'm just *fine*.

Intermission.

Act 2, Scene 1

That night. The farmhouse kitchen. Nana, Emily, Jack, and Jessie sit around the table, laughing and talking. A pitcher of ice tea and a covered cake-pan are on the table, along with dessert plates and forks. Leah and Stashu hover by, voicing the scene.

NANA: (signing only, Leah voicing) Tell me what they're called again. Those men, those little men in the funny green suits.
JACK: (fingerspelling, Stashu voicing) Leprechauns.
NANA: That's it! Leprechauns! I loved that movie! I loved the leprechauns! All the tricks they played? Oh, they were so clever! How come I never see a leprechaun here?
JESSIE: (signing only, Stashu voicing) There aren't any leprechauns, Nana.
NANA: Yes there are! Sure there are! I saw them! In the movie!

JESSIE: Leprechauns aren't real.
NANA: Ohhh! Movies make me so confused.

Jack, Jessie, and Emily laugh.

JACK: What about you, Emily? What was your favorite part?
EMILY: (signing, Leah voicing) Oh! Well… I don't know! I had so many!
JACK: (signing only, Stashu voicing) You liked it, huh? You could follow it okay, with Jessie and me signing?
EMILY: Oh, yes! Perfectly!
JACK: So, what was your favorite part?
EMILY: Well, I loved *him* of course. That actor, you know? What's his name?
JESSIE: (smirking, signing only, Stashu voicing) Sean Connery? 007? Huh! Who doesn't?
EMILY: And I loved… oh, I don't know! I loved feeling that I was someplace different! That beautiful little cottage? With that open fireplace?
NANA: (signing, Leah voicing) Couldn't you almost *smell* that pot of stew simmering there? I wonder what it would be like to cook like that, over a fireplace?
EMILY: (continuing her musings) And, and the clothes. And, oh, the *hills*! You never see hills around here! Soft, rolling green hills. And, oh… and the ghost? Ohhh!
JACK: (with a grin) The Banshee? She scared ya, huh?
EMILY: (shivering) The Banshee, ohhh!

Stops, stares at Jack, hands on hips.

EMILY: Wait. How did you know she scared me?
JACK: (mock grimace) You were squeezing my hand so hard I thought you'd break my fingers! Oh, b'golly, you did break 'em. See?

He lets his hand hang as though broken.

EMILY: Oh, I, I'm sorry! Are you all right?
JACK: Oh! Oh!

He blows on his thumb, and his hand which pops up, "magically" heals.

JACK: It's, it's a *miracle*!

He fingerspells "miracle" and Nana, Emily, and Jessie burst out laughing.

NANA: Ha! You a funny man, Jack! You want more cake, yes?
JACK: No, no! I can't really! Not after all that chili I ate.

NANA: You know you do! Fresh coconut. Made it myself. Here. A small piece.
She cuts a generous slice.
JESSIE: (to Jack) I told you they made good chili. (to Nana and Emily) He thought we didn't have any place decent to eat around here.

Emily walks around to Jack's side, serves him the cake, rests her hand on his shoulder. Jessie, noticing, acts even more rambunctious.

JACK: (signing to Jessie, Stashu voicing) I thought that, huh?
JESSIE: (signing only, Leah voicing) Well, words to that effect.
JACK: You're a fine one to talk! I didn't notice you going hungry.
JESSIE: What! You told me to get what I wanted!
JACK: A bowl of chili, a hamburger platter, and a chocolate shake?
EMILY: (signing only, Leah voicing) Jack's right. You ate a lot, Jessie.
JESSIE: I was hungry!
JACK: What do you think I am? Made of money?
JESSIE: (sobering, worried) Oh… what, are you *broke*? I've got some money upstairs. I was saving it for… oh never mind, I'd never have enough anyway. It's only five bucks but..

Jessie jumps up, heads for the stairs.

JACK: (voicing only, Stashu signing) Jessie, wait! Jessie. *Jessie*! Where's your class?

Jessie stops, turns, puzzled.

JESSIE: (signing only, Leah voicing) Huh? My class? You saw it! Well, most of them. At the Big Boy.
JACK: I *mean…*
JESSIE: I know what you mean. It was your treat, and you wanted to throw your money around and impress the socks off of me 'n Mama and Nana. And have everyone in the place eatin' their heart out, wondering who the handsome devil we were having lunch with was. Right? Am I right?
JACK: (taken aback) Uh… yeah. Yeah.
JESSIE: (speaking & signing) And we sure did show them, didn't we!
NANA: (signing, Leah voicing) We had a good time. A nice meal. The *salad* could be better, but…
JESSIE: (signing only, Leah voicing) And did you see the look on Darlene Werner's face?
JACK: (fingerspelling, Stashu voicing) Darlene?
JESSIE: Yeah! Darlene! You know—big hair, big chest, little sweater, littler brain.
JACK/EMILY/NANA: Ohhh! *Darlene!*

Jack signs a "D" by the nipples like swirling tassels. Nana and Emily giggle helplessly.

JESSIE: Yeah! That's her.
EMILY: She looked like, like… oh, like, like…
JESSIE: Like she wanted to throw herself at your feet on a bed of lettuce!

Jessie throws herself at Jack's feet, bowing as though he is a sultan. Jack, playing along, rises, lords it over Jessie, strutting and flexing his biceps. Emily and Nana erupt with laughter. Jack joins in a beat later.

JESSIE: Well? Didn't she? Didn't she?
NANA: Oh, Jessie! You are priceless! More tea, anyone? Or coffee? Jessie? Some milk?
JESSIE: Just tell me one thing, Jack, and be honest! Do men like that?

Emily and Nana look at Jack expectantly. Jack sobers, fidgets.

JACK: Uh, well… I don't know if "like" is the right word.
JESSIE: (slumps with despair) Oh geez… there's no hope.
JACK: Now what makes you say that?
JESSIE: Oh, come on! I mean, look at me!
EMILY: You're fine, Jessie. There's nothing wrong with you.
JACK: Your mother's right, Jessie. You're a beautiful girl.
JESSIE: See! That's what I mean!
JACK: Did I say something wrong?
JESSIE: You said "girl."
JACK: Jessie, there's girls, and then there's *girls*.
JESSIE: And—let me guess, Jack—I'm a girl.
JACK: Yes, damnit! And you should be proud of it! Any fool can want a *girl*, but it doesn't mean he wants to marry one!

Jessie shudders violently.

JACK: Jessie, you don't need to be afraid of men. We're not going to hurt you. We're not, we're not *leprechauns* out to trick you against your will. We're people! Flesh and blood. Just like you.
JESSIE: No, you're not! You're, you're… different!
NANA: He's a man, Jessie, that's all. Just a man.
JESSIE: (to Jack, vehemently) You look different, smell different, act different. You *think* different.
JACK: *Think* different?
JESSIE: Yes!
JACK: So, what are you saying? You want to be alone for the rest of your life?

NANA: Of course she doesn't! Jessie will settle down, have a family.
JESSIE: *I don't want that!*
NANA: Of course you do! A man to cook and clean for? Children to raise? 'Course you do.
JESSIE: I want someone to love me for *me*! I want him to look at me, and I want to know, that, that...
JACK: (gently) That what, Jessie?
JESSIE: (vehemently speaking & signing) That I'm enough! More than enough! That I'm everything. Everything! Me! Just me!

Jack, Nana, and Emily stare at Jessie in stunned silence. Emily rises, tries to embrace Jessie, but Jessie backs away, her signing angry as she confronts Emily.

JESSIE: (signing only, Stashu voicing) Isn't that what *you* wanted, Mama? Isn't that why you gave yourself to *him*, my father, whoever he was?
EMILY: (stung, signing only, Leah voicing) Jessie, don't... please...

Leah moves to stand protectively by Emily's side.

JESSIE: (pressing on) Isn't that why you left him, because you weren't?
NANA: (signing only, Leah voicing) Jessie, that's enough. Stop.
JESSIE: You *weren't* enough!
EMILY: (fighting panic) Jessie... later, okay? You and I, we'll talk... later.
JESSIE: Not for *him*!
EMILY: Jessie, no! You, you don't understand...
NANA: We don't talk about that here, Jessie.
JESSIE: (shouting & signing) Well why not?

Emily and Nana are stunned.

JESSIE: (shouting & signing) Did you ever stop and think that maybe, just maybe, I'd want to know? That I had a right to know? I used to think that it was me!
EMILY: You?
JESSIE: (shouting & signing) That everything would have been fine, that he wanted you, Mama... he just didn't want me.
EMILY: No, Jessie. That's not true!
JESSIE: Did he ever feed me? Did I ever fall asleep on his shoulder? Did he ever hold me? Did he ever *pick me up*?
EMILY: (half sobbing) *No!* He, he, he never knew, Jessie.
JESSIE: (shattered, signing & ragged whisper) Never? My own father?
EMILY: I couldn't tell him!
JESSIE: (signing & ragged voicing) Why not? Were you so ashamed of me?
EMILY: (desperate) No, Jessie! No!
JESSIE: Then why couldn't you tell him?
EMILY: (shouting & signing) Because he was married!

Stricken, Jessie looks helplessly to Jack and then at a grim Nana, who shakes her head and turns away. Leah reaches for Stashu, imploring his help for Emily, but Stashu looks away in silent, stubborn shame.

JESSIE: (ragged voicing & signing) Oh! Oh... you, you... oh Mama.
EMILY: (signing only, Leah voicing) I'm sorry, Jessie! I never wanted you to know, to be hurt...

She reaches out for Jessie, but Jessie backs away.

JESSIE: (bitterly, ragged voicing & signing) You're no better than Darlene.
JACK: (speaking only, Stashu signing) Jessie!
JESSIE: (bitterly, ragged voicing & signing) I thought, I always thought... you were *special*, Mama! Special!
EMILY: I'm not sorry I had you, Jessie.
JESSIE: (harsh voice & sign) But I am! You not special at all, Mama! You, you, you're just a *girl*!
 Jessie blindly turns away and runs upstairs. Exit Jessie. Nana, Emily and Jack stand for long moment in silence.
JACK: (speaking & signing) Don't you think somebody should go talk to her?

Nana and Emily do not move.

JACK: Right.

Jack slowly releases his breath and starts to head to the stairs. Emily stops him with a hand on his arm.

EMILY: (signing, Leah voicing) No. It's my place. I'll do it.
JACK: (speaking & signing) Sure you're up to it?
EMILY: (anxious, agonized) I'm her *mother*!

Emily bites her lip, turns, and, trailed by Leah, starts to head after Jessie while she still has her nerve. Jack watches her go, his face etched with concern and empathy.
 Nana utters a low, moaning sigh. Jack and Stashu turn to her in alarm. Jack takes the chair next to hers, holding her hand, while Stashu hovers nearby. Nana, Jack, and Stashu freeze. Lights fade over the kitchen table. A spotlight follows Emily and Leah.

Act 2, Scene 2

Moments later. Night. Jessie's bedroom. Jessie, crying, angrily tears open drawers, flinging clothes into a suitcase. Enter Emily, trailed by Leah. She picks up and folds a few clothes.

JESSIE: (harsh voice & sign throughout) Don't touch those!
EMILY: (signing, Leah voicing throughout) It's okay, Jessie. Just sit. I'll do it.
JESSIE: I said, leave them alone!

Jessie angrily knocks the clothes from Emily's hands. Emily momentarily recoils in the face of Jessie's anger. Then she picks up one of Jessie's shirts and hugs it to her chest. She strokes it gently, as though it holds a younger, tender Jessie. Emily lowers her cheek to the shirt collar, close to tears. Jessie is torn between fury and dismay.

JESSIE: Shit!

Emily lowers the shirt, folds it lovingly, and places it in the suitcase.

EMILY: You'll need a new jacket.
JESSIE: I don't need anything. I just need you all to leave me the hell alone!
EMILY: You've outgrown yours. I'll go get mine.
JESSIE: I don't want anything of yours.
EMILY: It can get cold, Jessie... out there. So cold...
JESSIE: (vehemently) Ever!
EMILY: You'll need boots. A hat. Gloves... money.
JESSIE: Will you *stop*?
EMILY: I wish I had known. I didn't think this day would come—so soon. You'll need a dress. I could've made you a dress... if I had known.
JESSIE: (ragged voice & sign) You're sending me *away*?
EMILY: You're going, Jessie. All by yourself. You're already half-way gone. Oh, Jessie! I know what you're feeling!
JESSIE: (vehemently) No! You don't! You have no idea!
EMILY: I look at you, and I see myself.
JESSIE: No! I'm not like you! I'm not!

Emily moves about the room, as though in memory.

EMILY: This used to be my room.

Jessie watches, wary and defensive.

JESSIE: Your room?
EMILY: I used to sit here, right under the window, and sew. First doll clothes from the scraps Nana gave me, and then clothes. For special.
 I loved to read! Stories, poems, books... I'd lay on my stomach and read for hours! And then I'd sit up and sew the dresses I pictured those ladies wearing, all those pretty ladies in their beautiful stories...
 I'd sew. Look out the window, and dream and sew. Dresses, one after another... I'd slip them on and twirl around, dancing, laughing, and dreaming—always, always dreaming. Then I'd fold them. Place them in the trunk. And save them..for special.
JESSIE: (harshly) This isn't a fairy tale, Mama!
EMILY: Yes it is, Jessie.

Jessie rolls her eyes and turns away. Emily grips Jessie's chin, forcing her to listen.

EMILY: (heartfelt) It has to be! Don't you see? If you don't believe? If you don't let yourself dream? Then all it is is just one long, hard road. There's no welcome! Nobody waiting for you at the end. And I don't want that for you Jessie. Never for you!
JESSIE: (bitterly) You were never going to tell me the truth, were you?
EMILY: (newly stung) I'm telling you the truth, Jessie. I'm telling you now!
JESSIE: No! You're doing what you always do, making believe.
EMILY: No! No...
JESSIE: You don't tell me anything, Mama! Nothing I need to know!
EMILY: I'm telling you, Jessie! I'm trying... this is so important!

Jessie scoffs and throws Emily off.

EMILY: (frustrated desperation) Listen to me!

Emily grabs for Jessie, but Jessie, with a hiss, turns on Emily with a look of cold, hate-filled contempt. Emily, startled, instinctively pulls away. Jessie slowly smiles, her entire manner hardening. Seductively, she moves in on Emily, taunting her. Emily backs away as Jessie advances.

JESSIE: (taunting) Which one did you wear? Huh? All those dresses, those clothes for "special"? Which one did you wear when you met *him*?
EMILY: Jessie... please.
JESSIE: Was it a *red* one? A *black* one? Did you wear your hair up, Mama? Huh? Did you wear silk stockings? High heels? Did you wear perfume? Lipstick? What color was your lipstick, huh, Mama? Ruby? Plum? Tangerine? Huh, Mama? What color? Huh, Mama? What color?
EMILY: (screaming & signing) *Pink! It was pink!*

Jessie freezes, stunned.

EMILY: What I did, it was wrong! All wrong. But I didn't know that then! At the time, it felt right. I thought, I thought, I thought *I* was writing the story!

She reaches to stroke Jessie's cheek.

EMILY: Oh Jessie... things *happen*. Things just... happen.
JESSIE: (sharp criticism) Not if you don't *let* them, Mama.

Emily flinches. Jessie holds her breath, afraid she's gone too far.

EMILY: You're tired, Jessie.
JESSIE: Mama, I… I didn't mean…
EMILY: We both are… tired!

Exit Emily and Leah. Jessie sits on her bed, dejected.

Act 2, Scene 3

Moments later. Kitchen. Lights come up to reveal Nana and Jack seated at the table, Stashu and Leah looking on.

NANA: (signing, Leah voicing throughout) Mistake.
JACK: (signing, Stashu voicing) Ma'am?
NANA: Big, big mistake.
JACK: (dismissive) Oh… *that*? Shoot, that wasn't so bad. All teenagers are prickly as porcupines. Feel the world owes them a living or something. She'll get over it.
NANA: And what does the world owe you, Jack?
JACK: (brought up short) Uh…
NANA: In Jessie's eyes you are such a man of the world. But I'm much older than Jessie. Much older. Years and years and… so many years! Sometimes I wonder why I'm still here.
JACK: (speaking & signing) Oh, now, hey! You're not that old! You still got plenty of years! *Plenty!*
NANA: (sharply) Oh! Save your pretty words! You! You, young ones! Think you can *talk* yourself in and out of anything! Nothing *means* anything to you! Not honor, not family, and especially not your word!

She pounds the table. Jack jumps.

NANA: I lived here all my life! Did you know that? *All my life!* See that stove over there? That wood-burning stove?

She points upstage to the stove.

NANA: See it? That was where they put me, my mama and papa, after I was born. I was born too early. "Pre-ma-ture" they call it now. A blue baby. The doctor told Papa to build me a box. But they put me in the stove instead.

Stashu moves protectively by Nana's side.

JACK: (caught up in story) And you lived.
NANA: Yes… I lived. Right here. With Mama and Papa, and my two brothers, and my sister. We had cows then. Chickens and goats. Pigs too. And we had a garden—a huge garden!

She sits back, looks around.

NANA: This house? Most of the rooms upstairs are closed off now, I'm an old woman. But then? Those rooms were filled—all of them. Mama and Papa rented them out. Family, friends, it didn't matter, they'd put anybody up. Anybody who'd help out, chop some wood, wash some clothes, keep the place clean—for only $6 a month! Stashu and me, we lived upstairs, after we were married…

JACK: Stashu?

NANA: My husband.

JACK: What was he like?

NANA: Stashu? Oh… He was a good man, you know? Quiet, strong, and always there.

Stashu's hand hovers above Nana's shoulder. Nana sighs.

JACK: Was he deaf too?

NANA: Stashu? No. Not deaf. Not Stashu.

JACK: Then how did you talk?

NANA: Stashu? Well, he lived here, in one of the rooms he rented from Mama and Papa. He'd eat with us. He saw how the family talked to me and just picked it up, same as you. Talk was never a problem.

Stashu smiles at the memory. He signs "I Love You" to Nana, but she doesn't see him, doesn't respond. Stashu sags slightly with despair.

JACK: Sounds like he was a real nice guy.

NANA: I liked him. We were good together. Papa, Mama, everyone saw that. We lived upstairs after we were married, to save money, until we could be in our own house. We had Leah here. Emily's mother.

Leah looks up.

JACK: So you stayed.

NANA: Yes… we stayed. First for Papa, and then for Mama.

JACK: (gently, speaking & signing) I'm sorry.

NANA: You are? Why? Does my life seem a waste to you?

JACK: I didn't say that.

NANA: But you are thinking that, aren't you? It might not have been everything I wanted, all I expected, my life. But it's been a good life. And do you know why? Because it is the life I was meant to lead. *Duty*! That is what shaped my life—duty! Being responsible. Giving back. It's not what they said, my brothers and their wives, my sister and her rich husband, not a burden. It is an honor! A gift! It makes you strong, duty. It makes you strong so you can bear anything—everything! Do you understand me?

Stashu and Leah both try to touch Nana, but can't.

NANA: (fiercely, fighting tears) But him! Him! Did he do his duty? Did he honor his wife? Did he honor my Emily? Words! So many words! But nothing we could understand. He had *ways*. Fancy words and fancy ways that still meant nothing. Nothing!

Leah looks shattered at this revelation. Stashu steadies her.

NANA: (forcefully) I asked you a question, Jack. And I'm still waiting for an answer. What does the world owe you?
JACK: The world? Nothing. But I owe you a lot. More than I can ever repay.
NANA: (mixed relief and regret) So, you are still leaving? Tomorrow?
JACK: Yeah…

He rises. Nana looks up, half afraid. Jack reassures her.

JACK: I'm just going out. Chop some wood. Want to make sure y'all have enough for the winter.
NANA: Jack…
JACK: (pressing on) And I want to check those screens. On the porch. I think they need patching.

Jack moves to pass Nana. She reaches out and grabs his hand.

NANA: Thank you, Jack. Thank you.
JACK: (gruff emotion) Yeah.

Nana pats Jack's hand. Jack returns the pressure, then turns to go. Exit Jack. Nana sits in her chair, once again tracing the checkered pattern of the tablecloth as Leah and Stashu watch.

Act 2, Scene 4

Very late that night. The screen porch. A bluish light illuminates Jack lying on top of his roll-out bed, the sheet folded at the waist to reveal his bare chest.

Enter Emily, clad in the same white cotton nightgown of before, trailed by Leah. She slowly reaches out and brushes a lock of hair back from Jack's forehead. Jack's eyes fly open as he grips Emily's arm and sits bolt-upright.

JACK: (speaking & signing) Emily!

He drops Emily's hand. Emily hugs herself, shivering with emotion.

JACK: What's wrong? Jessie?
EMILY: (signing only, Leah voicing) Hold me, Jack. Please, God, just hold me!

Jack reaches up and pulls Emily down beside him, strokes her back as she cries.

JACK: Shhhh. It's all right, Emily. It'll be all right... Shhh...

Emily sits up, but can't stop her tears.

JACK: (concerned) You okay? Jessie rough on you?
EMILY: I'm so ashamed!
JACK: You have nothing to be ashamed about Emily.
EMILY: How can you *say* that? After what I've done? Look at me! No husband, no home, no family!
JACK: (still speaking & signing) Why do you stay, Emily? Way out here? On the farm?
EMILY: (anxiously) Why? I, I... *because*!
JACK: (still speaking & signing*)* *Because why?* Why, Emily? Why?

Emily jumps to her feet, stands quivering with emotion.

EMILY: (defiantly) Because I have no place else to go! *Look at me!* What do you see?
JACK: (gently speaking & signing) I see a beautiful woman.
EMILY: A *deaf* woman!
JACK: That's no excuse, Emily. It's no reason to bury yourself.

He rises, moves to Emily, who turns on him.

EMILY: (with much feeling) I'm not like you! You and Jessie! You, you can go anywhere! Do anything! I can't! Don't you see? I tried! I tried! But I can't!
JACK: (speaking & signing) When did you try, Emily? When?
EMILY: (snapping anger) You know when!
JACK: (speaking & signing) With Jessie's father?
EMILY: I don't want to talk about it!
JACK: (speaking & signing) That wasn't trying, Emily.
EMILY: It was! It was so... it was so... hard! It was so hard! Reaching out like that? Opening myself up? Letting another person get close? I was scared! I'd never done anything like that! Never!
JACK: (speaking & signing) So why did you do it then?
EMILY: Because, because... I was afraid! I didn't want my life to just pass me by, like Nana's!
JACK: (sadly, speaking & signing) Is that how you see her life?
EMILY: Stuck out here, way out here, all alone. I didn't want that! I wanted a home! I wanted a family! Someone to love me!
JACK: (shouting & signing) Then why did you pick someone who was already married?

EMILY: (anguished screaming & signing) BECAUSE HE WAS THERE! BECAUSE HE WANTED ME!
JACK: Oh, Emily...

He pulls Emily against his chest. She resists for a moment, then clings to him, totally bereft. Jack rocks her, rubs her back. After a bit, Emily calms somewhat, and Jack lifts her chin, gazes in her eyes.

JACK: Do you remember when you first came out here? That first night? Was it just last night? Asking me if I was comfortable?

Emily nods her head "yes."

JACK: You said something then. Something that stuck in my mind.
EMILY: I said something?
JACK: You were talking about memories. How, sometimes they seemed so real...
EMILY: (finishing thought)... you can almost taste them, smell them, feel them.

Emily and Jack lock eyes, staring at each other.

JACK: Come away with me, Emily.

Leah and Stashu, startled, hold their breath.

EMILY: (brokenly, with regret) I can't.
JACK: We could be together. You 'n Jessie n' me...
EMILY: (anguished) Nana would never leave. And I could never leave Nana. Not after everything she's done for me.

Jack sighs heavily, aware that Emily is speaking the truth.

EMILY: Hold me, Jack. *Hold me.* Give me memories. Memories I can take out and touch, and taste, and feel.

Jack hugs Emily fiercely, she returns the hug. Then, heads touching, fingers touching, Emily asks a question.

EMILY: This is real, Jack? Isn't it? This is real?
JACK: (gruffly, with raw emotion) Yes, Emily... it's real.

Emily and Jack's fingers entwine. Stashu and Leah, watching over them, clasp their hands and bow their heads. Lights slowly fade.

Act 2, Scene 5

Thursday afternoon. The bus stop. Jack, duffel bag at his feet, ticket in hand, paces. Jessie sits on the bench, watches him, Stashu and Leah flanking her.

JESSIE: (speaking, Leah signing throughout) It'll come.
JACK: (speaking, Stashu signing throughout) You sure?
JESSIE: It's Thursday.

Jack checks his watch and swears.

JACK: Damn! Where the hell is it?
JESSIE: It's not two yet.
JACK: It's ten of!
JESSIE: What's your hurry?
JACK: I just like things to run on time.
JESSIE: I told you—
JACK: I hate being late, okay?

Jessie, stung, folds her arms and stonily looks away.

JACK: I'm sorry.
JESSIE: No you're not.
JACK: I *said* I was…
JESSIE: (turning on Jack) You can't wait to be rid of us, can you?
JACK: What? No!
JESSIE: Can't wait to get to Colorado and put as many miles between us as possible. Is that gonna be far enough for you? Colorado? Is it, Jack?
JACK: What?
JESSIE: You ran away from Margaret Mary!
JACK: Margaret?
JESSIE: Didn't you! *Didn't* you! Where'd you go that time, Jack? Texas? Was that far enough away from Margaret Mary? Was it?
JACK: (muttering) You don't know what you're talking about.
JESSIE: Because I'm just a kid?
JACK: I asked your mother to go with me!
JESSIE: (stunned) My mother?
JACK: Last night.
JESSIE: So, so… why isn't she here? Why aren't we going with you? You know I want to see Colorado! You *know* that! I told you that!
JACK: (sadly) She couldn't do it, Jess.
JESSIE: (shouting) Of course she couldn't do it! My mother? She wouldn't do something like that, just get up and run away with, with… she wouldn't *do* that, no matter what you heard!
JACK: I asked her to marry me!

JESSIE: (sucker-punched) Ohhh…
JACK: Jess…
JESSIE: Jessie! My name is Jessie!
JACK: Jessie then. Please, I don't want to leave…
JESSIE: (grasping at hope) You don't?
JACK: Not like this.
JESSIE: (newly hurt) Oh! Oh! Just, just leave! Just get out of here!
SHE JUMPS UP, STARTS TO RUN OFF, CROSSING THE STAGE.
JACK: (calling) Jessie!
JESSIE: (halting, livid) You had no right, Jack! No right! Come stay with us a few days? Think you know all about us? Ask my mother to *marry* you? You had no right!
JACK: Jessie! Wait!
JESSIE: Why should I? You know you're going to go away. You always go away! Why should I stay here and watch?
JACK: Jessie, please!
JESSIE: I never want to see you again, Jack! Do you hear me? I never want to see you again!

Exit Jessie. Jack shakes his head, turns to look in the opposite direction, then hoists his duffel bag. Leah and Stashu look off first in JESSIE's direction, then Jack's, then, shoulders sagging, heads bowed, they stand there, hands folded, the picture of defeat.

Act 2, Scene 6

Two months later. Fall. Night. The farmhouse kitchen. Nana, Emily, and Jessie, in sweaters, sit around the table. Jessie is doing her school work, Emily is mending, Nana is looking at a photo album, Stashu and Leah nearby.

NANA: (signing, Leah voicing throughout) Ah, here it is!
EMILY: (signing, Leah voicing throughout) What, Nana?
NANA: Your baby picture.
EMILY: My baby picture?
NANA: When you were baptized. Look! Emily, look!

Nana taps the album, Jessie and Emily follow her finger as she points out people in the long-forgotten photo.

NANA: There's me, Stashu, Leah and Arnie, holding you—Emily.

Emily shakily strokes the picture.

JESSIE: (signing, Stashu voicing until noted) Those were your parents, Mama? You look like them.

EMILY: I don't want to talk about it.
JESSIE: You won't even read his letters!
EMILY: Those are *my* letters, Jessie! Jack writes them to me!
JESSIE: Then why won't you read them? You read everything, Mama, why not them?
EMILY: (cornered, lashing out) Why, Jessie? Why do you read them, when they hurt you so?
JESSIE: Because, Mama. Because… I want to know!
EMILY: Know what?
JESSIE: What it feels like!
EMILY: (groaning sigh) Oh, Jessie!
JESSIE: He wants us to come! He wants us to go to Colorado!
EMILY: No.
JESSIE: He'll send us money, Mama! For the bus. It won't cost us a thing!
EMILY: I said no!
JESSIE: But Jack said—
EMILY: *I can't leave Nana!* Can you?
JESSIE: Why can't Nana come with us?
NANA: I'm too old, Jessie.
JESSIE: (defiantly) No you're not! You've been around all my life! You'll be around forever!
NANA: (rueful laugh) Oh, I hope so Jessie! To watch you finish growing up? I hope so.
JESSIE: But why can't you come?
NANA: Because my life is here, Jessie. With Stashu. With Mama, with Papa. With the babies we buried. With Leah… Leah and Amie…
JESSIE: But they're not here!
NANA: Yes they are, Jessie. They're everywhere I look. Oh Jessie! You are young! But someday, someday you will understand. Someday… just like Mama.
JESSIE: Mama?
NANA: You understand, Emily. Don't you?
EMILY: (heartfelt) Yes, Nana… I do.

There is a knock on the door. Jessie looks up, surprised. Enter Jack, duffel bag in hand. He stands in the doorway, shivering in his denim jacket.

JESSIE: (speaking, stunned) Jack!
JACK: (speaking & signing) Last time I was here the sun almost baked my brains out. Now here it is not even October, and I'm freezing my butt off. This is one sorry place y'all live in!
JESSIE: (speaking & signing) What, what are you doing here?
JACK: (speaking & signing) I just told you. And to top it off, I'm starving to death.
NANA: (Beaming, rises, bustles about.) Jessie! Warm up some stew. Emily, slice some bread.

JESSIE: Jack? What are you *doing* here?
JACK: (with a grin) Looks like I'm staying for supper.
EMILY: You're staying?
NANA: You heard the man. He's staying for supper. Move!
EMILY: You're really staying?
JACK: Yeah. I'm staying.

Emily reaches out. Jack grasps her hand. Nana bustles about.

JESSIE: (speaking & signing until noted) What about Colorado?
JACK: (speaking & signing until noted) It's still there.
JESSIE: Are you going back?
JACK: All depends.
JESSIE: Depends?
JACK: Didn't you get my letters? I mailed them. Once a week. Didn't you get them?
EMILY: We got them.
JACK: You read 'em?
JESSIE: (guiltily confessing) I… I read them.
JACK: (signing, Stashu voicing until noted) You were right, Jessie. Colorado's a big place. Wide open spaces, mountains, blue skies.
JESSIE: (signing, Leah voicing until noted) Did you see any eagles?
JACK: Eagles?
JESSIE: You never said, in your letters.
JACK: Yeah, I saw a few eagles. They have this huge wingspan, lets them get up real high. Funny thing though is they just fly around in circles. That whole wide-open big blue sky, and they just fly around in circles… got me to thinking.
EMILY: (signing, Leah voicing) About what, Jack?
JACK: The world's a fascinating place. Fascinating!
JESSIE: So why aren't you out there in it?
JACK: I am in it, Jessie. Right here. Right now. We all are.
JESSIE: What? We're not… here? In the middle of nowhere? Huh! You yourself said this is one sorry place.
JACK: That's right. I did. And I meant it.
JESSIE: (confused) Huh?
JACK: We owe some apologies, Jessie. You 'n me both.
JESSIE: Apologies?
JACK: To your mother, for starters. And your grandmother most of all.
JESSIE: (speaking & signing until noted) Mama? Nana? What for?
JACK: (signing, Stashu voicing until noted) Oh, Jessie… sometimes we're so busy looking down the road, for… for something, you know? That, that all-consuming, damn stupid something that probably doesn't even exist.
JESSIE: (signing, Leah voicing until noted) Yes it does!

JACK: "If I can just get here, if I could just get there, then, *then* everything would be perfect then! Just down the road apiece, that's where my life will change!"
JESSIE: It will! I *know* it will!
NANA: (signing, Leah voicing) Maybe. More likely not.
JESSIE: What?!?
JACK: (signing, Stashu voicing until noted) Places won't change you, Jessie.
JESSIE: (signing, Leah voicing until noted) You changed! All those places? They changed you!
JACK: Not enough.
JESSIE: You're from the East, but you talk Texas!
JACK: But here you talk sense!

Jessie's head snaps up at Jack's words.

JACK: I was like you. Just like you. Saying I was looking... when all this time I was just running away.
JESSIE: (hotly) I'm not running away!
JACK: Jessie, it won't matter where you go, 'cause wherever you go, you still gotta bring yourself.
JESSIE: (speaking & signing until noted) I want to see it, Jack! The world. I still want to get out there and see it!
NANA: (signing, Leah voicing) We know you do, Jessie. And you should.
JESSIE: You mean that?
EMILY: (signing, Leah voicing) While you're still young. Still have your dreams.
JESSIE: Don't you have dreams, Jack?
JACK: (voicing & signing) Oh yeah, I got dreams. But more important, I got memories.

Jack stands behind Nana and Emily, one hand on each shoulder.

JACK: I've been on the road a long time... a *long* time.
JESSIE: (signing, Leah voicing until noted) And now you're gonna stop? Here? In the middle of nowhere?
JACK: (signing, Stashu voicing until noted) Yeah. This is the place. What I've been looking for all my life.
JESSIE: I'm still leaving! I'm not staying here! Even if Mama is happy to see you. Doesn't mean I have to be.
JACK: No, it doesn't. Go ahead, Jessie. There's the door. But you'll be back.
JESSIE: Uh-huh! Not me!
JACK: You won't be able to stay away.
JESSIE: How do you know? What makes you so sure?
JACK: Ties, Jessie.
JESSIE: (speaking and signing) Ties?

Misunderstanding, signing "ribbons."

JACK: (voicing & signing until noted) Good, decent, caring people. *Ties...*

Jack bends and kisses Emily's head. She smiles and looks up at him. Jessie frowns thoughtfully.

JESSIE: (speaking & signing until noted) Okay. All right. I, I guess you can… stay
JACK: It'd be all right? You sure?
JESSIE: Yeah. I'm sure. But I'm warning you. I'm still gonna leave! When I'm old enough. When I finish school. First chance I get!
NANA: (signing, Leah voicing) You should go away, Jessie. To college. Become a teacher.
JESSIE: A *teacher*?
EMILY: (signing, Leah voicing) Like Jack.
JACK: (voicing & signing) No. Don't be like me. You don't have to be like me. Just be yourself.
JESSIE: I don't know what myself is.
JACK: (signing, Stashu voicing) But we do, Jess. We do. You're that brave little girl calling for help for her Pop-Pop. That funny kid who offered a stranger a place to stay, and then defended her family, warning him not to mess things up.

Jessie swallows hard.

JACK: (speaking & signing to scene's end) But mostly, Jess, mostly, you're a beautiful girl who's gonna grow up into an even more beautiful woman.

Wry laugh.

JACK: Huh! For once you didn't jump down my throat when I didn't call you Jessie. You realize that?
JESSIE: (speaking & signing until end) I… well, it's okay… now…
JACK: It is?
JESSIE: (with touching vulnerability) I mean, if we're going to be… a… family?

Jack studies Jessie for a moment. Emily, one hand on Jack's arm, reaches out and pulls Jessie toward their inner circle. She accepts hesitantly, then, both Jack and Emily embrace her. Jessie, with a gasp of relief, embraces them in turn. They hug each other, and freeze in a family circle as Stashu and Leah look on, delighted.

Nana steps forward. A spotlight illuminates her. Stashu and Leah look up, move to stand near her. Nana beams with approval at the sight of Jack, Emily, and Jessie, and once again addresses her departed loved ones. Stashu and Leah lean closer, listening to what she tells them, interacting with Nana, who clearly senses them.

NANA: Well, Stashu, he's come back to us. Our Jack…. They look good together, yes? They make a good family.

She hugs herself, sways slightly.

NANA: Maybe I was wrong, Mama, Papa. Our Jack, he is tall! Maybe as tall as my Stashu after all.

Stashu smiles. Leah looks from Stashu to Jack and back again, measuring. Nana cocks her head, as though listening.

NANA: I'll find out. Well how do you think? When I dance with him! At their wedding!

She turns in Stashu's direction.

NANA: Stashu? Stashu, would that bother you? My dancing? With Jack?

Stashu laughs, pantomimes his approval with a "be my guest." Leah opens her mouth in protest, as though she is still a young child.

NANA: Ahhh, good, good.

She turns in Leah's direction.

NANA: No, Leah, do not worry, child. Everything is fine. Your daddy and I, we just teasing each other. Everything is fine.

She turns and studies Jack, Emily, and Jessie once more.

NANA: (sighing softly) I am happy to see this, Stashu. Emily and Jessie happy. So happy to see this.

Stashu and Leah turn and study the scene with Nana.

NANA: But Stashu? I think… I think I will be even happier to see you. You and Leah, and Mama and Papa and Arnie too. It's been so long, my Stashu. So long.

Stashu and Leah move protectively closer to Nana.

NANA: It's funny, I only ever go down that road just a piece. To town and then back again. Here, at home. But Stashu? One day, I think, maybe I will go a little further. Just a bit. And you'll be waiting there for me, won't you Stashu? There, at the road's end?

Nana reaches out one hand. First Stashu, and then Leah extend theirs. Their fingers almost touch, their bodies are close, clearly illuminating that Nana is moving more toward their world than Jack's, Emily's, and Jessie's. All pause and look back at Jack, Emily, and Jessie. They freeze, pausing in their journey. Lights fade. Curtain.

About the Author

Michele grew up with a severe hearing loss in a hearing family and became progressively deaf in her 20s and 30s. She once stated:

> My hearing loss is definitely a challenge at times. However, early on I came to see it as actually a wonderful gift and my greatest strength. For I feel it gives me *insight*. I'm an expert lip-reader, a phenomenal speaker, storyteller and, yes, a musician singer/songwriter. When someone is talking to me I give them my full attention. I'm not only tuning into their words, but into their body language, their emotions, into the story *behind* the story. Oftentimes it's not so much what people say, as what they *don't* say that tells the true story.[1]

Verhoosky studied creative writing and theatre arts at Emerson College and graduated Phi Beta Kappa/Magna cum Laude from UCONN. She then went on to study ASL and playwriting at the acclaimed National Theatre of the Deaf, and was a two-time winner of The Sam Edwards Deaf Playwriting Contest. Her first award-winning play, *A Laying of Hands*, was produced by Onyx Theatre, where it went on tour and was applauded by Gallaudet University President, I. King Jordan, before returning to New York City in 1996 for its Off-Off Broadway debut at The Judith Anderson Theatre. The production earned a rave review from theatre critic, D.J.R. Bruckner, of The New York Times. Verhoosky was twice selected as a playwright-in-residence for the National and Worldwide Deaf Theatre Conference, sponsored by the National Theatre of the Deaf. During the conference, her award-winning play, *I See the Moon*, received a showcase production directed by Tony Award-winning actress, Phyllis Frelich (*Children of a Lesser God*) in 1995. She was back again in 1997 with Aaron Weir Kelstone directing the debut of *The Middle of Nowhere*. In 2002, Michele was selected to present a new original play at the sixth Annual Women on Top Theater Festival in Cambridge, MA. Directed by Patrick Graybill, *Beyond The Blue* also debuted her talents as a songwriter. In addition to playwriting, Michele has gone on to write and illustrate children's books. Her commissioned artwork has been exhibited in art galleries and auctioned by the American School for the Deaf at their recent 200th anniversary.

Note

1 Verhoosky, Michele. "Progressively Deaf Playwright/Artist/Songwriter." Email, 17 June 2020.

10
JAYE AUSTIN WILLIAMS, *A NOT SO QUIET NOCTURNE*

IMAGE 10.1
Source: Photo by Emily Paine, Communications Photographer for Bucknell University.

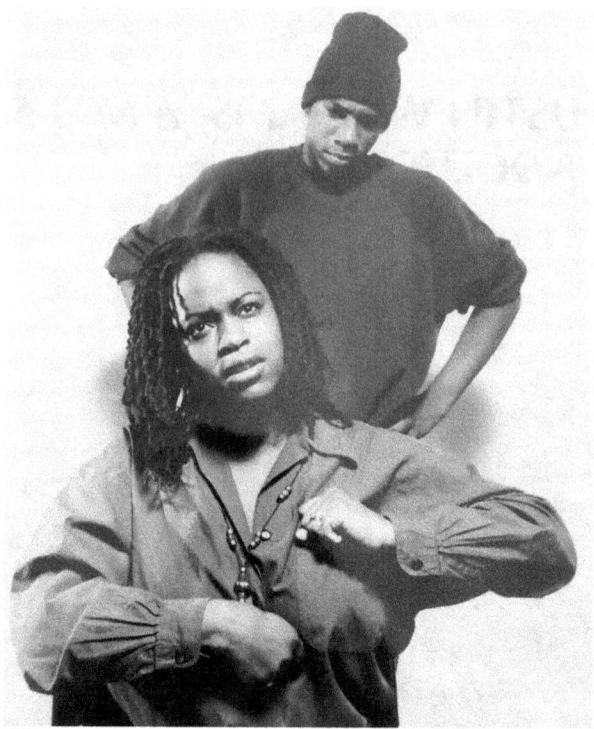

IMAGE 10.2 Michelle Banks as Charlyn (foreground), Darren Boone as Shalil (background) in *A Not So Quiet Nocturne*, directed by Jaye Austin Williams.
Source: Photo courtesy of Michelle Banks.

Synopsis

The play takes place in the present day, in an unspecified city. It concerns Charlyn Turnbull, an African American Deaf woman living with AIDS, which she contracted from her deceased husband who was a drug addict. Her dilemma, among many others, is how to properly care for her at-risk nephew, Shalil, with whom she is very close, while also navigating a complicated disease within a no less complicated health care system. She must instill in him that despite what he sees (an incarcerated father and a dead uncle) in this land where African American males are virtually an endangered species, there is still redemption in choosing life over death. Charlyn must accomplish this task in the face of mounting health complications of her own, and the likelihood that she will not win her own battle against AIDS.

Production History

A Not So Quiet Nocturne was commissioned by and developed for Onyx Theatre Company – a company devoted to Deaf and hard-of-hearing artists of color – in

1996. In 1997, Onyx produced a workshop production of the play at the Vineyard Theatre with support from the Vineyard's S.P.A.C.E. fund. Pulitzer Prize-winning playwright Tony Kushner came to see the show and fell in love with the play. He arranged for a reading of the play at the Joseph Papp Public Theatre, the producer of which was, at the time, George C. Wolfe. Shortly thereafter, he took the playwright, the lead actress, Michelle Banks (also Onyx's artistic director), along with two American Sign Language interpreters to the Breadloaf School of English near Middlebury, Vermont, for a residency and workshop presentation of the play. The play was a semi-finalist in the Cherry Lane Theatre's Mentor Project, after which it received a workshop presentation, which Yale University's Liz Diamond directed.

Onyx Theatre Company presented *Nocturne* Jan. 15–Feb. 2, 1997 at Vineyard Theatre, NY, NY.[1] Jaye Austin Williams, director; Cornell Riggs, set design; Ann Marie Duggan & Kristina Kloss, lighting design; Joanna Cummings, costume design; and Mio Morales, sound design. The cast was as follows:

Michele Banks – Charlyn
Darren Boone – Ensemble
Ann Marie Bryan – Ensemble
Robin Cornett – Counselor
Rodney Gilbert – Terrell
Laura Johnston – (Spoken) Voice of Charlyn
Jomo Kalman – Ensemble
Jon Malmed – Young Doctor
Lewis Merkin – Group Counselor
Walker Richards – Danny
Nancy Rogers – Dr. Avery
Joan Valentina – Lelia
Bernadine Vivani – Company Interpreter/Ensemble
Lisa Weems – Company Interpreter/ASL Interpreter (Character)
Devernie Winston – Young Charlyn

Thoughts on the Play

The playwright has graciously contributed the following retrospective about her play:

> I began writing *A Not So Quiet Nocturne* in the mid-1990s in New York City, while I was director-in-residence at Onyx Theatre Company. The nation was navigating through a second decade rocked by the disorienting nightmare called AIDS. This scourge was initially terrifying, because its scope was not completely known. As the '90s pressed on, however, it had become clear that the plague's main target was mostly young, white, gay men – a population that had been ravaged in droves since the early 1980s.

COVID-19, the current catastrophic plague of this century, appears to target everyone. However, as we're also seeing, anything dramatically impacting society writ large, impacts Black people exponentially worse. It is this comparison that concerned me as much in the 1990s as it does today. While Black folks have achieved much and made many inroads into mainstream society across the years, disproportionate black death rages on, a seemingly timeless "plague" and Black Deaf people are further compromised because of the complication their deafness poses to their blackness.[2]

I have always had a relationship to sound *and* to silence, having one ear that hears and one ear that doesn't – which is to say, a relationship to both hearing music and "Deaf music." I got to thinking about the mood of the nocturne – about the nocturnal (night), *le noir* (darkness, blackness). When the main character, Charlyn began to speak to me, I started to contemplate the difference between the European-rooted notion of the nocturne as quiet, eerie, brooding, and what I call the "music" of Black life, which certainly can be these, but is also so much more. To embrace Black *life* in its myriad expressions is to reckon with the turbulence by which it is so often plagued, and with the world's persistent unwillingness to "hear" (perceive/honor/value) it as integral to the living. Correspondingly, deafness is hardly "quiet" or "silent" in any one-dimensional way. Deaf people most certainly perceive the "noise" and turbulence of life – its joys and its terrors. And black deafness straddles the difficult gap between the joy of cultural belonging and the terror of societal hatred, neglect and ignorance.

This play, set in "Fall, the Present," was examining the rich sub-terrain that commingles Black Deaf people and the rest of the Black "community" that is so dramatically impacted by AIDS (among many challenges). I was plagued by the question: "How can something exponential be invisible?" The difficult circumstances by which I was surrounded growing up, and the various hustles folks had to do to pivot around them in order to survive, compelled me as a dramatic storyteller.

But there were also slippages; things I didn't yet understand as I do now. *Nocturne* uses the savvy, colorful language of the street and of the time without addressing, for example, the complexities of misogyny and *why* it circulates amidst some sectors of black social interaction. This can make the hatred and mistreatment of women appear cool, fun, and titillating, rather than something to be actively interrogated. Similarly, the use of the "N" word is something we are far more conscious about today. I did not use it excessively, and it does occur between black people in the play. However, when the audience is mixed, some context is necessary. The play runs the risk of using "good" vs. "bad" behavior as the yardstick to measure whether black people can (or should) be redeemed from suffering and struggle, rather than framing illegal behavior as a response to inescapable poverty, and questioning the ethics of the latter rather than simply the morals of the prior.

This leads to another problem: depicting blackness as only impoverished, rather than as a *structural* condition of being embattled, regardless of one's physical challenges or economic station in life. Black folks find themselves profiled, hated, assaulted, and worse, even when they are celebrities, accomplished professionals, and heads of state. Also, while intravenous drug use was a predominant mode of transmission between black people, *Nocturne* avoids any discussion of black queerness and the fact that many young black men, deaf and hearing, were being infected and dying because they were on the "down low" (in the closet about their homo- or bi-sexuality) and infecting the women with whom they were openly partnered. Addressing, at least to some degree, the complex (and persistent) stigma of queerness in the Black community would have added an important dimension.

Nocturne is also a bit utopian in certain ways: Charlyn is cared for by a noble therapist and an attentive physician, amidst a real-world climate of neglect and ignorance, and in which hospitals were utterly overwhelmed by the magnitude of the epidemic. Her brother, Terrell has TTY access to her from inside prison, when the likelihood of that in the 1990s was slim. Today, I would tone down the strain of sentimentality that runs through the play. I also forgive it as a symptom of my deep love for my family (who live in several of the scenes) and for the paradoxical beauty and complexity of Black folks' ordinariness.

I identified the black characters as African American in the casting breakdown. I had not yet learned to "trouble" this term – not to hate or reject it, but – to recognize, as the philosopher Lewis R. Gordon points out, that there are intricate distinctions between gesturing toward a *feeling* of African heritage (African American*ness*), and knowing, in no uncertain terms (transatlantic slavery having severed slaves from their African pasts) that one is *black*.[3]

These shortcomings notwithstanding, revisiting this play today, as not merely a "period piece," but as a study of a condition – antiblackness – that remains largely unchanged for black people, is deeply important.[4] The play is a meditation on unimaginable and unrecoverable loss. It is also about Black joy in the midst of suffering; not as a virtue, but as a function of trying to live. In so doing, it highlights the ways in which Black folks more readily conjoin across the otherwise firm partition between the deaf and hearing worlds. We do so in our desire to survive, and to create a rich, multifaceted Black culture, which includes the music, poetics, and deep attunement of Black Deaf people.

– *Jaye Austin Williams, July 2021*

David Lefkowitz noted in his Playbill article that *Nocturne*… is part two of Williams' AIDS trilogy, and it is with this play that she "strives to make deafness visible to hearing people and to bring the two worlds together."[5]

In her Amsterdam News review of the play, Linda Armstrong recognized that

> William's script has a strong impact because of the honesty of the writing and the honesty of the language.... It captures the drama, pain, anger, and desperation we feel when all aspects of our lives are crumbling around us. But, somehow, it manages to end on an upbeat note. Not an unrealistic happy ending, but a pause in time, where you just accept the tragedies and go on.[6]

D.J.R. Bruckner in a New York Times review emphasized that "the play's central idea – that life's richest times are brief and quiet – comes through so memorably."[7]

Deaf Gain

An authentic portrayal of the Black Deaf experience during the 1980s AIDS crisis as seen through the eyes of an African American, hard-of-hearing playwright with an extensive professional theater background. Additionally, Jaye Austin Williams was able to foster a collaboration with some of the most brilliant, innovative theater artists in the world today: George C. Wolfe, Tony Kushner, and Liz Diamond.

Notes

1. Lefkowitz, David. *Austin-Williams Nocturne to Examine Deafness, Race & AIDS*. Playbill, January 11, 1997. Retrieved from: https://www.playbill.com/article/austin-williams-nocturne-to-examine-deafness-race-aids-com-69269. Accessed 25 Jul. 2020.
2. I alternate throughout between upper case "Deaf" and lower case "deaf"; and upper case "Black" and lower case "black," to distinguish between cultural identity (upper) and a physical and/or structural condition that exceeds identity formation.
3. Gordon, Lewis R. *Bad Faith and Antiblack Racism*. New York: Humanity Books, 1995, Introduction, 1–2.
4. As of 2017, statistics from the Centers for Disease Control (CDC) indicate that AIDS is still fatal to 52% of black people who contract it, while most other populations infected with the HIV virus are now able to live with it as a chronic condition.
5. Lefkowitz, David. *Austin-Williams Nocturne to Examine Deafness, Race & AIDS*.
6. Armstrong, Linda. "'A Not So Quiet Nocturne' Explosive and True to Life." *The Amsterdam News*. February 1, 1997, 30.
7. Bruckner, Donald J.R. "Trying to Save a Nephew While Dying of AIDS 'A Not So Quiet Nocturne' Vineyard Theater." *New York Times*. February 1, 1997.

10
A NOT SO QUIET NOCTURNE

Jaye Austin Williams

Characters

CHARLYN, *African American Deaf woman, late 20s*
CHARLYN'S SPOKEN VOICE, *African American woman, late 20s*
LELIA, *Charlyn's mother, African American, early-to-mid 40s*
SHALIL *(Charlyn's nephew), African American, age 16*
TERRELL *(Charlyn's brother), African American, early-to-mid 30s*
DANNY *(Charlyn's husband), African American, early-to-mid 30s*
NURSE, *African American, 30s (portrayed by Charlyn's Spoken Voice)*
DOCTOR, *White, male, 30s*
DR. AVERY, *White female, mid-to-late 40s*
BOBBY-MACK, *African American, late teens, street-wise, tough, subdued, carries a boom box everywhere he goes*
COUNSELOR, *African American woman, mid-to-late 30s*
Two Sign Language interpreters/voice actors, *African American, 30s or older*
CLERK, *African American woman (portrayed by Charlyn's Spoken Voice)*
BOBBY-MACK'S MOTHER'S VOICE, *African American, 30s (portrayed by Charlyn's Spoken Voice)*

Home Movie sequence:
TERRELL, *age 18*
LELIA, *early 30s – Charlyn's mother*
YOUNG CHARLYN, *age 10 – African American Deaf girl, should favor the actress portraying Charlyn (Also appears live, as a memory)*

Notes

It is important that the character of Charlyn be portrayed by an African American deaf or hard-of-hearing woman who is fluent in American Sign Language (ASL).

It is also important that wherever it is indicated that characters sign and speak simultaneously, that the actors portraying those roles be comfortably conversant in ASL or Pidgin Signed English.

Finally, it is important that the play be performed accessibly, meaning that Charlyn's character is simultaneously voiced for hearing audiences, and characters whose lines are spoken only are signed for Deaf audiences. The only exceptions to this are noted in the script; i.e., the notation "Voices, no trans." When such a notation exists, it means Charlyn is using her speaking voice and not meant to be understood, for effect. When the notation "Sign, no trans." appears, it means one or more characters are signing and not meant to be understood, for effect.

There should be no stationary set. Set pieces/environmental furniture should float in and out, suggesting a persistent transience/impermanence. The only exception to this would be the "permanent" placement of a large digital screen which appears in many of the scenes, conveying TTY telephone conversations as well as captioning for film segments and dream sequences.

Prologue

Lights slowly fade as Frederic Chopin's Nocturne No. 7 in C sharp minor, Op. 27 begins to play.

Lights up on Charlyn who is lying asleep on a gurney set against a hospital wall. She is dreaming. She moves and twitches, slightly at first, and increasingly more violently.

Charlyn sits up as if entering a dream.

Lights up on a large television set, and on Charlyn, age 10, wearing a binaural body aid.[1] She is watching "The Honeymooners."

Charlyn watches herself, at age 10, from the "hospital" for a long moment.

Young Charlyn gets up and changes the channel. "Mary Tyler Moore" is on. She watches.

She changes the channel again. "The Dick Van Dyke Show" is on.

She changes the channel again. Arthur Fiedler is conducting the Boston Pops.

We hear the soundtracks which accompany these images, but the sounds are muffled. After she finds the Boston Pops, Young Charlyn watches a moment, then, bothered by the distorted sounds, unconsciously removes the ear molds from her ears. The sound disappears. We watch in silence with her. She begins imitating Arthur Fiedler's conducting.

Young Charlyn gets up to change the channel again. We see "snow" on the screen.

Sudden blackout. All sound disappears. Lights restore on Charlyn in the "hospital." A Nurse enters, and checks on Charlyn, still asleep. Blackout.

Act I, Scene 1

Fall. The Present. Fréderíc Chopin's Nocturne No. 9, Op. 32 in B begins to play. Lights up on Charlyn at a "cemetery."

CHARLYN: I can't grasp time anymore, Catherine. I just keep swallowing it like an open drain, watching the rest of it swirling around above my head. I think you get to borrow time when you dream. Your Grandma used to say it was the cheapest way to travel.

Laughs to herself.

CHARLYN: It's all backward. See, you were supposed to grow up, and after having brought me years of joy, and maybe a little aggravation, you would understand in a way I never could what your Grandmother tried to explain to me all those years ago. I only had you three weeks. Yet I can barely go that long without needing to come out here and talk to you.

Lights up on a different part of the stage. Charlyn's mother, Lelia is standing with Charlyn, age 10, looking up at her, listening to Chopin's Nocturne No. 7 in C sharp minor, Op. 27.

CHARLYN: She'd put an album on the turntable. There'd be a moment where she almost seemed to stop breathing. It would frighten me. Then her face would change, and I would see she was all right.
LELIA: (Signing and speaking to Charlyn, aged 10) I'm listening to something beautiful…
CHARLYN: I remember her hands painting calm seas in the air, rolling waterfalls, and then a big, full heart on her chest. (Pause) I thought of those hands the first time I held your little fingers in my hand and counted them. The first time your grandmother took my hand and placed it where she'd just drawn that heart.
LELIA: (To Charlyn, aged 8) That's what happens when music finds its way into your soul.

Lights fade on Lelia and Young Charlyn. We see a Super 8 home movie shot inside Terrell's first car in the early 1970s. The car, a 1965 Dodge Valiant, is driving up the Harlem River Drive in Manhattan. The camera sees Terrell, at the wheel, a young, handsome African American man, 18 years of age. The camera, in the passenger seat, pans to the back seat and sees Young Charlyn, age ten, sitting next to her mother, Lelia.

It is a happy time. Everyone waves to the camera when it discovers them.

Lelia looks down at Young Charlyn and smiles. Close-up on Young Charlyn's face, looking up at Lelia, smiling broadly. The movie screen freezes on Young Charlyn's face. Movie screen to black.

CHARLYN: I didn't understand. Years later, she told me I understood better than I thought.

Smiles.

CHARLYN: We'd all taken a drive up to Bear Mountain in late October not long before your grandfather died. I was eight years old that first trip. The leaves were loud with color. Your grandmother turned my little face to her and said, "That's what a chorus of voices sounds like – all of them different, yet all of them needing each other." That's when I fell in love with music, though I'd never heard it. "That's your music," she told me. "The leaves are doing a recital just for you." We made that drive to Bear Mountain every year for a few years after that, with Terrell and your Grandmother, so the leaves could sing for me.

Charlyn notices the "foliage" around her at the cemetery.

CHARLYN: There're a lot of trees here. Plenty music to keep my baby company. (Pause) God, Catherine. So much crammed into a day. Doctors poking, shrinks probing, clerks inquiring. Seems like only a week ago when I ran into Shalil at that bus stop. (Pause) It's been a whole year, Catherine.

Act I, Scene 2

The Nocturne abruptly cross-fades to hip-hop music and street sounds.

Lights cross-fade up on a bus stop a year earlier. Charlyn approaches it and waits. Shalil is walking by, wearing a Walkman, listening to the music the audience hears. He spots her. He walks over and taps her on the shoulder.

SHALIL: (Signing and speaking) What up?
CHARLYN: (Signing) What are you doing?
SHALIL: Just kickin'.
CHARLYN: Kickin'. Shouldn't you be "kickin'" at school?
SHALIL: (Shrugs) I didn't feel like going today.
CHARLYN: Oh, really? And why is that?
SHALIL: I don't know. I guess ain't nothing goin' on there I care about.
CHARLYN: When I was your age, it didn't make a difference what I cared about. My behind was in school, or red as that fire box over there.
SHALIL: You got whipped for not goin' to school?
CHARLYN: Damn right. You really think it doesn't matter?
SHALIL: (Laughs at this) Hell, no, it don't matter.
CHARLYN: Now, I know my brother didn't teach you to think like that.

Shalil is silent.

CHARLYN: What?

No response.

CHARLYN: Shalil, talk to me.
SHALIL: Nothing.
CHARLYN: What do you mean, nothing? That's a whole lot of something on your face.
SHALIL: My mother say she ain't care if I go to school or not.

Charlyn is silent. She looks at Shalil in disbelief, hoping he'll go on.

SHALIL: She did!
CHARLYN: (Cautiously) Why would she say something like that to you?

Long silence. Charlyn tweaks Shalil's nose affectionately.

CHARLYN: (Looking down the street) Here comes the bus, you gonna ride home with me?

Lights fade on them.

Act I, Scene 3

Lights up on Charlyn's brother, Terrell, sitting on Charlyn's living room sofa. Charlyn enters, carrying a soda. She and Terrell are in the midst of an argument.

CHARLYN: (Signing) I can't believe she would say something like that to Shalil.
TERRELL: (Signing and speaking) You can't ask if I want some soda?
CHARLYN: Get your own damn soda.
TERRELL: Shalil is a pain in everybody's ass. He's doing his "hangin' with the homeboys" routine every damn day. She's gotta say something that'll get through his thick "home boy" head.
CHARLYN: Uh-huh. At my husband's expense. Ain't enough he's dead. She's got to piss all over his memory too, right?
TERRELL: Oh, please. The son of a bitch pissed all over you, as far as I'm concerned.
CHARLYN: Don't start that!
TERRELL: No. No. You wanna dress me down about what me and my family ain't got together, but you gon' stay in your little dream world about your husband and the things you still wanna act like he didn't do…

Charlyn turns her face away so as to stop "listening." Terrell moves around the room to force his way into her line of vision.

TERRELL: Listen to me, dammit! That no count husband of yours is rotting in the ground like he was rotting above it. So's your baby. From the same shit gonna kill you. And you worried about his memory bein' pissed on?

The reminder hits Charlyn like a fist.

TERRELL: Truth hurts, baby.

Realizing he's stomped on a nerve, changes gears a bit.

TERRELL: Char, you gotta listen to me. You think I wasn't onto Danny and his bullshit? You think I didn't catch him scoring in front of Mr. Jimmy's two and three times a day? Wearing that goddamn beret like he some kinda Hewey Newton holdover or some shit.
CHARLYN: And what were you doin' in front of Mr. Jimmy's two and three times a day?

No response.

CHARLYN: You was running numbers, that's what you were doing. So don't you dare ride my baby's death like it's some royal high horse you can come stomping through town on.
TERRELL: Don't you turn this around on me! If I got to do something to keep shit hooked up for my family, I'm gonna do it. Danny ain't ever thought about feeding nothing or nobody but his damn habit. And that's what got you where you are, little sister! Standin' at death's door.
CHARLYN: Enough!
TERRELL: You damn right it's enough!

Blackout.

Act I, Scene 4

Lights up on the memory of Danny Turnbull. He is wearing a beret, well-fitting black jeans, and a sharp leather overcoat. He is completely focused on Charlyn, who turns to look at Danny. She walks into the past – into the moment they first met.

DANNY: (Smiling, irresistibly) Hey, gal. You live in 335 don't you?

Charlyn does not understand.

DANNY: What you lookin' at me like that for? Didn't you hear what I said? (Pause)

Terrell enters.

TERRELL: Yo, man. Don't be messing where you don't belong.
DANNY: Ah, man, what you worryin' about? I ain't messing with nothing, man.
TERRELL: You messin' with my sister.
DANNY: Oooooh. Your sister, huh?
TERRELL: That's right.
DANNY: Well, yo' sister fine, man. (Pause) Don't seem to wanna say much of nothing though.
TERRELL: She can say plenty. How she wants to say it.
DANNY: Say what?
TERRELL: She can't hear you, man.
DANNY: What you mean she can't hear me?
TERRELL: What, you stupid?
DANNY: Don't be coming at me like that. I'm just asking for the 411 on your sister.
TERRELL: Just don't want nobody fucking with her, that's all. She deaf, man. Understand?
DANNY: (Beat) Yeah, I understand.

Danny approaches Charlyn, and speaks slowly and seductively.

DANNY: Can you read my lips, baby?

Charlyn nods.

DANNY: Well, all right! Come on take a walk with me, gal. I got no idea where I'm headed, but I got you with me now, so I know I'm gonna end up somewhere good.

Terrell rolls his eyes, points a warning finger at Danny. Charlyn and Danny begin to walk together. Danny walks offstage. Charlyn walks back to the cemetery, and resumes talking to her daughter. Chopin's Nocturne No.11, Op. 37 in G minor begins to play.

CHARLYN: This is where your father ended up. Well, some place like it, anyway. (Pause) Seems like your Uncle Terrell and I were fighting every time I turned around after I met your father. (Pause) He was right, you know. Your father was a whole lot of things. Few of 'em good. But I was drawn to him like some people are drawn to jumping out of planes. He lived on the edge, and I thought that's where I wanted to live, too.

Act I, Scene 5

Lights up on Danny, sitting on a living room sofa. Charlyn walks into the scene, catching him shooting up. She stands in the doorway, stunned.

DANNY: Baby, look.
CHARLYN: I don't wanna hear it.
DANNY: Oh, come on, now, this ain't nothing!
CHARLYN: No, you ain't nothing – without your drugs.
DANNY: (Trying the flirtatious route) Aaw, come on. You know there's more going on here than that.
CHARLYN: Uh-huh. Peacocks look quite spectacular when they want some.
DANNY: (Sobers a moment) What you think, I'm conning you?
CHARLYN: (Charlyn shakes her head) Cons are shrewd. You're just addicted.
DANNY: Oh, baby, come on! I thought you had more faith in me than that?
CHARLYN: Faith?! Please. Like the kind you have?

Charlyn tries to leave. Danny blocks her path.

DANNY: Oh, shit. What you carrying on about? Ain't no danger here. The works is mine, baby. They clean.
CHARLYN: (Pauses, trying to collect herself) And that's a source of pride for you? Clean works?
DANNY: You know I wouldn't let nothing happen to you. I just need to feel a little something.
CHARLYN: (Shakes her head) It ain't me you been conning. (Beat) I think it's time to find another house of worship.

Charlyn exits in disgust, and walks back into the present, the "cemetery."

CHARLYN: The plane was going down, baby. And so I prayed. Prayed those works were clean. Prayed we weren't on that plane. Your daddy jumped first, with your little foot tangled in the rip chord. He hit the ground hard.

Blackout.

Act I, Scene 6

Sounds: A hospital emergency room on a busy night.

A young, white male doctor enters an ER cubicle at the same time as Danny enters, near death, on a gurney pushed by Nurse. The Doctor contemplates Danny's face, ever so perfunctorily.

DOCTOR: Well, well, well. I've seen this one before. Who is he?
NURSE: (Checking chart at foot of bed) Turnbull, Daniel.

DOCTOR: (To Danny) Back for more fun, eh, my man? (To no one in particular) When will they ever get it?
NURSE: They?
DOCTOR: (Looks at Nurse a moment) Relax. It's not always an all-out attack on "your people."
NURSE: Uh-huh.
DOCTOR: Uh. Huh. Did it occur to you I might've just been referring to the riff raff.
NURSE: (Beat) What occurred to me is that Mr. Turnbull's in rough shape, and so I'd best pick my battles and prioritize. It's not about me, or you, at the moment.
DOCTOR: Well, Mr. Turnbull here had better hope it's about me or there'll most definitely be no him.
NURSE: (Beat. She glares at him) Doctor, what does this man need?
DOCTOR: (Beat. Considers Danny again) Most likely, a pine box.

The Nurse starts to respond. Nurse exits. The Doctor looks after her, smirking. As he does so, Danny sits up and leaves the gurney, standing over the Doctor, observing him.

DOCTOR: (To Danny, as though he is still laying on the gurney) So. Mr.... what is it?

Checks chart.

DOCTOR: Turnbull. Right.

Begins examining him.

DOCTOR: I think this just might be your last time through these parts. I'm fixin' to send you down to my buddies in the basement. Nice cold cubicle all your very own.

Shakes his head. Lights up on Charlyn, isolated, waiting for some news.

DOCTOR: I know the secret, Danny Boy. See, they think it's the drugs you want. But we know what it is, don't we? We know it's that dark, cold room.

Lights fade on the cubicle. Doctor exits and heads toward Charlyn, who now begins pacing.

Act I, Scene 7

DOCTOR: Are you Charlene Turnbull?
CHARLYN: (Signing) Wait a second, the interpreter's not here yet.

DOCTOR: (Continuing, unaware of what Charlyn has just said) Your husband is not doing well.
CHARLYN: (Voicing and signing) I can't understand you. I need an interpreter. They're not here yet.

She is unintelligible to the Doctor.

DOCTOR: Oh, no. What is this?

Looking around.

DOCTOR: What's wrong with her, does anyone know?

A Nurse enters.

NURSE: Oh, sorry, doctor. We put a call in for a sign language interpreter, and we're waiting.
DOCTOR: Uh-huh. Well, look, her husband is about to buy the farm in cubicle 3, and she's gotta be told. Did they say what time someone's gonna be here?

The Doctor begins to leave.

CHARLYN: (Voicing, no trans.) Please! Wait. The nurse said the interpreter's coming.

The Doctor and Nurse can't understand her. Dr. Avery, the attending physician to Charlyn and Danny, enters and witnesses the Doctor address Charlyn.

DOCTOR: Lady, I don't have the slightest idea what you're talking about. (Over-articulating) Look, I'm gonna have the nurse deal with you, okay?
DR. AVERY: (To Doctor) Doctor, can I have a word with you?
DOCTOR: Sure.
DR. AVERY: (Approaches Charlyn. Dr. Avery addresses Charlyn firmly but compassionately, so that Charlyn can hopefully read her lips.) I'm gonna have the nurse put you someplace a little less crazy, okay? And I'll be in to see you as soon as the interpreter gets here.

Charlyn nods.

DR. AVERY: (To Nurse) Nurse, which cubicle is available?
NURSE: Five is empty.
DR. AVERY: Would you take Mrs. Turnbull there, please?
NURSE: Mmm-hmm.
DR. AVERY: Thanks. Listen, where's her husband?

NURSE: He's in 3.
DR. AVERY: What was he presenting with?
NURSE: He apparently seized, began vomiting and aspirating.
DR. AVERY: Has he been stabilized?
NURSE: He has.
DR. AVERY: Okay, I'll be right there.

The Nurse exits urgently and returns with a "cubicle" curtain. She sets it around Charlyn.

NURSE: (Also trying to be clear) Listen, why don't you wait in here until the interpreter arrives. Dr. Avery will be in to talk to you about your husband.

The Nurse exits cubicle.

Act I, Scene 8

The Emergency Room/Hospital sounds fade out, as if being swallowed by a vacuum. Charlyn is alone, and begins to examine all the instruments on the wall, all the syringes and sterile paraphernalia around the cubicle – all of which are imaginary.

Stark lights on the two doctors. Dim light on Charlyn standing upstage of the doctors in the cubicle, looking at them as if trying somehow to hear.

DR. AVERY: If I ever see you address another patient or family member the way I just saw you address her you can consider your ass officially in a sling, understood?

Dr. Avery begins to leave.

DOCTOR: Oh, come on. She's deaf as a post. What's the big deal?
DR. AVERY: "Deaf as a post." Gee, that's original.
DOCTOR: Look, you don't hang out down here.
DR. AVERY: Don't presume to lecture to me about E.R. duty, Doctor. I was down here in the trenches before medical school was even a consideration for you.
DOCTOR: (Beat) I was just trying to get things done as efficiently as possible.
DR. AVERY: Do you address all your patients as efficiently as you did mine?
DOCTOR: It was just an EXPRESSION for God's sake!
DR. AVERY: You raising your voice to me, doctor?
DOCTOR: I just wanted to let her know her husband was dying.
DR. AVERY: She's well aware of that.
DOCTOR: Fine. Look, you should know how it works by now. He buys it, I tell her, and it's on to the next case. I got drugs to administer and bodies to either sew together or pass on to the morgue. We got people dropping like flies around here.

Dr. Avery looks at him, disgusted and exits. Blackout.

Act I, Scene 9

From some elevated place, we see Danny, who removes his hospital gown, descends, and hands the gown over the edge of the cubicle to Charlyn. Charlyn sees the gown, collapses. Blackout.

We hear Charlyn scream. The Nurse re-enters. The Nurse attempts to be easily lip-readable for Charlyn, and tries to calm her down.

There is silence for a moment, out of which crescendoes Chopin's Nocturne No. 16 in E flat, Op. 55, increasingly distorted by voices and loud percussive sounds. This distortion in turn cross-fades into the rap of Tupac Shakur.

Act I, Scene 10

Shalil, Trey, and Bobby-Mack are sitting on a stoop, with Bobby-Mack's boom box blasting Tupac.

SHALIL: Yo, man, pass that bag over here. I wanna calculate my profits.
BOBBY-MACK: Yo, chill out, man. I'm countin' mine first. Yours coming. (To Trey) Yo, R.D. Rap was jammin', man.
TREY: Word. Yo, man, fuck the jam, you seen them kicks he be sportin'?
BOBBY-MACK: Riiight??!! I want me some of them three-quarter ones, yo.

Looks at Shalil.

BOBBY-MACK: Man, stick yo' fucking tongue back in your mouth.
SHALIL: Just thinking about the coin.
TREY: Yo, my man, you don't look like you thinking about no coin! Damn, nigga acting like he wanna do the wild thing with that rock and shit.

Bobby-Mack and Trey laugh.

BOBBY-MACK: Ah, leave my man alone. Just 'cause he born to this. The brother a true entrepreneur and shit. (To Shalil) Yo man, dig it. Yesterday, I thought I seen this bitch connection my pops used to be rappin' to.
TREY: Bitch be runnin'?
BOBBY-MACK: Yo, man. Don't no bitch I know be just runnin'.
SHALIL: Word. Can't be runnin' on your back.
TREY: Got to be ho'in', too.

They laugh, slappin' "Five."

TREY: (To Bobby-Mack) Yo, man, look. I dig having me some coin in my pocket just like anybody else. And I don't mean to be dissin' yo pops man, but I don't be messin' with nothing nobody's old man be hooked up with.
BOBBY-MACK: Yeah, well he wasn't no old man. He was too young to die.
TREY: Man, fuck that. Brothers out here be doing the leadbelly shuffle with ain't but ten years on 'em and shit. Your pops lived a long ass time, man.
SHALIL: Yeah. If you call that living. (Beat)

Act I, Scene 11

Tupac fades out. Lights cross-fade up on Charlyn and a counselor in the counselor's office. An ASL interpreter enters.

CHARLYN/INTERPRETER: (Voicing) I think I hear sounds in my dreams.
COUNSELOR/INTERPRETER: (Signing) You hear sounds? (Pause) How much do you hear? I mean, in your waking life? Do you hear anything?
CHARLYN/INTERPRETER: (Voicing) I guess I do hear some things. When certain people talk to me, I hear sounds, but I can't make them out. I know they're talking. But I also know that "talking" means something entirely different to you than it does to me. I... hear music... no, I dream music.
COUNSELOR/INTERPRETER: (Signing) Tell me about that.
CHARLYN/INTERPRETER: (Voicing) I see trees changing colors, flowers, children running.
COUNSELOR/INTERPRETER: (Signing) Charlyn, when were you diagnosed?
CHARLYN/INTERPRETER: (Voicing) A year-and-a-half ago.
COUNSELOR/INTERPRETER: (Signing) How?
CHARLYN/INTERPRETER: (Voicing) After I gave birth.
COUNSELOR/INTERPRETER: (Signing) I mean how did you get infected?
CHARLYN/INTERPRETER: (Voicing) My husband. He used. (Pause) Didn't tell me. I got pregnant. He deteriorated and died. I felt tired and sick way longer than I should've. Thought it was just grief. And childbirth. Went to the clinic. Met my doctor. When she got the results back on the blood test, she started talking about white counts, T-cell counts, stuff like that. And talking all around everything.
COUNSELOR/INTERPRETER: (Signing) You feel okay about how she's treating you now – I mean, medically?
CHARLYN/INTERPRETER: (Voicing) Well, you know sometimes people think I live life second-hand because I get their words through someone else. I straightened her out about that. Told her to talk to me like I exist. (Long pause) I wonder what it'll be like not to exist. To just... be gone.

COUNSELOR/INTERPRETER: (Signing) Charlyn, death is something we're all going to face one day. The difference is that for you it's become much more immediate, and the immediacy can be frightening.
CHARLYN/INTERPRETER: (Voicing) Yup. I walk around terrified all the time. How can I get myself to stop wondering at every little ache and pain, wondering if this is what death feels like? (Pause) I just want the dreams to stop.
COUNSELOR/INTERPRETER: (Signing) Where do the dreams take you?
CHARLYN/INTERPRETER: (Voicing) To times gone by, before all this.
COUNSELOR/INTERPRETER: (Signing) Do you feel good in the dreams? Safe?
CHARLYN/INTERPRETER: (Voicing) I do.
COUNSELOR/INTERPRETER: (Signing) Then why would you want them to stop?
CHARLYN/INTERPRETER: (Voicing) Because I have to wake up to these times, in the midst of all this.
COUNSELOR/INTERPRETER: (Signing) They say we dream about things when we're ready to start dealing with them.
CHARLYN/INTERPRETER: (Voicing) I am NOT READY TO DIE!!! (Pause) I just want to feel as safe when I'm awake as I do when I'm asleep.

Silence.

COUNSELOR/INTERPRETER: (Signing) So feeling unsafe is not unfamiliar to you, hmm?
CHARLYN/INTERPRETER: (Voicing) What's that supposed to mean?
COUNSELOR/INTERPRETER: (Signing; pause) Tell me more about Danny.

Act I, Scene 12

We hear street noise. Charlyn turns and looks into the past, where Danny and Terrell are standing out in front of Mr. Jimmy's grocery store, looking cautiously up and down the street as they talk, uncomfortably at best, to one another. The scenes of present and past overlap.

DANNY: (To Terrell) Hey, man, you seen Sloe Junie?
TERRELL: No, man, I don't be keeping up with him.
DANNY: I ain't ask you all of that, I just asked if you seen him?
TERRELL: Nah, man, I ain't seen him.
DANNY: Say he's supposed to come around here today or tomorrow to drop off some serious rock.
TERRELL: Yeah, well good for you. Like I said, I ain't seen him.
DANNY: Got some snow on him, too. Smooth as silk – like taking a breath of fresh air.
TERRELL: What you be slicing with?
DANNY: What you talking about?
TERRELL: I mean what you cut it with, man?
COUNSELOR/INTERPRETER: (Signing) What appealed to you about him?
CHARLYN/INTERPRETER: (Voicing) He was…

DANNY: Cut?! I don't be cutting my shit, man. I just told you, stuff's smooth as silk.
CHARLYN/INTERPRETER: (Voicing, overlapping)... smooth as silk.
TERRELL: (Noticing an imaginary man at the nearby pay phone) What I wanna know is how long that mu'fucka gon' stay in my office.
DANNY: Man, that ain't none of your office.
TERRELL: What the hell you know about it? You on the wrong end of your business anyway. I'm running mine. You usin' yours.
DANNY: Don't be readin' me, man. I'm just telling you the pay phone ain't your damn office.
CHARLYN/INTERPRETER: (Voicing) From the beginning Terrell didn't like Danny. I guess he called himself being protective of me.
TERRELL: I'll tell you this. Charlyn's my sister.
DANNY: How many times you gonna tell me that?
CHARLYN/INTERPRETER: (Voicing) He tried to act like he was my father or something.
COUNSELOR/INTERPRETER: (Signing) How did your father feel about Danny, by the way?
CHARLYN/INTERPRETER: (Voicing) My father died when I was 8.
COUNSELOR/INTERPRETER: (Signing) I'm sorry.
CHARLYN/INTERPRETER: (Voicing) Yeah, thanks. (Pause) So, Terrell wanted to become the father I no longer had I guess. He meant well, he just didn't have much... finesse.
TERRELL: Yeah, well. You can smoke that shit, shoot it up or whatever else you gonna do with it. But you even think about turning my sister out so you can pay for your jones, I'll kill you.
DANNY: (Amused) I ain't nobody's pimp, jack.
TERRELL: I don't give a shit if you is. But Charlyn ain't gonna be ho'ing for you, I know that, 'cuz I'll cut your ass up in a million fucking pieces if it comes to that.
DANNY: Man, why don't you stop trying to bother me, 'cause you can't.
TERRELL: You remember what I said, man.

Terrell exits.

DANNY: (Calling after him, playfully) Hey, yo, man. What about your phone calls? Look like your office is available now.

Laughs.

COUNSELOR/INTERPRETER: (Signing) So he was "smooth as silk," huh?
CHARLYN/INTERPRETER: (Voicing) Mmm. And it wasn't just that he wasn't afraid of death either. He flirted with it. Like kids do today, only, he was... softer, you know? None of this gun shoved down your pants kind of shit.

He caressed it, like death was a woman he wanted. (Pause. Slightly amused) Mama was afraid of him. (Pause)

Act I, Scene 13

Billie Holiday's "Gloomy Sunday" fades up. Lights up on Danny sitting on a sofa, laughing. Lelia enters with a beer and a glass. She joins Danny on the sofa.

CHARLYN/INTERPRETER: (Voicing) But there was a sense of music about him she was almost as hopelessly drawn to as I was. Next thing you know, she'd be talking about the old days and the hole-in-the-wall clubs she went to as a teen to listen to all the singers coming up, and she'd bring him a big old plate of food which he'd gobble up and fuss over.

Pause. The lights fade on Danny and Lelia.

CHARLYN/INTERPRETER: (Voicing) Shalil is like that. I worry about him day and night.

Act I, Scene 14

NWA's "Gansta Gansta" fades up. Lights up on a subway car. Shalil, Trey, and Bobby-Mack are talking loudly, as Bobby-Mack's boom box roars Tupak Shakur's rap.

SHALIL: (To Trey) Ah man, don't lie. You did that bitch and you know it.

The others laugh.

TREY: What!? Ah man, I ain't did shit! You seen that bitch? Think she be looking all that, probably been did by every dick at school – 'cept mine.

They all laugh. Overlapping:

BOBBY-MACK: Right?
SHALIL: Ah, man, shut the fuck up! Probably ain't the only boots you been banging, either.
TREY: Hey, yo. Don't be running down my shit out here in the street.
SHALIL: We ain't in nobody's street, man. We in the subway.

Shalil and Bobby-Mack laugh.

TREY: Yeah well all that's all right, but where I be banging boots ain't nobody's fucking business!
BOBBY-MACK: I hear that.

TREY: (To Shalil) Shit, what you, anyway, a fucking instigator?
BOBBY-MACK: Yeah, instigator!
SHALIL: Nah man. I ain't nobody's instigator. I'm a "entrepreneur."

Indicating Bobby-Mack.

SHALIL: That's what he told me.
TREY: Well, look, Mr. Entrepreneur, don't be playing with where I stick my—
BOBBY-MACK: Shh! Man, shut the fuck up. You act like you ain't had no kind of upbringing.
TREY: Oh, fuck you, man.
SHALIL: What upbringing got to do with it? Shit. Parents can fuck your shit up worse than anything, man.
BOBBY-MACK: Word.

They are all subdued for just a moment.

TREY: (To Shalil) Hey, yo. What stop we getting off at, man?

The train comes to a halt.

SHALIL: Man, who the fuck knows. This is as good a stop as any. Let's go.

Lights fade on subway scene.

Act I, Scene 15

Lights restore on Charlyn and the Counselor.

COUNSELOR/INTERPRETER: (Signing) Shalil. Who's he?
CHARLYN/INTERPRETER: (Voicing) My brother Terrell's son.
COUNSELOR/INTERPRETER: (Signing) Mmm-hmm. Is his mother still alive?

Silence.

CHARLYN/INTERPRETER: (Voicing) No more than Terrell is.
COUNSELOR/INTERPRETER: (Signing) That's a loaded response.
CHARLYN/INTERPRETER: (Signing) Hmph. Loaded. Yeah. That's what Barbara was ninety percent of the time.
COUNSELOR/INTERPRETER: (Signing) His wife?

Charlyn nods.

COUNSELOR/INTERPRETER: (Signing) Where do they live now?

Charlyn laughs ironically.

CHARLYN/INTERPRETER: (Voicing) On an island… not far enough away, with lots of people who dress the same, and have a penchant for wearing numbers on their breast pockets.
COUNSELOR/INTERPRETER: (Signing; pause) Both of them?

Charlyn nods.

COUNSELOR/INTERPRETER: (Signing) Goodness. How long have they been in?
CHARLYN/INTERPRETER: (Voicing) They've done eight months of a year sentence.

Lights dim on Charlyn and the Counselor.

Act I, Scene 16

In the dark, a small light bulb begins to flash. Lights up on Terrell seated at a small table, watching his TTY for an answer on the other end.

Charlyn walks into her bedroom where a small light is flashing, signaling the telephone is ringing. She answers the telephone, placing it on the TTY.

A large digital screen appears and conveys the following conversation, which is also voiced.[2]

TERRELL: HEY CHAR T HERE TROUBLE THEY TOOK ME AND BARBARA TO RIKERS [GA]
CHARLYN: WHERE'S SHALIL? [GA]
TERRELL: I NEED U TO CHECK ON HIM [GA]
CHARLYN: IT'S 2:00 IN THE MORNING U JUST NOW THOUGHT ABOUT GETTING SOMEBODY TO CHECK ON SHALIL? (Pause) U HAVE A LAWYER? [GA]
TERRELL: LEGAL AID SENT SOMEBODY LISTEN CHAR CAN'T STAY ON MUCH MORE NEED U TO FIND HIM [GA]
CHARLYN: OF COURSE I'LL FIND HIM. DAMN T… I GOT ENUF PROBLEMS WITHOUT THIS… DID THEY LET U SEE BARBARA? [GA]
TERRELL: NO. (Pause) SHE'S REASON WE GOT BUSTED. [GA]
CHARLYN: NEVER MIND THAT NOW I'LL GET DETAILS LATER (Pause) WOW! I GOTTA GET OVER TO UR PLACE THE SET OF KEYS I HAVE STILL GOOD? [GA]
TERRELL: YOUR KEYS SHOULD BE FINE CALL ME THANKS CHAR… [GA]
CHARLYN: I GOTTA GO… [SK SK]

Act I, Scene 17

Lights up on a small table with a plexiglass screen in the middle. Charlyn and Terrell approach from two different sides, carrying their chairs. They sit.

TERRELL: Nice of you to come and see me.
CHARLYN: You think this is about being nice?
TERRELL: Can't think of no other reason for you to come 'round here.
CHARLYN: No? I can think of one. His name is Shalil. But he doesn't have a clue about who he is, what he's doing, or where either of his parents will be next week, let alone in five years.
TERRELL: Oh, quit with the self-righteous routine, Char.
CHARLYN: Righteous shit. We got a problem, Terrell. Barbara done flunked out of every half-way house she's ever been in, you both get busted for some stupidity I couldn't even begin to explain to your son, and now you sitting up here snapping at me because I got the nerve to remind you this shit ain't all about you.
TERRELL: Yeah? How? You ain't even gonna be around in a couple years, so don't come strutting your "Great Black Hope" feathers around this way.
CHARLYN: (Pause) And where will you be, Terrell?

Lights out.

Act I, Scene 18

Lights up on a sofa in Charlyn's apartment. Charlyn has obviously given Shalil the news about Terrell's incarceration.

SHALIL: (Voicing/Signing) How long they holding him?
CHARLYN: Well, he had what they call an "arraignment." That means you go—
SHALIL: I KNOW WHAT IT MEANS!
CHARLYN: Shalil, don't yell at me like that.
SHALIL: Just… don't talk to me like I don't know the deal.
CHARLYN: I'm gonna say this once. I'm not gonna pin any medals on you for being up on court lingo. It's nothing for a fifteen-year-old to be bragging about, understand? (Beat) Under-stand?
SHALIL: Yeah.
CHARLYN: Okay then.
SHALIL: What they say about my mother?
CHARLYN: They'll go a little softer on her because she's an addict.
SHALIL: (Pause) This is some situation we got here.
CHARLYN: Yeah. (Pause) Well, you and me gonna make the best of it, okay?

Shalil nods his head. After a moment, Charlyn puts her arm around his shoulder.

SHALIL: They gonna let me go visit them?
CHARLYN: (Charlyn looks at what Shalil is wearing, trying to lighten the moment.) You not going like that, are you?
SHALIL: What's the matter with it?
CHARLYN: Well… don't you have some nice slacks you could put on.
SHALIL: Slacks?! What, like them people out there gonna be dressed for the People's Choice Awards or something?
CHARLYN: What I wanna know is, when is the "crotch-down-to-your-feet" fad gonna be over? It looks ridiculous. And hard as it is to get money together to buy clothes—
SHALIL: I got me a pair of jeans I think will be okay.
CHARLYN: They got holes in them?
SHALIL: They gonna be clean. (Beat) And the…
CHARLYN: The what?
SHALIL: You know. The… crotch, okay?
CHARLYN: (Tickled) Okay. What about it?
SHALIL: It's gonna be… closer to…

They burst into laughter.

CHARLYN: Closer to what?
SHALIL: Oh, man!
CHARLYN: It don't make no kind of sense for you young people to be walking around in clothes that don't fit.
SHALIL: Now you talking like grandma.
CHARLYN: (Laughs and shakes her head) Okay. Hmph! I used to swear I'd never talk like that to my kids!

They look at each other a moment.

CHARLYN: (Offering her hand) It's a deal?

Shalil nods. Lights fade.

Act I, Scene 19

Fade up of prison sounds. Then the sound of a prison gate opening and closing. Lights up on a small table divided by a plexiglass partition.
Terrell and Shalil are sitting, looking at each other. Shalil is dressed in nice slacks and a tailored shirt. There is a long silence.

SHALIL: Why you in here, Pop?
TERRELL: Don't play stupid, Shalil. I know your aunt Char told you what's going on.
SHALIL: I want YOU to tell me.

TERRELL: Don't take that tone of voice with me, boy.
SHALIL: Who are you to tell me shit?! You sitting up there behind that glass trying to act like you somebody's father or something.
TERRELL: (Pause) Look, Shalil. We gonna visit with each other, or we gonna do this?
SHALIL: You seen Ma?
TERRELL: No. They don't allow that.
SHALIL: Well. I'm going to see her right after I get finished here.
TERRELL: Give her my love, hear?
SHALIL: I AIN'T GIVING HER SHIT FOR YOU, MAN!
TERRELL: Shalil, I done told you—
SHALIL: NO! NO! Shit, man. Ain't been no goddamn car accident, okay? I ain't going to visit my parents in no goddamn hospital like them kids in the made-for-TV movies be doing. What I got?

Yelling out.

SHALIL: I GOT TWO FUCKED UP, NUMBERS RUNNING, DRUG-DEALERS FOR PARENTS.
TERRELL: SHALIL!!!
SHALIL: Shit! Naw, man.

Shalil storms out, leaving Terrell alone. Lights fade on him.

Act I, Scene 20

Charlyn rejoins the Counselor.

CHARLYN/INTERPRETER: (Voicing) My mother used to talk about "recurring motifs" in her music. Some of them were nice, you'd kind of look forward to them. Others were kind of haunting, and would bring a sense of foreboding with them.
COUNSELOR/INTERPRETER: (Signing) How old is Terrell?
CHARLYN/INTERPRETER: (Voicing) Ten years older than I am.

Lights up on Terrell, age 18 and Young Charlyn, in their living room.

LELIA: You see this child here? Looking up to you? And what you got to show her? Nothing worth a damn. What am I gonna have to do, knock you upside your head to get you to understand I don't want that element in this house?
TERRELL: Do what you need to do.
LELIA: Don't you sass me, boy. I won't have you running and dealing out of my house. Blessed with a good set of ears and still don't listen. So I'll put it to

you like this. You think you old enough to run with that kind of trade, then you old enough to live out on your own, hear?

Lights cross bump to Charlyn and the Counselor.

CHARLYN/INTERPRETER: (Voicing) She loved him. But she kicked him out. What's that old expression? If you can't listen you gotta feel? So my brother started feeling... more and more.

Act I, Scene 20

Lights up on a despondent Terrell, and Young Charlyn, looking up at him, both in a timeless place, as Charlyn in the present.

CHARLYN/INTERPRETER: (Voicing) Death is a funny thing. It doesn't just happen to the body, I don't think. I feel like I been watching him die for years. He's not sick with nothing like I am, but... he married a lot of bad choices. A junkie was one of them. That's like a slow leak in a rubber tire. It'll strand you in the middle of nowhere eventually. (Pause) After my mother told Terrell he had to leave, she started dragging me around to a lot of funerals. Didn't matter which dead body I was staring down at, I saw Terrell, staring up at me, asking how he'd gotten there.

Lights fade on Terrell and Young Charlyn.

COUNSELOR/INTERPRETER: (Attempting to sign) Is this the sign for "dead?"

Charlyn demonstrates it correctly.

COUNSELOR/INTERPRETER: (Voicing, making the sign) Dead.

Act I, Scene 21

Lights up on Lelia and Young Charlyn, sitting at a wake in a funeral home. There's a dead woman's body in a coffin.

CHARLYN/INTERPRETER: (Voicing) My mother used to say...
CHARLYN AND LELIA: (Signing and speaking to Young Charlyn) "Black folks been carryin' on our love affair with death for as long as I can remember!"

Young Charlyn looks up at her, not really understanding, but wanting to.

LELIA: She looks good, doesn't she?

Young Charlyn nods.

LELIA: I think Reverend Taylor 'n them say it was Luther Strode. Yes, yes. I remember now. When Hattie's sister Janelle… no, that wasn't her name – I'm thinking of Haywood 'n them's sister. But that was another undertaker did her body. What was the child's name used to sit up there in church and play that organ like the angels was singing in her ear? (Fishing) Sadie Thomas! Yes, Lord. She be sitting up to that organ playing her heart out. And be just as drunk as Lucifer.

Lights dim on them, but they remain in view, "frozen" in time. Lights up on Charlyn with the Counselor and Interpreter.

CHARLYN: Seems like there should be a line you don't cross with the dead, but some folks cross it anyway.

Lights dim on Charlyn and Counselor and restore on Lelia and Young Charlyn.

LELIA: Oh! Look at her hair. You know, she was so proud of her natural. What he call himself trying to do to her hair? I know folks done re-discovered that hot comb, but please!
YOUNG CHARLYN: It doesn't look so bad, Mommy.
LELIA: Maybe not, but it don't look like the way she wore it.

She goes into her handbag and pulls out a comb.

LELIA: I'm gonna see if I can't tease it up a bit – like them white folks do. Try to get some of the natural back into her hair. Don't want her to be screaming for all eternity, staring down at that pressed head of hair laying in the ground knowing that was the last thing people saw. She'd be fit to be tied.

She proceeds to tease, fluff, and adjust the hair of the dead woman.

YOUNG CHARLYN: Mommy, stop. Somebody'll see you.
LELIA: I am darlin'.
YOUNG CHARLYN: Mama—
LELIA: I'm going.

Lelia sits down. There is a long silence where only the dim organ music typical of funeral homes can be heard. Lights fade on Lelia and Young Charlyn.

CHARLYN/INTERPRETER: (Voicing) That haunts me.

COUNSELOR/INTERPRETER: (Signing) Memories do tend to dim with time. And so does the degree to which they disturb us. That will be true for you eventually.
CHARLYN/INTERPRETER: (Voicing) You keep talking to me like I'm gonna live 'til I'm eighty-five.

Silence.

COUNSELOR/INTERPRETER: (Signing) Charlyn, we may talk about death a-plenty when you're here. Comes with the territory. But as long as you're coming to see me, I'm never going to deal with you like you're dead, do you understand?
CHARLYN/INTERPRETER: (Voicing) I'm just trying to acknowledge the cycle of things, that's all. Life and death. Simple as that. I mean, years later when my mother died? Other women carried on at her funeral just like she had at all those other ones before. (Beat) I dream about those funerals a lot lately.
COUNSELOR/INTERPRETER: (Signing, slightly amused) Oh, I don't think it'll matter to us one way or another at that point what anybody does to our hair.
CHARLYN/INTERPRETER: (Voicing) Sure, you can joke about it. But a gun might be pointed at you, too. You just don't know where your sniper is.
COUNSELOR/INTERPRETER: (Signing, beat) True.
CHARLYN/INTERPRETER: (Voicing) No one can rescue me from this. I'm plotting and planning a way to outsmart death, all the while knowing there ain't no way for me to do it.
COUNSELOR/INTERPRETER: (Signing, beat) When did you lose your daughter?
CHARLYN/INTERPRETER: (Voicing) Do you really give a shit?
COUNSELOR/INTERPRETER: (Signing) Where'd that come from?
CHARLYN/INTERPRETER: (Voicing) You ask about her like she's some little detail your notes reminded you to cover.
COUNSELOR/INTERPRETER: (Signing, beat) Charlyn, how are you feeling about our sessions together?
CHARLYN/INTERPRETER: (Voicing) They're all right. You're just a little too nice too much of the time.
COUNSELOR/INTERPRETER: (Signing) I might make the same observation about you.
CHARLYN/INTERPRETER: (Voicing) Excuse me?
COUNSELOR/INTERPRETER: (Signing) I just think there's a huge tug-of-war going on inside you, and that you're too busy taking care of everybody lately to really roll your sleeves up and jump in with me.
CHARLYN/INTERPRETER: (Voicing) Any jumping in that goes on happens on my timetable.

Silence.

COUNSELOR/INTERPRETER: (Signing, pause) I'll tell you what. I've been wondering if a group situation, in conjunction with our sessions might be helpful. I'd like to refer you to someone I found out about through one of my colleagues.
CHARLYN/INTERPRETER: (Voicing) You bailing out now because I'm deaf?
COUNSELOR/INTERPRETER: (Signing) That's not it at all. I—
CHARLYN/INTERPRETER: (Signing) What, you think deaf people aren't supposed to get prickly?
COUNSELOR/INTERPRETER: (Signing) Where are you—
CHARLYN/INTERPRETER: (Voicing) The minute I get some attitude, you say, "Whoa, better send her back to her own kind," right?
COUNSELOR/INTERPRETER: (Signing) Your own kind? Are you serious?

No response.

COUNSELOR/INTERPRETER: (Signing) Have you taken a good look at me recently?

No response.

COUNSELOR/INTERPRETER: (Signing) I'd say we have a few more similarities than the rest of the world would care to ignore. And as for your being deaf, don't think for a minute that I view that as some excuse for you to treat people any way you please. Nor do I view it as an excuse to banish you anyplace. But your deafness is a reality, and I thought some additional support at this time might be useful. Are we clear?
CHARLYN: (Beat) I'm fine here. I don't need to join some deaf AIDS AA thing. I'm just… in a mood.
COUNSELOR/INTERPRETER: I can handle that. But the more "black light" we can shed on this, the better.

They look at one another a moment.

Act I, Scene 22

In the darkness, a telephone light is flashing. Charlyn enters and answers a telephone with TTY. The digital screen "interprets" the conversation.

CHARLYN: Hello? [GA]

Lights up on Terrell at opposite end of stage, sitting at a small table with a telephone and TDD.

TERRELL: HI CHAR THEY LET ME CALL SORRY IT'S SO LATE UMM THEY JUST TOLD ME (Pause) BARBARA'S DEAD... [GA]
CHARLYN: (Beat) WHAT?! MY GOD WHAT HAPPENED??? [GA]
TERRELL: SOME HELPFUL SOUL WITH A CONNECTION GOT HER SOME SHIT SHE TOOK IT, HAD A SEIZURE, PASSED OUT AND THEY COULDN'T BRING HER BACK [GA]
CHARLYN: I'M SO SORRY T—
TERRELL: (Cutting in) HOW'S SHALIL?
CHARLYN: OK SLEEPING HOW U? [GA]
TERRELL: HOW U THINK? [GA]
CHARLYN: YEAH SO WHAT'S NEXT? WILL THEY LET U OUT FOR (Pause) WHAT U HAVE TO DO? [GA]
TERRELL: I WAS... HOPING U WOULD... HELP ME TAKE CARE OF THINGS... [GA]
CHARLYN: OH T I DON'T KNOW WHAT TO DO... UMM... OK... TELL ME WHAT U WANT... WHAT FUNERAL HOME? [GA]
TERRELL: THE PLACE THAT BURIED MA... SHE LOOKED PRETTY GOOD WHEN THEY GOT DONE WITH HER RIGHT? [GA]
CHARLYN: (Beat) NOT NEARLY AS GOOD AS WHEN SHE WAS ALIVE, BUT YEAH I GUESS SO OK I'LL CALL THEM BARBARA HAVE A WILL OR ANYTHING? I MEAN, SHE EVER TALK ABOUT THIS WITH U? [GA]
TERRELL: (Beat) FUNNY... WE NEVER THOUGHT ABOUT DYING... TWO PEOPLE LIVING LIKE THE WALKING DEAD BUT NEVER REALLY SAW THE LIGHTS GOING OUT (Pause) LISTEN, CHAR, GOTTA RUN... [GA SK]

Offstage: Noise of inmates wanting to use the phone in the background.

CHARLYN: LATER SK SK.

TTY Screen disappears. Charlyn continues to herself.

CHARLYN: Surprised you didn't, Terrell. You were my big brother. I wanted nothing more than to be proud of you. Instead I watched you die again and again. You looked down at my face just as sure as I looked up at yours. Didn't you see I was grieving?

Lights fade. End of Act I.

Act II, Scene 1

Rikers' Morgue. Corridor. Shalil is sitting alone looking very low. Charlyn comes upon him.

CHARLYN: Hey.
SHALIL: Hey.
CHARLYN: You haven't gone in yet, have you?
SHALIL: No. They told me to wait for you.
CHARLYN: Good.
SHALIL: I wouldn't have gone in by myself, anyway.
CHARLYN: (Beat) Hey. You remember how I always used to tell you I could see a lot of your father in your face?

Shalil shrugs.

CHARLYN: You know who I see now?

Shalil looks at Charlyn, questioning.

CHARLYN: I see you. (Beat) You don't have to do this, you know.
SHALIL: I know.

Charlyn and Shalil stand. Attendant wheels out Barbara, covered by a green coroner's sheet, on a gurney. Charlyn and Shalil look down at her body.
 The attendant uncovers Barbara's face for identification. Shalil looks for a long moment. Shalil places his hands over his face. Lights fade on them.

Act II, Scene 2

Craig Mac's "Flava in Ya Ear" fades up. Lights up on Trey and Bobby-Mack, on a stoop. Shalil enters, noticeably despondent.

TREY: Hey, yo, Shalil. Bobby-Mack just been rappin' about that bitch connection up on 135, man.
BOBBY-MACK: Word. Yo, she said some good rock be runnin' over that way. Might be worth looking into.

A woman's voice from off-stage calls out.

VOICE: Tre-ey! Trey! Don't let me have to come out there and get you.
TREY: Ah, shit, man, that's my moms.
BOBBY-MACK: Gotta go when mama calls!
TREY: Ah, fuck you man. I'll still kick your fucking ass.
SHALIL: He just playing with you, man.
TREY: A'ight, I'm Swayze, yo.

Trey exits.

SHALIL: Light, man.
BOBBY-MACK: (Overlapping) All right.
SHALIL: (Beat) So your old man used to be runnin' shit?
BOBBY-MACK: Old lady, too.
SHALIL: No shit, man!
BOBBY-MACK: Straight up, yo.
SHALIL: (Beat) Yo man, I think I know the bitch you talking about. (Beat) My pops used to cop from her all the time… for my moms. Say she like a fucking hound dog – could track some bad ass shit. So I'm like, contemplating the profit in-centive and shit, know what I'm saying? Trying to make sugar out of shit.
BOBBY-MACK: (Beat) I hear that. Well, dig it. Let me find the bitch, yo and get this party started!

Bobby-Mack exits.

SHALIL: Party. Yeah, right.

Lights and music fade on him.

Act II, Scene 3

Hospital sounds fade up. Charlyn is seated on an examination table in Dr. Avery's office. An interpreter enters. Dr. Avery examines Charlyn.

DR. AVERY/INTERPRETER: (Signing) How're you doing with the new medication?
CHARLYN/INTERPRETER: (Voicing) So-so. Makes me nauseous.
DR. AVERY/INTERPRETER: (Signing) That happens sometimes, unfortunately. I wish I could tell you something better, but it seems to be a lesser evil than AZT, and I'd like you to try it for a while. Now, when we're done here, I'm going to have the nurse's station send a clerk in to see you, okay? Apparently, we're having some kind of hassle with Medicaid.
CHARLYN/INTERPRETER: (Voicing) What's going on?
DR. AVERY/INTERPRETER: (Signing) I don't really know, but I know it will work out.
CHARLYN/INTERPRETER: (Voicing) I was just down there dealing with them about… Catherine.
DR. AVERY/INTERPRETER: (Signing) Yeah, I think that's part of the confusion – that at one time you were both being treated at the same time.
CHARLYN/INTERPRETER: (Voicing) Dammit! Why can't they get it straight?
DR. AVERY/INTERPRETER: (Signing) I know. But listen to me. I'm not gonna stop treating you because of Medicaid's bookkeeping problems. So you just

talk with the clerk. I'm sure whatever the problem is can be solved, okay? Don't worry.

Dr. Avery exits.

Act II, Scene 4

A hospital clerk enters.

CLERK/INTERPRETER: (Signing) How are you today, Mrs. Turnbull?
CHARLYN/INTERPRETER: (Voicing) Well, I was fine until Dr. Avery told me about Medicaid. What's going on?
CLERK/INTERPRETER: (Signing) Yeah. Apparently, Medicaid got you and your daughter's accounts confused and… closed yours out.
CHARLYN/INTERPRETER: (Voicing) What do you mean, closed mine out! We're… we were… two separate people.
CLERK/INTERPRETER: (Signing) I know, Mrs. Turnbull. First of all, relax. It's fixable. It happened because both your initials were the same, your address was the same, and I guess they thought, you know, what's the likelihood that two C. Turnbulls at the same address were both being treated for AIDS at the same hospital.
CHARLYN/INTERPRETER: (Voicing, beat) Where have these Medicaid people been while the shit's been hitting the fan?
CLERK/INTERPRETER: (Signing, beat) Listen, we figured out pretty quickly what happened and we're gonna take care of it, not to worry. We just wanted to alert you to it. Dr. Avery knows the situation and she's cool.

Lights fade on Charlyn and the Clerk.

Act II, Scene 5

Lights up on Charlyn's living room. Shalil storms in.

SHALIL: Why the mother fuckers gotta fuck with me, yo!
CHARLYN: What's going on?
SHALIL: (Now signing and speaking) Man, Bobby-Mack went and opened his big fucking mouth—
CHARLYN: Hey, hey, hey.
SHALIL: Sorry, yo, but now some big-ass dude is looking for my ass 'cause he thinks I pocketed some coin didn't belong to me.
CHARLYN: Shalil, you dealin'?
SHALIL: NO, I'm not dealin'.
CHARLYN: Then why anybody got cause to be after you?
SHALIL: I just ran a package over to some people.

Charlyn turns away in disgust. Shalil gets into Charlyn's line of vision.

SHALIL: I didn't look in it. I don't even know what was in it. Aunt Char, it's nothing like what you thinking. I'm just mad at Bobby-Mack because he wasn't straight up with me about something. Goddamn, man! I'm gonna kick the shit out of him when I see him. (Charlyn glares at him.) I'm serious, yo. I'll do some serious damage to the mother—
CHARLYN: Shalil! You wanna kick somebody's ass?
SHALIL: That's right, yo. I do. And I will.
CHARLYN: Come over here and sit down.

Charlyn motions Shalil over to the dinette table. She goes to the kitchen counter and pulls out a deck of cards and slams them down on the table.

CHARLYN: Kick mine.
SHALIL: (Stunned) You shittin' me, right?
CHARLYN: Try me. And watch your mouth!
SHALIL: I don't know how to play no cards.
CHARLYN: Well you better start learning.

Charlyn starts dealing out a hand for Gin Rummy.

CHARLYN: Cards have been in this family since the old days in Virginia.
SHALIL: Yeah, but what any of this got to do with me?
CHARLYN: Everything. You talking about kicking the shit out of somebody, you got to learn to do it right.
SHALIL: (Sucks his teeth) Shit!
CHARLYN: Shhh! Hush up and pay attention now.

Shalil stares at the cards on the table. Charlyn begins reviewing her hand. Shalil reluctantly picks his hand up and half-heartedly studies his cards.

CHARLYN: I want you to know I learned from the best.
SHALIL: (Disinterested) Right.
CHARLYN: I sure did. When I was about your age, we used to play until all hours of the night, me, your Grandma, and Emma, one of your Grandma's funeral-hopping buddies.

Lights dim on Charlyn and Shalil and fade up on Lelia and Emma. As the lights change, Charlyn enters the past and joins the others at a dinette table in Lelia's eat-in kitchen. Lelia is wide awake, staring at her hand. Charlyn and Emma are fast asleep, their heads down on the table, cards in hand.

LELIA: (Tapping Emma, who is seated to her left) Emma?

Emma awakens, groggy.

EMMA: Hmm?
LELIA: It's your play.

Emma groggily surveys her hand, makes a play, and goes back to sleep. Lelia studies the play Emma has just made. Then looks at her hand. She taps Charlyn, who awakens, groggily.

LELIA: (Signing and speaking) It's your play.

Charlyn looks at her hand, then looks around and notices the sun coming through the windows.

CHARLYN: What time is it, Mommy?
LELIA: (Signing and speaking) Time for you to play.

Charlyn is tickled at her mother's tenacity. She wakes Emma.

CHARLYN: You realize Mommy's been sitting up here playing cards with us, and we laying up here sleep.
LELIA: And it's a good game, too.
EMMA: Mmm-mmm-mmm. Y'all, I'm going on home.

Emma begins to leave. Lelia is still sitting, staring at her hand. Lights dim so we are aware of Lelia studying her hand through this next exchange.

CHARLYN: God only knows what time she'd actually put those cards down and go to sleep. But I know one thing, she beat the crap out of us every time.
SHALIL: Sure she did. She be sitting up there all night cheating, looking at everybody's hand while y'all be sleeping.
CHARLYN: Don't miss the point here, Shalil. If you must know, I asked her one time if she ever cheated.

Lights up full on Lelia, still reviewing her cards, addressing Charlyn as if she is with her.

LELIA: (Signing and speaking) No fun that way.
CHARLYN: But it was a sure way to win, I told her.
LELIA: (Signing and speaking) And exactly how much satisfaction would that provide me, doing one-up on people who can't protect themselves.
SHALIL: Yeah, well, that ain't how it is on the street. It's me first, later for y'all. If I'm busy worrying about you and what you ain't got, I could get good and dead worrying.
LELIA: (Signing and speaking) Put all your attention on getting yourself ahead, next thing you know, you out there in front all by yourself, ain't got nobody

to lean on if you hit some kind of wall while you out there running, taking, getting ahead.

Silence. Lights fade on Lelia.

CHARLYN: Whole lotta folks on the street doing that. You're so much better than that, Shalil. (Pause) When was the last time you went to see your father?
SHALIL: Please. Let him rot in there, I don't give a shit.
CHARLYN: Shalil. Go and see him.
SHALIL: No!
CHARLYN: Shalil, I'm not him. I want you to see him. It's important that he sees you.

Shalil storms out, and walks into the "Visitors Room" at Rikers.

Act II, Scene 7

Terrell enters. They sit in silence.

TERRELL: So…?
SHALIL: So…what?
TERRELL: So… you come all the way over here to see me and don't got nothing to say?
SHALIL: Man, you lucky I'm here at all.
TERRELL: Uh huh. Yo, why it got to always be like that?
SHALIL: Man, you kidding me, right?
TERRELL: No, I ain't kidding you. Can't you treat your father with some respect?

Shalil just looks at Terrell. Silence.

TERRELL: Well, if you can't do that, can you at least tell me how you been doing in school?
SHALIL: Man, what you think, I'm stupid? School's something you ask about when you give a damn, okay?
TERRELL: First of all, don't be cussin'. Second of all, you think I don't give a damn? That's why I'm in here, cuz I don't give a damn? ANSWER ME!
SHALIL: YES! That's exactly why you in here.
TERRELL: Bullshit.
SHALIL: Yeah?
TERRELL: That's right.
SHALIL: Well, I ain't buyin' it.
TERRELL: Well, I ain't gotta sell you on nothing.
SHALIL: Oh, yeah you do.

TERRELL: Yeah? How's that?
SHALIL: Man, what, are you stupid now? I gotta tell you everything?
TERRELL: I'm telling you, watch your damn mouth with me, hear?
SHALIL: I don't gotta watch shit.
TERRELL: Oh, big man.
SHALIL: ANYWAY! We was talking about you giving a damn. Which you don't.
TERRELL: And how the hell you presume to know that?
SHALIL: Cuz if you really gave a shit about me… you and Ma woulda done a whole lotta things different. THAT's how the hell I pre-sume to know what I know.

Silence.

TERRELL: We did the best we could.
SHALIL: Yeah, well your best was shit, and her best done got her cold and dead in the ground.

Long silence.

TERRELL: Get the hell outta here.
SHALIL: No problem.

Shalil heads for the door.

TERRELL: SHALIL!

Shalil stops in his tracks.

TERRELL: Never mind. I… wish I knew how to do this different, but I don't…

After a moment, Shalil exits. Lights fade.

Act II, Scene 8

Lights up on Charlyn in the counselor's office. An interpreter is present.

COUNSELOR/INTERPRETER: (Signing) You seem tired today.
CHARLYN/INTERPRETER: (Voicing, beat) Ever been in Harlem early in the morning?
COUNSELOR/INTERPRETER: (Signing) Mmm-hmm.
CHARLYN/INTERPRETER: (Voicing) Everything's very quiet. You can probably say that about a lot of places. But there's something about Black folks taking a time-out from getting knocked upside the head by life that makes me want to grab a cup of Ms. April's coffee and curl up on my stoop with

the morning sun wrapped around me watching the few people out and about enjoying some kind of peace from it all. (Pause) Tired? Shit! I feel like the mediator standing between two warring countries.

Lights up on Danny frozen in time the way we last saw him.

CHARLYN/INTERPRETER: (Voicing, pause) That's what I loved about Danny. He was at peace in the middle of a war zone. He was definitely a casualty. But in the meantime, he ducked the bullets as long as he could. That someone could do that so gracefully, excited me. And when he stood in front of me, it was like being paralyzed by fearlessness – seeing it at its barest, most effortless.
COUNSELOR/INTERPRETER: (Signing) And now?
CHARLYN/INTERPRETER: (Voicing, shrugs) Bad shit and bad judgment can happen to everybody.

Lights fade on them, and up on Dr. Avery's examining room.

Act II, Scene 9

A Nurse is preparing the examination room. Dr. Avery enters.

DR. AVERY: Hi.
NURSE: Morning, Doctor.
DR. AVERY: I sent for a T-cell report on Charlyn Turnbull from the lab several hours ago. Have they sent it up yet?
NURSE: Yes, I think they have.

Charlyn enters the room.

DR. AVERY: Hello, Char.
NURSE: Hi.
CHARLYN: Hello.
DR. AVERY: (To Nurse) Can you bring that report to me and send a copy up to Dr. Breen?
NURSE: (Beginning to leave) Sure can.
DR. AVERY: And give him a call and remind him I'm waiting for those endocrine studies on Culver, okay?

An interpreter arrives.

NURSE: Sure will.

Nurse exits.

DR. AVERY: (To Interpreter) How are you?
INTERPRETER: (To Dr. Avery) Fine, thanks.
DR. AVERY/INTERPRETER: (Signing, to Charlyn) How you doing today?

Begins her examination.

CHARLYN/INTERPRETER: (Voicing) Been a rough few days. A lot of fevers lately.
DR. AVERY/INTERPRETER: (Signing) Night sweats?

Charlyn nods.

DR. AVERY/INTERPRETER: (Signing) Okay.

Examines Charlyn in silence a moment.

DR. AVERY/INTERPRETER: (Signing) You still in your support group?
CHARLYN/INTERPRETER: (Voicing) Mmm-hmm. And I'll tell ya' something, I don't know how I'd make it without those folks.

Pause. Dr. Avery nods.

DR. AVERY/INTERPRETER: (Signing) I need you to lay down for me, okay?

Charlyn lays down on the exam table. Dr. Avery continues to examine her.

DR. AVERY/INTERPRETER: (Signing) Did you keep that G-Y-N appointment we made?
CHARLYN/INTERPRETER: (Voicing) Yeah. I went last Tuesday.
DR. AVERY/INTERPRETER: (Signing) Good. I'm waiting for a report back from the lab. When I get it, we'll talk about whether I've seen any changes since last time or not.
CHARLYN/INTERPRETER: (Voicing) You think there'll be any?
DR. AVERY/INTERPRETER: (Signing) Oh, Char, it's so hard to say. The medication we've got you on is so new, we haven't had a lot of time to see what affect it has on the kinds of cervical irregularities you've been having.

There's a long silence. Dr. Avery listens to Charlyn's chest quite a while, and examines her pelvis and stomach. Dr. Avery stops examining. They look at each other.

CHARLYN/INTERPRETER: (Signing) You have kids?
DR. AVERY: Mmm-hmm. A son.
CHARLYN: What do you do when he has fevers?
DR. AVERY/INTERPRETER: (Signing) Well, I remember one time, he had a fever that spiked so high, I think it was 104, I sent my husband out to get as

many bags of ice as he could carry, and we just filled up my son's bassinet with ice and put him in it. When he started shivering, I took him out and wrapped him up in a blanket and just held him. He shook and shivered, and finally broke the fever.

CHARLYN/INTERPRETER: (Voicing) That's exactly what my mother had to do when I ran high fevers like that. I had meningitis.

DR. AVERY/INTERPRETER: (Signing) How old were you?

Charlyn holds up three fingers.

DR. AVERY: Is that how you… (points to her own ears)?

Charlyn nods. She reminds Dr. Avery of the sign for "Deaf." Dr. Avery copies it. Again, a long silence.

Act II, Scene 10

The lights change to indicate the passage of time. During the change, a dim light allows us to see Charlyn dressed in a hospital gown and transported to a hospital bed. When the lights come up, her condition has deteriorated considerably.

Shalil enters. They look at each other a long moment.

SHALIL: Hey.
CHARLYN: Hey, yourself. (Pause) So you gonna stay a while?

Shalil sits.

SHALIL: I don't like seeing you like this.

Silence.

CHARLYN: Seen your dad this week?
SHALIL: Here and there.
CHARLYN: Mmm-hmm. Which one of you's here, and which one's there?

(They laugh. Shalil shrugs. Silence.)

CHARLYN: You know that little box on the shelf in my kitchen?
SHALIL: What about it?
CHARLYN: I used to see you looking at it all the time.

Shalil shrugs again.

CHARLYN: I want you to have it.

SHALIL: I don't want to get into this.
CHARLYN: Get into what? We're talking about a box.
SHALIL: No we not.

They look at each other.

CHARLYN: All right. We're not.
SHALIL: SHIT! Man, why y'all do this shit to me?
CHARLYN: Shalil, I can't think of a single person who's gotten out of this life being able to give it a one hundred percent fairness rating. Can you?

Silence.

SHALIL: How'd they get like that?
CHARLYN: (Pause) It's like the wrong side of the tracks fell on your father. He didn't seek it out. You gotta understand that. Necessity drives people in directions they'd steer clear of in better circumstances. He had his own ideas about how to take charge of things.
SHALIL: Look, all I know is, I ain't his damn father. He s'posed to be mine. But don't let me say nothing about his running numbers for a living. He be talking about "I can't work for no white man, and day after day be having his foot on my neck. Goddamn neck ties like a noose, anyway." I say, "so then work for a Black man, Pop. Work for yourself." What I get? "Don't be running down that Clarence Thomas 'by-your-own-bootstraps' shit to me."

They both laugh at the irony.

SHALIL: It's just all backwards, that's all. It ain't like they was busy trying to teach me right from wrong and I was giving them shit for it. They was busy doing wrong. I was bucking the wrong they was doing.
CHARLYN: I know.
SHALIL: I mean… you been… you been more of a mother to me then I've ever had in my whole life.
CHARLYN: Well now, don't sell your mother short. Was she someone who had all sorts of avenues open to her?
SHALIL: Uh-uh, I ain't with that. Only "avenue" she knew was the one that led up her nose. She lived for using and feeling good. Everybody else I know be bitching about they mother don't be letting them do shit. Well, my mother be letting me do any damn thing I want, long as I don't forget to make that one stop before I bring my ass in the house.
CHARLYN: (Stunned) She actually had you copping for her, Shalil?

They look at each other.

SHALIL: Aunt Char, this family be dropping like gang members in East L.A. (Pause) What I got when you leave here?
CHARLYN: A whole lot more than you think. You know, we have these rules. We're taught the parent raises the child. Well, sometimes it doesn't work out like that. Sometimes the parent is just too damn banged up and bruised.

Indicates her head and heart – but Shalil needs more. Trying to clarify.

CHARLYN: Whenever I was afraid of anything, your grandmother would take my face in her hands, turn to me and say, "Come on, now. Get your guts up." Looked stern when she said it, but I always knew she loved me more in those moments than perhaps any others, because she knew courage was the only thing she could pass down to me that would really get me through the rough times. That's a kind of legacy, don't you think?

They look at each other.

CHARLYN: So you get your guts up, hear?

Act II, Scene 11

Shalil exits and Counselor enters. There is no interpreter present. Counselor has apparently learned some sign.

COUNSELOR: Hey.
CHARLYN: Hey.
COUNSELOR: It's good to see you.
CHARLYN: Thanks. Wow! Look at you!
COUNSELOR: Well, I'm trying. How you been doing?
CHARLYN: Up and down. Terror's in remission though.
COUNSELOR: (Smiles. A long, peaceful silence) A friend told me about visiting a young man in the final stages of AIDS. She was amazed by his energy – he was the one that was dying – and yet she left feeling completely energized by him. She was astounded by that. And by a particular thing he said. He told her he had no choice but to choose this death – that it felt non-oppressive that way; that it kind of diffused death's power for him.
CHARLYN: Mmm-hmm. There comes a point where you stop trying to negotiate, you know? You just try to imagine, at 3:00 in the morning today, not being here at 3:00 in the morning tomorrow.

They sit in silence a moment. Lights fade on them.

Act II, Scene 12

Lights up on Charlyn standing at her daughter's small headstone.

CHARLYN: They tell me it's too cold out here for me. It's not cold at all. I woke up today feeling a bit better than I have in a while, so I decided to come and visit with you. Any day I wake up with a little energy is a gift. Don't like to think of it as cheating death though, 'cause you know how your grandma hated cheating.

She looks around listening to the leaves. A chorus of voices begins to vocalize a stormy, siren-like nocturnal melody.

CHARLYN: What did your Grandma call it?

She fingerspells the word fluidly, creating a cascade of water in the air, as she does.

CHARLYN: N-O-C-T-U-R-N-E.

Lelia appears, looking down at Young Charlyn, and signs along with Charlyn.

CHARLYN: Nocturne. It's kind of quiet. Except sometimes it erupts into something not so quiet – but something that… seeks quiet once again. (She looks around, listening again. She smiles) Today, it's not so quiet. Today it's you and your grandma…

The people from Charlyn's past appear all around her, in her memory.

… and a whole chorus of voices. And you're singing… (She signs, but there is no spoken voice)… just for me.

Lights fade. End of Play.

About the Author

Dr. Jaye Austin Williams is Assistant Professor and C. Graydon and Mary E. Rogers Faculty Fellow in the Department of Critical Black Studies at Bucknell University, where she specializes in the melding of drama, cinema, performance, and Black Feminist theories with Critical Black Studies. She worked for 30 years in the professional theater as a director, playwright, actor and consultant, on and off Broadway and regionally. As an actor, she took part in the National Theatre of the Deaf's Professional Theatre School in the summers of 1984 and 1986, later appearing in several Little Theatre of the Deaf performances in the late 1980s, and appeared in the 1984 Hangar Theatre Production of Mark Medoff's *Children of a Lesser God*. She was director-in-residence for Onyx Theatre Company in New York City throughout the 1990s. In 2005, she directed a production of Ntozake Shange's *for colored girls who have considered suicide when the rainbow is*

enuf for Gallaudet University's Theatre Arts Department. Today, she teaches and speaks nationally and internationally on the structural and global implications of antiblackness and its myriad performances, both subtle and overt, in modernity. She is completing a monograph entitled, *Staging (Within) Violence: Towards a Radical Black Dramaturgy.*

When asked to describe what kind of theater she would like to make, Austin Williams stated in her entry in the Lincoln Center's Director's Lab Directory:

> I'm interested in making theatre which explores paradox, contradiction, irony – as a piece of music explores point and counterpoint, consonance and dissonance. I believe such exploration will help re-engage our audiences and to encourage them to think, rigorously, from head to toe.[3]

According to an interview with the author-director in *Drama – Over the Director's Shoulder,*

> When she graduated from Skidmore College in 2004 with a theatre degree, Williams began to find difficulty with getting roles. 'I didn't look conventional…The casting industry is just a wretched industry in my view,' says Williams, 'I was never thin enough, fat enough, this enough, that enough.' It became clear to her that if she wanted to act and find her place in the theatre industry, she would have to start writing stuff for herself. This led her to writing six plays in total [including] A Not So Quiet Nocturne (2001) and Passion Play: A Parable (1998); they remain my two prides and joy.[4]

Notes

1. Binaural refers to both ears. A binaural body aid is a hearing aid worn in a harness or clipped on to an article of clothing, with two wires extending from it which each go to one ear.
2. The digital screen also conveys the conventional TTY signals i.e., "GA" meaning Go Ahead, and "SK" meaning Stop keying, which indicates one is signing off. These cues are indicated in brackets and are not spoken.
3. Lincoln Center Theatre – Director's Lab Directory. Jaye Austin-Williams. Retrieved from: http://www.lct.org/dirlab/Director.asp?ID=5. Accessed 25 July 2020.
4. Kelly, Thais. "Drama – Over the Director's Shoulder." Across the Bridge. Retrieved from: https://tartyogurt.wordpress.com/drama/. Accessed 25 July 2020.

11
MIKE LAMITOLA, *PROFILE OF A DEAF PEDDLER*

IMAGE 11.1
Source: Photo courtesy of the National Theatre of the Deaf.

316 Mike Lamitola, *Profile of a Deaf Peddler*

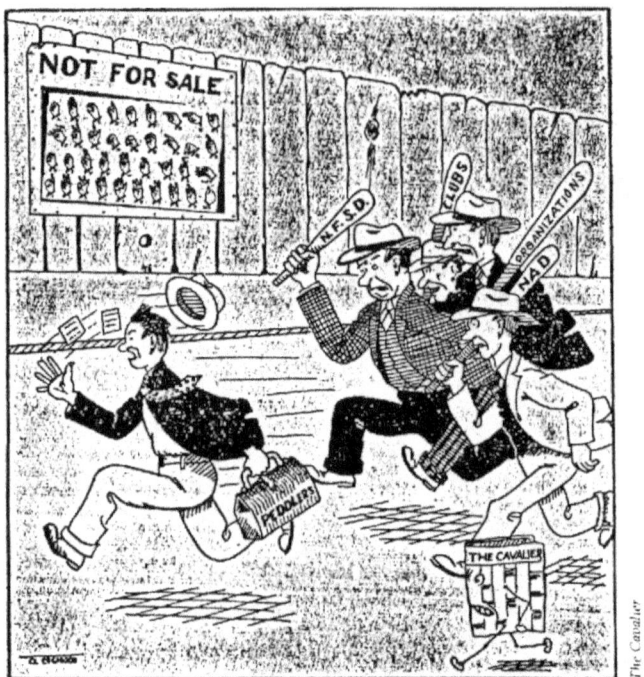

A 1948 Cavalier cartoon.

IMAGE 11.2 1948 cartoon that accompanied Jack R. Gannon's original story, *Profile of a Deaf Peddler,* which inspired Mike Lamitola's adaptation.

Synopsis

As Paddy sits in his neighborhood diner among friends and acquaintances, a deaf-mute suddenly approaches. The man is handing out manual alphabet cards that ask for small donations. A confrontation begins, but not for the reasons the peddler might expect; he finds that Paddy is also Deaf. But, while both men share a common language and culture, they are much more aware of their differences. That is, until Paddy recognizes the peddler as a long-lost friend named Johnnie from school. The two men soon rekindle their friendship, opening the door for a moving and insightful conversation about the path each has traveled. Paddy learns that Johnnie found success on his own terms, even as peers viewed him as the lowest member of the deaf community. This play also explores how Deaf peddlers came to be and why they are still here today.

Production History

Profile of a Deaf Peddler premiered June 2–13, 1999 at New Perspective Theatre Company in New York, NY. Original Story by Jack R. Gannon; conceived and

directed by Mike Lamitola. Produced By New York Deaf Theatre. Production Stage Manager, Jen Prosceo; Electrician/Lighting Technician, Omar A. Jaslin.

Developed by: Suzy Baker, Michelle Banks, Frank L. Dattolo, Michael P. Ralph, Ed Walthall

The play was remounted and produced by NTD for a national tour during the 2001–2002 season. It was directed by Aaron Weir Kelstone; LeTishia Whitney, Production Stage Manager. The ensemble was as follows:

Joy Bates
Robert DeMayo
Ruthie Jordan
Ian Sanborn
Daniel H. Taylor[1]

Thoughts on the Play

One day in the mid-1990s, Mike Lamitola read and was deeply moved by a sidebar, *Profile of a Deaf Peddler,* written by Jack R. Gannon. The story was within Gannon's *Deaf Heritage*, a seminal book on the history of deaf people in America.[2] The question that struck Lamitola while reading the story was,

> …are Deaf people really better off today? There are times when we need to look back and see where we came from in order to understand where we are going. Today we have computers, TTYs, closed-captioned television, telephone relay operators that allow us to contact any hearing person anywhere, anytime. We have social services, Vocational Rehabilitation, interpreting services that enhance our education experience in any school, college, or university. We have acquired government protection for our equal rights under the Americans with Disabilities Act (ADA) and other state and federal laws. We cannot deny the impact that medical advantages or as some say disadvantages (such as cochlear implants) have had on our lives and on our culture as well. Last but not least, our language, American Sign Language, has been researched, recognized, and given a status equal to any foreign language in our American society. I still wonder why it's a foreign language when it is the language of Americans.[3]

Lamitola's ruminations – articulated in his director's notes in the program of his 1999 premiere – were what spurred him to adapt Gannon's story into a oneact stage play. It is one of the few plays in this volume that is strongly rooted in Deaf culture. It involves traditional storytelling with narrations, role-plays, pantomimes, and flashback reenactments by an ensemble of actors. The drama is didactic in its approach, and sometimes this is needed to drive a point home with Deaf audiences. A common tendency in Deaf culture is that Deaf people like language to be direct and in black-and-white. Typically, there is little room for ambiguity in ASL – what you see is what you get.

The play uses the Deaf theater convention of hearing characters maintaining their own roles (Chef, Waitress) while voicing for Deaf characters who have dialogue in ASL. Universal gestures are sometimes employed by the Deaf characters when communicating with hearing characters – just as deaf people are wont to do in real-life situations when interacting with hearing people. Also, in one instance, sign-mime is used. This is an ASL storytelling technique – sometimes known as Visual-Vernacular – that incorporates movie camera shots (wide shot, medium shot, close-up, bird's-eye-view, slow-motion, freeze frame, etc.) by use of ASL, gestures, and body movement.

Deaf Gain

This play paves the way for more Deaf and hard-of-hearing writers to adapt for the stage (or TV/film) literature created by other writers like themselves. The more this is done, the less cultural appropriation will occur in the entertainment industry.

Notes

1 Promo postcard, *Profile of a Deaf Peddler*. National Theatre of the Deaf, Hartford, April 14, 2002.
2 Gannon, Jack R. *Deaf Heritage*. National Association of the Deaf, Silver Spring, 1981. 257–258.
3 Playbill, *Profile of a Deaf Peddler*. New York Deaf Theatre, New York, June 2, 1999. 2.

11
PROFILE OF A DEAF PEDDLER

Mike Lamitola

Characters

PADDY, *a professional deaf person, 40s.*
JOHNNIE, *a deaf peddler, late 30s to early 40s.*
YVONNE, *a deaf woman, late 20s to early 30s.*
MOTHER, *hearing female/Voice actor.*
CORBETT, *hearing Male Woodshop Teacher/Voice actor.*
 Some of the actors will play a variety of characters to fit the needs of each scene.

Notes

This story takes place back when there were no TTYs or TDDs, closed-captioned TVs, Vocational Rehabilitation offices, telephone relay operators, and no such law as the Americans with Disabilities Act (ADA). The word "mainstream" was not yet in our daily vocabulary. The "cochlear implant" had yet to make its debut. This was a time when the sign for "institute" meant not only the school one attended, but one's home and life. It was a time before research brought recognition and validation that "the sign language" deaf Americans used was indeed a true language (ASL).

The whole play is to be performed on a bare stage with minimal sets, props, and scenery. When there is a need for a place or scene, the actor simply uses his/her mime/pantomime skills; the emphasis is on character development and ASL skills. The use of sign mime, pantomime, and any visual gestures is necessary to help communicate this story.

Editor's Note: this script used the names of the original ensemble members who were involved in the play's development: Suzy Baker, Michelle Banks, Frank L. Dattolo, Michael P. Ralph, and Ed Walthall.

DOI: 10.4324/9781003112563-23

Scene

Setting: Coffee Shop; 1960s

A waitress is on one side of the counter; she is working, cleaning and serving people using pantomime throughout the scene. She knows a few signs and gestures. Paddy walks in and sits at his usual place. He is a regular here at the coffee shop. He orders his food verbally with a few gestures and signs that he has taught her over the years.

PADDY: Hi! My name is Paddy. (The name sign is "P" hand shape on the chest.) Paddy is an unusual name. My mother named me after her grandfather. It's an Irish name; both of my grandparents came from Ireland. My parents are Irish, through and through.

Everyone in my family is hearing. I'm the only deaf person; I became deaf from high fever at age five. Doctors told my parents not to let me learn sign language, and they put me in a "regular" public school. I had so many problems. You see, my parents themselves were teachers, and they didn't know what to do with me. They tried to help me, but I was having problems, both, inside and outside of school.

Later, they decided to send me to a school for the deaf. It was the best decision they ever made, and I am forever grateful to them. I lived at the school for the deaf all year long except during Christmas vacation, summer vacation and occasional weekends. Gosh, I hated coming home. Do not misunderstand me, I love my parents and family, but it was boring and difficult, since no one in my family could sign. Communication at home is limited. Oh yes I can talk fairly well, but being able to speak doesn't mean that I can understand spoken English or lipread that well. I have to say, I love sign language because with it I can understand everything.

This is my favorite coffee shop. I come here every Saturday morning. There is Stella; she's my favorite waitress. She knows some signs because I taught her a few here and there.

WAITRESS: (Gestures cup)
PADDY: (Gesture and voicing for himself throughout the scene with the waitress)
Tea with lemon and sugar.
WAITRESS: Four lemons?
PADDY: One! (Pause) Brrr, cold outside!
WAITRESS: Yes, it's very, very cold.

Signs "very" wrong; looks like "fucking."

PADDY: No, no, no, that's a "dirty" sign.
WAITRESS: What's the sign for "very"?

Paddy shows her the correct sign for "very."

WAITRESS: Oh, oh, okay. Very. Okay. I'll be right back.

Gets order.

PADDY: (Looks at menu to see what he wants)
WAITRESS: (Brings tea. Paddy see that there are four lemons in the tea. He points to them and she takes out three and places them in his hand. After a bit of cleaning up, she's ready.) What can I get for you to eat?

She prepares as if challenges are coming.

PADDY: (Gestures he wants eggs sunny side up with bacon: "Egg with sun with strips.")
WAITRESS: (Doesn't understand)
PADDY: (Repeats the gesture slowly. Waitress still doesn't understand. Finally he changes his explanation: "Eggs crack open, breast mounted on plate with pig nose.")
WAITRESS: (Copying his pig gesture) What?
PADDY: (Acts out a pig making noises oink, oink)
WAITRESS: (Laughs) Eggs sunny side up with bacon. Bread?
PADDY: (Nods head yes, signs sloppily) Toast, yes.
WAITRESS: (Tries to copy that sign awkwardly. Goes to place the order and returns.)
PADDY: Your two children?

Gestures "thumbs up."

PADDY: They're good?
WAITRESS: Good! Crazy Devils, but good.

She gestures: eye, heart, two children.

PADDY: (Puzzled, and then laughs) Oh, you mean "I" like this, not "eye." "I love them." (Pause) I'm flying to Washington DC. I'm going to Gallaudet College.
WAITRESS: What? Slow, please!
PADDY: (Gestures) Washington Monument (Gestures D and C using British two-handed fingerspelling). Deaf college there. Gallaudet College. I'm giving a lecture.
WAITRESS: Washington DC, that's wonderful! Exciting! When are you leaving?
PADDY: Next week Thursday.
WAITRESS: For how long?
PADDY: Two, three days. See friends too.
WAITRESS: I will miss you.

Gestures miss as in "miss something." Paddy corrects her with correct sign for the concept.

WAITRESS: You're my favorite. I'll be right back.

Gets order from cook.

PADDY: (Starts to eat)

Just then a man walks in from the audience. He is passing out little cards to the audience members.

MICHAEL: To some, the deaf peddler was the lowest form of the deaf human animal. Educators resented the peddler because he represented a failure of school and society to cope with him. To the college educated deaf person the peddler is generally loathsome. To the average deaf American he is resented, feared, hated, or ignored. The deaf community leader sees the peddler portraying a harmful and mistaken image of the average hard-working, honest deaf American. These leaders believe that no self-respecting deaf person would peddle.

By the time Paddy finishes his speech, the peddler arrives and hands him a card.

PADDY: (Signs ASL) Are you deaf?
JOHNNIE: (Not wanting any confrontations with deaf people, he backs off.)
PADDY: Wait – stay, please. I know you. We went to school together.

Hugs Johnnie.

JOHNNIE: (Doesn't immediately recognize him.)
PADDY: We played football! I blocked for you – you were the halfback. I'm Paddy!
JOHNNIE: You got so fat!
PADDY: (Hugs him the way deaf people do when greeting long-lost friends.) Yeah, well I'm older now and well…. it's been a long time…. Anyway, I remember the first day I met you. You remember that?
JOHNNIE: (Goes into flashback and reintroduces himself) My last name is Gisser, first name is… Johnnie!

Does something playful, both laugh.

PADDY: I remember you lived near me in Southern Missouri. I lived on one side of town, you on the other.
JOHNNIE: Yes, you lived near the church. You visited me on the farm. You were a city boy.

PADDY: Yeah, yeah. Remember when I milked the cow and couldn't even hit the bucket. HA! Your father was so mad. How are you? How's your family?
JOHNNIE: (Hesitating) I'm fine, fine! (Pauses) My family, I don't know. I haven't seen them in years. You know we don't communicate much.

Johnnie's mother approaches.

MOTHER: I need to go into town. I will be back in about two hours. I want you to finish milking the cows, take the bales of hay down to feed the horses, next…clean out the pig-pen, and then gather up some wood for the fireplace. Don't forget the pot roast has to come out of the oven at 5:45PM.

Throughout the scene, Johnnie is asking for clarification and repeating the request his mother is asking, while she becomes increasingly frustrated. Mother faces audience for her monologue.

MOTHER: For the longest time we didn't even know Johnnie couldn't hear. I kept takin' him to the doctor and this man, "the Doctor," would tell me there was nothing wrong with him…that Johnnie was just stubborn.

When he was five years old, he went to school. Only the principal there told me that Johnnie had to leave. They couldn't keep him – on account of his being so disruptive and not paying attention in class. I finally went to another doctor who told me Johnnie was… umm…well, you know…he couldn't hear. So I kept him home and just let him work on the farm.

Lord, I felt awful! I knew for sure it was my fault. See, I had the flu when I was three months pregnant. The Lord must have punished me for something I did, or something I didn't do.

Well, I had no idea what to do. I didn't know anyone who was deaf, or anyone who knew anyone who was deaf. What did I know about raising a deaf child? I just figured when he got older…things would get easier. I was wrong. Things only got worse.

He don't pay attention to me. He don't understand me. Shoot, I can't even get him to follow simple directions. He has no friends. He just does what he can. Sometimes it feels like he just doesn't want to be a part of this family. I guess that's just the cross we got to bear.

Mother fades away as Johnnie continues his conversation with Paddy.

JOHNNIE: I had a hard time understanding them, and well…they don't sign and well you know…, (Awkward moment) farm life for me is boring. I'm lonely. I'm too much trouble for them and umm umm….
PADDY: (Sensing his uneasiness) Hey, I remember you were always fixing things. You made wonderful things with wood. Remember that game you had

given me, with the marble ball rolling down one level and dropping to the next level and so forth. I still have it in my office at home. You were the best.

WAITRESS: (After cleaning up, serving others and going on a short break, she returns. She watches Paddy and Johnnie converse a while.) Do you want something to eat or drink?
PADDY: (Interprets: Food, drink?)
JOHNNIE: No thanks!
PADDY: Come on, I'll pay!
JOHNNIE: (Gestures to waitress) Coffee, black.
PADDY: (To Johnnie) Food?
JOHNNIE: Eggs. (Explains that he wants sunny side up and also explains sausages by gesturing a meat grinder.)
WAITRESS: Oh…sausage! Would you like toast?

Sloppy sign for toast.

JOHNNIE: (Corrects her sign for toast. Waitress smacks Paddy in the arm for not teaching her the correct sign.) Yes, four!
WAITRESS: (Points at Paddy and mouths "don't end up like him!" Before bringing the order to cook, she addresses the audience.)
MICHELLE: Deaf peddlers are not a new or recent phenomenon. Accounts of deaf people begging appeared in early publications. No statistics exist on deaf peddlers, so other than personal accounts, little is known about them.
WAITRESS: (Drops off Johnnie's food order)
PADDY: So what happened after you graduated?
JOHNNIE: Graduated? Not me! I dropped out.
PADDY: What? I thought you went into carpentry. You were good. You were always great with your hands.
JOHNNIE: Yes, I was.
PADDY: You remember the wood shop teacher, Corbett (name sign with C and drooping mustache)?
JOHNNIE: Yes, good teacher, tough and strict. He was old man. Where is he now?
PADDY: He died. Oh, a long time ago.
JOHNNIE: What about you, what are you? A janitor?
PADDY: (Not wanting to brag) Umm I'm a teacher, and an administrator at a school.
JOHNNIE: What do you teach? I remember you always read books. You were such a bookworm, like your eyes were glued to the pages. You were always reading some history book or another.
PADDY: That's what I teach…History.

Smiles awkwardly.

WAITRESS: (Brings the order to Johnnie, which is the cue for Michael to begin the next monologue)
MICHAEL: It is commonly believed that a majority of peddlers were young deaf adults, who did poorly in school and dropped out. These low-achievers usually see themselves as failures at home and at school, and have developed an apathetic attitude. They are generally the victims of a lack of communication at home and are not understood or liked at School. They are considered "trouble makers."
PADDY: (Sees the ABC card of the manual alphabet that Johnnie had given him earlier) WHY?
JOHNNIE: That's personal. I have my reasons! So what? You have your money; I want money, too. The same as you!
PADDY: But you were so good; you worked so hard in school.
JOHNNIE: You don't know what I've been through.
PADDY: Okay, maybe I don't know everything, but peddling? Where's your self-respect? The community won't respect you. People look down on you.
JOHNNIE: I don't care!

Turns to address the audience.

FRANK: The self-respect that deaf leaders talk about does not bother the peddlers. They either never developed any or soon lost whatever self-respect they had through repeated failure and frustration. Peddling gave them independence. It brought in money which they never had access to before. It provided them the opportunity to break free, to travel, to seek adventure, to be "somebody" even if labeled a peddler. They had been on the "other side" too long to care.
MICHELLE: Johnnie had been "Voc," which means that he was majoring in vocational subjects. If only he had completed the course, he would have graduated with a vocational certificate.
PADDY: You had wonderful training in wood shop. You were the best! Your work is still hanging in the school halls and lobby. The auditorium still has the school emblem you made. All you had to do was finish the vocational training.
JOHNNIE: Yeah, I know. Corbett was a good teacher.

Flashback to Voc class. Frank is Johnnie, Ed is Corbett, and Michelle is another student helping Johnnie. Johnnie and Michelle are fooling around; both laugh.

CORBETT: Stop that! No fooling around near the machines! Now remember safety first. Put on those safety goggles.

They do.

CORBETT: OK! OK!.... Then measure...

Uses wrong sign for "measure." Johnnie corrects him.

CORBETT: twice,

Wrong sign for "twice." Johnnie corrects him.

CORBETT: cut...

Wrong sign for "cut." Michelle makes fun of his sign, using a sign for "fornication," then makes the sign for cut showing one's fingers being cut off.

CORBETT: That's what'll happen to you if you don't pay attention...and cut it once, got it?
JOHNNIE: (Clarifying for Yvonne): Measure twice, cut once.
CORBETT: Yeah yeah, well anyway. Measure twice, cut once.

Still signs it wrong.

JOHNNIE: (Measures the wood twice.)
CORBETT: Okay now, turn on the saw. Now careful, push it S-L-O-W-L-Y.

Fingerspell slowly, very slow.

JOHNNIE: (Turns on the machine and cuts the wood.)
CORBETT: Good boy, Johnnie, Turn it off. Okay now sand it. (Wrong sign for sand; to Johnnie) Nice and smooth, get all those rough edges out! (To Michelle) No, wrong way, go with the grain. Okay, good!

Scene fades away.

MICHAEL: Johnnie had come to school when he was about 12 years old. His family had not known there was a school for deaf children, and when they did, he was too late and too far behind to fit into the regular academic program. He was much older than many of the other students in his class. But there was no question about his skill in the woodworking shop.
FRANK: (Does a sign-mime story about first arriving at a deaf school at 12 years old. The story will include arriving with parents, the parents leaving him behind, frustrations of learning a language, the joys of knowing a language, and then being the oldest kid in class. The story also includes feeling left out, lonely, angry and frustrated with his homework. The scene ends in a conflict with the dorm supervisor and him packing up and leaving.)

MICHAEL: Unfortunately, he was unable to get along with his dormitory supervisor, and he grew disillusioned with school. When he was 19 years old, he quit and got a job in Kansas City.

MICHELLE: Most of the peddlers seem to have acquired good vocational training or at least have a marketable skill, but they are unable to hold a job for a variety of reasons. The inability to communicate – to understand and be understood – is one. This makes it difficult for them to become a participating member of their families, or to get along with their employers or co-workers.

Michael plays the boss and Michelle plays a co-worker of Johnnie's. Throughout this scene there is no voicing, just action – NOT in the style of a silent movie, but simply a scene with no voice. Michael and Michelle are hearing; they are talking about work and laughing. Johnnie will try to be involved and communicate with them. The workers don't purposely exclude Johnnie. It's just a way of life. After Johnnie punches in late for work, the boss tells Johnnie to sweep the floor, take out the garbage, and then tells him that there's no smoking allowed. Johnnie confronts the boss, the co-workers and eventually becomes upset and quits.

JOHNNIE: (In gestures and voice) Fuck you!

Walks out.

MICHAEL: (To audience) They mistake friendly teasing as abuse. They become suspicious and think they are being cheated with low salaries – which is sometimes true – and they feel that they are always being given undesirable tasks, ones that other workers avoid. They become loners, disillusioned, bitter and frustrated at work. Their absences begin to increase, or they start coming to work late until it reaches a point where they either quit or get fired.

Back in the restaurant again, Paddy and Johnnie are at the table. The waitress is cleaning up their table.

PADDY: Okay so you quit your job. What you been doing since then?

JOHNNIE: I tried to work in other places: as a mechanic, and as a food clerk. I even took a job pushing around those garment racks on wheels. Everywhere I went, they all hated me. They took advantage of me. I was always "the last to know, and the first to go." Then one day I met these two deaf guys on the street. They asked me to join them, so I followed them while they showed me the ropes. They were experts in peddling. Hey! I've traveled all over the country! Here, I'll show you!

Gestures: Texas, San Francisco, Chicago, and NYC.

PADDY: Texas, San Francisco, wow Chicago.

Waitress watches this and understood the last one.

WAITRESS: (She fingerspells N-Y-C), New York City! I know that one.
JOHNNIE: I've had a wonderful time. And I've learned a lot. I know where to find things dirt-cheap. Then I sell the stuff and rake in the money. I made enough to buy a Dodge. You remember last time I saw you at Gallaudet, I drove my red Dodge? I bought that car with peddling money. I learned enough to strike out on my own.
MICHELLE: Not all peddlers, of course, are as independent minded as Johnnie. Many of them work for ringleaders who provide transportation and the items to peddle and then skim off a large percentage of the intake for "expenses." Peddlers' "merchandise" varies and includes such items as packages of needles, shoelaces, razor blades, pencils, Band-Aids, trinkets, combs, manual alphabet cards, and other cheap items.
PADDY: Alone? It must have scary and tough to go off on your own.
JOHNNIE: Nah, it's easy. I'm my own boss. I split with no one and I take care of myself. I've met all kinds of people. Many hearing people, they think I'm stupid or dumb. They give me money and say "poor, poor deaf guy, here – take the money." I take it. With other people I sorta play these games. For example, I would go to the airport...

Michelle and Frank will act out how he would go to the airport and see a rich woman wearing a fur coat who is in a hurry. He would "accidentally" walk in her path and pretend to be knocked down. He would then act afraid and offer her a peddler card. When she tries to apologize, he would indicate that he is deaf. The woman in a rush would hand him money.

JOHNNIE: A fifty-dollar bill.
FRANK: (To audience) The income also varies. In the late forties and early fifties there were reports of one peddler making $75 a day. Another claimed he made $40 in three hours and still another reported grossing $4,600 over a 16-week period. One crew leader bragged of making $1,300 in 14 days. It is doubtful if any of them paid taxes on this income. It is generally believed that most peddlers want their listeners to believe that their peddling is a highly rewarding undertaking. Such income only creates more resentment among the honest deaf wage earners.
JOHNNIE: Easy money!
PADDY: (Chuckles, amused and amazed at the same time.) Well, you might have a point there. Not all hearing people think you are stupid and dumb. There are some really nice people.
JOHNNIE: True, yes there are. Hearing women. Wow! Some of them are really nice! One woman I met in a bar, we "talked" with body language and she bought me all these drinks. Then she took me to her place. Such a rich

woman, and she lived all alone. I stayed with her for about a month. What a HOT lady, all she wanted was SEX, SEX, SEX.

Visual images added while saying SEX, SEX, SEX.

JOHNNIE: This other woman once wanted to have me with two women at the same time. WOW! HOT!
WAITRESS: (Comes over and wants to know what they're talking about) What's that sign?

Referring to the sign of one man having sex with two women.

PADDY: It's not important. Can I have ice water, please?

Waitress goes to get water.

JOHNNIE: I have met many different women. I never paid for one of 'em. Never! It was easy for me.

Takes a moment.

JOHNNIE: But Deaf people…they're a different story. They act mean and think they're better than me.
PADDY: Why? We support each other. I'll always be there for my deaf friends.
JOHNNIE: You maybe, but the rest of them, no way! They see me coming and start swearing at me, calling me lazy, and telling me I'm a bad "role model" for deaf people. One deaf man told me I'm going to hell because I rip off hearing people. They say hearing people see me peddle and they think all deaf people peddle.
PADDY: Well, you know I agree with that. People see you peddling, and they think all deaf people are the same. It gives deaf people a bad image. It makes it harder for deaf people who work hard to compete with hearing people.
JOHNNIE: (Angrily) I tried to compete, and I got "screwed over" in the hearing world. I tried to be nice and work hard and they gave me lousy pay. I tried to do all my work and hearing people kept giving me dirty work that they don't want any part of. Deaf people have no right to tell me what I should do. I tried!
MICHAEL: Deaf persons have been laboring under a mistaken public image for years. They have been trying to steer that predominant image of deaf persons away from one of charity. Deaf people realize that if they are to ever reach full citizenship they cannot continue to be considered "objects of charity."
FLASHBACK: *Michelle enters as Yvonne. She is in a deaf club, standing off to the side of the bar in the room when Johnnie enters.*
JOHNNIE: Where is the restroom?

YVONNE: (Looking around with a "talking-to-me?" look)
JOHNNIE: Where's the bathroom?
YVONNE: Oh, you are talking to me. Ummm, hmmm, let's see, I think it's to the left, down the stairs, go through the door and turn left. There is a tree right there.
JOHNNIE: (Turns to go before he realizes something) Very funny, outside! You're a riot! Please tell me where it is.
YVONNE: Down the hall, turn left; you can't miss it.

As Johnnie leaves, she turns to her friends.

YVONNE: WOW, he's cute!

Johnnie returns.

YVONNE: Nice tree?
JOHNNIE: Yes, the best. I could hide behind it. Are you from here?
YVONNE: No, I'm from my mother.
JOHNNIE: Oh I see, your lucky mother – a beautiful girl like you.
YVONNE: Ha, yeah you're pretty funny too. You're new. I have never seen you here before.
JOHNNIE: I just arrived in town and heard about this deaf club. Drove around and saw some deaf people signing outside, and some going up the stairs. I looked up and saw people signing through the window. Parked my car and came up the stairs. The big heavy guy by the door asked me for $2 for non-members. And here I am.
YVONNE: Car? You drive a car? Yeah, sure you have a car.
JOHNNIE: It's true…I do. It's right outside, a red Dodge.
YVONNE: What do you do? What kind of job do you have?
JOHNNIE: I'm a printer. Now I am on 4 month…uh…4-week vacation. Just travelling around. You want a drink?
YVONNE: (Nods yes)
JOHNNIE: (Orders two beers from the bartender, and hands her a beer.) What's your name?
YVONNE: Yvonne *Signs her name, Y near left shoulder.*
JOHNNIE: Johnnie.

Signs his name.

JOHNNIE: Nice to meet you. (After a quiet moment) Which school you go to?
YVONNE: Oh, a public school near here, with special speech classes. What about you?
JOHNNIE: A residential school for the deaf.

YVONNE: Oh yeah? How did you like it?
JOHNNIE: It was OK. I'm happy I left there. Now I'm on my own and traveling around. What kind of work you do?
YVONNE: Oh, I um, I work around here. Some odd jobs, a maid for a hotel.

Recognizes someone offstage.

YVONNE: Excuse me one second.

Goes offstage.

JOHNNIE: (While waiting, he goes to see where Yvonne went and watches. When he see her coming back, he returns to his usual spot.) You okay?
YVONNE: (Appears a little aggravated) Fine! Fine!
JOHNNIE: Who is he?
YVONNE: Oh, that's Carlos. He's a friend.
JOHNNIE: Friends don't make their friends moody.

Signs smaller.

JOHNNIE: You work for him?
YVONNE: (Surprised) What you mean? No, I don't work for him.
JOHNNIE: Why'd you give him money? You peddling?
YVONNE: What're you…being nosy, watching everything I do?
JOHNNIE: No, I just figured it out. Why else would you give him money. He's a big man and seems pretty bossy. I don't think you're a whore, so it must be peddling. You work under him, right?
YVONNE: Alright, I work for him. He takes most of what I sell. I don't like it.
JOHNNIE: (After a while) Stick with me, you can keep whatever you make. I'll teach you.
YVONNE: I thought something was off with you. You have a car, you dress nice and you've got money in your pocket. You peddle too!
JOHNNIE: (Smiles) Come with me.
MICHAEL: They went on the road together, spending hours and weeks at a stretch peddling. They made the rounds of bars, restaurants, and resorts where they knew they'd get the most response. They slept in their car to save on motel expenses and ate meagerly. They managed to save up enough money and decided to get married.

Johnnie and Yvonne go around the room peddling imaginary cards and picking up imaginary money from audience members. They walk on stage and count money, hug, and get into their "car." They huddle and share some food together. He proposes to her, and she accepts. He picks her up as if going over a threshold.

MICHELLE: We bought a small house with a white picket fence and garden near my parents' home. Johnnie bought a pick-up truck with money left over.

FRANK: I went into the trash removal business. People liked me. I picked up around the cans. Other trash removers, the hearing guys, never did that! We were happy! We had a family with two children. We had a house, and I had my own business.

MICHAEL: As with many marriages, problems began surfacing in Johnnie and Yvonne's life together; problems they were not able to cope with. There were no community services where they could get assistance or counseling. Friction developed and their marriage went on the rocks....

YVONNE: My husband Johnnie isn't home yet. Lately, he comes home late and drunk. I don't know how much longer I can tolerate his behavior. And he's becoming more and more dependent on me. He expects me to handle his business, write his checks, make his phone calls.... I'm getting really tired of this whole routine. I feel like I'm controlling his life. It just reminds me of how my parents used to control mine....

You know, I wasn't born deaf. I got sick when I was 2 years old from meningitis. Of course, my family was devastated. I was placed in an oral school program with a heavy emphasis on speech training. See, my parents never fully accepted my deafness. They made every effort to try to make me a hearing person. They would take me to doctors all over the country for a cure and dragged me to every church in town for a miracle. They were so overprotective of me.

Anyway, one day when I was about 14 or 15 years old I managed to get out of my house to go dancing with a friend of mine at school. At that time, I knew only a few signs. I met a deaf guy there named Carlos and I thought he was neat. He was about six or seven years older than me. I was fascinated with him because of his signing. I just wanted to be around him. He taught me so much about sign language and a lot of other things that I was so naive about. He was a peddler and made a lot of money. He invited me to travel with him. So I decided to run away with him and experience the real world. I left home at 16 and never finished school.

I thought Carlos would take care of me, but instead he just started manipulating me. He taught me all about peddling, but he kept most of the money that I earned from doing it. He took control of my life just like my parents did. I realized I was stuck. I had no real job, and it was doubtful I would have a chance for any kind of future. I didn't want to go back to my parents and I couldn't leave Carlos. I didn't have any place to go, so I stayed with him.

That was until I met Johnnie. The first time I saw him, it was love at first sight. He was very special. He was funny, charming and easy to get along with. Although he didn't know how to read or write or sign like everyone else, he was smart. We were able to communicate well with the help of a lot of gesturing. I guess that's what attracted me to him. We've been married for 4 years. We have two children, one is 3 years old and the other just turned one.

JOHNNIE: (Enters the room. He has had a few beers. He wants to give Yvonne a hug, which she refuses. She pushes him away.)
YVONNE: It's late! Where have you been?
JOHNNIE: (Calmly and trying to sober up) I'm sorry! I worked late. I'm hungry, what's to eat?
YVONNE: Nothing. You're too late. The kids and I ate and you missed it, sorry!
JOHNNIE: OK, I'll make something.

Goes to the refrigerator and opens it. He is surprised.

JOHNNIE: There is nothing here except one egg, a little bit of milk and an old tomato. Where's the food?

No response from Yvonne. He starts to cook the one egg.

JOHNNIE: How are the kids?
YVONNE: (Disbelief that he took the last egg) What about tomorrow? What will I feed the kids with? You go and get stinking drunk, spending all of our money. Where's the money? Give me the food money!
JOHNNIE: (Emptying his pocket, he hands her what change he has)
YVONNE: That's it! That's our food money? What were you thinking? We need more money. We need food. The children need new clothes. I'm stuck home all day, watching the kids feeding them, washing them! You go out all day and come home drunk, and then I have to feed you too. You need to find more customers to collect trash from.
JOHNNIE: (So frustrated that he says nothing.)
YVONNE: Well, that not my problem. Ok, Ok, then go back to peddling on Sundays.
JOHNNIE: (Visually says NO! Goes to the egg and realizes it burned. He dumps it in the trash.)
YVONNE: What are we going to do?
JOHNNIE: I tried! I work hard all day! I get up early, go on my route and do my job. I work hard, I give you all the money I make.
YVONNE: It is not enough! We need more! (Calming down) Please sit down.

He stands there and looks at her. She grabs him and pulls him to the chair. He pulls away.

YVONNE: I want to explain something to you, please sit down.

He does.

YVONNE: I am thinking that it will be best if we separate. I want you to get out of the house.

He gets up and walks toward the children's room. She blocks him.

JOHNNIE: I want to see my children.
YVONNE: No way! They are sleeping and you're drunk.

He tries to sidestep her. She blocks him again. He tries again and she pushes him away.

YVONNE: You will leave now. I will take the children and go to my parents' house tomorrow. You can come back tomorrow to pack up, but get out.
JOHNNIE: (He stands there and looks at her as if asking why.)
YVONNE: Get out NOW!

He doesn't move.

YVONNE: Now!

Slaps him. Black out.

MICHAEL: Johnnie lost his family, the business, the house, and returned to peddling.
JOHNNIE: (Goes to his jacket and puts it on as in the beginning of play.)
MICHAEL: Most peddlers pay no taxes and unless they find employment before old age. They have no social security benefits and have to be placed on welfare.
JOHNNIE: It's getting dark out now. I need to leave and get back to my work.

Prepares to leave. Once again he goes around the room and starts collecting cards and money.

PADDY: It was sad to learn about the bad news, yet it was still nice to see him again. I couldn't help but notice how much he had changed. His once cheerful personality had been dulled. His zest for adventure had gone out of him. What was once exciting to him was now a chore.
JOHNNIE: I am a deaf-mute. I have no job. Please pay what you wish. God bless you.

He walks to the front of the restaurant, turns around, looks at Paddy, and then leaves. The end.

About the Author

Mike Lamitola, born in 1955, was well known throughout America and abroad as a Deaf actor, director, and educator, recognized on television and stages. He directed several plays for the National Theatre of the Deaf (NTD), as well as

other Deaf theater companies and children's theaters in the U.S. and internationally. The last play he directed, just months before his passing in 2003, was Willy Conley's *The water falls*.

Before he started his professional acting career with the NTD, Lamitola earned his bachelor's degree in social work from the Rochester Institute of Technology via the National Technical Institute for the Deaf (NTID). During his studies, he became an acting favorite with NTID's performing arts program and its resident troupe – Sunshine and Company. This led to joining the NTD (which often performed at NTID) for ten years as an actor. Two of his favorite NTD roles were Long John Silver in *Treasure Island* and Neverfere the horse in *Parzival*. Nationally, he appeared in various roles including: Stanley in *A Streetcar Named Desire*, with Emmy Award winner Julianna Field in Washington, D.C.; with Deaf West Theatre in Los Angeles in their production of *One Flew Over the Cuckoo's Nest*; as Orin in *Children of a Lesser God* in regional theaters and at The Deaf Way, an international celebration of Deaf culture and arts. He also performed with the Fairmount Theatre of the Deaf and the Chicago Theatre of the Deaf.

On television, Lamitola was a featured performer in *True Blue*, *A Different World*, *Sesame Street*, and *Reasonable Doubts* with Oscar award winner, Marlee Matlin. He also appeared on numerous shows as a guest artist.

As an educator, Lamitola taught annually in the Young Scholars Program at Gallaudet University, and for a youth theater group in Worcester, Massachusetts. He also served as a teaching artist in the schools for the New Jersey State Council on the Arts, including being a workshop leader for actors at New York Deaf Theatre. His wealth of educational and professional experiences led him to help establish Deaf theater companies in India, Iceland, and Mexico as well as provide workshops in China, Japan, and Sweden. His work as a playwright was informed by his many years as a theater professional and his love of the character discovery process that occurred in the rehearsal room.

In 2003, he returned to NTD where he served as Artistic Director until his death.

12
WILLY CONLEY, *GOYA – EN LA QUINTA DEL SORDO (IN THE HOUSE OF THE DEAF MAN)*

IMAGE 12.1
Source: Photo by Willy Conley.

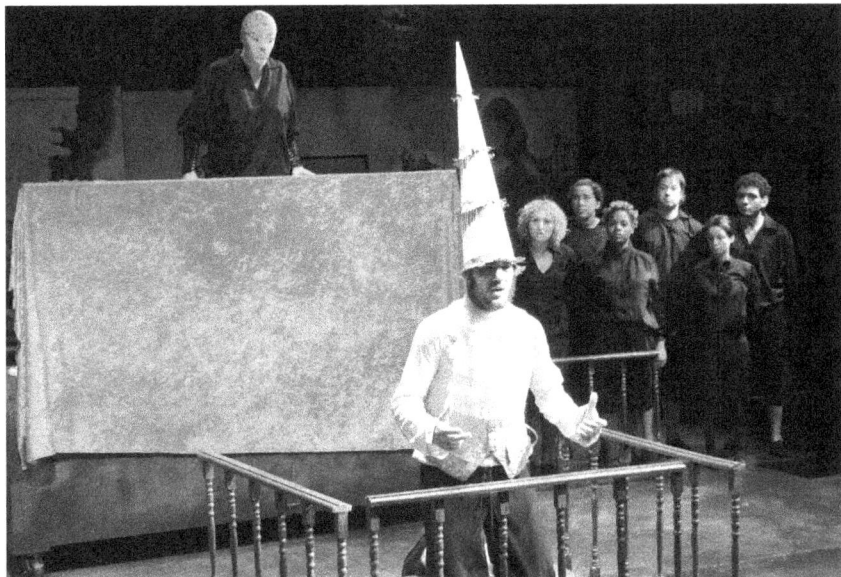

IMAGE 12.2 Actor Joseph Pfaff as Goya on the testimonial stand during the Spanish Inquisition scene from *Goya: en la Quinta del Sordo*. Behind him are Julia Golden (Phrenological Spirit), and the jury: Alesya Starayeva, Mandie Smith, April Jackson, Warren Trofimenkoff, Marianna Devenow, and Rocky Abu-Atteeyuh (left to right); directed by Willy Conley.
Source: Photo by Willy Conley.

Synopsis

At night, a woman in mourning makes a ritualistic visit to the gravesite of a loved one, unaware of spirits lurking nearby. Meanwhile, a Spanish artist named Goya buys a country house from a deaf man. He and his servant move in and get settled. Over time, Goya paints portraits and pastoral scenes and develops a close relationship with the Duchess of Alba, his lover and muse. But slowly, illness creeps in affecting Goya's hearing and art. He begins to see elements of madness and menace lurk in his work as a result of witnessing societal evils while progressively losing his hearing. His servant suspects the contents of Goya's paints and brushes may be the culprit.

During a serious bout of illness, Goya endures a long, absurd nightmare that brings him face to face with the horrors of Spanish society. After he awakens, he shares his visions with the Duchess. He suddenly feels the urge to create a new form of art that condemns the foibles and follies of Spanish society. He wishes to publish his etchings for the world to see but is unable to afford it. The Duchess makes a deal that she will support him if he paints a large nude portrait of her. Soon, word leaks out about the nude painting. Goya gets summoned to the

Spanish Inquisition to be put on trial for obscenity and defaming the Church. At the 11th hour, the king and queen save him from execution. They recognize the immense talent and truth in Goya's work, and thereby name him the royal court painter of Spain. Goya reflects on his richly textured life as the Duchess watches him die.

The woman in mourning revisits the gravesite except that this time she finds that someone has opened the grave and left a skull nearby. She carefully picks up the skull, brushes off the dirt, and gently carries it away. It turns out that she is the Duchess of Alba trying to protect and preserve Goya's legacy.

Production History

The play had its world premiere in the Gallaudet University black box theater (now called the Gilbert C. Eastman Studio Theatre), Washington, D.C., March 1–9, 2002. It was then produced in July 2002 for a three-day run as part of The Deaf Way II International Arts and Culture Festival in Washington, D.C. Original concept, choreography, and mask design, Iosif Schneiderman; set design, Ethan Sinnott; costume design, Rosemary Pardee; lighting design, Jeffrey Grandel; and stage manager, Jacob Fisher. The original cast was as follows:

Duchess of Alba – Laurie Anderson
Witch, Bat – Bellamie Bachleda
Bat – Jennifer Ferrer
Goya's Servant, Jester, Police – Jay Bunnag
Grand Inquisitor, Monk, Tree Giant, Donkey – Frank Germinaro, Jr.
Queen Maria Luisa – Elena Madina
Whore, Girl, Owl – Beverley Miderland
Monk, Matador, Donkey – Andres Otalora
King Carlos, Executioner, Deaf Person, Lynx – Daniel Pfaff
Christ, Prisoner, Executioner, Bull, Deaf Person – Preston Ponder
Goya – Peter Regan
Witch, Owl – Tiffany West
Crowd – entire cast, except for Peter Regan[1]

After being invited to be a part of Questfest International Theatre Festival in January 2008 at Towson University, *Goya* was rewritten and remounted. As preparation for the festival, the play was produced by the Gallaudet University Theatre Arts Department in the Gilbert C. Eastman Studio Theatre, November 8–11, 15–18, 2007. The production was also a selected participant of the Kennedy Center American College Theatre Festival, Region II, at Carnegie-Mellon University in 2008. It won first place honors. Assistant Director, Mask Designer and Builder, Choreographer, Iosif Schneiderman; Scenic Designer, Ethan Sinnott; Lighting Designer, Jason Arnold; Costume Designer, Laura Ridgeway; Sound Designer, Daniel Taylor; Production Stage Manager, Jacob Fisher.

The cast was as follows:
Joseph Pfaff – Goya

Daniel Pfaff – King Carlos
 Policeman
 Deaf Person 1
 Crowd
Hector Reynoso – Monk 2
 Deaf Owner
 Tree Giant (bottom)
 Vulture Judge 1
 Matador
 Crowd
Andrew Weidig – Monk 1
 Grand Inquisitor
 Vulture Judge 2
 Donkey 2
 Goya's Servant
 Crowd
Alesya Starayeva – Witch 2
 Crowd (prostitute)
 Owl
Kalena Smith – Duchess of Alba
 Crowd
April Jackson – Evil Spirit 1
 Joker
 Crowd
Rocky Abu-Atteeyuh – Christ
 Crowd (crippled beggar on wheels)
 Donkey 1
 Bull
Warren Trofimenkoff – Deaf Person 2
 Crowd (thief)
 Prisoner
Julia Golden Phrenological Spirit
 Crowd (Phrenology vendor)
 Executioner 2
Marianna Devenow – Young Girl
 Evil Spirit 2
 Bat
 Crowd (poor, hungry girl in backpack)
Mandie Smith – Lynx
 Evil Spirit 3
 Executioner
 Crowd
Danielle Graybill – Witch 1
 Queen Maria Luis

Tree Giant (top)
Crowd (wealthy lady)[2]

Thoughts on the Play

In 2001, Willy Conley met with a Deaf friend who was a former actor with the National Theatre of the Deaf and Deaf West Theatre. His name was Iosif Schneiderman, an incredibly talented theater artist, originally from Russia, who trained and performed with the Moscow Theatre of Expression and Gesture. Both men admired each other's work and wanted to find a way to collaborate on a theater project. Schneiderman pitched the idea of creating a play about Goya, a famous deaf artist that Conley knew very little about at the time. It seemed interesting enough, and at the time, Conley was looking for a play to direct for Gallaudet University's Theatre Arts program for the following season in the spring. Incidentally, the university was planning to host The Deaf Way II, an international festival that celebrated the arts and culture of Deaf and hard-of-hearing people, during the summer of 2002. The festival had a call for plays from around the world, and Conley thought it would be a fun challenge to submit whatever they developed with his students for the spring show.

When Schneiderman began discussing the development of dialogue for the play, Conley questioned if they really needed to write lines to be signed in ASL. Conley suggested that they create a visual, nonverbal, movement piece on aspects of Goya's life. It would not require signed or spoken language and would be totally accessible to all audiences – Deaf, hearing, and people from other countries with foreign languages.

Many people were not aware that Francisco de Goya became profoundly deaf in mid-career. His most provocative work was created soon after. Perhaps most did not know that Goya happened to purchase a home in the countryside of Madrid that was already labeled "Quinta del Sordo," (house of the deaf man). Previously owned by a deaf man, the villa was clearly marked for all who passed it. Some of Goya's darkest and most profound art, "The Black Paintings," were literally painted on the walls of this villa.[3]

Conley and Schneiderman's exploration in movement, masquerade, and gestures began with one etching as a keystone to build on – a self-portrait of Goya asleep at his drawing table. Goya labeled this drawing: "1st Dream. Universal Language."[4] Conley decided that this etching would represent the turning point for when Goya became deaf. All of the scenes before and after it were built from his other etchings and paintings as inspiration for their dramatic scenarios.

To help the actors internalize the scenario images, which fueled their improvisations, Conley embedded Goya's images into the written script and sequenced them in a way that revealed some semblance of a plot. He also made PowerPoint slides to project Goya's work on a larger scale to help the actors absorb the details in his sketches and paintings.

Their questions for dramatic exploration were: What was Goya's dream of universal language? Was it gestures? Paintings? Writings? Body Language? A wish for people to communicate the truth through a common language? When one loses the sense of hearing or sight, does humanity's truth become clearer and more honest? And, what happens when an artist strives to reveal the truth? Throughout the development of this visually oriented drama, they discovered insights into Goya's satirical humor, his mockery of the social mores and superstitions of his time, his caustic views on the ills and follies of humanity, and the effect of his deafness on his art and relationships with people.

Conley stated that he is forever indebted to Schneiderman for sharing with students his phenomenal skills in mask-making, creative movement, and pantomime to help develop and shape the original version of this play.

Deaf Gain

Willy Conley's approach to writing this play was quite different from the other plays in this volume. His nonverbal (and non-sign-language) play's foundation was laid out with a sequence of pantomimic scenarios (inspired by Goya's art) for the actors to build on. The scenarios were revised based on further improvisational development from the ensemble. The play was ultimately written and directed in such a way that audience members of any language background would have direct access to the performance without the need for spoken, written, or signed language. In other words, the aim was for a diverse audience to have a total theater experience a la Cirque du Soleil.[5] Since Goya was one of the forebears of the modern art movement, this play brought to light how Goya's deafness may have contributed to the rise in his prominence.

Notes

1 *Goya: en la Quinta del Sordo*. Gallaudet University Theatre Arts Department. Washington, DC: Playbill, 2002.
2 *Goya: en la Quinta del Sordo*. Gallaudet University Theatre Arts Department. Washington, DC: Playbill, 2007.
3 Tomlinson, Janis. *Francisco Goya y Lucientes 1746–1828*. London: Phaidon Press, 1994. 239.
4 Stoichita, Victor I. and Coderch, Anna Maria. *Goya, The Last Carnival*. London: Reaktion Books Ltd, 1999. 133.
5 Cirque du Soleil, an incredibly popular and wildly successful performance company, eschews spoken language, and instead uses acrobatics, clown plays, creative movement, puppetry, pantomime, projection, dance, masks, music, and songs in foreign languages to provide an all-encompassing experience – without any language barriers – for a global audience. The company has been known to employ Deaf performers at times for various shows.

12

GOYA – EN LA QUINTA DEL SORDO (IN THE HOUSE OF THE DEAF MAN)

Willy Conley

Characters

FRANCISCO DE GOYA
DUCHESS OF ALBA
SERVANT
KING CARLOS
QUEEN MARIA LUISA
GRAND INQUISITOR
INQUISITOR
EXECUTIONER
CHRIST
JESTER
TWO WITCHES
TWO Monks
TWO POLICEMEN
YOUNG GIRL
TREE GIANT
ARTIST
MATADOR
BULL
TWO JUDGES (VULTURE AND CROW)
TWO DONKEYS
TWO DEAF PEOPLE
PHRENOLOGICAL SPIRIT/ PHRENOLOGY VENDOR
DEAF OWNER
BAT
LYNX
OWL
EVIL SPIRIT #1
EVIL SPIRIT #2
EVIL SPIRIT #3

Notes

Since there are very few opportunities for Deaf actors to perform on stage, every effort should be made to assemble a predominantly Deaf and hard-of-hearing cast. At the very least, the actor for Goya must be Deaf.

This play is not necessarily an accurate or historical account of Francisco de Goya's life, but more of a visual, serendipitous expedition into aspects of his world. The play's journey involves gestures, pantomime, masquerade, dance, movement, projections, and visual effects, including phantasmagoria, to explore the development of Goya's hearing loss, and the impact his deafness may have had on his life. Some of Goya's paintings, Los Caprichos etchings, and certain events in Spanish culture inspired the following scenes. The ensemble will use masks to portray various characters, allowing some actors to play two or more characters apiece. The actors should wear clothing similar to what Goya wears, as they are all part of his imagination. This will allow costume pieces to be used for quick changes and representations of characters.

Unless the actress playing the Duchess is comfortable performing in the nude, she should have a flesh-toned body suit to make it appear that she is nude at times. The play needs to be underscored by haunting, surrealistic music, and sound effects.

It is suggested that a large, rolling platform (with two or three steps) be built as a way to easily create levels, and quickly establish or change scenes. It can have secret trap doors and openings to insert set pieces. Free standing, moveable wood railings could be used as fences, gates, courtroom barriers, and so forth. Blank muslin-covered flats of various sizes can be used on easels and other means of support as a way to offer surfaces for shadow play, projection, and places where Goya can create his "imaginary" sketches and paintings.

On the walls inside the quinta del sordo are various images (partial or complete), reminiscent of Goya's Black Paintings. It is not necessary to use exact images from the real quinta del sordo; they can be of Goya's other drawings, caprichos, or paintings.

1. An Unknown Grave

Dead of night. A dim light comes up revealing low-lying fog around an open grave. A solitary light comes up on a hooded figure: the Phrenological Spirit. The spirit pulls back the hood to reveal its head covered in a tight-fitting, white cloth mask entirely over the face with a Phrenological map of words all over it. It carries a netted bag of skulls to the grave. Dark, unrecognizable creatures crawl about. One has been digging away at the grave with its hands. Another creature crawls out and beckons to the others. They freeze after seeing something approach from afar. They shove dirt back into the grave, close the lid, and exit.

A woman carrying a lantern and a flower glides slowly and eerily toward the gravesite. She is wearing a mourning dress with a veil over her head. She sets the lantern on the rail and lays the flower on the grave. She notices fresh dirt around the grave and looks about. Then, she goes into a mournful pose by the graveside rail in deep thought. It should be obvious that this is a ritual of hers. Lights go down on her as morning light comes up. By then, she has gone, leaving the lantern on a rail, which becomes the front gateway to the quinta del sordo.

IMAGE 12.3 Phrenology Head.
Source: Image courtesy of Karen Watson, The Graphics Fairy.

IMAGE 12.4 La Leocadia (or The Seductress).
Source: Photo courtesy of Museo Nacional del Prado.

2. An Artist Buys a Country House from a Deaf Man

Goya steps backward onstage as if climbing down from a horse carriage. He is carrying his easel, paints, and brushes, looking around, unsure of where he is. He stops by the rail with the lantern to take a breather, rubbing his head. Behind him enters his bumbling, out-of-breath Servant carrying all of Goya's other belongings.

Although there is no sound of their voices, both men mouth words as realistically as possible during this exchange. The words do not have to be exact and can be ad-libbed; this also applies to all silent, mouthed dialogue from here on out.

GOYA: Where the hell are we?

Goya – En la Quinta del Sordo (In the House of the Deaf Man)

SERVANT: Hold on, let me find the map, sir.
GOYA: I know that villa is up on the hill around here somewhere.
SERVANT: I found it!
GOYA: Well, hand it over.

Both pore over the map. The Deaf Owner enters.

SERVANT: (no voice) Excuse me, sir. Do you know where this villa is located?

Deaf Owner looks at the map and gestures "right here."

GOYA: (mouthing "loudly") DO YOU KNOW WHERE THIS VILLA IS LOCATED?

Deaf Owner first tries to clarify in gestures that he cannot hear or speak. Then, he points to the map and gestures that the villa is "right here." He goes on to gesture that the house is his, it's been for sale, has so many acres with two floors, that he's been waiting for the buyer to show up, and etc. There is still no voicing in the following exchange.

GOYA: What's the matter with him? Can't he talk?
SERVANT: I think he's a deaf mute.
GOYA: HEY – CAN YOU HEAR ME?

Makes a loud noise, like knocking on the easel or hitting a couple of paint brushes together.

GOYA: Now what do we do? This mute can't help us.

Makes fun of the Deaf Owner's gestures.

SERVANT: I think he is saying this house is his.

Deaf Owner nods his head and shows them a deed proving his ownership.

SERVANT: Yep, he's the owner. This is it! Shall I get the money ready?

Goya looks over the deed and the property, not showing whether he likes it or not, and then nods his head. Deaf Owner holds out the deed for Goya to sign. Goya waves him off and holds out his hand to the side. Deaf Owner is puzzled. Servant anticipates what Goya wants and gets out

IMAGE 12.5 Quinta del Sordo, Goya's country estate on the outskirts of Madrid.
Source: Wikimedia Commons.

a brush and a small jar of paint. Goya dips his brush in the jar and paints his signature. Deaf Owner looks at the signature and becomes dumbfounded. He points to Goya's signature and mouths the word Goya. Goya nods his head.

DEAF OWNER: (gestures) WOW! You paint, all the world looks at your art, kisses fingers.

For the first time, Goya smiles, showing pleasure that even a deaf man knows of his paintings. Deaf Owner hands the deed to Goya but then quickly withdraws it, holding out his hand. He gestures money. Servant hands over a bag of money to Goya to give to Deaf Owner.

Deaf Owner gives Goya a large skeleton key. Servant gestures – a bit too eagerly – to Goya that the key is for opening the door to the house. Goya gives him a hard stare and nabs the key from him. He holds the key up, and time leaps forward as Servant takes the key and replaces it with a brush and palette. Deaf Owner looks longingly at his home as he exits. Goya proceeds to mix paint and begin his work.

3. Inside the Quinta del Sordo

A month later. In the darkness, a circle of lit candles appears, seeming to float in the air. When more lights come up, it shows Servant slowly carrying Goya's famous hat of candles to him. Goya puts it on, moves around the stage, with palette and brush in hand, and paints by candlelight. A framed light comes up on a large, vertical flat. He moves around with deep, artistic expressions, painting with bold, imaginary brush strokes.

IMAGE 12.6 Francisco de Goya y Lucientes; Self-Portrait in the Workshop. (Note hat with candle holders on the brim.)
Source: Wikimedia Commons.

Goya – En la Quinta del Sordo (In the House of the Deaf Man)

A light comes up behind the silhouette portrait screen showing the dark outline of the Duchess of Alba in a standing pose, with back slightly arched, and hands in her hair as if she were primping. Goya chats and jokes (no voicing) with the Duchess while working. He goes behind the screen and we see a silhouette of him whispering sweet nothings in her ear. She still hasn't moved. He goes out to the front of the frame.

IMAGE 12.7 Vintage Silhouette Portrait Set-Up.
Source: Image file courtesy of Wellcome Images, a website operated by Wellcome Trust, a global charitable foundation based in the United Kingdom.

He paints imaginary strokes following her outline on the screen in a passionate way. The strokes build with intensity and rhythm that vaguely suggests lovemaking. He paints to a high point of energy and then releases himself with the climax of a final brush stroke. She relaxes from her pose soon after his "release." Her arm reaches outside of the screen. Goya takes her hand, kisses it, and helps her off the platform.

Goya helps button up her dress. She admires the imaginary "painting," feeling flattered and honored. He kisses her hand and holds onto it lovingly. He becomes drawn to the contours of her fingers and gently pulls her to his drawing table. He begins to quickly sketch her hand. He becomes so engrossed that he doesn't notice her slowly backing away, understanding that he needs to be left alone to do his work. Servant escorts her out and comes to look over Goya's shoulder at his sketch. Goya mistakenly looks sweetly at him, thinking the Duchess is still standing there. Goya commands Servant to take away the silhouette painting. Servant does so in a casual, careless manner. Goya scolds him for not being more careful with his cherished art piece. As Servant goes off, he reacts favorably to the gorgeous figure he's carrying away.

IMAGE 12.8 The Duchess of Alba Arranging Her Hair.
Source: Wikiart.

4. Childhood Memories

At his drawing table, Goya's mind wanders, thinking of other happy images from his life. The ensemble comes out and re-enacts: (1) a game of Blind Man's Bluff; (2) the matrimonial fortune-telling game of girls with a blanket tossing up a straw mannequin to see who will get married first; (3) and, then a Mardi Gras-like party. Someone from the crowd of "kids" pulls Goya out of his reverie and into the Blind Man's Bluff game to participate. After this, Goya is led into the other two crowd scenes.

IMAGE 12.9 Blind Man's Bluff.
Source: Wikimedia Commons.

At the end of the matrimonial game, Goya is left with catching the mannequin in the air while the kids run off. He sees that the mannequin is dressed just like him.

IMAGE 12.10 The Straw Manikin.
Source: Wikiart.

While dancing during the Mardi Gras scene, Goya notices what looks like evil spirits creeping into the happiness but they are merely innocent children having fun with horror masks. This is marked by a short freeze (or freezes) during the dance. After the Mardi Gras scene, he ends up back at the drawing table in the same body position when his mind began wandering. The banner with the smiling face (which slightly resembles him) brushes over his face, ending the scene. The banner is left behind somewhere on stage to establish Goya's omnipresence throughout the play.

IMAGE 12.11 Burial of the Sardine (Note Goya's smiling face on the banner.)

Source: Wikimedia Commons.

5. The First Sign of Goya's Illness

Feeling inspired, he quickly sketches some images, then calls for the servant to set up an easel on the platform. Working fast, Goya mixes lead paint and fluids unknowingly inhaling paint dust, and habitually putting his brush into his mouth at times. Servant who has been watching him goes over and takes the paintbrush out of Goya's mouth.

No voicing, although an occasional gesture here and there to help with context.

SERVANT: You're mixing up all of these paints and getting that stuff in your mouth. You know that's not good for you.
GOYA: Get out of my way, you're interfering with my process here. Go on.
SERVANT: Ok, but keep that paintbrush out of your mouth. I'm serious.
GOYA: Go!

Goya begins to paint the childhood scenes that he recently daydreamed. Phantasmagoric images of these scenes appear around him.

The Phrenological Spirit creeps in from out of the dark, along with Evil Spirits 1, 2, 3, who watch Goya. He gets a little woozy, but tries to keep on painting. The spirits slowly turn around the platform that Goya is standing on. He shakes his head and looks around. The spirits disappear quickly. Goya looks at his can of paint and puts it down. He decides to stop to get outside for fresh air.

6. Goya Observes the Horrors of Spanish Street Life

He calls for his servant to get his hat and coat. He steps off the platform, and is immediately transported to the streets of Spain, walking and observing some of the horrors of life: the homeless, the beggars, the crippled, the thieves, the alcoholics, the prostitutes, the rapists, the incarcerated, and etc. (Actors do not wear masks in this scene.) The street is not literally the street but life around Spain. It is as if Goya has walked all over the country. He sketches his observations in a daybook.

IMAGE 12.12 Lunatic Behind Bars.
Source: Wikiart.

Every now and then, Goya sees the Evil Spirits appear between the street people, unsure whether he is imagining them or not. A Monk walks by. One of the street people accidentally bumps into the monk. He yells and kicks the person. A homeless man without legs wheels over to Goya begging for money. Someone of royalty walks by and sneers at some of the street people. A Policeman chases a crook. And, etc…

IMAGE 12.13 Beggars Who Get About on Their Own in Bordeaux.
Source: National Gallery of Art.

At some point, a Phrenology Vendor — actually the actor playing the Phrenological Spirit without the mask — approaches, wearing a sandwich board advertising a Phrenology chart, or "Head Readings." Goya waves the vendor off. This is the one person on the street with whom Goya does not sympathize with or relate to. When Goya is not looking, the vendor comes up from behind and abruptly places his hands on Goya's head to try to feel the contours of his scalp. This startles Goya and he pushes the vendor away.

IMAGE 12.14 Phrenology Chart.
Source: Wikimedia Commons.

7. Goya Hurries Home with a New Vision

All of these observations disturb Goya to the point that he rushes home to draw what he witnessed on the streets. The transition to going home begins with Goya tossing off his hat and flinging off his coat, both of which the Servant catches before hitting the ground. The next thing Goya does is get back to his painting materials.

While mixing paints, he puts the brush in his mouth to hold, while freeing up his hands to do other preparatory things. The Servant approaches from behind and mouths words about not putting the brush in his mouth. Goya doesn't respond. Then, Goya sees Servant out the corner of his eye and chews him out for lurking around; he tells him to get out of his sight.

Goya resumes his work but the fumes start to affect him again. He struggles through this and furiously paints the new subjects he just witnessed on the streets. Meanwhile, images of Spanish street life are revealed on stage.

Goya becomes increasingly dizzy and nauseous to the point that he momentarily faints. The Servant rushes to his aid. He brings on wet cloths to soothe Goya's head and gives him medicine. Goya falls asleep. While the Servant tidies up the studio, he accidentally drops something. Goya does not react. The Servant makes some more noise but still, Goya does not respond. Eventually, Goya wakes up. He struggles to get back to work at his table.

SERVANT: (mouthing words, no voice) Thank God, you're awake, sir. You've been sleeping for hours and hours. You had me worried. I was about to—
GOYA: (mouthing) What did you say?
SERVANT: I said you had me worried. I was about to call a doctor.
GOYA: What?? What are you whispering for?! Speak up!!
SERVANT: I SAID YOU HAD ME WORRIED. WAS ABOUT TO CALL A DOCTOR. YOU'VE BEEN ASLEEP FOR HOURS AND IT'S NOT EVEN NIGHT TIME YET.
GOYA: Stop playing games with me – I don't feel good. C'mon, use your voice.
SERVANT: But I have been using my voice.
GOYA: What? I can't hear you!

They argue further until Goya gets physical with Servant and loses his temper as he realizes he has totally lost his hearing. Servant tries to comfort him.

8. Discovering the Source of Goya's Deafness

Goya determined to go on, goes back to work mixing paints again. Servant eyes him while sweeping the floor. Goya becomes faint again, and as before – he almost passes out. Servant comes to help him. Servant now knows that the fumes of paint, lead, and acids are causing Goya's illness. He takes the equipment and supplies away.

GOYA: You bastard, I'm working here. What the hell are you doing?? Give that back to me before I beat you to a pulp.

Servant writes something on paper about the paints and lead poisoning. Goya throws the paper away.

GOYA: You sonavabitch! Get outta my way! Can't you see I'm creating a masterpiece here?

Servant grabs him and gestures that the fumes are causing him to be ill; the information sinks in. Servant moves the paints away and gives Goya a pencil and paper to make his creations. Goya reluctantly gives in. Servant goes back to sweeping the floor. Soon Goya stumbles around, obviously dizzy and ill again. He falls onto the floor. The Phrenological Spirit and Evil Spirits reappear and swirl around him. Goya points them out to the Servant, but the Servant doesn't see anything. The Servant holds up the broom in defense to appease Goya. He still doesn't see anything. Goya grabs the broom from Servant and tries to hit the Spirits, but they have disappeared. Goya rests his head up against the wall, or sits on the platform, to calm his mind.

9. Duchess Learns of Goya's Deafness

The Duchess shows up to visit. The Servant comes forward to take her coat. She has heard that he lost his hearing but doesn't believe it. She calls out to Goya but he doesn't look up. She taps him on the shoulder and he jumps, thinking one of the evil spirits have come for him. She hugs him but he doesn't reciprocate with any passion. She guides him to his table so they can communicate by writing on paper. She asks about what happened. He tries to tell her that he was asleep one moment and the next his hearing disappeared just like that. He explains about the appearance of the evil spirits, acting out how they behaved, but she doesn't understand what he's talking about. He then quickly begins to sketch their images. The Duchess copies the facial gestures that Goya showed of the spirits, and has fun with them, as if hand gestures were a new thing for her to play with. He admonishes her to get serious, but she continues to exaggerate the facial gestures, teasing and tickling him, trying to snap him out of the doldrums. Goya lightens up a little, ending with him hugging and kissing her lovingly.

IMAGE 12.16 The Black Duchess.
Source: Wikimedia Commons.

After a moment, he asks her what to do. She guides him back to the table to encourage him to keep drawing, and thinking positive. After all, he is still a great artist. He tries to tell her more details about the spirits he saw, but she is more interested in seeing him continue to sketch, whatever images they may be. He shifts his focus back to drawing and becomes engrossed. The Duchess, expecting this and not wanting to disturb the momentum, slips away while watching him longingly. Servant enters and puts her coat over her shoulders while she is leaving, never taking her eyes off of Goya.

10. Goya's Dream of Universal Language

After a while, Goya looks in the direction where the Duchess left, and sees the Servant there instead. Goya asks where the Duchess went. Servant gestures that she left. He asks Goya if he needs anything. Goya gestures no and sends him away. He opens his daybook to find the rough sketch of the

IMAGE 12.17 Sueño 1. Ydioma universal. El Autor soñando [Dream 1. Universal Language. The author dreaming.]
Source: Photo Courtesy of Museo Nacional del Prado.

Phrenology Vendor. He puts his hands on his head like the vendor did. He begins to draw to expand upon that memory.

A bluish moon light comes up revealing the Phrenology Spirit on the periphery of the stage near him. As Goya sketches he nods off but shakes himself awake. A Bat, an Owl, and a Lynx enter and strike an evil posture.

All of the characters in the following dreams sequences now wear masks.

Feeling incredibly tired, Goya puts his head down in the cradle of his arms. The moon rises. Fog seeps up through the floor under the table. The Bat, Owl, and Lynx move in on Goya and his workspace. The Lynx sits on the table drumming its claws. This "awakens" Goya although he's still in a dream state.

The Phrenological Spirit emerges behind Goya's head as he wakes into this nightmare.

Throughout the following dream sequences, the Phrenological Spirit disappears and reappears at appropriate times and places, occasionally reaching for Goya's head.

The Bat, Owl, and Lynx do a strange, circling movement around Goya. They grab him as he struggles to break free. They hold him down while the Lynx nonchalantly takes his drawing and tears it up. All do an eerie dance, and exit leaving Goya behind who is unsure whether he is awake or in a dream.

The people that Goya saw earlier on the streets enter. They wear grotesque masks, moving in odd ways, and dancing about Goya. One person grabs Goya's arm while someone else grabs the other arm. They pull him back and forth in a tug-of-war. Then they shove him from one person to another leading to a group of them lifting him up and then dropping him. After the drop, the crowd freezes. Goya looks at them, totally confused. Feeling assured that this was some crazy vision of his, he looks skyward and closes his eyes. The crowd unfreezes, nabs him, and picks him up. They dump him onto the platform and roll it around in a circle while he tries to stand and right himself.

11. The Cruelty and Hypocrisy of Monks

After a few revolutions of turning the platform, the crowd moves it to a different location. One by one they slowly climb onto the platform after him, but stop suddenly when they see something offstage. They become frightened and ashamed when they see a monk enter. The First Monk, carrying a cross (a crossed-arm gesture), has a peculiar marching rhythm. A Second Monk, praying, follows him. Then Christ enters with his arms straight out to the sides as if bearing a large cross. He is followed by a Soldier and an Executioner. The Executioner whips Christ every now and then. Others in the crowd follow the procession. Throughout all of this, a Jester prances about making fun of everyone, and having a grand old time.

The Soldier and Executioner push Christ onto the platform. A little slapstick ensues with the Monks trying to set Christ up properly, but keep hitting themselves in the head

with the stick that is across Christ's shoulders. Second Monk unrolls a long sheet of imaginary paper to hold out for First Monk to read from.

FIRST MONK: (to the crowd below; in universal gestures, or in absurd gestural gibberish) This is a sad, unfortunate event. This man has destroyed God's rule. He was wrong to promote God's word to the people. Only I am allowed to preach God's word, not him. God is upset! This man is to be punished. You people are to be punished too – you listened to him! God will punish all of you. Now, we will first punish Christ by fire. And then, you will punish yourselves.

IMAGE 12.18 A Procession of Flagellants.
Source: Wikimedia Commons.

The Jester jumps up in excitement and gestures to the crowd to self-flagellate. The Monks march Christ off the platform to burn offstage. The crowd follows while flagellating themselves, keeping in step with the rhythm of the march. The Jester continues to joke around, ridiculing and whipping people.

The Jester spots Goya standing outside of the crowd, and draws attention to him. The crowd rushes in slow motion to grab Goya, but he outruns them just as they are getting close. The crowd dissipates.

12. Spoonfeeding the Deaf

A couple of witches stalk Goya, taunting him all the while. Their attention gets diverted by the entrance of Two Donkeys dressed in monk's clothing. Each Donkey rides on a human wearing padlocks over the ears. Goya watches this from a distance. The Donkeys get off and gesture vulgar gibberish to each other. They catch the two humans trying to eavesdrop and decide to lock up their "hearing" and "knowledge." Now deaf, they complain that they can't hear. The Donkeys force-feed slop out of buckets to the deaf with a spoon, and end up over-feeding them. Meanwhile, the Witches who have been watching try to physically

IMAGE 12.19 Thou Who Canst Not.
Source: Wikimedia Commons.

act out the Donkeys' vulgar gestures and movements. The deaf pass out.

The Donkeys kick them awake and order them to bring food. Plates of meat on bones are brought in. The donkeys slobber and chew on the meat and throw the bones away. The witches scramble and fight each other for scraps. The Donkeys laugh, burp, and fart. They kick the deaf awake and hop on their backs again to exit.

IMAGE 12.20 Los Chinchillas.
Source: Wikimedia Commons.

13. Police Brutality

Two Policemen carry a Young Girl on stage. She is suspected of being a whore. Young Girl tries to run off but one of the Witches trips her. The Policemen grab and force her into a sexual situation. The Witches laugh. After the Policemen have their way, they exit. Young Girl cries. One of the Witches, who has been chewing on a bone, throws it away. Hungry, Young Girl grabs it off the ground. She tries to eat it but it tastes horrible, so she throws it away. Goya inches toward her in an attempt to help, but he sees a horrific figure approaching, so he steps back to a safe place to watch.

IMAGE 12.21 They carried her off.
Source: Wikimedia Commons.

14. The Tree Giant

Young Girl tries to escapes, but is frightened back on stage by the Tree Giant who has tree branches for arms. Tree Giant lumbers onto the platform and is rolled forward toward Young Girl. She cowers, saying prayers. The Witches join in praying to the Tree Giant.

TREE GIANT: (in nonsensical, universal gestures) You slut! I have been watching you! And, you, you, and you – are all sinners. You're going to burn in Hell!!

15. Goya's Alien Dance

The Tree Giant is spun around on the platform and rolled offstage. One of the Witches sees Goya and torments him. He puts his hands up to his head as if this may be a disturbing illusion in his mind. The Witch copies his movement. Goya moves his hands in a different way. The Witch copies him some more. He creates an unusual gestural movement – a dance of sorts. The Witch copies again. Street people begin to enter to watch this intriguing gestural exchange. Someone from the crowd becomes fascinated by this, comes forward, and creates his or her own freaky dance movement. Before long, everyone participates and gets caught up in doing an alien mob dance. Goya slowly slips away only to be stopped by a Matador stepping forward.

IMAGE 12.22 What a Tailor Can Do!

Source: Wikiart.

16. The Bullfight

The mob stops dancing. They all run up to the platform and form rows as if evolving into a bullfight arena. They cheer for the Matador. The Matador grandly holds up a pair of bull horns, as if asking the crowd: "Who dares to be a bull that wants to fight me?" All of them shake their heads refusing to volunteer until one them gets pushed out into the middle of the arena. The crowd member reluctantly accepts. He pretends to be a Bull by doing

IMAGE 12.23 Pedro Romero Killing the Halted Bull.

Source: Wikimedia Commons.

a *Visual-Vernacular*,[1] *gestural description of himself becoming a big, muscular bull. He grabs the bull horns. The crowd laughs and cheers. The Matador challenges the Bull to charge by waving his red cape. After a couple of rounds, the Matador stabs the Bull with imaginary darts. The Bull gets tired and it is then that the Matador takes out his imaginary sword. The Bull charges one more time and the Matador slays him. Goya is shocked and upset to see a human slaughtered.*

Goya comes forth and tries to comfort the dying Bull. Matador picks up the pair of horns, holds it up, and proudly shows off how victorious he is. The crowd goes wild. Goya gestures that the Bull is a person, not an animal. The Matador ignores him and walks away picking up flowers that were thrown at his feet by the crowd. The crowd cheers some more, while a few come down to drag away the dead Bull. Goya, alone on stage, stands there appalled by the inhumanity of it all.

17. The Spanish Inquisition Denounces Art

A Policeman suddenly enters carrying the pointed end of an easel forward like an arrow, scaring Goya aside. The easel gets set on the platform. The crowd re-enters from a different direction throwing stones from where they entered. They think Goya is one of them and encourage him to throw stones as well. Another Policeman enters dragging a handcuffed Artist by rope. The Executioner follows close behind. The Artist has on a tall, conical (dunce-like) hat. A Vulture and a Crow – a judge and his clerk, respectively – solemnly enter. The Artist is tied up to the easel. A young female member from the crowd runs to the Artist to be with him, but she is slapped away by the police. The Crow sets up a rail before the Vulture and holds up an imaginary scroll of paper.

IMAGE 12.24 There Was No Remedy.

Source: Photo Courtesy of Museo Nacional del Prado.

VULTURE: (in ugly, gestural gibberish) You are charged with leading a new revolution for art and freedom. You have broken the law by creating non-traditional art. I pronounce you guilty! You are to be burned at the stake!! Case closed.

The restrained Artist spots Goya outside the realm of all this. Pleading with his eyes and cuffed hands, the Artist tries to communicate to Goya to help save him. Goya gestures that he can't hear.

A torch is lit and passed on from person to person on up to the Phrenological Spirit who ignites the Artist. The crowd enacts individual flames with their arms and hands, in essence becoming one big bonfire consuming the Artist. More and more smoke rises with color, lights, and shouting. At the highest moment, the Artist breaks free from his bondage. At the same time, Goya slowly spirals back to his drawing table. Lights goes to black.

18. Goya Reveals His Dream to the Duchess

When the lights come back up, Goya is at his table, startled awake, gesturing "Free!" which is the same movement the Artist made when breaking free. The Phrenological Spirit fades away. Goya walks over to examine his easel on the platform, which was an instrument of punishment during his dream. He goes back to his drawing table and begins to sketch furiously.

IMAGE 12.25 It's Time.
Source: Photo Courtesy of Museo Nacional del Prado.

DUCHESS: (rushes in, gesturing) Goya, are you alright? What's bothering you?

Goya tries to speak but finds himself speechless from the horrors he has witnessed. He begins to write what he wants to say but feels limited with this way of communicating.

GOYA: (in universal gestures and movement) I had a strange dream, a crazy, terrible dream. One like I've never seen before. It was hell. But this dream was very real. It was life as I see it today. I understand the truth of my dream and must do something to help the people of Spain. My paintings…my paintings! I can use my paintings. They must be more than art. They must show the horrors of life that surround us. I must fight my illness…. I want to draw pictures of the mad monks and judges. I must show that they are devils and deal with sorcery. They commit such monstrous, atrocious crimes.

GOYA: But how do I show this? Up to now, my reasons for painting have been weak: pretty

IMAGE 12.26 Where is Mother Going?
Source: Wikimedia Commons.

landscapes; wealthy people; children playing. They may be beautiful pictures but what do they mean? Why do I paint them?

DUCHESS: (mouthing the words) Why don't you paint what you dreamt?

GOYA: (gestures) I can't understand you. Please show me what you're saying.

DUCHESS: (universal gestures) Why don't you draw what you dreamt? Make prints and publish them so that people all over can see the problems and evils of Spain.

GOYA: (gestures) You mean I should make etchings of my drawings and have them published?

DUCHESS: (gestures) You are famous. All of Spain will buy your new art.

GOYA: (gestures) I don't have the money to publish such a book.

DUCHESS: (gestures) I will give you money. But, first you must draw another beautiful picture of me.

GOYA: (gestures grandly) Anything for you, my sweet Duchess.

DUCHESS: (gestures) I want you to draw something really big…breathtaking…

She does a few Spanish dance steps.

GOYA: (gestures) That is lovely. A painting of you dancing in the candlelight!

DUCHESS: (gestures) No, no…something more… a painting that will touch the hearts of those who look upon it. If a mad man looked at it, it would ease his conscience. If a child looked at it, he would become still and behave.

GOYA: (gestures) Yes! But what?

She gestures the idea of taking her clothes off and posing for him.

GOYA: (gestures) A painting of you?

DUCHESS: Not just a normal painting. A huge painting of me nude.

GOYA: But I can't…. You know the monks would arrest you and have you burned at the stake.

DUCHESS: (gestures) I'm not afraid. I believe in you, not the monks. Let them burn me. I don't care.

GOYA: (embraces her; gestures) My sweet Duchess, I can't believe you're saying this.

DUCHESS: Shhh, go on, start painting before I change my mind.

GOYA: Thank you so much.

Goya calls for the Servant to set up a bed on the platform for the Duchess to lie down on. The Duchess leaves the room to change into a robe while he fusses with getting the bed set up just the way he wants it. The Duchess enters. The lights dim and she disrobes. He gestures to her how

IMAGE 12.27 The Naked Maja.
Source: Photo Courtesy of Museo Nacional del Prado.

he wants her to pose. He starts to paint, working feverishly and quickly. As he does this, the naked Duchess shifts her poses accordingly, and settles into one of lying sensuously on pillows the way Goya gestured/painted with his paintbrush. Servant enters with a large, horizontal frame, and just as he sets it firmly onto the platform, Goya creates his final brushstroke coinciding with lights that snap on to reveal the Duchess, frozen in pose, looking just like the painting, The Naked Maja. Goya leans against the frame, exhausted and stares off in space.

19. The Controversy of The Naked Maja

Someone walking past the quinta del sordo notices the naked painting and is horrified. She informs another person walking down the street who stops and peeks in. That person informs someone else, and so on until a Monk is notified. The Monk informs the Police who end up entering Goya's house and serving him a court summons for obscenity. Goya reluctantly follows him off.

20. Goya's Inquisition Tribunal

The lights change as Goya is taken away to the Inquisition. Rails are set up to create the courtroom. The Monks put a drape over the nude painting and set it upstage. The ensemble forms a group to represent the jury. Goya is placed on his knees on the witness stand. The Grand Inquisitor and Inquisitor, his assistant, enter.

They walk over to the painting and peek beneath the drape. Disgusted, they cross themselves and proceed to sit down. Grand Inquisitor flips through Goya's Caprichos portfolio.

GRAND INQUISITOR: (silently mouthing the words) How do you explain these disgusting art pieces, Francisco de Goya?

IMAGE 12.28 Those Specks of Dust. Source: Wikiart.

Goya doesn't respond. Inquisitor holds up a caprichos and repeats what the Grand Inquisitor said. Goya continues to look forward and not reply. Inquisitor walks toward Goya and holds the drawing to his face, which gets Goya's attention. Inquisitor mouths more words, but Goya stops him with a gesture and indicates that he cannot hear.

Inquisitor goes to the Grand Inquisitor and informs him that Goya can't hear, making gestures of ears closed, locked up with the key thrown away. People laugh. The Grand Inquisitor pounds his gavel on the table for silence. He tells Inquisitor to interpret what he just asked Goya. Inquisitor interprets into universal gestures to Goya. Silence.

GOYA: (gestures) I am a simple man. I'm not clever at putting things into words.

Grand Inquisitor doesn't understand the gestures. Inquisitor whispers the interpretation in his ear. The Grand Inquisitor pulls out Caprichos #23 of the whore being carried off by monks.

GRAND INQUISITOR: You wrote on this drawing: "To treat a good, brave woman like this, who for her bread and butter has served the world so willingly and industriously – shame! shame!" What do you mean by this?

No response.

GRAND INQUISITOR: Who is treating this woman badly? The Holy Tribunal? (no response) Who?? (no response) Once more…who is treating this woman badly?

Inquisitor interprets in gestures.

GOYA: (gestures; Inquisitor interprets in Grand Inquisitor's ear.) Fate.
GRAND INQUISITOR: Fate!? What do you know about fate?
GOYA: (silently, mouthing in an unclear way) The demons.
GRAND INQUISITOR: I can't hear you!
GOYA: (mouthing "louder") The demons.

Grand Inquisitor confers with Inquisitor. They don't understand.

GOYA: (long, explicit gestures) Demons.

Grand Inquisitor acknowledges this with mild surprise. He records this response in his records. He pulls out another drawing out of the portfolio.

GRAND INQUISITOR: What's the meaning of this one? (no response)

Inquisitor takes the paper and brings it to Goya's face. No reply. Grand Inquisitor shows him another one. Inquisitor delivers it to Goya again. Each delivery is like a punch to Goya's face, increasing in speed and intensity. Goya grows weary and woozy. Drawing after drawing gets taken out and questioned. Time becomes compressed as the inquisition goes on and on.

The court crowd leans in, staring, hungry for an execution. The Grand Inquisitor, Inquisitor, the jury, and court bystanders slip on masks from the horrific dreams that Goya had earlier and create grotesque movements in place. Goya grows tired and faints on the stand. As he slips in and out of consciousness, the Evil Spirits, including the Phrenological Spirit, appear mysteriously on the periphery of the courtroom.

Goya musters his last bit of energy, straightens up, and pronounces that the Grand Inquisitor and his assistant are devils. All hide their masks behind themselves. The Grand Inquisitor closes Goya's file with a slam. He orders the dunce's cap to be put on Goya and have him sent away.

21. The Queen Sees her Caricature

King Carlos and Queen Maria Luisa unexpectedly enter the courtroom. All bow to the king and queen. The Queen walks over to Goya and gently gestures for him to stand. She takes off the cone hat and throws it at the Inquisitor. She asks what this is all about. The Grand Inquisitor gestures for the assistant to show the King and Queen the file. Very solemnly they leaf through the artwork.

GRAND INQUISITOR: Goya said he drew all of these as a gift for her majesty.
INQUISITOR: A book that he hopes you will publish for all of Spain.

King Carlos expresses joy at the drawings. He comes over to Goya and gives him a slap on the back.

GRAND INQUISITOR: Your majesty, there is one last caprichos that is most offensive. It is of you. He hands the Queen an etching of herself as an old hag in front of a mirror: "To Death." The Queen looks hard at herself in the drawing. The crowd comes in closer.
KING CARLOS (IN GESTURES): I would like to try my hand at drawing cartoons like these someday. These are wonderful!

The Queen laughs.

QUEEN: (in gestures) Goya has been our number one painter for many, many years. He has learned well with us. These illustrations are excellent! Wildly satirical and honest. They show the truth. Only a fool is angry at the mirror who reproduces his likeness. Our country of Spain is old, but there's plenty of life in her still. We can learn to accept the truth about ourselves – especially if told with humor like this.

IMAGE 12.29 To Death.
Source: Photo Courtesy of Museo Nacional del Prado.

22. The Last "Incriminating" Evidence

The Grand Inquisitor quickly goes over to the covered Naked Maja painting.

GRAND INQUISITOR: (silently mouthing) Now, wait just a minute. (His expression is that of revealing an ace up his sleeve.) I have one final thing to show you that will absolutely shock you!

He snatches the drape off of the painting with flair. Much to the Grand Inquisitor's surprise is that the reveal is of the The Clothed Maja painting.

In actuality, it's the actress playing the Duchess, fully clothed, lying in repose within the large frame.

QUEEN: What a beautiful painting!!! I don't know what the problem is but I now I pronounce this tribunal over.

Grand Inquisitor and Inquisitor are totally baffled. They begin arguing with one another while leaving the courtroom. Goya bows to his royal subjects.

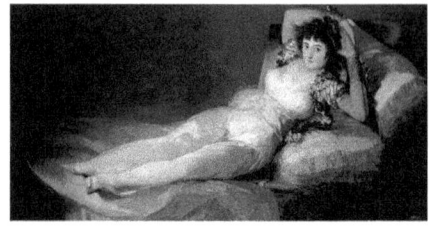

IMAGE 12.30 The Dressed-Up Maja.
Source: Photo Courtesy of Museo Nacional del Prado.

QUEEN: Goya – we accept your gift. Now, you accept ours.

She presents Goya with a medal and honors him as the royal artist of Spain.

QUEEN (GESTURES): We will see that your drawings are printed and distributed throughout all of Spain.

All bow to Goya. The King and Queen exit and then the rest of the people in the courtroom follow suit.

Goya, exhausted, walks proudly along the framed painting of The Clothed Maja, admiring it. Meanwhile time passes as elements of the courtroom are taken away, except for the Grand Inquisitor's table. Goya picks up his palette and brush which were propped up against the base of the frame.

23. After the Tribunal

Servant enters to take away Goya's palette and brush. Goya reluctantly gives them up. Servant hand him two canes. Both become considerably and simultaneously old. Servant hugs him, and then removes the frame off of the platform. The Duchess who has been lying frozen in pose, unfreezes, gets up off the platform, and holds Goya's arm. She walks with him as he hobbles upstage toward the door out of the quinta del sordo. He takes one last look and sees all of his paintings on the walls. Characters from his imagination and dreams appear in masks and move around in their typical ways. At some point all of them remove their masks and one by one and exit, leaving the masks piled up on the Grand Inquisitor's table. Goya turns around and resumes his departure from the quinta del sordo. When the door opens, a bright light backlights him. He looks back at the Duchess one last time. They look at each other with much love, and then he's gone as the door closes behind him.

IMAGE 12.31 I Am Still Learning.
Source: Wikiart.

24. Goya's Hereafter

As the lights go down on Goya, the grave from scene 1 appears downstage so that the cover opens out to the audience to show the simple engraving: Goya 1746–1828.

In this case, the audience sees a reversed view of the grave, as if they were in the graveyard looking out. The Phrenological Spirit with the bag of skulls is hand-digging into the grave. As in the beginning, the woman in mourning approaches the grave with a lantern and flower. It is the Duchess. The Phrenological Spirit notices her, snarls, and leaves. She is surprised that the grave is open. She kneels and picks up a skull covered with dirt. She cradles it with loving care, brushing off the dirt, and wraps it in a cloth. Then, she steals off into the darkness. The End.

IMAGE 12.32 Goya's Tomb.
Source: Wikimedia Commons.

About the Author

Willy Conley is an award-winning playwright whose work appeared in *American Theatre, Theatre for Young Audiences Today, The Deaf Way II Anthology, Deaf World, Stages of Transformation, The Tactile Mind, No Walls of Stone, Deaf American Poetry, Deaf American Prose, Deaf Lit Extravaganza, Tripping the Tale Fantastic, This is What America Looks Like, The SAGE Deaf Studies Encyclopedia,* and *Daring to Repair Anthology*. He has one novel, *The Deaf Heart*, two collections of poetry, *Listening through the Bone* and *The World of White Water*, and two books of plays: *Vignettes of the Deaf Character and Other Plays* and *Broken Spokes*. His most recent book from Routledge/Taylor & Francis is *Visual-Gestural Communication – A Workbook in Nonverbal Expression and Reception*.

Conley's plays have had professional productions both nationally and internationally at venues including the Kennedy Center, the Boston Center for the Arts, Tanz Atelier, Baltimore CenterStage, Imagination Stage, Vagabond Theatre, Amaryllis Theatre, the National Theatre of the Deaf (national tour), the Boston Playwrights Theatre, Imagination Stage, Olney Theatre, Ethnic Cultural Center and Theatre, Walnut Street Theatre, Bailiwick Repertory Theatre, Trumbull Theatre, Dixon Place, Omaha Diner Theatre, and off-off Broadway. He has garnered awards from the VSA arts 2000 Playwrights Discovery Competition, the Sam Edwards Deaf Playwrights Competition, The American Deaf Drama Festival, the Baltimore Playwrights Festival, the '99 and '97 NeWorks Festival in Boston, the Laurent Clerc Cultural Fund, the 2007–2008 Schaefer Professorship, the Lamia Ink! International One-Page-Play Festival, and a PEW/National Theatre Artist Residency grant (at CenterStage).

Conley, born profoundly deaf to hearing parents in 1958, grew up in Baltimore, Maryland, and went to public schools before the concept of mainstreaming and support services for the deaf and hard-of-hearing was created. He received a B.S. degree in Biomedical Photographic Communications from the Rochester Institute of Technology with support from the National Technical Institute for the Deaf. He went for further studies in a master's equivalent program in medical photography at the University of Texas Medical Branch in Galveston, Texas, where he ended up as the first (and perhaps only) Deaf person to receive certification as a Registered Biological Photographer.

He moonlighted as an actor and received his first professional acting job with the Sunshine Too national touring company. This led to the more prestigious gig of traveling on national tour with the NTD for three years, acting in *The Dybbuk, King of Hearts,* and *The Odyssey*. He has also performed with the Fairmount Theatre of the Deaf, New York Theatre of the Deaf, Quest Visual Theatre, the Colonial Theatre, Pilobolus Dance Theatre, and LAByrinth Theater Company. He can be seen in the films *Wrong Game* and *Stille Liebe (Secret Love)*; and the television programs: *Law & Order: C.I. (Silencer), WETA Deaf Cinema Showcase,* and *CBS Sunday Morning With Charles Kuralt*.

After leaving NTD, Conley went on to Boston University to study playwriting under Nobel laureate, Derek Walcott in his graduate playwriting program. After receiving an M.A. degree, he was offered a teaching position with the English Department at Gallaudet University, which later evolved to becoming a professor in the Theatre Arts Department where he wrote, and directed, a number of his plays: *Playing Seriously, The water falls., The Fallout Shelter, Vignettes of the Deaf Character, The Deaf Chef, For Every Man, Woman, and Child, Broken Spokes,* and *Goya: En La Quinta Del Sordo (in the house of the deaf man).*

Conley returned to graduate school once again and received his MFA in Intercultural/Interdisciplinary Theatre from Towson University in 1998. He is now a retired professor and former chairperson of Theatre Arts at Gallaudet University in Washington, D.C. where he taught for 30 years.

Note

1 Visual Vernacular, or Sign-Mime as it is sometimes known, is a form of ASL storytelling (in the Deaf community) that is gestural and cinematic. The storyteller employs motion picture camera techniques (wide shot, medium shot, close-up, bird's eye-view, slow motion, freeze frame, etc.) by use of signs and body movement. For more information on this, see pages 186–190 in Willy Conley's book, *Visual-Gestural Communication*, New York and London: Routledge/Taylor & Francis, 2019.

13
MICHELLE A. BANKS, *REFLECTIONS OF A BLACK DEAF WOMAN*

IMAGE 13.1
Source: Photo courtesy of Michelle Banks.

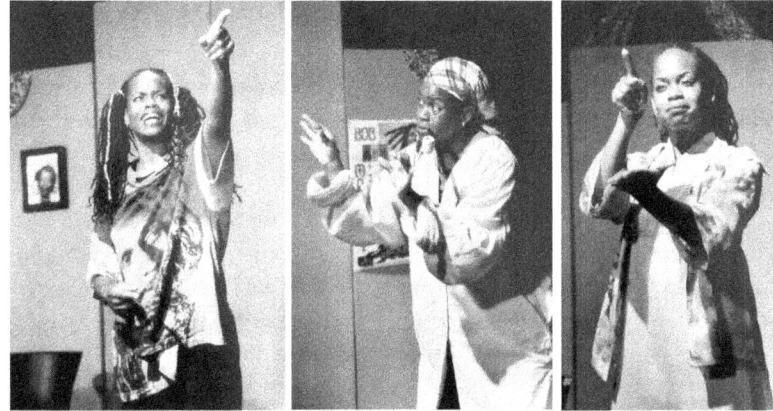

IMAGE 13.2 Michelle Banks in *Reflections of a Black Deaf Woman* directed by Jeffrey Anderson-Gunter at the Leimert Park Theatre.
Source: Photo courtesy of Michelle Banks.

Synopsis

Reflections of a Black Deaf Woman is the story of a special bond between a deaf mother (Miz) and her daughter (Azealea). Told through dramatic and humorous vignettes taken from Azealea's journal, the play is underscored with music and percussion. The narrative unfolds with alternating perspectives between Azealea (during childhood, adolescence, and adulthood) and Miz. A seemingly parallel journey of their lives is revealed as they experience struggles to be loved, discrimination, racism, and triumphs.[1]

Production History

In 2002, Michelle Banks received the Christopher Reeve Acting Scholarship to produce and act in *Reflections of a Black Deaf Woman*. The play was produced by Mianba Productions (Banks' production company) at the Leimert Park Theater in Los Angeles, California, in 2003. It was directed by Jeffrey Anderson-Gunter and voice performed by Carlease Burke.

In 2006, Mianba Productions and The Victory Theatre Center co-produced the second production of the play in Burbank, California, for a six-week run. It was directed by Jeffrey Anderson-Gunter with Theresa "Mama T" Sharp as the voice performer. Taumbu, the drummer, played various musical instruments.[2]

The show has had subsequent productions at the National Black Theatre Festival, the Los Angeles' Women's Theater Festival, Ohio Wesleyan University, the John F. Kennedy Center for the Performing Arts, and Tidewater Community College's The Jeanne & George Roper Performing Arts Center.

Thoughts on the Play

Reflections of a Black Deaf Woman is a one-woman tour de force that cleverly blends drama and humor. The play intimately reveals the intermingled lives of a Black Deaf mother and her daughter from the perspective of Black Deaf culture. Although not autobiographical, it was inspired by the life experiences of African-American Deaf women. According to an online review from Backstage, "Bank's show is spirited and comfortable…viscerally capturing…pain and confusion. We feel both the intense, almost proprietary connection between mother and daughter and the fear as the world opens up for them."[3]

Another review from the Glendale News-Press observed that "for an education in multiculturalism, a better lesson can't be found than *Reflections of a Black Deaf Woman*…, full of charm accented by disturbing revelations…. What one is witnessing is storytelling at its most fundamental level."[4]

Deaf Gain

Although several Deaf theater artists have performed lengthy one-person shows, none have published their written work. This is the first substantial monodrama to be published by a Deaf writer.

Notes

1. Banks, Michelle. "'Reflections of a Black Deaf Woman' Synopsis and Production History." Received by Willy Conley. 21 October 2020.
2. Ibid.
3. Webb, Jennie. "Reflections of Black Deaf Woman." 9 February 2006. *Backstage*. Retrieved from: https://www.backstage.com/magazine/article/reflections-black-deaf-woman-25632/.Accessed 20 October 2020.
4. O'Neal, Dink. "'Reflections' Interesting Look at Struggle." 25 January 2006. *Glendale News-Press*. Retrieved from: https://www.latimes.com/socal/glendale-news-press/news/tn-gnp-xpm-2006-01-25-gnp-victory25-story.html. Accessed 20 October 2020.

13
REFLECTIONS OF A BLACK DEAF WOMAN

Michelle A. Banks

Characters

AZEALEA BROWN, *Azealea is an African-American, Deaf daughter in her late 20s or early 30s and is fluent in American Sign Language (ASL) and Black ASL (BASL). She is a second-generation Deaf African-American in the family and is more academically successful.*

MIZ BROWN, *Miz is an African-American, Deaf mother in her late 40s or early 50s and is more fluent in BASL than ASL. She is the first-generation Deaf African-American in her family. She grew up in the South and attended a segregated school for the deaf and colored, where she acquired BASL as her native language. She completed her education in 8th grade.*

Notes

Vo, an African-American hearing female, voices for both characters, Azealea and Miz, throughout the show.

The capital D in "Deaf" in character descriptions reflects that both characters, Azealea and Miz, are culturally deaf, not from a medical perspective.

Live music with various musical instruments is used to create the sound effects and moods throughout the show.

Scene 1 – "My Life" (Azealea)

Jazz Blues music is playing before the show. Vo is interacting with people in the house. Azealea enters onstage and prepares herself. She begins to sign; music fades. Azealea and Vo ad-lib a conversation. Then Azealea turns to the audience.

AZEALEA: What you see in my hands is a diary of my life. Yeah, you know I ain't finished with my thoughts yet. And I'm sure you wanna know what I do, huh? Let me tell you something. It's not really for you to find out 'cause I've yet to figure it out. So, to hell with it. I just know who I am and that's all that matters. I'll let you in on a secret but you gotta keep it within this room. Promise? I'm a S T R I P P E R! Yeah, you don't believe me?! Huh?! Well… I ain't tell you where I strip! Of course, it's for men ONLY! Ain't interested in none of them women!! Well… gotcha!

On a serious note… I am a well-known actress. I've performed in more than 30 movies. (To an audience member) Say what?! You've not seen me before? It's because you haven't! This is what happened… these movies have been shelved forever and never have been distributed. You may have seen pictures of me everywhere. A poster. A snapshot. A nak… Never mind… What I'm trying to say is… being an actress doesn't mean fame. It means working on your journey of self-discovery. That's what I'm into right now.

My mom… my mom has always encouraged me to be somebody. She'd take me to a ballet class, an acting class or a swimming class just to see what I could do. She always did her best for me. I'll always love her for that. Ain't that something a mother should do for her child? Absolutely! If it weren't for her, I wouldn't be here today. It makes me proud to be able to give something back to her. When she was younger, she didn't have much education. Back then, she had difficult times struggling for herself and raising me at the same time. But she'd made it through! It was because she had her own senses and knew what she was doing for both of us to survive. Now she is so happy that she's remarried and has progressed very well with her life. Whatever she can give, she offers all the LOVE to me. Her love has taught me to accept who I am today. That love she has for me made her write poetry about life. So, I've embraced my life.

Girl! When I was younger, I thought I was ugly. As a dark-skinned African-American woman, I was not supposed to be attractive in the eyes of the beholders. You know, the standard of beauty in this society is undoubtedly BLONDE, BLUE EYES, A TINY STRAIGHT NOSE, and THIN LIPS. Well, don't believe that "*HYPE*"! Who the hell do they think they are telling me what beauty is?! I have my own definition of beauty! When I was small, I always wondered why God made me so ugly that I thought I looked like an orangutan! I thought my being ugly had to do something with Chad, my father. He must be UGLY for real! Maybe it isn't true… I only saw him ONCE. Though, my mom always told me that beauty came from within and I had to believe that I was beautiful. So, I've found my own beauty…

Maybe I'm not a model, but I know I'm a beautiful Black Deaf Woman. I just know that, baby.

Dancing to the drumbeats.

AZEALEA: Because I've found the treasure of inner beauty; of knowing myself; understanding my nature. My sense of self is defined by my long black dreadlocks, sexy black eyes, a broad nose, and full luscious lips. A Nubian Queen... that's who I am!

Mom didn't think it was worthwhile to tell me anything about Chad. She had too many terrible memories with him. I stopped calling him DAD when I was four. Since then he hadn't earned that title – "D A D." He never did what he was supposed to do – to love me or teach me unconditional love. I guess this is why the first time that I've ever loved a man; the first part of my life got really fucked up! But thank God, I've changed. Although he passed away from his third stroke four years ago, I still carry the memory of our last conversation at his house. I've come to realize that he did the best he could.

I've not seen my brother Sammy in many years. I don't know if he is still alive or dead. I knew only a little about him. Something terrible had happened to him and he was in and out of a mental institute for two years up to his disappearance. Although he is gone, I still want to know what he's like and what he looks like now. Hope he is happier wherever he is.

Well, life goes on and it's only my mom and me. That's what counts. Life ain't as simple as you think but we've lived through it. We've learned our life lessons during our good and bad times. That's what life is all about.

Azealea exits... jazz resumes.

Scene 2 – "Little Azealea" (Miz)

African drumbeats are heard in the background along with Miz's entrance and her mime of giving birth to Azealea. Vo assists Miz with the birth delivery. The drumbeats fade gradually after the birth.

MIZ: Thank Jesus... I be takin' good care of my baby, Azealea. She waz the heaviest and chubbiest baby I be carryin'. Much bigger than Sammy. She sho' tore up my punaani. When she waz four, she be buggin' me about her dad, Chad. I told her that he ain't worth a dime talkin' 'bout and that her brother, Sammy, who God knowed I couldn't put up with, don't add up to a nickel. I didn't wanna badmouth her dad, but I hadta say something so she'd stop buggin' me 'bout him. Well, I told her that Chad took Sammy with him. They left us for good and ain't comin' back to us no more. And I ain't saying no more 'bout them – both ain't worth fifteen cents. Just like that, she stopped buggin' me about him. She been quiet 'bout it for such a long time. Oh, I felted kinda bad for her cuz she alla confused and lonely. I wanted her to know I'mma here for her... I looked into her eyes and said, *"You have me. We be together no matter what, honey."* Oh, that sweet smile! Praise the Lord, I'mma all she has.

Lookin' at her made me go back in my life. I be alla alone like her. Ain't have no sister or brother. My mom and dad be leavin' me with my aunt cuz they won't know how to take care of me. Not that they didn't want me cuz they thought I waz deaf and dumb. But they juzt thought it'd be betta that I went and lived with my aunt 'till I waz 16. She waz a good "mother" to me but she ain't know any better either. I ain't as smart as my daughter 'cause I waz alla the way behind in school. I couldn't read and write very good. I waz a drop-out when I turned 15 and went to work in a factory. I worked my ass off makin' moola so that I coulda stay outta trouble. That's where I met her dad, Chad. I remember our old times.... At first, I be afraid for he coulda hear, but hey... he waz a charmer. He be bringin' me a rose and learnin' a few signs every day. We be drivin' up the hill to see the sunset every single night! When I found out I be pregnant with Sammy, he axed me to marry him when sun waz set. Ohhh... what a night it waz! Well... I never knew he be that different after marriage. Anyway, that's alla behind me now. I guess... I've moved on. I don't want no mistakes for my daughter. I want her to have a better life than I did.

By the time she waz 8, I knowed my daughter waz smart. I sent her to the best public school that I knowed of where she be learnin' all them big words. There ain't no other deaf children but her in that school. I thought she being alone with all other hearin' children, she'd be alrite and get some help. But I waz dead wrong! She had problems at school. She wazn't makin' any friends there, cuz them twisted-heads didn't want a "deaf and dumb friend." I KNOW, she ain't DUMB, but just DEAF like me! I told her to leave them be and go on with her classes.

As time had passed, she thought she had a "friend" that nobody coulda see and she'd talk to him. I thought that waz kinda normal for her to imagine somethin' like that. One day, she came tellin' me 'bout her "boyfriend"... a hero that I often told her about at bedtime. She'd loved to hear stories 'bout Bob Marley from Jamaica. That's where my family came from. She told me she waz gonna take Bob to school with her so she coulda show off her "boyfriend"... boyfriend!

African drumbeats begin again as Miz exits.

Scene 3 – "Bob Marley" (Azealea)

Mix of West Indies music – African drums and Reggae play throughout the scene; Azealea enters as a ten-year-old girl.

AZEALEA: I've a secret friend! His name is Bob Marley. Lemme tell you a story about him. Bob waz a good man cuz my mommy said so. Ya know he waz from my hometown. Yeah, Kingston! He hada dark long, thick dreads and they felted and looked like lamb wool. He must look like Jesus with that

kind of hair and his skin would glow like bronze. But he dressed like a rebel. That waz the only difference between them two, Jesus and Bob. Anyways, Bob made da bomb music that made you wanna dance all day and all night. I'd always move my body with rhythms whenever I'd hear his music in my head. Although I couldn't hear, his spirit still woulda flow inside me. Every time my mommy read me stories about him, I'd just close my eyes and swing my head like Ray Charles woulda. Every time I did that, I'd get a spin head and gone to sleep.

Azealea falls asleep.

AZEALEA: (Wakes up) Where am I? Look at Bob and them Wailers… they took over our home country playin' reggae. I waz there in the crowd tryin' to get close to Bob. People were jammin' and I went along with them makin' vibes. When it waz time to go home, dey be screamin' for more and wouldn't leave. Bob hada jump off the stage and sneak out of the commotion. Bob grabbed my hand and people chazed afta we. We ran far, far away from everyone 'til it waz just him and me. We got on a raft, trying to find a secret haven where no one coulda find or bother us. We be layin' down on the raft and witnezin' a beautiful night with them stars blinkin' and shinin' upon us. Finally, we arrived on the other side in Montego Bay and we waz happy. We saw how beautiful the bay waz with the reflection of silver-like moon sparklin' throughout the night. We decided to go for a swim. We jumped into the water. Ahhhh! It waz so warm! We be playin' in there for hours and hours. We caught fish and cooked them by the fire. We be talkin', playin' reggae with his guitar all night long, and eatin' fried plantains, ackee, mangoes and drink coconut water. There… the moon waz goin' down and the sun waz comin' up. We coulda see the bright orange-yellow rayz from the sun beamin' below the horizon of the island. Wow! 'Til somebody came faas with us.

 I felted a cold wind comin' my way. The sand waz blowin' into my face. There a gray shadow of a figure showin' up on our turf. My joy of bein' with Bob Marley waz gone! I waz pissed! So I hada look up to see who it waz that messed up my night with Bob. It waz HIM! Someone I knew from my hood. But I ain't remember his name. Oh dat ole fool ain't tryin' no stuff with me. I'mma gonna beat him up for stirrin' up my private time with Bob Marley! But… sho' enuf Bob and he look alike! Oh Lord! What I be seein' here?! Same dreads and glowin' like Jesus. I hada jump back and take a real good look at them two again. Yes! Dey sure look like brothers. Now dat ole fool waz signin' to me, *"Hey babe, what cha doin' here?"* My eyes blinked thousands of times. Wait a minute! Didn't he juzt sign to me, huh?! I asked, *"Ain't you deaf?"* He replied, *"C'mon girl, what cha thinkin'? I be signin' to you, right? O' course!"* I looked back at Bob… I saw that he waz a little jealous and restless. I holla at dis ole fool, *"Yo! Bettah leave Bob and me alone. I ain't*

here for no problemo!" He waz laughin' in my face and jumpin' up and down like a chimp! He said, *"O' girl, why you be trippin'! Hey?! Who's the hell is Bob, anyways? Ain't he speakin' our language, huh?"* I shrugged. *"Yeah... I know you from somewhere, but I don't know your name." "O' you know me, huh? Well, lemme tell ya what my name is. I'm Dan Marley." "What?! You mean to tell me your last name is M A R L E Y?" "Yeah, what's the matter? Yo ain't feeling me, huh?" "No! I mean... yes... I knew it! You know Bob Marley, the famous musician... he be playin' jammin' reggae. You must be his brother! Ain't he great, eh?"* He looked at me like I waz some sorta a leper. *"Look, babe, I don't know what your talkin' about, but I sho' know he ain't my brother!" "You sho'? Cuz my mommy told me he had one or two brothers. Y'all look alike." "Whatever you say! I don't care what your mommy told you, but I ain't have no brother awright! I'mma just alone like you."* Alone?! What he be talkin' about. *"I ain't alone... I'mma wit Bob."*

She turns to see Bob, but realizes he is not present.

AZEALEA: Where did he go?! He's gone! Dan waz lookin' at me and wonderin' what waz goin' on. *"Hey, babe I'm sorry, but I ain't see no Bob Marley here. I'm stone def and ain't see none of reggae goin' on in here, awright. I gotta go now, baby. My peeps are waitin' for me. I'll see ya around... Peace!"* Dat ole fool left me too! He musta think I'mma crazy. No! No! Don't leave me! Why be you leavin' me?! No! No!

All of sudden, I woke up. It waz just a dream. I looked at the poster on dat door... there Bob Marley holdin' his ole guitar and smilin' in my face like dat ole fool. I pointed to him and said, "Don't you ever dare leavin' me again, EVER!"

That's my story! What's funny? Not Funny!

Before the music comes to a halt... Smack! A loud drumbeat is heard as Azealea hits someone.

Scene 4 – "Chaos" (Azealea)

Azealea sits in the corner with a dunce hat on.

AZEALEA: When is he gonna get me? Will I get suspended? I was put in the corner for hitting a teacher in the face. This white teacher who looked as skinny as a toothpick came up to me and grabbed me by my right ear. Ouch! She told me to shut up. She brought me here to the principal's office and told me to stay put until he came in. Then she left me here alone in that big room. And this tiny light-skinned black secretary with those big ol' assed glasses came into the office to take a peek at me and to make sure I didn't do anything stupid. Then she had the nerve to shake her head in disgust. (*Azealea makes faces.*) Suddenly the door slammed.

He's gonna send me home for sure. But I don't care. Hey... I DO care! All I wanted them to do was to hear my story about Bob Marley. I didn't do nothing wrong. I know I knocked the teacher out... but it was none of my fault. She was in my way when I tried to punch that nerd-looking boy who was spitting and laughing at me about my Bob. The class went out of control and was poking fun at me. All I wanted to be their friends. How could I explain to her that I was sorry? She didn't want to believe me. That dim-witted teacher didn't know what to do with me in that classroom. So here I am!

Hey... that big fat bald-headed white man ain't gonna spank me for sure. He could talk to me about anything, but ain't touching my black fanny for nothing. He had never understood me anyway. He had his funny way of communicating with me as if he was talking to some sorta Alien! Sure enough he scared himself for talking to me like that.

That wobbly dupe just came in and gave me a nasty look. He walked towards his desk and just plopped his big fat ass in that chair. He looked blankly into my eyes and said, *"What's going on? You know you are wrong for hitting a teacher like that."* Now he's talking to me as if I were retarded.

I made all of those noises to distract him. That same secretary came into the office to find out what was wrong. The principal just smirked and stared at me, waved for her to leave and lock the door. He got up and walked awkwardly to me saying, *"What the hell is wrong with you? Why are you doing that? You're not gonna get away with this."* He started to grab me. I ran to the door but the door was already locked. I turned and said, *"Don't you dare touch me 'cause if you do... my mom is gonna shoot your BIG FAT ASS!"* He blurted, *"Say WHAT?! Didn't I hear you right?! Shoot my BIG FAT ASS?! I'm gonna get your NIGGER ASS for talking to me like that! Don't you ever talk back to me 'cause you know you're wrong! Who do YOU think you are telling me what to do and what not to do, NIGGER?!"*

Long silence.

AZEALEA: He called me NIGGER! He was the first person, white or black, who ever called me that name. I looked at him. He looked at me as if he already peed in his pants. Now, he realized I was not the only one who was in trouble! The principal tried to come towards me but I got around his desk. He smirked and said, *"Look child... I... I... I'm... very sorry. I shouldn't have called you that. But you can't have your way all the time."* I cried, *"What are you talking about? It's not about my way... it's about the way YOU and THEY treat me! It was an accident. They were laughing at me."* Then he said, *"I understand. But you know... we're trying to help you cope with your handicap in the classroom and you are not helping us by hurting the teacher."* I blurted, *"No... you don't understand. See... you don't listen to me. I told you they hated me! Can't you see I didn't mean for it to happen like that?! Yes, it was an accident, but a DAMN GOOD one!"* He scolded me, *"Oh Jesus! Azealea... I'll have to send you home immediately!"* I said,

"*Fine!*" He said, "*That's it! You're suspended for 2 weeks! When you go home, you better think about your behavior! I want to see you on your best behavior when you return. Is that clear?*" I just stared at him. He repeated it firmly.

Azealea makes faces.

AZEALEA: His round face got so red that his pimples were poppin'. He told me to get out of his office 'cause he couldn't handle me anymore. He told his secretary to take me to my locker to get my stuff and to send me home with a note. She came in and tried to grab me by the arm. I warned her not to touch me. She just shook her head in disgust and walked with me down the hall.

Azealea exits… African drumbeats are heard again.

Scene 5 – "Reality" (Miz)

Drumbeats stop as Miz enters.

MIZ: Of course, I remember… I waz mad about them kickin' my daughter out of school for this bullshit! I be pissed off. Not really at her, but at the teacher for letting the class go wild, laughin' and mockin' her. They thought that my baby waz crazy. I told that teacher that my baby ain't crazy like her and that Azealea waz alla furious with their stupid behavior. And that white bitch ain't do nothin' about what she waz supposta do. She deserved a big blow! Oh my my my… how DARE that fat-ass white bastard called my little girl nigger! I waz 'bout to beat the shit outta him. Yeah. That's right! They hadta call the police to hold me back. I ain't let them idiots near my child no more! No more! I felted bad all 'bout this situation and seein' my Azealea get hurted and cry like this. I turned to my daughter, "*Azealea, I'm sorry. You hadta go through this. This won't happen to you again.*" Azealea dried her tears and responded, "*Mom, it's aiight and it wasn't your fault. You didn't know any better and there's nothing you could do about it.*" I thought out loud, "*That's what I said about my aunt.*" Azealea pulled my sleeve for her attention. I looked back at her, "*Yes, Azealea… there be something I can do 'bout changin' it. I'mma gonna find you a better school where you be with all Deaf children, how 'bout that?*" Azealea said animatedly, "*Yeah… O.K., mom!*" We hugged and went home. NEVER again had she gone back to that school! After that incident, she be goin' away to a school for the deaf, where none of them people be makin' fun of her. We both were happy!

Azealea waz so excited she always came home talkin' 'bout them deaf friends and even brought one to our house. She be sharin' the same things with them. Even her *"boyfriend,"* Bob Marley. Azealea got into many things like sports and theatre. She stayed there throughout high school. She waz sho' one of the smartest students and graduated with honor. I be so proud of her.

Yeah... now she gotta be the most popular girl in the school and even with boys. And you know what! She wanna be like me. Well, she's getting' to be a young lady. She just turned sweet 16. I get so nervous when she be talkin' about them boys. Alla she be thinkin' about waz them sleek snakes!

I be worryin' about her. I didn't want her to get hurted like I did back then. When I waz about her age, something happened to me. At that time, I waz still livin' with my aunt and her no-good boyfriend. One evening, I waz home alone makin' a sandwich. My aunt's boyfriend came home drunk. He went inta the kitchen behind me. I couldn't hear him. He grabbed my breasts and I be screamin'. He slapped me and held my mouth. He laid me down on a table. I coulda smell his stank alcohol all over me. He took his pants down and torn my panties under my skirt. He waz already inside me. When he waz done with me, he left me there on the floor. And I held my knees and cried. He threatened me not to tell anybody cuz if I did he'd hurted me again. He said nobody would believe me cuz I waz deaf and dumb. So I never said nothin' 'bout it. For three months I didn't know I waz pregnant. Cuz I be still havin' my periods. One morning my stomach hurted real bad. I went to toilet and all of sudden the baby came outta me. I'd lost my first baby. I never told this to nobody not even my aunt.

Miz cries.

MIZ: Thank God! That's all behind me now. I don't wanna her to go through the same pain. What I be gonna do now? Without Azealea? Now that she be grown and be away from home. I dunno... have no one be talkin' to, fussin' at, cryin' or laughin' with. Oh God... Now she's on her own! I dunno what to do. Lord, help me!

Dear God...

Praise be unto thee... help me see and be your light for you have done me so good! Show me the way and what I should do about myself. I be willin' to do better. I gotta have the strength in me and prove that I can shine! May you bless my life with your grace. Oh my Azealea! May you anoint her and watch over her while she be miles away from me. Thank you for everything you've given me. Amen!

African drumbeats play as Miz exits.

Scene 6 – "My Lost First Love" (Azealea)

As Azealea enters as a teenager, the drumbeats fade.

AZEALEA: I just knew I'd be in love with a guy. But who? There were some cute boys at my residential school for the deaf, but they were too immature for me. So, I looked elsewhere right here in my home neighborhood for some real love. There was a guy that I'd drool over. He was so tall and awesomely

handsome. His skin was as dark as chocolate and as smooth as silk. Though, he was hearing and 23 years old. I had barely turned 17 and was still a virgin. Even though boys and I had played doctors and nurse, and we even had patients, this was different. But with him ALONE, I'd really play with him. I'd stand around the corner waiting for him so that I could take a good glance at his body with all the lustrous muscles. That was the real thang! He was a streetwise guy hanging out with his homeboys and smoking weed. I also heard some rumor he would get laid with all the girls he could get in the neighborhood. But I didn't care. I had to have him. He was so FIIIINE!!

One hot summer day, I was walking home from a friend's house and I happened to walk past him and his homeboys. They were whistling at me. I pretended that I didn't notice them. Then one of his homeboys grabbed my arm and he started saying something that I couldn't make out. They knew I was deaf. They had seen me before on a yellow school bus with all deaf students when it dropped me off at home on Fridays. That homeboy would mock me in sign language. I was staring at that cutie pie; I really wanted to see whether he would do something about it or not. He just stared back at me and grinned. I'd never seen such white teeth… just like white-out. He led me away and told one of his homeboys to chill. He made a gesture telling me to ignore them and to talk to him. We walked down the block and chatted a little. His name was Tony.

I would tell my mom all about Tony but she didn't like him. She thought he was too old for me and that he had nothing better to do. Yet, I talked to him. One evening, he stopped by to see me. My mom wasn't at home; she was working overtime. Tony asked, "Ain't your mommy home?" "No, she's at work." Suddenly his eyes were wide-open, and I knew what he was thinking. He invited himself in and locked the front door. I wasn't supposed to have guys in my house without her supervision. But it didn't matter now cuz I let him in… we sat on the couch and I offered him something to drink. We were talking then he started to kiss me. Wow! He was a damned good kisser. He unbuttoned my blouse. He put my hands on his crotch. He was hard as a rock. I was kinda scared. His zipper was already opened and I said nervously, "STOP!" He told me to chill. He held me firmly and took off my pants. He thrust and I groaned & mooaanned!

He would come by whenever my mom was not home. Eventually, he stopped coming around 'cause I heard he was seeing another girl. I was kinda hurt because I was already in love with him. I wept for hours. Two months later, I found out I was pregnant. I didn't know what to do. So, I went to see Tony. He was with his homeboys playing some dice and he didn't really want to see me. I told him it was important. Tony led me away from them and asked annoyingly, "Now, what do ya want?" I told him about the baby. "No shit! Ain't my baby! I know other homeboys done had you!" I said, "No! You are the ONLY guy that I've been with." He said angrily, "Oh man! Stop bullshittin' me – I ain't have nothing to do with that!" He just

walked away not only from me but also from my entire life. I lost my one true love. Well, I thought I did.

I had to do something about it 'cause I didn't want my mom to find out. So I decided I'm not having this baby! I took a hanger, went to the toilet, and tried to abort the baby. I stopped because it was too painful to continue with it. I got so sick that I vomited all day. Eventually, my baby came outta me. My mom never knew about it to this day.

Scene 7 – "College Life" (Azealea)

AZEALEA: I decided to leave home to escape from the surreal episode. I thought going away would help ease my pains about Tony and my miscarriage. I realized, however, I had to move on and do something with my life. Attending a college was my only choice. You see... my mom didn't have much money; yet, she was able to support part of my college education by working two jobs. And I was fortunate enough to receive a four-year scholarship to help pay off the remaining tuition. Yet, I missed... home sweet home.

In a good way, going to college had helped me deal with a lot of stuff. There I met some cool peeps from back home who were so into the "old school hip-hop."

As "Old School" hip-hop music, It Takes Two, starts playing, Azealea dances to the rhythms.

AZEALEA: They thought they were so BAAADD!

The music stops playing.

AZEALEA: Everyone was trying to see who had the best *"moves"* on the campus. I had a lot of fun. They partied and smoked weed almost every night! I partied with them sometimes but didn't try anything. I ain't crazy enough to try this stuff! My mom said if I did anything stupid, she would come and drag my black ass back home! So, I ain't gonna mess my black ass up for this! I got along pretty well with them because they respected me as a person. They didn't care if I were deaf, black or a girl. That was cool!

I didn't date at all because I was too scared to get hurt like Tony did me. But there was a particular guy in my chemistry class who I thought was cute. He was hearing and knew some sign language. He was a senior majoring in English. I was a second-year theatre major. In my class he would stare at me for a long period of time. I guess he was fascinated with interpreters and sign language. One day, he purposely sat in my chair in the front row. I hesitated to talk to him. I was gonna tell him to get his sorry-ass out of my chair. But he was too cute to be yelled at. He smiled at me and I smiled back at him. Then, he let me sit and he moved another chair to sit next to me. When the

class ended, he came over to me to talk. Ever since that moment, we often studied together and made love all night long.

Two months later, he disappeared all of a sudden. I didn't know what was going on with him. Several weeks went by and still no sight of him. I was depressed not knowing where he was or why he left me without saying goodbye. I was feeling the same kind of agony I had with Tony. I was furious with myself for falling in love again! Then I heard through the grapevine that he was in jail for selling drugs to an undercover cop. I never knew he sold drugs and it broke my heart to see a brother like him falling into the same old trap. I went to jail to visit him. He was happy to see me but felt ashamed at the same time. Yeah, I was happy to see him, too. But I was devastated to know that he blew away his chance to graduate in one month. For that reason, I told him that we'd better split up. He understood.

I continued to study acting until I graduated. I didn't bother to get involved with anyone for a while because my schoolwork was too important to get lost in love again. No. That's not true. I'm still afraid of the hurt, but... I still think about him sometimes.

Scene 8 – "Chad, The Father" (Azealea)

Azealea becomes a little bit older; now in her early 20s.

AZEALEA: Thinking. Thinking... about him, too. Yeah... my Dad or should I call him Chad? I've always thought of him as Chad since I was four. I didn't think he'd like for me to call him *"Dad,"* neither did I. Well, I came back home right after I graduated and found little work in show business. I decided to stay close to my Mom so that I could get reacquainted with myself. Sometimes I wondered why my relationships with men were unhealthy. Did I ever wonder that my intimate relationships have to do with my not knowing Chad? Yes! They sure did! Eventually, I confronted my mom about him. At first, she was reluctant to tell me anything about him because there weren't any good things she could say about him except that both of them produced two great children, of course, Sammy and me. To my surprise, she told me he lived not far from us. It was like a *BIG SLAP* on my face knowing that he had *LIVED* in this area all along! She said he never bothered to come around to see me or bring my brother along to play with me. All I know he had hurt my mom... something like a sharp knife piercing into her heart. I wish I knew what else he had done to make her suffering so *UNBEARABLE*. He didn't treat her very well and wasn't all that faithful to my Mom. He threatened to take Sammy and me. Nevertheless, he only could take Sammy with him and handle him better because Sammy could hear. Mom let him go with his Daddy. Though, she's been missing Sammy so much. It was a misery not only for her, but also for all of us.

I found where he lived. Ten blocks up the street from us! Where had he been all these *GODDAMN* years?! I took a long breath and walked up to his small two-story house.

Drumbeats sound like a knock-knock.

AZEALEA: A lady opened the door. Who could that be? His wife? Girlfriend? My half-sister? She looked a bit younger than my Mom. She asked sternly, *"Who are you? To what do I owe this visit?"* I replied, *"I'm looking for Mr. Brown. I'm… his daughter."* She said, *"Oh… so you must be Azealea? Finally, I got a chance to meet you – his other child!"* I was like, *'OH MAN! DON'T START THIS…'* I didn't even know why I was there in the first place. I was about to leave, but she said to wait and went back in the house. A few minutes later, came out the door was a short man about 5'3," in his mid-40s or 50s, brown-skinned man with a reddish-brown mustache and his bald head shaped like a *"football."* Damn, I did not realize that mom was right in calling him a "colossal-headed midget!" I remember I used to look funny like that, but again my mom said beauty comes from within. My look is much more refined now. Looking at him… he seemed weary and came across as if he just finished smoking some crack. He stuttered, *"Aint… Ain't… you…… you Miz's child?"* I replied, *"Yes, I am Miz's child!"* His eyes became watery. I could see an arrow going right through his heart! He knew I knew. I held my tears back and refused to show him how much I loathed and missed him at the same time. This was a very awkward moment for both of us. We just stood there and said nothing for a few seconds. For a moment, it was awkward, but we hugged anyway. He invited me in. He kept on apologizing or making excuses for not being available for most of my childhood. I noticed he'd been stuttering a lot. And it was getting too annoying, but there was nothing he and I could do about it. So, I changed the subject by asking him about Sammy. He looked away and wouldn't say a word. I repeated the question. Finally, he admitted that Sammy ran away from home too many times and got in trouble with the law. He then joined a gang. He was jumped by his rivals and survived a blow to his head. He had been in and out of a hospital getting his psychological therapy. One day, he was gone. Nobody knew where he was. He has been missing ever since. I asked him, *"Then why did you keep us separate all these years?" You could have let him stay with me and my Mom or visit us."* He stuttered, but this time louder, *"I… I… I was… lonely and I wa… wanted him with me. I… I thought I'd raise him to be… be a r..r..responsible man. But I F… F… FAILED him! My bad. It came back to… to h… h… haunt me forever for leaving you and Miz!"* Puh-leeze! Stuttering about *'… trying to raise him to be a RESPONSIBLE man…' shit*! I wanna slap him upside the head for destroying this family – my Mom, Sammy, and me. He did it for his own selfish reasons. He should have been RESPONSIBLE

enough to keep the family tight and be the breadwinner for the family. He didn't know what THE HELL he was talking about 'cause his SSSTUT-TERIINNGGG ASS got caught up on him for not being a responsible man! But I had to be calm throughout our conversation otherwise this would have backfired on me. Again, we changed the subject back to me. He asked me how I was doing. I told him little about my school and my relationships with men. I asked him bluntly, *"Why is it so hard to find a good man?"* He ignored my question and just couldn't answer me. Before I got up to go home, I asked him the last simple question, *"Why didn't you come to see me?"* He thought for a minute and plainly said, *"I... I... I just could not... not b... b... bear seeing Miz in... in your eyes."* That was his last answer to everything he knew. I thanked him for the visit. It was the last time I saw him.

Azealea exits. African drumbeats begin again.

Scene 9 – "Rebirth of My Life" (Miz)

Miz enters and the drumbeats stop playing. She is in her mid-40s or early 50s.

MIZ: Yes, Azealea went to see... her Dad or shoulda... excuse me... should I say Chad as she's called him. After all those years, she... finally came to me and asked 'bout him. I couldn't refuse to... uhm... deny her right to know 'bout him no matter what he'd done to us in them old days. I didn't try to stop her from seein' him cuz she has right... the right... to see him and... to umm... find out more about her father. I didn't want to say too much about him cuz it was bad enough to bring back the... night... nightmares of our OLD ROTTEN marriage. After we got married, he changed all of sudden without any warnings. He was nothing, but a ma-nip-u-la-tive, unfaithful husband. Then one night I came home... earlier than expected and caught him with the other woman in OUR OWN BED! From that night on, he be gone... was gone for good.

 I must admit I was so glad she got the courage to visit him. So he could see how stupid he was for missing all these years with her. And see how great she has turned out to be. I know I've done a good job raisin' my baby ALONE! Well, enough said! All I can say is... it was very... what's the word? (*Snaps her fingers.*) Ah... healing for Azealea to deal with her personal issues and that helped her move on.

 As you can see, I've changed. It's because of my daughter. My dear... no... pre-cious Azealea! She has an... umm... oh yes... impact... on my life. Seeing my daughter graduate from college gave me the... the... what's the word... ah... motivation to turn my life around and to make myself a better person. Two things that I've got done....no... wait... better word would be... accomplished....in the last few years: education and marriage. See, I'm getting better with them big words... my vocabulary and

my ability to "speak" or sign "properly." Wow… And of course, I've learned to read and write better now than before. I feel more comfortable with who I am right now. I went back to get my GED and entered a community college.

There is where I met a wonderful man and fell in love with him. We got married.

We are still VERY married for three years now. I was surprised and scared… no…

T E R R I F I E D! I never thought I'd find my love again… not after Chad or at my AGE! Maybe I was still too angry with my "ex" or didn't believe anyone would wanna get with an OLD MAID like ME! But I was wrong… anything is… possible. Love can be mys-te-ri-ous… you never know what it coulda… could do for you. It could crawl on you and scare the hell outta you. I'm serious about this… my husband… he's blew… blown my mind away about what love should be like. It took me a little while to accept his love. He is so… different. Oh geez! I've never met a man like him before and he has been so wonderful to me. Of course, I am much happy… happier now.

Oh… by the way, I'm still learning more about myself and still growing. Before my life changed, I was illiterate. My daughter appreciates my sacrifices and that has taught me to be proud as a mother. You know everybody has dreams, something to believe in. Some people play music or paint. I write poems that help me find the truth in me.

Scene 10 – "Self-Discovery" (Miz)

MIZ: Azealea, I have something to tell you from my heart.

Azealea, you have grown into yourself: a Beautiful Black Deaf Woman – a whole new person. Always remember who you are and where you come from. Whatever happened in the past was part of your childhood with pain and happiness. Whatever happens in the present is your adulthood. As you know I've always encouraged you to be somebody, you are YOU. Always remember lessons learned that pave the way for your struggles and successes. You must never give up; continue your journey. There will be obstacles but see them as strengths. You are Black, Deaf, and a Woman. Let those strengths guide your life with pride! I love you. I have always and always will.

Scene 11 – "Life II" (Azealea)

Azealea, as an adult, enters with enthusiasm to talk to the audience.

AZEALEA: I've realized now that life, itself, is a gem. People have their own struggles and successes. I have my own. So has my mom. So, do all of you. We have a lot in common. For generations, our ancestors have imparted a legacy to triumph over oppression. That's the reason for my diary.

You see I'll always thank my mom for who she is and what she has done for me. The truth is... I don't know what I would do when she is gone. But I know I will continue to carry her spirit with me as long as I live. I'll always remember her determination for she has celebrated my maturity.

My life may seem like a rollercoaster, but that's reality. I've learned to accept the truth of my own consciousness and appreciate it. That manifests my own identity as the universe constantly unfolds before me.

You know... meeting Chad... no... my Dad for the last time was a good thing. Seeing him had given me a better understanding of what kind of a man I deserve. Although he didn't know the answer to it, it helped me work through my issues and see men in a different light. I had to release all of my "old" wounds and begin all over again with NEW LOVE. Good news... yes, I'm engaged to a man who happens to be deaf and a lawyer. I met him through our mutual friend at a Kwanzaa ceremony last year. He is amazingly charming and funny! He's so FINE, too! Finally, I've found a good man... my soul mate, a man who can love and accept me for who I am. God is good! We have a balance of everything. We both want to have children: a boy and a girl. We look forward to raising our children in a loving and nurturing environment. We also look forward to growing old together and teaching our children moral values that my mom passed down to me. As far as my acting career I guess I will just chill and concentrate on getting pregnant! Yeah! I will be riding him every night! Whew... Ah... do you know what I would like to do? I'd loved to write children's books. That's what I'll do next! Hey... we all contribute to this life...Now, I will close with this poem dedicated to my mom.

Scene 12 – "The Reflection of a Black Deaf Woman" (Azealea)

The spotlight is now on her and contemporary jazz is heard throughout the scene.

AZEALEA: I am the Reflection of
 a Black Deaf Woman
 whose pride has revealed
 the truth of herself.
 My universe is embodied
 with the desire of holy spirit
 and harmony.
 My dignity can not be broken
 because my presence is as
 pure as a higher kingdom.
 My life experience is as genuine as
 a story being told.
 It is woven with a set of colors
 like a rainbow in the sky.

It fulfills the imagination like:
a bird soaring higher
a jewel glistening
a flower blossoming.
But… the other side of my life
has had a dark void that needs
to be filled in and my wounds
are embraced with tender care.
They have transcended into
a reality of abuse.
It fulfills the imagination like:
a glass shattering
a broken promise
a lost child.
Life has its own beginning and ending
of everything that evolves around me.
I have to live up to my virtue of
essence… then again that's
who I am as
The Reflection of a Black Deaf Woman.

Music fades as the light on her fades out.

About the Author

Michelle A. Banks, a native of Washington, D.C., is an award-winning actress, writer, director, producer, choreographer, motivational speaker, and teacher. She co-wrote the plays *There's Butter, But No Bread* – an adaptation of *Waiting For Godot*, and *Black Women Stories: One Deaf Experience* for Onyx Theatre Company.

Her television appearances include a *Yahoo!* commercial, the ABC's 10–8, the Showtime Series *Soul Food*, *Girlfriends* (UPN), Lifetime's *Strong Medicine*, and a T.V. pilot, *Sole*. She has also starred in the movie *Compensation*, directed by Zeinabu Davis. It has received rave reviews at film festivals worldwide, including Sundance, Burkina Faso's FESPACO, and the Toronto International Film Festival. The film ran on BET-Black Starz and Sundance cable channels as well. Banks also had a cameo appearance in Hilari Scarl's documentary about Deaf entertainers, *See What I'm Saying*. Banks credits Jadolphus CW Fraser, an independent filmmaker, in introducing her to filmmaking; she co-directed his feature debut, *Always Chasing Love*.

Banks participated as 1 of 13 actors for NYC's 2008 ABC Diversity Talent Showcase. Her theatrical appearances include The C.A. *Lyons Project* at Alliance Theatre in Atlanta, Georgia; *Story Theatre* with Open Circle Theatre; *Big River* at the Mark Taper Forum in Los Angeles, California, and Ford's Theatre in Washington, D.C. She also performed in *For Colored Girls Who Have Considered Suicide*

When the Rainbow Is Enuf at the Henry Street Settlement Playhouse (New York City) and the Globe Playhouse (Los Angeles). Her *For Colored Girls* ensemble in Los Angeles won the 2003 NAACP Theatre award for "Best Ensemble." Banks was one of the first two Deaf African-American actresses to interpret for the Broadway play *Having Our Say* by Emily Mann.

After receiving her Bachelor of Arts degree in Drama Studies from the State University of New York at Purchase, Banks founded Onyx Theatre Company in New York City, the first deaf theater company in the United States for people of color. Her work with Onyx for 11 years earned the Cultural Enrichment Award from Gallaudet University and the Distinguished Service Award from New York Deaf Theatre. Her other achievements include a featured article in the February 1998 issue of ESSENCE magazine, Program Coordinator for Deaf West Theatre's Professional Acting Summer School, Director of American Sign Language for Arena Stage, Broadway, and Centerstage, the Outstanding Achievement Recognition Resolution of 1996 from the Council of the District of Columbia, an Individual Achievement Award from the National Council on Communicative Disorders, and the Laurent Clerc Award from Gallaudet University for her social contributions to the Deaf community.

Banks completed her master's degree in Organizational Management, specializing in Organizational Leadership from Ashford University in 2015. Her producing and directing credits include *A Raisin in the Sun, Look through My Eyes, Silent Scream, Z: A Christmas Story, What It's Like?* (One Man Show), and *In Sight And Sound: DE(A)F POETRY I, II, & III*. Currently, she is the Artistic Director of Visionaries of the Creative Arts (VoCA) based in Washington, D.C. www.visionariesofthecreativearts.org.

Michelle Banks is a true pioneer and ambassador for Deaf people of color. Recognizing that there has been a severe lack of employment opportunities for deaf and hard-of-hearing actors of color, she has become a leading advocate for inclusion and diversity in casting. She believes that promoting a greater number of these actors in the theater requires a necessary change – a commitment to not only recognize, but also hire, talented deaf and hard-of-hearing theater artists of color. In addition, Banks has stated that producers, writers, and directors need to be more proactive in reaching out to Deaf actors of color by creating more roles for them, and casting them in non-traditional roles, not only for stereotypical ones.

14
SABINA ENGLAND, *LOST IN THE HEREAFTER*

IMAGE 14.1
Source: Photo by Sabina England.

IMAGE 14.2 Sabina England performing in her solo sign-language dance poetry show, *Allah Earth: The Cycle of Life*, in Tucson, Arizona.
Source: Photo by Bill Ross.

Synopsis

Sitara and Farid are a young married couple madly in love with each other. Farid is speeding on his way to a job assignment and is killed instantly when his car gets slammed by a truck and falls into the river. He awakens in the afterlife, where he is shocked at his new state of being dead. He refuses to accept his death as he keeps trying to communicate to Sitara who cannot see or hear him. Sitara is also in denial as she cannot accept that her husband is dead. She clings onto the hope of seeing him one last time and tries to search for a sign from him in the afterlife. Sitara and Farid embark on a journey to accepting death as a new reality; Farid learns to adapt to his permanent state as a soul living in the afterlife, while Sitara finally acknowledges that her husband is dead and gradually lets go of him, so that he can move on and rest in peace.

Production History

This is the newest play in the anthology. It has not been produced yet.

Thoughts on the Play

Lost in the Hereafter is a play about death, grief and the afterlife. Sabina England wrote this play based on her own traumatic experience of losing her spouse in a fatal car accident. Most people were not able to relate to her loss. Losing her spouse opened her eyes to the illusion of reality that we live in. Life is not temporary, yet death is permanent. However, death shouldn't be so scary—we all die and we can't change that. But does life truly end at death? The play shows death from two perspectives: the man who has just died, and the woman who loses him.

The play includes a chorus of dancers who are symbolic of the afterlife—they may represent souls, *apsara* (angelic beings in Hinduism and Buddhism) or *baa* (souls of departed humans with wings) in ancient Egyptian culture. In the beginning of her script, England stated that the dancers were optional. When asked why a seemingly crucial element of the script was not obligatory, she explained that she is a big believer in artistic direction. Depending on the director and target audience, a director should decide if they want a minimalist, clean-cut play (more ideal for a hearing audience) or a lavishly visual masterpiece for a deaf audience. She thinks that dancers would be more interesting to incorporate for a deaf audience, since deaf people are very visual and always have their eyes glued to dancers and other visual happenings onstage. Hearing people, on the other hand, don't care that much about visuals; they are more tuned in on dialogue, audio, music and voice. This has been her personal observation from doing performance art, theatre and filmmaking.[1]

England's intent is to make the play visually alluring to both Deaf and hearing audiences. Additionally, actors could either use American Sign Language or voice to portray the characters.

Deaf Gain

Sabina England is the first known Deaf playwright who identifies as Indian Muslim. Her new play, *Lost in the Hereafter,* breaks new ground in the realm of Deaf-written plays that deal with spirituality and the afterlife.

Note

1 England, Sabina. Email to Willy Conley. 21 October 2020.

14

LOST IN THE HEREAFTER

Sabina England

Characters

FARID (*Lead, Male*)
SITARA (*Lead, Female*)
THE IMAM
PROFESSOR NIKOLI (*Older Female*)
ALMAWT
RIEL
DANCERS (*Optional*)
The Imam and Almawt can be played by the same actor.

Notes

Time: Now
 Place: Here and there
The dancers perform some kind of a beautiful, poignant dance during parts of the play. During the dancing, there will be special lighting changes. Think of them as a chorus, a group of ancestors, apsara, angels, ethereal beings.
Lighting is a huge factor in showing differences between the physical realm of Earth and the spiritual world of afterlife. I expect lighting cues to vary greatly and change colors and tones.

Act I, Scene 1

The lights come up. The stage is bare and simple, with a table and two chairs. Sitara is putting plates on the table. Farid enters, sneaking onstage. He surprises her with a bouquet of fresh flowers.

FARID: Good morning. I got you something.
SITARA: Oh! This is nice. Thank you. I wasn't expecting this.
FARID: I wanted to surprise you, baby. Breakfast looks good. I'm starved. Let's eat.

Farid and Sitara embrace each other and sit down at the table to eat.

SITARA: These flowers smell enchanting. They brighten up the whole room.
FARID: Yeah, it's gloomy outside.
SITARA: The sky looks drab. No clouds in sight. It's gray everywhere, but already my mood is improving. Thanks again, my love. Did you have a restful sleep last night?
FARID: I slept well. I meditated today. I'm feeling more clear minded. This food is so good. What is that book you're reading?
SITARA: It's a collection of ancient poems from India written in many languages. Professor Nikoli suggested this book to me. I need inspiration.
FARID: Why's that?
SITARA: As you know, I'm trying to work on my poetry but I lack the right words to express my sentiments. So I'm looking for inspiration, in hope that something will hit me and words flow through my fingers like a river.
FARID: Show me something from the book. I want to hear a verse that reflects how you're feeling at this moment.

Sitara scrolls through the book and stops at a page.

SITARA: Aha. Here is one. This is written in the Bodo language hailing from the lush green hills of Assam. (Beat) These sweet perfumes/this shining sun/ these birdsongs fill the countryside/this day seems made for love.
FARID: That's beautiful. Good way to start my day. I bring you flowers and you bring me poetry. We make a good team. You're my better half, you're the brains and you keep everything running.
SITARA: If I'm the brains, who's the cute one?

They laugh.

FARID: Me, baby. Of course. You are everything to me, you know that. I want you to push yourself and keep writing. Whatever words are in your mind, just go ahead and put them down on paper, even if you don't think they sound good. Don't give up. Hit me with a verse. Now.
SITARA: Now?
FARID: Yeah, come on. I'm trying to push you. Let's go. I want to hear something.
SITARA: Let's see what I come up with. (Beat) In spite of the gray sky/I dream of a bright sliver of yellow ray. (Beat) Is that good?
FARID: Well. That's not too bad. I detect no passion. You're holding back.

SITARA: My mind is blocked. I must figure out a way to unclog pores in my brain.
FARID: Just let it all go. Surrender yourself to the pages. The pen is your weapon, just take a stab and keep going.
SITARA: I know. You're right. Will you fast today?
FARID: Yes. After I finish this delicious breakfast, I will abstain from all food and drink until the sun sets.
SITARA: How have your fasts been, Farid?
FARID: It's hard, baby. But it's good for my discipline. It helps me focus on my goals.
SITARA: You're doing fine, Farid. As a reward for your steadfastness, I will cook a large dinner for you when you return tomorrow night.
FARID: Will there be steak? I like how you pepper the steak.
SITARA: Steak or no, it's a surprise. But I promise you love it. Food always tastes good when you're feeling extra hungry.
FARID: I love everything you make. Alright, Sitara, look at the time. I need to go now. I want to get there early before anybody else. Thanks for breakfast, meri maharani. I feel nourished.
SITARA: Anything for you, my love.
FARID: My beautiful, gorgeous wife. How did I get lucky to be with you?
SITARA: You are lucky and you know it. Text me when you get there, so I know you're fine.
FARID: I will. When I get home tomorrow, I want to hear all the verses you have written.
SITARA: I shall see what I come up with.
FARID: Good girl. I know you can do it. I love you, Sitara.
SITARA: Love you too, Farid. Until tomorrow, then.

They embrace. Farid exits. The lights dim. Sitara looks out at the audience, as if she's looking out the window. Time passes. She checks her phone, but no messages yet. Hours have gone by. She looks out at the audience again and checks her phone, but has not received any new messages. She looks worried and exits. The light goes out.

The light comes up again, but with a different color. Sitara is onstage. Someone approaches Sitara and tells her the bad news, but we don't hear it. Her expression changes. She crumbles on the floor. Sounds of wailing and screams (off-stage). The person turns away and retreats. Light fades but remains.

Act I, Scene 2

Mourners enter in a line and spread out onstage. They move around and dance slowly albeit mournfully. There is soft music playing, a mixture of world music, a variety of instruments and chanting. A robed religious authority, the Imam, emerges onstage and the dancing ceases.

IMAM: Family, friends, fellows. We are gathered here today to celebrate the life of Farid. His life was unexpectedly and tragically cut short. There are no words to express the shock or sorrow at this news. What I can say is this. He was a devoted spouse, faithful son and brother, and loyal friend to the community. He was a kind-hearted person who would give up his free time to help someone in need. Each one of us in this room have the fortune to know him. We all have a story that we can share to remember him. (Beat)

As it has been decreed in the Holy Quran. To Allah we belong and to Allah we return. We pray for his soul so that he may find peace in the afterlife. May Allah grant him Jannat. May he soar among the birds and fly through the stars of the Great Sky. Ameen.

All speak onstage: Ameen. Sitara is being consoled by others. They pick her up and help her to a chair where she sits. One of her friends, Professor Nikoli, lingers by.

NIKOLI: I'm very sorry for your loss, Sitara. I can't imagine how you feel.

No response.

NIKOLI: You and Farid were such an exceptional, phenomenal couple. You were so good for each other. It always warmed my heart seeing you two together. I enjoyed having Farid in my classes. He was my favourite student, you know. Everyone adored him. He was an incredible man.

Sitara stays silent, looking mournful.

NIKOLI: I'm just a phone call away if you need me.
SITARA: Okay, professor.

Nikoli waits a moment for her to say something else but she stays silent. Sitara then looks at Nikoli.

SITARA: Thank you. That will be all.
NIKOLI: I know you need some space so I will let you be. I will drop by later and check on you.
SITARA: Okay. Thanks.

Nikoli exits. The Imam comes over to speak with Sitara.

IMAM: Sitara? Is there anything I can do for you?
SITARA: No.
IMAM: I am truly sorry for your loss.
SITARA: Yeah.

IMAM: I want to tell you something. The unexpected news of the sudden passing is the worst part. You've already gone through the shock of receiving the news and making arrangements to bury your spouse. Now comes another hard part – having to accept that Farid is gone. (Beat) Sitara?
SITARA: He's not gone.
IMAM: I know, Sitara, he'll always live in your heart. He's up there with you.
SITARA: That's not what I mean, but ok.
IMAM: Would you like to talk?
SITARA: No.
IMAM: I'm always available if you need someone to talk to. I can provide guidance to you. We can pray or just talk. Whatever you need.

The Imam gathers his things and is about to leave.

SITARA: Wait.
IMAM: Yeah? Are you alright, Sitara?
SITARA: Is it all done? Are you sure we haven't forgotten anything else? I feel that there needs to be more prayers recited, more flowers picked for him…
IMAM: Yes. A hundred percent. We have done everything that is required to help him pass over. (Beat) Don't worry, Sitara. I've done my duty to ensure that your spouse will be at peace. I've said all the prayers and performed rituals that would rest his soul. Now it's your turn to help him cross over to Jannat. Pray for him.
SITARA: Yes, Imam.
IMAM: I promise you that we have done every necessary step to help him rest in peace. You must not be too harsh on yourself, Sitara. Give yourself some time to mourn and grieve.
SITARA: Right. Thank you, Imam.
IMAM: You take care of yourself, alright?
SITARA: Yeah.

The Imam looks at her for a few moments, waiting for her to say something. She keeps silent. The Imam then gathers personal things and exits. Sitara is alone now, except with a portrait of Farid on a table onstage. Sitara is numb. She then looks at the picture of Farid and walks toward it. She picks up the portrait.

SITARA: I can't believe it. You're—You're gone.

Silence.

SITARA: It doesn't feel like it, Farid, one moment I was with you and we were talking and making plans for the future—

Voice trails off.

SITARA: You're not gone, are you?

Looks around.

SITARA: Farid? You're here? Yeah. You're here. They say that people go to Heaven when they die. Is it true? Are you here? You can't be gone. Please. I can't stand the thought of you being completely gone! Is Heaven real, Farid? Please tell me you're here but you live in another world. You can see me, can you? (Beat) Hello. Hello?

Silence.

SITARA: I miss you.

Silence.

SITARA: Are you there?

Silence.

SITARA: I don't know if you're there.

Silence.

SITARA: I don't know if Allah is real, or if there's a Heaven.

Farid enters onstage and he listens to her. Audience doesn't see him yet.

SITARA: Allah. Hey Allah? If you're there? God? Goddess? Dios? Lord? Divine Supreme Being. The Great Mystery. The Creator of the Universe. Whatever you are. To all the angels, spirits, master guides, ancestors, whoever is up there? In another realm that we can't see? Please look after my Farid and make sure he is happy and safe. I want him to rest in peace. I don't want him to feel any pain. I don't know what it was like for him to die. I can't stop thinking of that… the moment that he knew he would die.

Farid speaks to her but she can't hear him or see him.

FARID: No, don't say that. I am here.
SITARA: At the moment of – death – I hate that word – death. Death sounds so final. I won't say that word again. When he was about to leave Earth, did he think about me? Was he scared? Was it quick? Painless? I hope he wasn't in too much pain.

FARID: What are you talking about? I am here. I'm right here, Sitara. Why are you talking like this?
SITARA: I don't understand why this happened.

Talking to no one in particular.

SITARA: Why did you take Farid away from me? We were supposed to spend our whole lives together. I feel like I woke up in the wrong universe!
FARID: We are spending our lives together. Why are you acting strange?
SITARA: This was never supposed to happen. No! This is all wrong!

She softly sobs to herself and rolls up in a ball.

FARID: I'm coming back to you, please listen to me. I'm here, Sitara.

Sitara still cries softly.

FARID: Sitara?

He walks to her and tries to touch her but can't.

FARID: Sitara. I'm here. Please hear me. I am here. I can see you. I'm not gone! I'm here, Sitara. I'm with you. Please don't cry, baby. I'm here and I'll always be with you. I'm not dead!

She keeps crying.

FARID: Oh god baby. I wish I can make you see me, send you a message that I'm still alive. I'm fine. I'll find a way to come back to you.

He tries to grab some paper and pen; nothing works.

FARID: Goddamnit—Sitara! Hear me! Can't you hear me? Can't you feel my presence?
SITARA: I think I must be crazy but sometimes I feel that you are here with me, Farid.
FARID: Yes! I am here! I'm right here, Sitara—
SITARA: Will I always wonder every day whether you can see me? I'm stupid.
FARID: No, you're not stupid! Goddamnit, Sitara, open your eyes, look, I'll find a way to come back and make you see me. This is just a bad dream, okay?
SITARA: This is not real life. I am dreaming, right, Allah? You're trying to teach me a lesson about how I should never take love for granted. I got it now. Please wake me up from this horrible dream and take me back to Farid.

Waits; nothing happens.

SITARA: Farid? Are you here? Come back. I love you and I'm sorry for any mean things I've ever said to you.

Waits; nothing happens.

SITARA: Farid? Goddamnit. I said I'm sorry! Come back.

She cries again.

SITARA: I can't believe this – wake me up from this horrible dream.

FARID: Please, Sitara, I'm not dead. I'm here with you.

He tries to shake her, but he cannot touch her.

FARID: I'm dreaming, too. Sitara. Wake me up!

He starts becoming frantic and tries any way to wake her up, by grabbing onto objects or furniture, but he cannot touch any objects and he increasingly gets upset. Sitara is still crying, curled up.
 A robed figure comes onstage. Neither masculine or feminine. This figure is called Almawt. A teenager named Riel accompanies Almawt. They both watch Farid freaking out and trying to touch objects.

ALMAWT: Farid. Be calm. You're making it worse on yourself.
FARID: You can see me? Hello? Hey!
RIEL: Hello back to you.
FARID: Both of you can see me?
RIEL: Yes but only we can see you.
FARID: Only you can see me? Why?
ALMAWT: We are here with you, Farid. I will guide you and Riel will help you go through the steps.
FARID: What steps?
ALMAWT: Toward acceptance.
FARID: Look. Can you make this dream stop? I don't know where I am. Can you help me go back home to my wife?
ALMAWT: I will help you accept the situation you are in. I cannot help you return to your wife. In a way, you are already home. What you see and feel now, this is not an illusion. This is the reality you are in.
FARID: You are rambling nonsense, I don't know what you mean.
ALMAWT: You're in your true state now, Farid. Your wife has some time before she'll reach her true state, too. Riel has also accepted this.

RIEL: I'm still adjusting but I'm getting used to it.
FARID: I don't understand. What are you talking about? Where am I?
ALMAWT: Do you remember the last thing you saw before you appeared here? Think about it and try to remember how you got here.
FARID: I was driving to another city to take over a job assignment and it was early in the morning – I drove really fast because I wanted to get there early—
ALMAWT: Go on.
FARID: A large truck came on the road. There wasn't much room and I remember that my car was being pushed over to the side, and then—

Farid realizes what happened and he falls silent.

ALMAWT: Do you remember, Farid?
FARID: Yeah. My car went into the water over the bridge.

He looks at them.

FARID: I'm dead. I'm dead, aren't I?
ALMAWT: In a physical sense, yes. You had expired through a physical plane. Now you're in the astral plane. But you're not actually gone, you still exist in the form of a soul. But your human existence is gone. You have died.
FARID: No, no. I can't be really dead. This is a bad joke.
RIEL: It's not a joke. I passed away a few weeks ago, too.
FARID: You're dead?
RIEL: Yeah.
FARID: But you're just a kid! How old are you?
RIEL: I was almost fifteen when I died.
FARID: What happened?
RIEL: I died in the hospital. From leukemia. Now I'm here. And so are you.
FARID: You are crazy.

Farid turns to look at Sitara.

FARID: Sitara! Hey! I'm here! Why can't you hear me?
ALMAWT: She can't see you, Farid.
FARID: This is the worst prank of all time. This is not funny. I can't get out of this—
ALMAWT: You won't get out of it but I can help you make this less painful.
SITARA: (to herself) Farid – please come back.
FARID: I'm right here!
ALMAWT: You both need to understand that this has already happened and you need to accept it.
FARID: Accept what? None of this is real!

ALMAWT: You have passed away and you cannot go back to the physical form on Earth. The life you knew does not exist anymore. You are dead.
FARID: I'm not dead! I'm still here, and I can speak and talk to you, dammit.
RIEL: But your wife can't hear you. You know that.
ALMAWT: Take a moment and look at yourself.
FARID: I'm still here, aren't I? I'm not dead! Look, my body is still here.
ALMAWT: Only because you are under the illusion that you're still in your physical body.
FARID: There is no illusion, my body is real and I can feel it. Look!

He touches his arms and legs.

FARID: And I can see you both!

Points to Riel.

FARID: This one has a body!
RIEL: When I appear to you, yes. But when I'm in my true form, no. I don't have a body.
FARID: None of this makes sense. Where am I? Where have you guys taken me to? Let me go!
ALMAWT: Your death was sudden and unexpected, Farid, so you still need time to process and grieve. Look around and see; we are in the astral realm, not in the physical plane on Earth. You are in an outside layer of the physical world. You are holding onto the illusion that you are still alive in your physical human form on Earth. When you finally accept that you are dead, the illusion of your body will disappear and you will realize your true form in light.

Farid stares at Almawt dumb-founded and then ignores them.

FARID: Hey Sitara! I'm right here.
ALMAWT: No matter how much you try to yell and touch objects, it won't work.
FARID: Then what about ghosts? Why am I not a ghost already?

Points to Riel.

FARID: Is that a ghost?
RIEL: No.
ALMAWT: Ghosts are spirits who won't move to the light. They are trapped.
FARID: Why? And what do you mean by the light? How are they trapped?
ALMAWT: When people die, their souls must keep moving toward the light to move onto another plane in the realm. But some of them don't want to move and they want to stay here on Earth, so they get stuck.
FARID: Why don't some people want to move to the light?

ALMAWT: Because they want to stay close to their loved ones.
FARID: Like me?
ALMAWT: Yes.
FARID: I don't want to leave my wife.
ALMAWT: You'll always be together. But you can't stay here and be stuck while she lives out her life. It's not good for you or for her.
FARID: I'm not leaving my wife.
ALMAWT: Then she won't move on and she'll always be sad and lonely for the rest of her life.
RIEL: Neither one of you would be able to move on. Is that what you want?
FARID: No. (Beat) But I don't want her to think I'm leaving her.
ALMAWT: You are dead. You already left her.
FARID: I'm not dead! (Turns to speak to Riel.) Am I dead?
RIEL: Yes. We both are.
FARID: What about your parents? Don't you have any brothers or sisters? Are they here with you?
RIEL: No. I'm the only one who died. My family is still alive.
FARID: You're alone?
RIEL: No, my ancestors are here, too. I've met them.
FARID: Where are my ancestors, then? Why aren't they here with me?
ALMAWT: You will meet them when you are ready, Farid.
FARID: If I leave my wife and go toward the light, will I see her again?
ALMAWT: Yes. When you're in the soul form, you have more freedom to move and travel anywhere. Once you move toward the light, you will become more free. You will forge ahead to a new world, a new layer.
FARID: Is it like Jannat?
ALMAWT: In some cultures and religions, they call it Heaven. Islam teaches there are seven levels of Jannat, or seven astral realms. Some simply call it the universe. The Hereafter. In the end, it's all the same place.
FARID: What about Allah? Does God exist?
ALMAWT: It's not my place to tell you.
FARID: Why?
ALMAWT: It's about what you believe in.
FARID: (Speaks to Riel) Is this person for real?
RIEL: I was confused, too. But it's true.
ALMAWT: Your beliefs will shape your afterlife.
FARID: How does that work?
ALMAWT: If you are Muslim, you would see a Muslim-style Heaven. If you're Jewish or Christian, you may experience an afterlife as described in your beliefs. If you're Buddhist or Hindu, you would have a different observation of the afterlife. However, it's all the same, albeit perceived differently.
FARID: What about atheists? Where do they go?

ALMAWT: I can't really tell you that either. Where they go after their death depends on their perception. They may go to the cosmos… or to a familiar comforting place, their childhood home or favourite place on Earth.
FARID: If I want to rest on the beach, will I see a beach?
ALMAWT: Yes, if that's what you want.
FARID: With many stars spread across the blue sphere, like how my wife always wanted. She loves to look up at the sky at night and name all the constellations. (Beat) Hey. What about hell? Where do bad people go? Rapists, murderers, terrorists?
ALMAWT: There's hell. But I haven't seen it. I don't want to. It's the darkest, lowest level in the realm. Don't focus on that, Farid. You must reach the right state of mind and move toward the light, elevate yourself beyond dimensions.
FARID: How do I do that?
ALMAWT: (points to side of stage) Go to the light.

Farid stares at the light. The light is enthralling. Angelic, soothing music of many world cultures play. The chorus appears onstage and dances around the light and entices him to join them. Farid is captivated. He walks around the chorus and watches them dancing as he closes his eyes and feels the warm light bathing onto his skin. The music and dancing cease and the chorus fades away into the darkness.

FARID: That's beautiful.
RIEL: It's worth it. I promise.
FARID: You went there?
RIEL: Yes. And I'm going back in there.
ALMAWT: How do you feel?
FARID: I feel peace. Some kind of an unusual soothing peace, it's not like anything I have felt before. It's pure love.
ALMAWT: Once you accept that you are no longer in the physical form, you move toward the light and you will see many more stunning worlds. The possibilities are endless, with no limits.
FARID: I want to—

The light appears again, with music playing. Farid walks toward the light and then hesitates. The light and music fade.

FARID: What about my wife? My parents? Everyone I know and love?
ALMAWT: Well, they're not here so they can't go with you.
FARID: I don't want to leave them. They're the most important people to me. They need me. I need them.
ALMAWT: Everyone needs each other. But you're dead, Farid. You cannot go back to your physical form.
FARID: Why not? I still have things to do, my wife needs me, we have plans.

ALMAWT: I understand that. I do. But nothing will change the fact that you are dead. You have a choice: stay here and become stuck or go toward the light.

FARID: But how do I tell my wife that I'm fine? I want to tell her not to cry too much over me.

ALMAWT: You can try to send her a sign, a message.

FARID: How?

ALMAWT: By appearing in her dream and showing her that you are in a good place.

FARID: You mean I can do that?

ALMAWT: Yes, it's possible. But you need strength and patience. Try to remain calm and focus. Can you pick up or touch anything?

Farid tries touching a few objects, nothing takes hold.

FARID: No. Goddamnit.

ALMAWT: We have some work to do. Riel will teach you how to do it.

RIEL: It took me a while, but I did it. You will learn fast.

FARID: Thanks. I'm sorry but this is weird. I am really dead, huh?

RIEL: Yeah.

FARID: I can't believe it. I still feel like I'm alive.

RIEL: That feeling will go away soon. I expected my death because I was ill and my body was shutting down, but I was not prepared for how different the afterlife would be.

FARID: When did you die?

RIEL: Some weeks ago. But here, it feels timeless.

FARID: Did you have a funeral?

RIEL: Yes. I watched the whole thing. My parents put a lot of flowers around my casket. There was music, too. It made me feel good because they took the time to honor me.

FARID: Wait a minute. What about my funeral? Did I have one?

ALMAWT: Yes. Not long ago.

FARID: I missed it! Was my wife alright? Who was there? Did they pray for me?

ALMAWT: If you come with me, we can show you the whole funeral. Here in this world, anything is possible.

FARID: You can take me back to the past and show me? Like a replay?

ALMAWT: Yes. We will also train you to accept your new form.

FARID: You won't try to lure me and trap me somewhere, will you?

ALMAWT: No. You have full freedom to go anywhere you want. You can go to any level in the universe. I won't stop you.

RIEL: You're safe here, Farid. Don't worry. Nobody can hurt you here in this world. I can come and go anytime I want. I was nervous at first like you, but it's safe out here.

FARID: Why are you both helping me?

ALMAWT: It's my duty to help people once they depart the physical plane. It's what I do.
FARID: Alright. I will go. Nobody here can see me anyway. You might as well take me to wherever you are going. But can I come back and check on my wife?
ALMAWT: Yes, of course. Anytime. Come to the light.

The light shines again, with heavenly music playing. Farid takes a moment and puts his hands toward the light, feeling the warmth of the rays. He then walks toward the light, captivated. Almawt and Riel follow him behind. Blackout.

Act I, Scene 3

The lights come up. Sitara is lying in bed in her room. There is knocking on the door and a ring of the doorbell.

SITARA: Come in! Door is unlocked.

Sitara stirs and gets up as Professor Nikoli enters holding some bags. Nikoli looks concerned for Sitara.

SITARA: Come in, professor. I need someone to stay here with me. I might go crazy from loneliness.
NIKOLI: I bought you something to eat. I figure you must be hungry.
SITARA: I'm not hungry.
NIKOLI: Eventually you will be hungry. You have to eat anyway. I made Farid's favourite dish. Mole poblano. Chicken with pure chocolate sauce, brewed for hours. It's from an old family recipe in Mexico.

Nikoli sets the bags on a table.

SITARA: Farid will appreciate that. He will enjoy eating it.

She stops and remembers.

SITARA: Sorry. I mean, I will eat it. Thank you.
NIKOLI: How are you feeling today?
SITARA: I don't know. Numb.
NIKOLI: I hear you. The pain must be numbing, yeah.
SITARA: I want to die. I don't want to exist anymore.
NIKOLI: Is it like a large black hole inside you? As if you have lost your home and are trying to find your way back, but there's nowhere to go?

SITARA: That's exactly how I feel. As if my whole world has imploded and I've fallen through the hole. Nothing is important anymore. Everything has changed.

NIKOLI: I know, Sitara.

SITARA: All my past worries don't matter anymore. I lost the most important person in my life. Now my eyes are wide open. All the silly things I worried about? It's nothing. Nobody knows how bad the pain is inside me. I lost half of my soul, my body, like someone cut me in half and threw a part of me into the ocean and I can't find it and I can never get it back. Not ever.

NIKOLI: Oh my darling Sitara. I wish I could do something to take away your pain.

SITARA: Death is the end. It's final. Once people are gone, they are gone forever. They never come back. It's the end.

NIKOLI: Yeah.

SITARA: I look around and people have no idea how lucky they are. Everyone has their partners with them. Me, I got nobody now. I would do anything in my power to bring him back.

NIKOLI: I know, Sitara.

Sitara breaks down.

SITARA: I can't believe this is real.

Nikoli holds Sitara in comfort.

SITARA: I just want to die, Professor. I hope I die soon.

NIKOLI: Why?

SITARA: Because if I'm dead, I'll see Farid again. You know, like in the afterlife.

NIKOLI: Please don't think of ending your life, Sitara. Your soul is too precious to waste.

SITARA: I don't know.

NIKOLI: Live your life.

SITARA: Why?

NIKOLI: Think about what Farid would want. Farid was an incredible man. He loved life. He was more alive than anyone I knew. Do you think he would be happy if you kill yourself and you see him again in the afterlife?

SITARA: No. He would be upset if I hurt myself.

NIKOLI: So don't do it, ok, Sitara? Don't hurt yourself.

SITARA: Maybe. Death would be better than being alive and feeling the pain in my heart.

NIKOLI: Don't say that.

SITARA: I know, Professor. No, I don't know. I'm just saying my thoughts out loud.

NIKOLI: Can I tell you something?

SITARA: Yeah. Go ahead.
NIKOLI: I don't know all of your beliefs and I'm not trying to tell you what to believe in, but I want to tell you that death is not the end. Yeah, it's the end of a human life. The end of life as we know it. But life and death is a cycle. The cycle that keeps going.

Farid comes back onstage and he listens.

NIKOLI: You know I grew up in Mexico. We have a holiday called Day of the Dead. Every year, we celebrate it and remember our loved ones who have passed away. On that day, they come back. They sing, dance, eat, drink. Death is not a moment of sorrow, but a journey to a new world. It's a joyous celebration. I guess what I'm trying to say, Sitara, please don't see Farid as gone. Farid is not physically here anymore but he is still somewhere, and he's worried about you.
FARID: It's all true, Sitara. Listen to her.
SITARA: Yes. You are right. He is not gone.
NIKOLI: I'm saying you need to be strong for Farid because he can't talk to you or hold you. When you keep crying and mourning, it hurts him and puts him in pain looking at you like that because he cannot comfort you.
SITARA: I haven't thought of that…
NIKOLI: If you want Farid to rest in peace, you need strength within yourself because he can't give you that. You must give it to yourself.
SITARA: But Nikoli—
NIKOLI: Yeah, honey?
SITARA: I'm confused. What are you saying? I have to let him go? Like I should forget him?
NIKOLI: No. I'm saying you need to accept that he's not here and he's not coming back. Even he needs to accept that. How do you think he feels right now?
SITARA: He must be upset and confused.
NIKOLI: Yes. If you suddenly die today, you would find yourself in a new place without a body. I imagine that Farid is trying to understand why he is dead. Speak to him as if he's here. Tell him what happened. It might be good for you and him.
SITARA: But I still don't understand why it happened. Why him?
NIKOLI: I don't know, Sitara. That's the mystery of life… why do certain things happen? We will never understand.
FARID: Baby, please. Talk to me. I don't understand what happened to me. Sitara. You have to explain everything to me how exactly did I die?
SITARA: I'm scared. I can't even say the word. I don't want to think of him as – dead.

She stifles a sob.

FARID: I'm not dead! No! I am still alive!
SITARA: I don't want to let him go. I want him to stay here.
FARID: I'm not going anywhere. I'll be with you forever.
NIKOLI: He is here. With you, in your heart. He's looking over you.
SITARA: But I won't let him go! I don't want him to leave me here all alone.
NIKOLI: I know, Sitara. You won't lose him, he will be with you. But it won't be the same again.
SITARA: You are not listening. If he is here in spirit form, then I want him to stay here with me forever.
FARID: I can stay here if you want me, Sitara. I won't go anywhere.
NIKOLI: But that's not healthy. He would be trapped in the same place and you would not be able to move on with your life.
FARID: Don't listen to her!
NIKOLI: You basically want him to be a ghost and stay trapped here.
SITARA: I don't know. I'm confused.
NIKOLI: You are awash with many emotions. It's normal, Sitara. Take a breath and clear your mind.
SITARA: I want to find a way to see him. Even if one last time. I want to talk to him. Just one word, one moment. I need to know that he's safe on the other side.
FARID: I'm here, Sitara. I can see you and hear you. Talk to me.
NIKOLI: He's listening.
SITARA: How can you tell?
NIKOLI: I can sense his presence. It's very intense. He's here in the room with us. Do you feel it?
SITARA: Yes. I feel him. I think he's next to me but I wonder if I am daydreaming.
NIKOLI: No. It's real. He's here. Can I tell you something?
SITARA: Yeah. Go ahead.
NIKOLI: When I was ten years old, mi abuela, my grandmother died. One day my mama and I were in the living room. The whole house was quiet. We suddenly smelled a whiff of vanilla cigar. The kind mi abuela always smoked. Nobody else smoked. The smell was fresh, really strong. We looked around to see where the smoke came from, but nothing. My mama, she knew it was her mother. Saying that mi abuela was right here, smoking and being with us. It happened a few times but then it stopped. We knew that she had moved on.
SITARA: Wow.
FARID: Hey, baby. Meri maharani. Listen to me. I will find a way to reach you, Sitara. I'm going to make sure you can see me. Just be patient, okay?
NIKOLI: You have to believe that Farid is with you and he is listening. He's waiting for you to talk to him. You don't have to hold it in. Don't be afraid. Open up and tell him everything.
FARID: It's true. I'm here and I'm waiting for you to say something. I'm listening. Please talk! Say something to me.

SITARA: Assuredly I will. But Nikoli, I want to see his face and hold his hands and hear his voice.
NIKOLI: I know, Sitara.
SITARA: I am miserable. Empty. I want to die.
NIKOLI: I know.
SITARA: I'm scared because if I tell Farid that he's not here on Earth anymore, I'm afraid he would leave me and be gone forever. So then I can't feel his presence anymore.
FARID: No, it won't be like that! I am not gone. I'm not leaving you.
NIKOLI: I don't think the afterlife works like that. It's a completely extraordinary new world, you know? Perhaps spirits have more freedom and movement. Farid could come back anytime and be with you, but not in a physical way.
FARID: She's right.
SITARA: How do you know?
NIKOLI: I don't. But I believe it's very possible. For thousands of years, distant cultures from far corners of the world shared similar ideas about the afterlife. I like to think there may be some truth in that. Do you think there's nothing after death?
SITARA: No. I refuse to accept that he's gone forever. I feel him and I know he's out there.
NIKOLI: Yeah. Farid is not gone. He is alive up there.
SITARA: Yeah.
NIKOLI: I'm sorry if I sound kooky or something.
SITARA: No, professor, this helps me. Your assurance that there is much more to the universe than life on Earth. But I am confused. I am struggling with my emotions.
NIKOLI: Why?
SITARA: I don't know how to grieve. My mind is overwhelmed. How do I process all this? Should I be happy that Farid is alive in another world? All I want is to have him back alive.
NIKOLI: There is no right or wrong way to get through this. You're a poet, Sitara. Why don't you express your sorrow on paper? Maybe it will help you cope.
SITARA: Yeah. Maybe I will write something later. Do you mind leaving? I'm tired and I need to rest.
NIKOLI: Sure, no problem. Text me if you need anything.
SITARA: Thanks.
NIKOLI: Eat your food. Don't let it go cold. Don't starve yourself.
SITARA: I know.

Nikoli exits. The lights change. Sitara paces around the stage. Farid approaches her.

FARID: Sitara? Please tell me everything. I still don't know how it happened—

SITARA: Oh, Farid. My darling beloved husband. I miss you terribly bad. You have no idea. I wish I could see you.
FARID: I'm right here, Sitara. Next to you, in front of you.
SITARA: I feel like I can feel your soul here. Isn't that crazy?

Talks to herself.

SITARA: No, he is here. I can feel it. He's here with me.
FARID: I am.
SITARA: Farid?
FARID: Yeah.
SITARA: Farid, do you know what happened? I can't even say it or think about it—(She weeps softly.) You were in a car accident.
FARID: Yes.
SITARA: I wasn't there so I didn't see it happen. But the police told me that you drove really fast when a huge truck appeared. I don't know. The police said you steered too far right to avoid hitting the truck… your car fell over into the water.

Farid looks sad and crumples down.

SITARA: You drowned.
FARID: I don't remember.
SITARA: That makes me sick. I cannot imagine the moment of your death. (Weeping) I hope it was quick and painless, Farid.
FARID: To tell you the truth, Sitara, I don't remember any of it. I only remember driving, but that's it.
SITARA: I feel ill every time I think about how you died.
FARID: I'm not dead! (To himself) Yes, I am dead. She can't hear me. Goddamnit.
SITARA: I pray to Allah that you still exist somewhere in a different form. I can't stand the thought of you being gone forever. Not one trace of you. It really upsets me.
FARID: I know, baby girl. But don't think that.
SITARA: Your soul is precious, your love exquisite. It can't be gone. It must remain somewhere.
FARID: Yes. I still exist. My soul is intact.
SITARA: Farid. I don't—I don't have the strength to talk. Please, darling, stay with me. I need to keep your presence, cradle your hand and embrace your warmth. She moves toward her bed and lays down. Farid moves toward her.
SITARA: Let me hold your love, Farid.
FARID: I'm here. I won't leave you. He tries to touch her but can't.

He hovers over her. The lights fade out. Blackout.

Act II, Scene 1

Flashback scene. Sitara and Farid are sitting on the ground, looking up at the stars. The lighting is blue and there is a digital projection of stars on the ceiling and all over the walls.

FARID: Have you ever wondered what's out there in the universe?
SITARA: Sometimes. I think everyone does.
FARID: Do you think aliens exist?
SITARA: I don't know.
FARID: I think there is more to the universe. We cannot be the only livable planet out of a billion galaxies. The thought is staggering.
SITARA: It would be unusual if we were the only ones. That feels lonely.
FARID: Yeah, but you know what? Experiments in physics have shown unseen forces happening around us. Forces that we can't explain or understand. Everything is a mystery.
SITARA: I love it. Would you travel the stars with me?
FARID: Yeah. Of course, meri maharani. You know the stars are flaming hot and bright. It's not safe to go near a star, it would burn you up.
SITARA: Mmm. Then I want to go to Neptune. And you're coming with me!
FARID: Neptune? Why?
SITARA: It is filled with diamonds.
FARID: Yeah but you would die on there. It's freezing cold and too far away from the Sun. It's too dark. I don't think there's oxygen on Neptune so we would not breathe.
SITARA: So? Diamonds are pretty. At least I would die surrounded by beauty.
FARID: True. I think if I die suddenly, I would want to die happy and peaceful.
SITARA: Don't say that. You're not gonna die. We will have a good long life together, Farid.
FARID: I know, my queen. We will have children and grow old together, and then they will grow up and have babies of their own, too.
SITARA: Will you still love me even if I am wrinkled and hunched?
FARID: Forever. Looks are not permanent, but your heart is. I don't care how you look, Sitara. It's your soul I love and cherish. You always support me and understand me when I need you. I couldn't ask for anyone better.
SITARA: You completely get me, too, Farid. I am blessed and grateful to have you in my life. Don't ever leave me.
FARID: No, baby. Never. I will never leave you.

They hold each other. Light fades out. Blackout.

Act II, Scene 2

Flashback scene. Farid and Sitara first meet each other on a blind date. They both enter onstage and look around shyly. Farid sees Sitara and recognizes her.

FARID: Hello? Sitara? It's me, we met on the app.
SITARA: Farid?
FARID: Yeah. Hey there.
SITARA: You look different from your photos.
FARID: Well, I hope that's a compliment. Are you impressed?
SITARA: Actually, you look much better. You have a nice smile.
FARID: Thanks. When I saw your pictures online, you reminded me of a Greek statue I saw in Athens.
SITARA: (Sighs) That's such a cliched line.
FARID: No, wait, I mean it. I went to the Acropolis in Greece over the summer. I took a lot of photos. There's a picture I can show you on my phone....

He takes out his phone and swipes for pictures.

SITARA: Yeah? Let me see.

Farid shows her something on his phone; she looks impressed.

SITARA: Wow! We actually look similar.
FARID: You two have the same smile, when your lips curl like that. And your nose. It's uncanny.
SITARA: (Laughs) This is surreal. How can an ancient Greek statue from thousands of years ago look similar to an Indian woman in the 21st century?
FARID: Right! Life is strange like that. I hope I'm not scaring you off?
SITARA: No, this is cool. I love her hair too. Maybe I should do my hair like that.
FARID: Yes, and you can make over yourself like a caryatid.
SITARA: Caryatid? If I remember my history right, isn't that a sculpted female figure in an ancient temple?
FARID: Yes! How did you know that term?
SITARA: I took an archeology class in college. I love ancient history, it's one of my favourite topics.
FARID: Mine too.
SITARA: That's a coincidence. You stalked me online, huh?
FARID: Not at all. I went to Athens as part of a study group. But hey, you messaged me first, so who's the stalker?
SITARA: Haha. Stop. You're making me blush.
FARID: You're a poet, right? You have published poems?
SITARA: Yes. Some magazines, two books and some websites. You can google me.

FARID: I already did. And there was one particular poem that you wrote, that I really like.
SITARA: Which one?
FARID: It was actually a poem set in ancient Greece. So, I figured I'd try a pickup line on you.
SITARA: Well done, Farid. You did it. I took the bait. But somehow, I am glad you like my poetry.
FARID: I'd love to talk more about your poetry. You ready to go and get some dinner? Or have you changed your mind?
SITARA: Let's get food. I'm famished. We can eat and talk some more. You seem cool. I like you.
FARID: Me too. We can discuss our interests in ancient history.

They exit. Lights fade to black.

Act II, Scene 3

Light comes up. In the afterlife, where Farid, Riel and Almawt are standing together.

ALMAWT: That was the first time you met your wife.
FARID: Yes.
RIEL: Your wife seems really kind.
FARID: One of the kindest women you would ever meet. I miss her.
RIEL: Are you alright?
FARID: No, I'm not alright. But what can I do? I have to pretend I am fine.
RIEL: I know that feeling.
FARID: Anyway. What day is it?
ALMAWT: I don't understand.
FARID: I want to know, how long has it been since I have died?
ALMAWT: There's no concept of time here. I can't tell you.
RIEL: Almawt doesn't know. Souls and ethereal beings in the afterlife don't know what time is. The sun doesn't set or rise here. There's no nightfall. Time doesn't exist.
FARID: I need to know how long it's been.
RIEL: Yeah me too. I wonder how my mom is doing. I want to follow up and check on her progress. How is Sitara? Is she much better now?
FARID: I don't know. I'm going to visit her now.

Farid walks to the other side of the stage and the lights come up. Sitara and Nikoli are seated at the table, eating.

NIKOLI: This curry is delicious. Very spicy. Where did you learn to make this?

SITARA: My Amma taught me. Most summers when I went to India to visit my family, Amma showed me how to make kadai curry and I cooked it many times; it's totally ingrained in my brain. It's my favourite.

NIKOLI: Thanks for inviting me over. The last time you made dinner for me… has been too long. When Farid was still here. Before he… (She hesitates)

SITARA: It's okay. You can say it. He's dead. I've accepted it. It has been three months since he died.

FARID: (To himself) Three months? What? Impossible. It was just yesterday… (To Riel) To be honest, I don't remember what a month feels like. When was the last time you saw your family?

RIEL: I can't recall. But I am worried about my mom. She is shutting out everyone. I wish I could talk to her and tell her I'm fine.

FARID: Maybe you should send her a sign.

RIEL: I have tried but she did not pay attention the last time I saw her. I kept sending her little signs, like a white feather on the ground. She didn't notice any of it.

FARID: Maybe you should visit her in her dream?

RIEL: I plan to try. Have you done it yet?

FARID: I'm training myself. But it takes too much energy and I need to practice. I've been touching objects too.

RIEL: Yeah, I see that you are making good progress. By the way, the food smells good. Your wife must be a great cook.

FARID: The best cook. She knows all the Indian and Pakistani dishes. Whatever you wanted to eat, she could easily whip it up without a recipe.

Other side of the stage.

SITARA: I wanted to tell you that I wrote a new poem about Farid. It has been a healing process.

NIKOLI: That's wonderful to hear. I am glad you're writing again. Have you shared the poem with anyone? Can I read it?

SITARA: No. Not yet. Sometimes I look at the poem and I think it's rubbish. I don't know how to write anymore. Some days, I have so much to write, and other times, I feel dull and have nothing to say.

NIKOLI: Don't push yourself too hard. Write when it feels right.

SITARA: Yeah. When I'm ready, I want to read the poem and perform for Farid. While he watches me, looking down from Jannat or wherever he is.

FARID: (Calling out) I would love that.

SITARA: I feel weird doing that, though. Performing a poem for a ghost.

She laughs to herself.

FARID: I'm not a ghost, baby. I'm more alive over here!

NIKOLI: It doesn't matter. Do what feels right. Besides he's not really a ghost, is he? He's a spirit, free in the other world.

FARID: That's right! The professor knows it.
SITARA: Yes, yes, yes. He is free as a bird. You know, I wish there could be an open discussion on death in our society. Way too many people are afraid of it. I loathe the way people look at me with pity, as if I am the only one who has suffered a loss. It's such an alienating experience.
NIKOLI: People are scared of death, because they don't know what happens after they die.

Other side of the stage.

RIEL: (Speaking to Farid) If you want to send a message to your wife, you cannot send a big sign. It's too complex and not always possible. It's easier to send a small sign. A reminder, a memento that instantly makes her think of you.
FARID: Such as?
RIEL: My mom loves red foxes; they are her favourite animals. I would send a red fox into her garden and when she looks at the fox, I play my favourite song on her phone. That would get her attention and hopefully she would know it's a sign from me.
FARID: Do you have enough energy to perform those actions?
RIEL: I am honing my skills, but I need some practice.
FARID: What about dreams? How can I enter my wife's mind while she's sleeping?

Almawt enters.

ALMAWT: When you want to enter a person's dream, they must be in the right state of mind.
FARID: What would be the right state of mind?
ALMAWT: Peaceful. Tranquil. It requires some effort to maintain positive energy.
FARID: So, to enter her dreams, my wife has to be calm? Should I wait for her to call out for me?
ALMAWT: They can call out for you or you could appear in her dream as a pleasant surprise. But their mind needs to be calm. You cannot go in if their thoughts are stormy and full of torment.
FARID: But that's how it is for my wife. I sense that sometimes her mind bursts full of pain. How can I tell her to be serene and soothe her thoughts?
ALMAWT: You could try to shine some of your light into her soul. Send your love to her. Calm her.
FARID: How do I do that?
ALMAWT: Just look over her. Stand near her. Guide her.
FARID: That sounds simple but I'm not sure how to do that.
ALMAWT: Just go and be with her. Don't overthink it.

RIEL: I will try that with my mom, too. I need to find a red fox for my mom's garden but where do I find one?
ALMAWT: Come over here.

They walk toward the front of the stage and look out ahead.

ALMAWT: You don't need to find a red fox. Remember you are in a different world. Here, there are no physical limits. Just imagine a red fox and it will appear in her yard.
FARID: Is it really that simple?
ALMAWT: Yes. But it requires immense concentration.
RIEL: There are no limits here. Let me try this. Riel takes a moment to focus.

During this scene, beautiful colors of lighting change while soft ethereal music plays.

FARID: Hey! I see the fox, but it's floating around in the air.
ALMAWT: It's a figment of his imagination. He's daydreaming. We're looking into his mind.
FARID: It's fiery red. It almost looks like a phoenix. I wish my wife could see this; it's enthralling.
RIEL: (Opens his eyes) There's my mom. She's working in the garden now.
FARID: You have your mom's eyes. And her smile! You both are nearly identical.
RIEL: I know. People always told me that.
ALMAWT: Do you see that bird on the telephone pole?
RIEL: Yeah.
ALMAWT: Now imagine that bird as the red fox. It will fly down to the ground and when your mother turns to look at it, it will appear as a red fox to her.
RIEL: (Focused) Hey, Mom. Turn around. Look at me, Mom. I'm here. Look for my signs. I'm calling out to you…
FARID: She's turning! She's looking at it now! She's smiling. She knows it's you.
ALMAWT: Keep your thoughts on that fox-bird.
RIEL: She's taking out her phone to take a photo. I will play my favourite song. I pull up the playlist. I scroll down to find my favourite song. I press play. Now!

We hear a faint clip of his favorite song playing.

FARID: It's working! I hear it.
ALMAWT: That's a great song. A steady bop.
FARID: She looks shocked. She's stepping out of the physical world for a moment and she can't believe this is materializing.
RIEL: She knows it's me. She's looking around, and up at the sky…looking up at me. Mom, I see you. You're not alone. (Beat) I love you, Mom.
FARID: She's crying but she looks happy.

RIEL: I feel calmness in my aura now, knowing that she knows I'm still around.
FARID: I can feel it too. Her mind is at peace.
ALMAWT: You can come back and visit your mom anytime and when you get near, she will behold your love and it shall bring joy to her.
RIEL: I know. I want her to be better. She's always sad and it hurts me. She knew that I would not live long so she was ready for me to die. But once death happens, people are not as prepared as they think.
FARID: She seems like she's finally starting to understand that you are fine.
RIEL: She does.
ALMAWT: Today, she starts her progress of moving on and letting you go, Riel. So that you may liberate your soul in the Hereafter.
RIEL: Yeah. It's not good for me to stay around. I'm starting to be trapped, like I can't move.
FARID: Me too. It's imperative for both me and my wife to find acceptance so I can move to the light and she lives her life.
ALMAWT: Yes. You're understanding now. Let's continue. We will help you prepare so that you may contact your wife and say goodbye to her.

They exit. Blackout.

Act II, Scene 4

The lights come up. Nikoli and Sitara are in the living room. Farid lingers in the corner, watching them.

SITARA: Hey come in. What made you decide to come by and see me?
NIKOLI: I have something for you. I was cleaning out my office and found a book that you would enjoy.
SITARA: Aww, professor, thank you, but you don't have to do that.
NIKOLI: Oh come on, where else would I put my books? My bookshelves are cramped as they are. And anyway, I'm downsizing.
SITARA: I saw the announcement online. Is it true that you are retiring from the university? You won't teach classes anymore?
NIKOLI: It's all true, Sitara. I am tired. I'm getting old, but not that old. I want to enjoy my life while I still have energy. I want to take a permanent vacation and spend my money and have a good time.
SITARA: You deserve it, professor. What are you going to do now?
NIKOLI: I want to travel and see the world. I will fly to Morocco and Sudan next month. I haven't seen Nubian pyramids yet. Speaking of pyramids, this is the book I want to give you. It's about prehistoric civilizations before the start of ancient empires. A history of prehistory.
SITARA: Wow! I love this stuff. Thank you!
NIKOLI: Farid actually used this book for one of his papers in my class. He left some notes in the book.

SITARA: Oh! I can see his handwriting here. He wrote notes everywhere! This makes me feel closer to him. Thank you, professor.

NIKOLI: Of course.

SITARA: (Flipping through the book) Here's one. When Cleopatra was born in Egypt, the pyramids were already thousands of years old. He wrote a question here…: "Did Cleopatra marvel at the sight of pyramids, daydreaming thousands of years past, or did she merely see them as markers of history?"

NIKOLI: A very good question to ponder….

SITARA: Do you think there are pyramids in the other world? Can Farid fly around and visit Egypt? Do you think he could time travel and see what Cleopatra looked like?

NIKOLI: Those are some more good questions to consider. I like to think that the afterlife must be very magical.

SITARA: I believe it. I want to believe that Farid is happy and having fun in the other world.

NIKOLI: When you think of him, what do you think about?

SITARA: His smile, warmth, love. I think of the marvelous memories we had together. I laugh at the old jokes he used to tell me, and it makes me grateful.

NIKOLI: That's how Farid wants you to remember him. The good times, the loving memories you built together.

SITARA: Yes. Now it's time for you to make new memories for yourself, to travel and see exotic places around the world. You have to text me photos. I want to see all of these wondrous ancient places you visit. Hey. Thank you for being such a good friend to me.

NIKOLI: Well, of course. You are the niece I never had. How is that poem you're writing? Is it done?

SITARA: It's still a work in progress.

NIKOLI: You should come to my retirement party. Maybe you can read your poem for me there.

SITARA: Let me think about it.

NIKOLI: (Looks at watch) Sure. Hey, look. I hate to cut this short, but I have to go. You take care of yourself, Sitara, okay?

SITARA: I will. I bid you a splendid night, Nikoli.

NIKOLI: Adieu. See you at my party.

Nikoli leaves. Farid remains and watches Sitara, but she doesn't notice him. Sitara gets up and looks around. She sighs.

SITARA: Sometimes I don't know what to do with myself. I feel good when people come visit me but when I am alone? I feel sad and empty. I hate this. (Beat) Oh Farid. This book has you all over it. There are your notes everywhere. I love it. (Sighs) My life is terribly dull without you, Farid. I miss your jokes and your hugs. (Beat) Hey, Farid. I like talking to you. I suppose you don't hear me but it makes me feel better when I talk to you.

FARID: I do hear you, Sitara. Every word, meri maharani. Keep talking, my queen.
SITARA: I hope you hear this. I wonder if you're standing here, looking at me? Or are you far away? Are you flying around like an angel? What does the afterlife look like? (Beat) I have to let you go, Farid. This is not healthy. I want you to be free. I don't want you to stay here and suffer for me because of my selfish desires.
FARID: Hey, you are not selfish. You are just hurting, baby.
SITARA: Sometimes I don't want to be awake because I am reminded of the pain of losing you. I prefer to sleep as long as possible. Anyway, I'm sleepy.... Farid, did you know that I started praying? You know I didn't pray much before but now I do most nights. It brings me comfort.

Sitara prepares to go to sleep. She prays to Allah.

SITARA: Dear Allah, Goddess, angels, ancestors. Whoever is out there? I send you my love. I ask you to please look after my husband's soul. Can you make sure he rests in peace and that he is blessed and free in the other world?

She gets up and gets into her bed.

SITARA: Good night, Farid.

She falls asleep. The lighting changes and music changes. Hours pass by. The dancers emerge onstage and dance around her while soothing, angelic music plays. Farid enters. The music changes. The dancers change their pace and move around him as he approaches Sitara. Farid looks over at Sitara and slowly touches her face. A moment of nothingness. She feels it and awakes. She touches her face, looking confused and turns her head up and finally sees him. They stare at each other in a moment of awe, as if they cannot believe that they can finally see each other again after a long time.

SITARA: Farid?
FARID: Sitara.
SITARA: Farid—Farid! It's you.
FARID: You are beautiful. Absolutely ravishing.
SITARA: I have been waiting long for you.
FARID: Your skin is soft.
SITARA: Is it really you?
FARID: Yes.
SITARA: I love that twinkle in your eyes. Oh Farid, come to bed with me.
FARID: Okay baby.

He sits on the bed next to her and stares at her adoringly. They embrace emotionally.

SITARA: Where have you been? Are you ok?
FARID: I'm fine. I promise. I want to let you know that I love you so much and I am proud of you for being strong.
SITARA: What? I don't understand.
FARID: You have been resilient in how you handled this.
SITARA: Handled what, Farid? Anyway. How was work? I made you dinner, but you took too long to come back, and the food is cold now.
FARID: I am dead, Sitara. Don't you remember?
SITARA: But I made you breakfast, and I read an old poem from Assam to you. The air is sweet and fills with the song of birds. You were driving to another city for work. You said you were so hungry because you were fasting, and you couldn't wait to eat dinner with me.
FARID: Yes. That was ages ago, Sitara. You already buried me in the ground. Don't you remember?
SITARA: Remember what? What day is today?
FARID: Time has passed. I have moved on and I want you to move on.
SITARA: Farid, no. Please don't be like that! Why are you acting bizarre?
FARID: I want you to keep working on that poem. It will be magnificent. It makes me jubilant when I see you live your life.
SITARA: This isn't real, right? Am I dreaming?
FARID: Yes. You are dreaming, but I am real. I came to you tonight so I can see you and talk to you.

Sitara looks devastated and takes a moment to compose herself.

SITARA: Oh Farid. (Beat) Are you really dead?
FARID: Yes, baby. I'm sorry.
SITARA: I forgot that you're dead. When I saw you, it felt like I just saw you at breakfast yesterday. Deep down I had hoped that you were alive again.
FARID: I know. I feel the same way sometimes.
SITARA: Thank you for coming to see me. (Beat) I've waited and prayed for this moment.
FARID: I have tried many times to speak with you, Sitara, but it has not been easy to reach you.
SITARA: I feel like I should be crying right now because you are dead. I'm ecstatic. You are here! My darling Farid. I feel a huge rush of blood coming up inside me. My heart is pounding fast. I cannot believe you are here with me. I am gratified. I had to stay strong for you because I did not want you to agonize over me while you were in transit to the other world. You look well by the way.
FARID: It's different. Out here, I am liberated. Like I've been given back my wings. Like a bird, I can fly anywhere.
SITARA: Are you suffering?

FARID: No. Don't worry about me. Let me assure you, meri maharani. I am fine. Where I am, it's nothing but pure love and light. But Sitara, it pains me to see you like this. You have to take care of yourself. I hate to see you languishing in grief.
SITARA: My Farid. I'm sorry I can't help it. I am so alone. Nobody knows how I feel. I am empty and lost without you.
FARID: You are not alone. I am here with you. You are loved. I love you fiercely with all my heart. Remember that my love runs through your veins.
SITARA: Yes. My love swirls around and down into your soul, too.
FARID: Yes baby. I know. I feel it. Your love carries me wherever I go.
SITARA: Where are you? I mean, where do you go?
FARID: I'm here, right here with you.
SITARA: But you're gone. Where do you live now? Is Heaven real?
FARID: I come and go. I am in another world, but I don't know how to describe it to you. It's like Heaven. It's incredible. You will be there someday when it's your time, Sitara.
SITARA: I hope so.
FARID: I know it so, Sitara. Whenever you need me, I'll be here for you. You can always talk to me. I'll be there whenever you call out for me.
SITARA: Farid. I can't believe you're gone. I mean. I know you're there but it's not the same anymore.
FARID: I know, baby. I'm sorry I can't do anything else.
SITARA: I don't know what to do.
FARID: You just have to stay strong and keep going. You can't stay like this forever.
SITARA: Yeah.
FARID: Please for my sake. You have to live your life.
SITARA: I promise you. Do not worry about me. (Beat) I have to let go of you.
FARID: Thank you. Truly. (Beat) Do you promise me that you will continue to thrive?
SITARA: I promise.
FARID: Keep writing. Do not be afraid of your feelings. Open up your heart, bare your soul.
SITARA: I have many poems to conceive, words to write. And I will share them with people.
FARID: Yes. You will live a long life on Earth. You will do important work. You will put positive energy out into the world.

Someone calls out for Farid; he turns and gets up from the bed.

FARID: I need to go.
SITARA: Who was that?
FARID: My guide.
SITARA: You have a guide? Is it like an angel?
FARID: Something like that, yes.

SITARA: When can I see you again?
FARID: I don't know. I will come to you and see you in your dreams. I will take you to Neptune, like we talked about before.
SITARA: Really? Can you do that?
FARID: Someday. It will be a surprise. We will dance in the cosmos amongst the stars, fly to Neptune and witness the glittering blue diamonds that you have dreamed of.
SITARA: That would be sensational.
FARID: You can wear that purple dress, my favourite one that brings out your eyes.
SITARA: We can have a picnic on Neptune. I'll make your favourite meal. Bangers and mash.
FARID: Yes. With a little bit of chutney and garam masala.
SITARA: I've never understood why you liked mixing that with the sausages.

They laugh.

FARID: I love you, Sitara. I love you so much.
SITARA: I love you too, Farid. With all my heart, mind, body and soul.
FARID: I'll see you soon, meri maharani. My queen.

Farid walks away into the light. Sitara is alone onstage. She looks out longingly. The lights fade out on her spot. Farid is met by Almawt and Riel.

RIEL: Seeing you gave her closure.
FARID: Yes.
RIEL: So now she knows you're not really gone, but just living on another plane.
FARID: Something like that yeah. I feel better, too. I needed that. (Beat) Can I ask you something? How do you feel about having your life taken so early? Were you scared?
RIEL: Everyone around me kept praying for a miracle for me to live long. But I knew I would die. I prepared for it. I was scared but strangely calm, because I knew there was something next for me.
FARID: But don't you feel cheated? Like everyone else got to live and graduate from high school and marry and have children, but not you?
RIEL: I did at first. I was angry at the universe for giving me this untimely end. Why me? Why did I have leukemia? There was no choice but to accept it. I could be angry, or I could accept it and let go.
FARID: What are you going to do now? Will you try to go and rest in peace with the other souls?
RIEL: No. No time for rest. I don't want to rest in peace like everyone when they die. I want a new role on this plane, in this afterlife. I'm going to help people.
FARID: Help people? What will you do?
RIEL: I will assist people in their transit to the afterlife. I want to help troubled souls find peace and move to the light. There are some who are trapped and

linger in the physical world because they're scared. Maybe that's why I died so young so I can help others.

FARID: I can see it. You have a purpose to help others. You tremendously helped me.

RIEL: You are the first person I have worked with. So, I learned from working with you.

FARID: Well then, do I get an A plus for teamwork?

RIEL: 100 percent.

Act II, Scene 5

Retirement party for Nikoli has just started. Nikoli chats with the Imam. Sitara enters with a gift. She hands it to Nikoli who looks surprised.

NIKOLI: Sitara! You came! Ten minutes early, but it's fine. Thanks for the gift.

IMAM: It's great to see you again. I haven't seen you since the funeral. You look like you're doing much better. How are you?

SITARA: Nice to see you again, too, Imam. Well, I have good and bad days but today has been splendid. I feel alive and happy.

IMAM: I can tell. You're glowing positively today.

SITARA: Thanks. Actually, I came early because I wanted to tell you both something. (Beat) I saw him.

IMAM: You mean your husband? Farid? You saw him?

SITARA: Yes. I saw him. With my own two eyes.

NIKOLI: Where? When? Tell us everything, if that's alright with you.

SITARA: Last night. In my dream. It was incredible.

IMAM: Masha'allah, Sitara. No wonder you are beaming.

NIKOLI: Tell us more.

SITARA: He appeared as himself, but he was made of light. Like an angel. We said goodbye. At that moment, I knew it was time for me to let go of him. For both of us. So, I can move on and live my life and Farid can fulfill his purpose in the other world.

IMAM: What do you think his purpose is?

SITARA: I don't know. But I do know there's another world, life after death. Death isn't the end. I know he's free.

IMAM: Nikoli was just telling me that you have been writing a poem.

SITARA: Yeah. Seeing my husband again inspired me and I finished the poem. I want to share it with you both, if you want to hear it.

IMAM: Absolutely.

NIKOLI: Let's hear it!

Light comes up on the other side of the stage, where Farid and Riel are talking to each other.

RIEL: Are you ready to go?
FARID: Yes. I'm ready. I'm going all in into the light. She's let go of me. What about you?
RIEL: I can finally move on, too. My mom doesn't need me anymore. She's fine now.
FARID: I'm going to look at Sitara one more time. I have a feeling she's going to share her poem with her friends. I want to hear it.
RIEL: Go ahead. I'll wait for you.

Farid walks over to where Sitara and the others are. He stands by as she begins to read her poem. As she recites her poem, lighting changes colors and shades to reflect an ethereal mood onstage. Dancers appear and move around her slowly as she performs her poem.

SITARA: In the ever-expanding universe, on this green earth,
there breathe a billion souls.
Yet I yearn for ye, and only for ye,
In the mornings, I awaken and
realize you're gone.
I touch your side of the bed, it's bare.
At nightfall, I slumber and toss around,
Feeling your absence.
Hollow I feel, part of my soul amiss,
I gaze unto the darkness, a light appears,
My eyes witness a form, draped in gold,
rays radiating from the skin.
Is that an angel?
No. It's you!
Oh my heart. Your eyes blow mine open!
You lift the sorrow off my face,
bathe me with your amour.
You are alive, moreso than your physical form on this green
earth,
You arouse me, push me into this world,
It's time for me to live
while you prosper unto the other world.
I love you… I love you… I love you so much!
NIKOLI: It's beautiful. I think Farid would really like it. I like how you described him as an angel. Because in a way, he was an angel to you while he was alive. He took great care of you.
SITARA: Yes. Now I have to take care of myself.
IMAM: You're taking care of him, too. You're letting his soul know that everything will be fine.
SITARA: Definitely. Today for the first time, I feel okay now.

Calls out to Farid.

SITARA: Farid… I accept that you are gone. You may go anywhere, wherever you need to be.
FARID: You know I will always be there when you need me, Sitara.
SITARA: Don't worry, Farid, I know you're not really gone. I can still feel your soul flourishing and your love burning inside of me. Go be free. I will live my life on Earth and when it's time, we will be together again.
FARID: That's right, meri maharani. My queen.

Farid walks back to the group. The Imam moves to the other side of the stage and becomes Almawt.

IMAM/ALMAWT: Are you ready to go?

FARID: I am ready.

They walk to the light. Almawt and Riel enter into the light and disappear. Farid looks toward the light. He stops and turns to look back at Sitara one more time. Sitara knows. She turns to look at Farid. They make eye contact.

SITARA/FARID: (Together) I love you.

Farid walks toward the light. The light brightens. Music gets louder as he gets closer to the bright light. He reaches his arms out and feels the warmth of the light. Music plays frantically. The light absorbs him, and he is gone. The light then slowly fades out. Sitara has witnessed the whole thing. She smiles. She turns away and walks the other way and exits offstage.
 Blackout.
 The End.

About the Author

Sabina England is a fully Deaf playwright, performance artist, and filmmaker. She graduated with a Bachelor of Arts in Theatre from University of Missouri and a certificate in Filmmaking from London Film Academy.
 In an essay on Deaf Playwriting, England wrote:

> Being a deaf playwright is funny business. I'm profoundly deaf and I can't hear people talking, but I still write dialogue as how I imagine it in my head. One piece of advice that is always given to playwrights is to observe one's surroundings and eavesdrop into others' conversations so one can learn to write realistic dialogue like how people talk. Well, I can't eavesdrop and spy on others' conversations! I just make up something while I watch two strangers

in public and then I run with it... I have to admit that I've developed a habit of writing plays with verbal dialogue for hearing actors. Growing up, I had been so used to watching hearing-abled actors talking and conversing with their voices that it had not occurred to me to write a deaf play.[1]

Her plays have been produced in London, UK, at such locations as Soho Theatre, Tristan Bates Theatre, Theatre Royal Stratford East, and East 15 Acting School: *How the Rapist was Born; A Study of the Human Condition; I Love to Eat, Drink and be Sad; Chess for Asian Punks, Greek Losers, and Dorks;* and *Dear Me, Where's My Angel?*

England is also an award-winning filmmaker, having recently won a Jury Award for her sign language poetry film, *Deaf Brown Gurl*, which was honored by Lady Filmmakers Film Festival in Los Angeles, California. She was also selected to perform her solo sign-language dance poetry show, *Allah Earth: The Cycle of Life* at the New York International Fringe Festival in Greenwich Village, New York City.

She currently lives and works in St. Louis, Missouri. You may visit her website for more information at SabinaEngland.com.

Note

1 England, Sabina. "Deaf Playwriting – A New Art Form." 07 April 2016. *Howlround Theatre Commons*. Retrieved from: https://howlround.com/deaf-playwriting. Accessed 19 August 2021.

AFTERWORD

As I write this in December of 2020, there is an ongoing protest through social media and the mainstream press by 70-some Deaf actors railing against Hollywood for casting yet another hearing actor in a deaf role – namely, Nick Andros, in CBS All Access TV series' *The Stand,* adapted from Stephen King's novel. Not one professional Deaf actor was called in to audition for the role.[1] In 1994, a TV miniseries of *The Stand* was produced with Rob Lowe cast in this very same role. Twenty-six years later this miscasting problem continues. There is an ongoing parallel of ignoring or overlooking Deaf and hard-of-hearing writers for the performing arts. The Deaf talent is there and available to be employed, but the powers-that-be have been persistent, knowingly or unknowingly, in their neglect. As evidenced in this anthology, it is clear that there is an emerging body of original plays by Deaf and hard-of-hearing playwrights.

When examining the long timeline of theater created by hearing people, beginning in 535 BC – when Thespis enthralled audiences by hopping on the back of a wooden cart reciting poetry as if he was the characters whose lines he was reading – Deaf and hard-of-hearing theater-makers have climbed on board late in the game. The Hearing players have come from a long heritage of language-centered performances, carrying with them a tremendous depth and breadth of community-specific theatrical experiences. From observing the playing field – i.e., the playhouses of the world – the Deaf players have mostly been relegated to the back as second stringers, or understudies, struggling to get the chance to come forward to play and get their work seen and heard. Their time should come relatively soon now that the works of other minorities (i.e., African, Hispanic, Asian, LGBTQ) have emerged.

It may help to briefly review the origin of Deaf theater to appreciate the current state of the art of Deaf and hard-of-hearing playwrights. According to Rochester Institute of Technology professor emeritus, Dr. Robert Panara, Deaf

theater originated with community theater. The first evidence of this was in 1865 when the Clerc Literary Society was founded in Philadelphia. At that time, literary societies were very popular, not just in the deaf world but in the broader society as well. People would give lectures discussing books and plays, even at times performing short works. Within the deaf world, those skits and stories were mostly original works – stories "of their own." Oftentimes, deaf club members suspend club business to call folks to the floor to perform a skit, a common occurrence also in Deaf schools and literary societies of the Deaf.[2]

In 1959, one such club was the Dramatics Guild of the District of Columbia Club of the Deaf founded in a clubhouse on Pennsylvania Avenue in DC where their performances were given. The guild recognized the need and desire for an independent amateur theater of the deaf. Eventually, this community theater group evolved into the Frederick H. Hughes Memorial Theatre, named in honor of Dr. Frederick Hughes, a professor at Gallaudet College. Their primary goal was to provide entertainment, such as drama, pantomime, revues, etc., for deaf and hearing people in the metropolitan Washington area. Also, the Hughes Memorial Theatre's aim was to encourage the cultural development of deaf persons in acting, directing, staging, scriptwriting, theater and costume design, make-up, and related arts through experimentation research, and education. All subsequent productions were staged in Gallaudet College's Chapel Hall.[3]

Professor Hughes, an exceptional signing actor, who shared his gift of "sign acting" and theatrical excellence in the classroom, established courses in drama at Gallaudet, from which the program grew to a four-year Bachelor of Arts program.[4] He directed many plays for the college, one of which was *Arsenic and Old Lace*. This turned out to be perhaps one of the most revolutionary events in Deaf theater history.

In 1942, while the Fulton Theatre (now Helen Hayes Theatre) was in the middle of its premier run of *Arsenic and Old Lace* starring Boris Karloff on Broadway, the play's producers received a letter from Gallaudet College junior Eric Malzkuhn. He was the president of the college's drama club expressing interest in the play and requesting permission for the club to stage their own production on campus. Malzkuhn and the club got more than they bargained for; not only did they receive permission but also an invitation for the group to come to Broadway to perform the show for one night. After previewing the play at Gallaudet, the Deaf student actors rehearsed in New York for three days with several members of the Broadway cast, including Boris Karloff, to help get acclimated to the Broadway stage and set. Karloff even offered his own costume and his lucky shoes to Malzkuhn, who performed Karloff's role. On Sunday, May 10, 1942, an off night for the still-running Broadway production, Gallaudet students performed the play entirely in American Sign Language before a sold-out deaf and hearing audience, with two interpreters speaking the dialogue for hearing patrons, of which the audience was almost entirely comprised. This performance, though brief, was a revelation. It marked the first time a sign language play was presented by deaf actors in a major public theater and received such prominence.[5] John

Ferris wrote the following headline for his column in the Washington Sunday Star that read: "Gallaudet Players Invade New York to Present Their Version of 'Arsenic and Old Lace,' Reminding That the Theater is Alive."[6]

Beginning around 1957, 15 years after the ground-breaking Gallaudet-Broadway event, three deaf grass-roots theater groups were forming in New York City – the Metropolitan Theatre Guild of the Deaf, the New York Hebrew Association of the Deaf, and the New York Theatre Guild of the Deaf. According to Stephen Baldwin in *Pictures in the Air*, "these three amateur deaf theater groups usually performed short original skits, mime shows, poetry, or sign-song programs, but no full-length productions." Meanwhile, on Broadway, Anne Bancroft – a relatively unknown actress at the time – was preparing for her stage role as Anne Sullivan in William Gibson's play *The Miracle Worker,* based on Sullivan's relationship with a deaf-blind student, Helen Keller. Bancroft visited schools for deaf children to help develop her character. What follows is a long and complex journey – well described in Baldwin's book – involving a friendship with Dr. Edna Levine, a well-known psychologist who worked with the deaf, appeals for arts funding from the federal government, and collaborations with Arthur Penn and David Hays, the director and lighting/set designer, respectively, for the Broadway production of *The Miracle Worker*. After a period of time, this culminated with David Hays forming the National Theatre of the Deaf, guided by influential Deaf and hearing educators and theater artists from New York and Gallaudet, which finally put Deaf theater on the map.[7]

Once early NTD actors (Miles, Mow) experienced validation of their acting craft by the general public, they became inspired to write original plays, one of which became a Deaf theater classic: *A Play of Our Own*. From there, future generations of Deaf playwrights developed from the cross-pollination of NTD's long-running, summer Professional Theatre School where the acting company worked closely with new, incoming Deaf theater students from around the world.

Perhaps one of the earliest opportunities for Deaf playwrights to develop new works was NTD's Deaf Playwright's Conference, beginning in 1978, which ran concurrently with the summer school. The first National and Worldwide Deaf Theatre Conference, which invited two to three playwrights to workshop new plays, began in 1994. In the meantime, New York Deaf Theatre ran the Sam Edwards Deaf Playwright's Competition (now Sam Edwards New Play Reading Series) for a number of years. Gallaudet University managed the annual Hlibok playwriting competition (sponsored by the Hlibok family in honor of Deaf playwright Bruce Hlibok) for Gallaudet University students. The National Technical Institute for the Deaf (NTID) offered the American Deaf Play Creator's Festival beginning in 1996 and continuing for several years. Deaf Spotlight Theatre in Seattle hosted a ten-minute short play festival.

More opportunities should open up for Deaf writers as more Deaf theater companies, festivals, and conferences crop up and people become increasingly interested in the culture and art of Deaf people, accepting them as differently

abled. The combination of these factors will, hopefully, lead to higher artistic quality, output, and greater recognition for the writers.

In this book's introduction, it was noted that a number of well-known plays produced on Broadway involving deafness or deaf character(s) were written by hearing writers and with hearing protagonists, through whom the audience sees the deaf character. Examples were: *The Miracle Worker* (William Gibson), *Children of a Lesser God* (Mark Medoff), *Clybourne Park* (Bruce Norris), *Johnny Belinda* (Elmer Harris), *Runaways* (Elizabeth Swados), *Tribes* (Nina Raines), *I Was Most Alive With You* (Craig Lucas), *The Little Flower of East Orange* (Stephen Adly Guirgis), *The Heart is a Lonely Hunter* (adaptation, Rebecca Gilman). Despite over 48 million deaf and hard-of-people residing in America, not one play written by a Deaf or hard-of-hearing playwright has had a play produced on Broadway or in a LORT (League of Resident Theatres) theater.

The living playwrights in this volume were asked to contemplate the above and respond to the following questions:

1. Considering this glut of cultural appropriation by Hearing writers, why do you think Deaf and hard-of-hearing playwrights have not had their plays produced in Broadway and LORT theaters to date?
2. What would it take to get them there?

Michele Verhoosky

I have learned through life that shaking up the status quo often meets resistance born from fear. Fear of change. Fear of a misperception of "otherness." As Deaf/hard-of-hearing playwrights, each of us is an ambassador. We bring to theater a rich heritage of language and culture, yes. But, more importantly, our authenticity underlines our humanity. Like any classic well-loved underdog story, our plays transcend our own proverbial backyard to become a universal story, linking and uplifting us all. The divisiveness, then, no longer is a barrier, but a bridge.

So, I say we all keep persevering. Keep creating. Keep being excellent in our craft and in our person. Always remember we are ambassadors. What we do and say matters. Reach out, reach across, reach back.

Stephen Baldwin

From my experience since 1978, there are several reasons for that lack of representation. Most d/Deaf playwrights after not finding much success do not continue in theater and tend to return to the careers they had. They basically give up because they were not encouraged or supported by the public or even by their theater peers. Sometimes they have little patience, hoping to win a Tony without merit. It took Eugene O'Neill years of patience and practice and stage-reading his plays with the Provincetown Players before he got his Broadway debut with *Beyond the Horizon* in 1920. Thousands of hearing playwrights have given up, and

it's not surprising that there are not that many qualified deaf playwrights who were basically a one-play deal.

There are many factors for that loss of interest and patience. Their plays are too focused on Deaf culture, deaf world, and ASL. Many lacked the expected universal element plays should have. For example, *Children of a Lesser God* had a strong universal theme about communication. Additionally, most deaf playwrights do not have a literary agent to promote their proven plays. It is hard to find a creative hearing director or producer willing to take a chance with a deaf playwright (probably for economical or artistic reasons). In my 45 years of being in the theater, I have only had two hearing directors who took a chance with my plays. We got as far as the college and community theater level, which was my original intent.

History proved that NTD's two deaf-themed, ensemble-created plays – *My Third Eye* and *Parade* were not commercial successes. Hearing audiences were more interested in the NTD plays that were written and adapted by hearing writers. Broadway producers have not wanted to gamble on a Deaf playwright; to succeed on Broadway is to appease the hearing audience. And, who cares about an angry deaf actor on stage? *Tribes* and *Children of a Lesser God* were exceptions. The use of a hearing protagonist who signs is what has made plays commercially attractive.

Requiring professional interpreters and hearing voice actors is expensive. The best bet for Deaf playwrights is to have their plays produced by a Deaf theater company like New York Deaf Theatre, Deaf West Theatre, Visionaries of the Creative Arts, and etc. From there, if the play is successful, solicit the script to a big city producer. If commercially viable, hop over to off Broadway and see what happens. Overall, we are looking at five years of planning to make something like this happen.

Sabina England

Playwrights have to get their plays workshopped as they try to advance through different production levels (staged reading, small production, bigger budget production, etc.). Who is going to pay for the interpreters or captioners? Many small theaters and workshops don't have the funds to do this. I've asked festivals for interpreters, and they had to rely on volunteers or student interpreters.

A lot of successful playwrights know the right people; they know theater producers and artistic directors who are looking for new plays to produce. They may have agents/managers who can get their plays solicited and be read for future consideration. Most well-known, successful theater companies will not read unsolicited plays. I really don't know any successful playwrights who are successful on their own for writing plays. Most writers I know aren't based in New York City, London, or Los Angeles, but the ones I know who live there, work in different jobs that pay better making it possible to live there. Many writers that I know are in smaller cities. Playwriting doesn't pay much, and most

playwrights (and writers) have second jobs and don't live in the right city to pull off connections.

I think many deaf artists/playwrights try to avoid Deaf-themed plays that because it seems cliched. As a Deaf woman of color immigrant, I find it gimmicky to write a play about being brown/Indian, being deaf, being Muslim, etc., because it seems more like an ensemble project (such as *The Vagina Monologues*, which is made up of various women from many different backgrounds who give monologues on gender issues, misogyny, domestic abuse, etc… issues that affect women, for being women).

Also, I want to avoid writing a deaf-themed play of a cliched deaf lead character falling into the stereotypical role of the angry deaf person who hates being deaf and struggles being deaf. The few times I have tried to submit my deaf themed pieces to deaf projects, I was told that they don't want deaf themes because it's "cliched!"

Patricia A. Durr

Years ago, there was an editorial piece written up after some Hearing actor had been cast in a Deaf role for a major play (I think perhaps *Tribes* – I can't recall right now). A Hearing playwright speculated that the reason why the majority culture is drawn to seeing representation of Deaf people played by Hearing actors is because becoming Deaf or disabled is something that can happen to them, and it hits too close to home. They can detach better and feel safer if the play may be about or use a Deaf person as a plot device. But if the Deaf character is actually a real live Deaf person then they have to confront the fact that this person is real and not an imaginary figure put up on the stage to teach us something and then disappear after the Hearing actor takes a bow.

This fear of how to make Deaf plays accessible to Hearing audiences has really sold us short. When we produced *META* back in 1993, I had to fight for permission/authorization to have at least one of the performances without voice. We always knew from LIGHTS ON! Deaf theater that the one performance we had voice interpreters changed the energy in the theater – Hearing audiences laugh and react at different times and to different things than Deaf audience members do. So when *META* was co-produced with NTID, a Deaf college, and LIGHTS ON! I was told by someone in the theater department that all the performances must have voice over. I met with the director of the college who granted me permission to have one performance without. It was at this performance that the Hearing reviewer from the local newspaper came and wrote up his review. He always came to LIGHTS ON!'s plays when there was no voice over as he wanted to experience the play for what it was rather than what he was being told. My Hearing students have submitted written responses to certain sign language productions about how impactful it was to experience a no-voicing performance despite not knowing ASL. Similarly, we have seen this with success of the film *The Tribe*, which is in Ukrainian sign language and has no captions or voice over.

Hearing people can and do appreciate exposure to more authentic Deaf experiences without voice.

Theater is very expensive and really requires a big backer/producer. Deaf folks don't have much capital. Years ago, when we were getting ready to launch LIGHTS ON! back in 1991, Phyllis Frelich, a prominent Tony and Emmy award winning Deaf actor, said to me,

> It will never work. I'm sorry to say but you can't have a theatre company committed to producing Deaf plays only. It's too small of a niche. Hearing people won't come, and Deaf people are too small of a group to cater to. Producing plays costs way more than what's earned from ticket sales – even for good and popular plays.

Rather than discourage me from pursuing our mission of producing Deaf plays, it instilled in me the knowledge that we would need grants. Ideally, a foundation or the NEA or the U.S. Department of Education, as it did for National Theatre of the Deaf, would back a theater company devoted to producing Deaf plays and that company would be committed to keeping the works as authentic as possible, affording audiences the opportunity to see the productions without voice over.

Another way to get us there – the National Association of the Deaf. They should invest in producing at least one Deaf play a year. In 1980, the NAD backed *Tales from a Clubroom* by Eugene Bergman and Bernard Bragg. NAD had plans for a creative cultural component where they invested in #Deaftalent and #Deafmade but it never materialized, just as they had dropped the ball in allocating funds for film production. The origins of the NTID theater department were born out of original Deaf-themed productions – largely led by Robert Panara, who help established the National Theatre of the Deaf, and NTID's theater program. However, NTID has only produced about 20 Deaf plays. The rest of the works – over 150 – have been Hearing plays with signing. Gallaudet University, the epitome of a Deaf-centered universe, has also only produced a few Deaf-themed productions. The National Theatre of the Deaf only produced two Deaf-themed plays since its founding in 1967 and hasn't done such a production in decades. Deaf West Theatre of late has met success and popularity by producing Hearing musicals but has never really committed to producing authentic Deaf plays.

Deaf organizations, college programs, and theater companies need to return to the root of the root of our soul. Our professional, regional, community, and college theater groups, by and large, have not invested in Deaf scripts and thus Deaf people themselves. Instead, they opted to produce imitation theater. Hearing and Deaf theater needs to invest in Deaf playwrights and creatives. Workshops should be hosted and experimentation with play creating should take place. A significant stumbling block for Deaf playwrights has been the burden of the written word. Thus, the majority of Deaf playwrights to date are White Deaf men who have high English skills. No disrespect to any of them because they have been

dedicated to representing Deaf experiences for the stage, but we often write what we know and the lack of diverse voices within Deaf theater is very telling. Kudos to Bergman and Bragg, Eastman, and Miles who each attempted to preserve "Deaf vernacular" via writing their scripts in English gloss. Thankfully, people like Willy Conley and Monique Holt have been fostering more creative ways of scriptwriting. Conley was an early advocate of using video technology to record some early improvisational work in attempts to best represent and capture ASL Deaf discourse and dialogue. Much more can be done in this realm.

Most importantly, Broadway and LORT need to invest in Deaf plays. They have the funds and the means to invest in Deaf playwrights and to stage Deaf productions. ASL artistry, multimedia productions have much to offer that has not yet been seen on Broadway and LORT. Culturally appropriating ASL and Deaf characters for their own purposes is no longer acceptable. Nor should it ever have been. Just as Deaf View/Image Art (De'VIA) – visual art about Deaf experiences, ASL literature, and Deaf cinema have been pigeon-holed as being "for Deaf eyes only" and regulated to Deaf spaces (schools, clubs, organizations, Deaf studies conferences, colleges, etc.), we are starting to see some breakthroughs. It has been a long time coming and is long overdue. It is imperative that as we move forward and advocate for Deaf theater on Broadway and in LORT theaters, we make sure this theater is representative of Deaf experiences beyond replicating White Male Deaf gaze and lens. Within our Deaf World, there are many voices that have never been seen nor fully understood. They especially deserve a day in the sun. This way when Deaf underrepresented actors take their bow, the audience sees that while ableism sucks, there is life among the Deaf and it is beautiful.

Michelle A. Banks

Onyx Theatre Company and Tony Kushner tried to bring Jaye Austin-Williams' play, *A Not So Quiet Nocturne*, to the Public Theater when George C. Wolfe was the Artistic Director. We did the reading at the Public Theater, but I think Wolfe was not feeling us back then. If we had persuaded Wolfe to produce it at the Public Theater then Jaye would have been the first Deaf playwright to have been produced in a LORT theater. We almost made history…alas, I think they were not ready for us at the time.

I think there is not enough support from the theater community, especially commercial producers, to get a deaf playwright's script produced on Broadway or in a LORT Theater. Also, most of us have not had representation by agents or managers. Perhaps their plays were not what theaters were looking for or maybe they were not appealing to them.

I think Deaf playwrights need to do more workshops/readings and invite people from the industry to come and see their work. Their next step would be to follow up with meeting with these people. Sometimes, we don't know what to do next. We need a representative who believes in us and would work hard to get us to the next level. (Jaye did not have a representative back then. Had she

gotten one when we had the reading at the Public Theater, her play would have been produced just like that!)

Jaye Austin Williams

Why, indeed, is there *still* virtually no representation of work authored by Deaf and hard-of-hearing playwrights on mainstream stages in 2020??!! Given the impressive list of work written to include Deaf and hard-of-hearing performers across the years, one would think space would have opened by now for Deaf and hard-of-hearing creators as well as performers of art.

It seems to me, as the film and theater industries have always been market-driven, and continue to be to this day, that Deaf artistic presence has, correspondingly, been susceptible to that persistent joker in the entertainment industry deck: the marketplace and its appetites; and few markets are *enduringly* friendly to what is framed as "novelty." And Sign Language (I don't use ASL here, because I strongly suspect that Deaf and hard-of-hearing artists who use sign languages are experiencing similar struggles globally) was susceptible to that novelization across the three decades (the 1960s through the 1990s), from the period of discovery (the NTD era through the Mark Medoff period, into the AIDS era and Broadway's approximately two-decades-long love affair with ASL-interpreted theater and Deaf audiences across the 1980s, 1990s, and a bit into the 2000s (including highlighted regional theater performances such as Howie Seago's role at the Kennedy Center, Monique Holt's at the Shakespeare Theatre, and extending to Hollywood and the phenomenon of Marlee Matlin). All of these encompass the very opportunities questioned here.

But then, the novelty wore off, leaving Deaf and hard-of-hearing artists to find their own niches where they could. So, these questions point to something that is not easy to have to face: an entertainment industry that does not understand that Deaf and hard-of-hearing creative artists have long been ready to compete in that market on their own terms. But, as that industry has struggled to figure itself out, and while the marketplace has shifted its attention to the virtual landscape, the live theater has become an insecure terrain, despite its having managed to sustain, better than many other civic spaces, its commitment to the hard-won accessibility mandates of the 1980s and 1990s. But that shift to virtual has defaulted back to a focus on largely white, cis-gendered, able-bodied people who have the primacy on screen, with a few novel appearances by Deaf actors (and other tokens who "pepper" the scenes in various ways) here and there. But certainly, the industry did not think to bring Deaf screenwriters and producers along. A handful of Deaf and hard-of-hearing artists have made some strides in film, television, and live theater across the years, but there have certainly not been enough opportunities to go around.

Also, as long as true access between the Deaf and hearing worlds requires hearing people to do the work of learning a language and gaining at least a fundamental knowledge of and respect for Deaf cultures (and we know, of course, that

Deaf "culture" isn't a monolith), Deaf and hard-of-hearing artists will remain at the margins, trying to reinvent their legibility in the hearing world while awaiting the cycling back 'round of deafness as novelty once again.

Aaron Weir Kelstone

I believe Deaf playwrights have been up against systematic oppression/obstruction. Deaf individuals interested in the arts are consistently discouraged by parents, Vocational Rehabilitation, and other figures of authority in their lives to pursue a career in the performing arts simply because it is not seen as a practical approach to earning a living for a deaf person. The solution to that would be for organizations to provide equitable access to training at the educational level in the performing arts.

For those who persist, access to educational training that will allow them to develop their artistic skills to achieve a professional level of competency is daunting. Gaining access to degree programs related to the performing arts is obstructive. Again, the solution for that is providing equitable opportunities for Deaf playwrights to workshop their work, offer public-staged readings, and allow them to serve as interns/apprentices or participate in residencies in LORT theaters for playwriting development.

For those who continue to persist, access to the normal channels for developing stories and plays are not accessible. Hearing playwrights, who have worked through the educational process, developed their networking relationships, and have their ear to the ground gain access into an iterative process for workshopping, staged readings, intern opportunities at LORT theaters, residency support, grant support to continue the development of their work. There are no avenues like this for deaf playwrights. To create such avenues, organizations need to offer access to training, at the professional development level, that enhances the Deaf playwrights' ability to "write," develop, present, and revise their work to the best of their ability.

Some stories by deaf and hard-of-hearing writers are often not well expressed in English because it is not their primary language. Lacking the training to express themselves visually and technology to support the recording, editing, and developing of captured kinetic of an expressive language (ASL) is not readily available. There are several written forms of ASL; however, support and access to training would allow Deaf playwrights to document their creativity – very much like a musician composes notes and scales to represent their musical creativity or dancers use their dance notation to show their movements, Deaf playwrights lack support for expressing their visual language. Instead, they are forced to express themselves in a foreign language. I believe certain theaters should be available and willing to host, rehearse, and produce deaf plays as part of their seasons.

In summary, several playwrights in this collection have made steps toward creating broader access – a universal design of sorts – within their plays. They

have invented ways to make their work visually alluring and accessible to as wide-ranging an audience as possible – something not normally observed in the works of plays by Hearing writers who primarily write for the ear. Deaf playwrights often think of creative ways to provide spoken English in conjunction with signed language on stage along with captivating visual imagery in some shape or form.

Michele Verhoosky utilized characters who double as spirits while providing signed or voiced lines of the other characters on stage. Jaye Austin Williams made her play more visual by incorporating pre-filmed home movie scenes on a projection to be blended in with the live scenes. She also included TTY (Teletype Text) phone conversations. To draw in a bilingual audience, the National Theatre of the Deaf ensemble created a highly visual production involving a circus sideshow, a choreographed dance and poetry in ASL, and object manipulation (large fabric and balls, symbolizing a mountain, chaos, and a birthing process). Willy Conley's play has no spoken or signed language; instead, pantomime, creative movement, masquerade, universal gestures, and phantasmagoria were used. Shanny Mow adopted the stylized dramatic convention of Japanese Kabuki theater and deconstructed it to make it his own. Michelle A. Banks employed live music on stage with various instruments to create the sound effects and moods throughout her one-woman show. Sabina England involved dancers who performed beautiful, poignant dances during parts of her play to signify a chorus, a group of ancestors, apsara, angels, ethereal beings. Dorothy Miles went the extra mile by providing translations to make her scripts bilingual – a tremendous timesaving, cost-efficient maneuver; otherwise, an ASL/English translator would need to be hired to provide the translations to the actors and director.

It is my hope that that these extra efforts will inspire Deaf and hard-of-hearing writers to continue to create original work and catch the eyes of influential directors and producers who will take new scripts of our Deaf culture and stories to Broadway and beyond.

Notes

1 Kilkenny, Katie. "Deaf Community Members Protest Hearing Actor Playing Deaf Character on 'The Stand': "Enough Is Enough." 20 December 2020. *The Hollywood Reporter.* Retrieved from: https://www.hollywoodreporter.com/news/deaf-community-members-protest-hearing-actor-playing-deaf-character-on-the-stand-enough-is-enough. Accessed 8 February 2021.
2 Christie, Karen and Durr, Patricia. "Deaf Theatre Mid 1800s to Mid 1900s: Video: Robert Panara Discusses the Origins of Deaf Theatre." Retrieved from: https://heartdeaf.com/heart/content/timelines/theatre/timeline.html. Accessed 8 February 2021.
3 MSS 77, Hughes Memorial Theatre, Collection of Hughes Memorial Theatre, 1959–1986." *Gallaudet University Archives.* Retrieved from: https://www.gallaudet.edu/archives-and-deaf-collections/collections/manuscripts/mss-077. Accessed 8 February 2021.
4 Christie, Karen and Durr, Patricia. "Deaf Theatre Mid 1800s to mid 1900s."

5 Baldwin, Stephen C. "Broadway 1942…Arsenic and Old Lace." *The Voice* Nov./Dec. (1989): 20–22.
6 I.S.F. "Miscellaneous." *American Annals of the Deaf* 87.3 (1942): 295–297. JSTOR, www.jstor.org/stable/44388391. Accessed 8 February 2021.
7 Baldwin, Stephen C. *Pictures in the Air: The Story of the National Theatre of the Deaf.* Washington, DC: Gallaudet University Press, 1993.

For Product Safety Concerns and Information please contact our EU
representative GPSR@taylorandfrancis.com
Taylor & Francis Verlag GmbH, Kaufingerstraße 24, 80331 München, Germany

www.ingramcontent.com/pod-product-compliance
Lightning Source LLC
Chambersburg PA
CBHW051347290426
44108CB00015B/1912